Aesthetics of Interaction in Digital Art

Katja Kwastek

foreword by Dieter Daniels

translated by Niamh Warde

The MIT Press
Cambridge, Massachusetts
London, England

Ludwig Boltzmann Gesellschaft

First MIT Press paperback edition, 2015

© 2013 Massachusetts Institute of Technology

All rights reserved. No part of this book may be reproduced in any form by any electronic or mechanical means (including photocopying, recording, or information storage and retrieval) without permission in writing from the publisher.

MIT Press books may be purchased at special quantity discounts for business or sales promotional use. For information, please email special_sales@mitpress.mit.edu.

Set in Stone Sans and Stone Serif by Toppan Best-set Premedia Limited. Printed and bound in the United States of America.

Library of Congress Cataloging-in-Publication Data

Kwastek, Katja.
Aesthetics of interaction in digital art / Katja Kwastek ; foreword by Dieter Daniels.
 pages cm
Includes bibliographical references and index.
ISBN 978-0-262-01932-3 (hardcover : alk. paper)—978-0-262-52829-0 (paperback)
1. Interactive art. 2. New media art. 3. Aesthetics, Modern—20th century. 4. Aesthetics, Modern—21st century. I. Title.
N6494.I57K89 2013
776.01—dc23
2012049423

10 9 8 7 6 5 4 3 2

Contents

Foreword

The literature on interactive art examines the actual experience of the actors in the interaction process marginally if at all. The reasons for this disregard include the heterogeneity of subjective experience, the difficulty of carrying out intersubjective comparisons, and the complex relationships of the technical, social, and aesthetic parameters involved. Interactive artworks are based on a mixture of different objective and subjective factors superimposed on one another. The following objective, material aspects can be identified: the artistic work as a material construct and as an interface with a technical apparatus, and the processes that are programmed to run on this apparatus. The subjective, contingent factors involved are the behavior of the individual users, the social interaction between users, and the artist's intentions as they are implemented in the artifact together with the programmer's implementation. As this inventory shows, the subjective and objective aspects are closely related and sometimes interchangeable. In addition, crucial roles are played by the mise-en-scène of the work as an exhibit and by the changing cultural contexts (e.g., art museum, media-art festival, exhibition of technology). Together, all these factors shape the actors' potential behaviors and approaches to the work, and thus also the interaction processes themselves.

Proceeding on the basis of genuinely art-historical premises, this study on the "aesthetics of interaction in digital art" opens up new perspectives within this complex topic. The concept of interaction, generally discussed in relatively abstract terms, is given concrete form (especially in the case studies), but it is also set in the context of different theories of aesthetics, which have seldom been examined to date with respect to their substantial significance for interaction. One of the outstanding features of this book is the manner in which it presents clear—and at the same time multifaceted—cross-references between theory formation and work analysis.

Today's discourses (science and technology studies, actor-network theory, theories of embodiment) are, of course, also taken into consideration. At the same time, however, elementary concepts from the classical repertoire of art history and cultural history are refreshingly revisited: work, action, aesthetic experience, play, aesthetic semblance.

The re-examination of these terms serves to integrate the discussion with traditional thought on aesthetics since Friedrich Schiller. The exploration of the concept of play, for instance, places interactive art in a cultural-history context that extends far beyond the time span of a few recent decades within which it is typically framed. This is the basis on which Katja Kwastek develops a systematic theory of aesthetics of interactivity. Her approach breaks away from traditional research, which often has a technocentric view, by putting the primary emphasis on the interactive process and the recipient's experience of it.

On the one hand, therefore, interactive art is not only emphatically claimed but also analytically proved to have unique characteristics. On the other hand, the futuristic rhetoric that has accompanied this type of art since the 1980s is implicitly criticized. The glorification of innovation, which can often be cloaked in a technicistic or an ideological mantle, is relativized by the reminder that interactive art also has other attributes—to the benefit of the artworks concerned and their aesthetic potential.

Kwastek identifies interactive art as an example of the hybridization of the arts and of their various genres. Hybridization should not be confused with artistic totality (as represented by the notion of the *Gesamtkunstwerk* or the concept of immersion) or with boundary dissolution (between art and life or art and politics, for instance). It is, in the first place, a phenomenon that is intrinsic to art, a phenomenon that has been aptly designated by Theodor Adorno as a "fraying" (*Verfransung*) of the boundaries between genres. Hybrid forms in interactive art arise out of the conjunction of elements of theater, music, film, video art, and the visual arts with a variety of digital technologies. The essential characteristic of the hybridization of the arts is that the hybrid form cannot be broken down into its individual components: the whole is more than the sum of its parts. Consequently, interactive art likewise cannot be cleanly broken down into discrete aspects that might then be examined within their respective specialist disciplines (art history, media theory, film studies, music studies, or theater studies, as well as HCI and interface studies). Since the 1960s, contemporary art has been a prominent setting for such hybrid, intermedia practices, partly because its environment tends to be comparatively permissive. Art history in the academic realm, by contrast, lags somewhat behind the other cultural sciences with respect to developing these topics as fields of inquiry for its own discipline.

What is special about this book is that it unites a distinctly art-historical approach with the discursive world mentioned above for the purposes of field-testing and gradually extending the different methodologies applied in art history. Interestingly, this perspective—which is as innovative as it is tradition-bound—is built on two core concepts of art history: the materiality of the artwork and the individuality of aesthetic experience. Materiality (contrary to all the rhetoric about digital immateriality) is still essential for the aesthetics of interaction and thus for the latter's basis in subjectivity (contrary to all rhetoric about digital posthumanity).

The foundation of aesthetic experience in subjectivity—as an essential characteristic of work analysis in art history—is first comprehensively substantiated by reference to theory and then systematically applied to the case studies, which name and elucidate the sources of the aesthetic experience. In place of the oft-encountered amalgam of artists' declarations of intent, art critics' jargon, and second-hand or third-hand descriptions (often based on documentation rather than on personal viewing), these case studies highlight the significance of the primary experience of the work. Katja Kwastek examines a question that researchers have tended to neglect: Which interaction is intended by the artist, and which interaction actually takes place in the exhibition situation when the public engages with the work? Following this line of investigation, exemplary cases are used to reassess the role of the recipients and of the creators of interactive art, as well as the similarities or differences between them.

Only on this basis was it possible to develop one of the core theses of this study: the possibility of reconciling reflective aesthetic distance with immersion in the "flow" of interaction. The methodical examination of subjectivity and its complex relation to what constitutes the artwork's objectivity, as well as the confirmation of the importance of personal aesthetic experience in the case studies, provide a dual basis for an understanding of interactivity that can be applied to all the relevant artistic disciplines, including visual art, sound art, Internet art, and performance art.

Kwastek makes clear, therefore, that the questions of aesthetic experience she treats in relation to interactive art also should become a part of the basic research that can be applied to all the art forms of the twentieth and twenty-first centuries. As Marcel Duchamp declared in his 1957 lecture "The Creative Act," "The personal 'art coefficient' is like an arithmetical relation between the unexpressed but intended and the unintentionally expressed." The results of this study indicate that Duchamp's statement should apply not only to the creative act but also to the receptive act.

The undertaking to provide a set of methodological tools which is suitable not only for interactive digital art but also for other contemporary art forms is thus honored, as is the promise of a new contribution to the general media theory of digital technology. The crucial if not always apparent importance of aesthetic factors for the various modes of interaction also found outside the artistic context, and the growing importance of the digital parallel world in daily life, are worthy of further research from this art-specific perspective. Katja Kwastek demonstrates that even the most classical concepts of art history can be a starting point for a contribution to this innovative and hybrid field of inquiry. Just as the "iconic turn" extended the subject matter of art history to non-artistic imagery, this book shows that art history can be rewardingly applied to forms of hybrid culture that are not primarily iconic, but processual and action-based.

Dieter Daniels

Preface

Berlin, House of World Cultures: People balance on flexible metal plates, illuminated by stroboscopic light. Others point clumsy portable bar-code scanners at objects displayed on supermarket shelves, or lounge in seating areas watching videos or listening to audio files. In conference rooms, people discuss questions of art, technology, society, and politics. Workshops invite you to tinker with little electronic animals. Everywhere, people of diverse nationalities come together to chat, welcome friends and colleagues, or have a drink. This is the world of new media art. Artists lecture about their own work. Theoreticians take part in workshops on software innovations. Visitors and artists discuss how the artists' works might be improved. People work or play on laptop computers. Children test the boundaries of interactive installations. And a few art historians stand around in amazement: Is it not they who should give lectures about art, and not the artists? How is it possible that the boundaries between activism and art are ignored here without any inhibition? Is this an exhibition, a conference, or a trade show? Are the scientific methods of art history of any help in approaching this cultural event? Above all, to what should those methods be applied—to the concepts presented in artist lectures, to the artifacts produced in spontaneous workshops, or to the random interaction of visitors with exhibits?

What you have just been reading is a bit of text from one of my first attempts to begin writing this book. I decided to include it in the preface because it helps to make some important points. First, it testifies to the astonishment of a traditional art historian (me, ten years ago) confronted with artistic and cultural practices that had little in common with the main topics of that art historian's university education. Second, it helps me today (now that I have gotten used to the formats of art and culture described above) to put myself into the position of colleagues, friends, audiences, and potential readers who might still consider new media art somewhat "special." In writing this book, I tried to consider readers (academic and non-academic) who are less familiar with cultural events and artistic expressions like those described above.

I came to be interested into new media art through my interest in digital technologies, having worked in the field of digital humanities long before I began to frequent media arts festivals. Out of curiosity, I began to explore how artists use digital technologies.

The next step was a walk along the dike with my mother, then the artistic director of the arts association of Cuxhaven, a little town in northern Germany. While talking about our views on contemporary art, we soon agreed that we should bring an exhibition on new media art to Cuxhaven. The result was a big international exhibition and conference on "art and wireless communication" that turned out to be very influential for my perspective on new media art and its aesthetics. Here I could experience the balancing of artistic intentions, curatorial premises, and audience expectations at first hand. Realizing that the aesthetics of interactive media art was still widely unexplored terrain, I decided to dedicate a book to the topic.

In 2006 I joined the Ludwig Boltzmann Institute Media.Art.Research. in Linz, intending to finish writing the book there. In Linz, not only did I have an opportunity to work with a great group of colleagues from various disciplines and to conduct extensive empirical studies; I could also profit from the activities and the archive of Ars Electronica. This book is thus also a result of encounters with people present and works presented in Linz in the second half of the 2000s, not only during the Ars Electronica Festivals but also year-round.

Still, on this whole research itinerary, I remained the art historian. Just as often as I found myself attempting to impart my passion for the field of media art to art history colleagues, I found myself proudly representing art history, my original discipline. This fact also informs the book. I aim to show what art history can offer concerning the scientific processing of interactive media art, but also to show that interactive media art can challenge and enrich the traditional methodology of art history.

The book addresses the theoretician as well as the practitioner. It is at the same time introductory and theoretical. In addition to suggesting an extensive theory of the aesthetics of interaction in digital art, it offers both a terminological and a historical introduction to the field, and it presents exemplary case studies. It discusses unique characteristics of interactive media art, but at the same time it opens up connections to related objects and fields. It scrutinizes existing theories so as to contextualize its field of inquiry within the various disciplines. Though the guiding criterion for this contextualization is, of course, the relevance of existing theories to the arguments I want to make, the reader may notice a slight focus on German scientific traditions. My hope is that pointing to some of the lesser-known (and perhaps not yet translated) discourses from my country of origin may further encourage the interdisciplinary and enjoyably border-crossing "un-discipline" of media art history.

This is a static book about processual art. I have included only few images, feeling that the works dealt with are at best experienced live or by means of video documentation. Although I have tried to describe the artworks so as to make their workings clear, you are welcome to consult the extensive online documentation that most of the artists provide. I have refrained from giving addresses, as addresses are subject to frequent change. You will find them easily using any search engine.

Acknowledgments

I started writing this book while I was member of the faculty of the art history department of the Ludwig Maximilians-University Munich. I especially thank Hubertus Kohle, who supported my research from the very first day. But I also have to thank all other colleagues and students at the department for making working there a delightful and inspiring experience— especially Gabriele Wimböck.

Once the research perspective had begun to take form, it was a great chance to be able to deepen it while acting as a visiting professor at the Rhode Island School of Design in 2006, on invitation by Teri Rueb.

The same goes for the Ludwig Boltzmann Institute Media.Art.Research. (LBI), which was a wonderfully interdisciplinary environment. I thank Dieter Daniels, who invited me to join the team and who has provided incredible support ever since (including his immediate offer to contribute a foreword to this book). Furthermore, I am grateful to all the colleagues I had the chance to work with in Linz, among them Gabriele Blome, Günter Kolar, Sandra Naumann, Dietmar Offenhuber, and Gunther Reisinger. The same goes for the people representing the partners of the LBI—especially Claudia Lingner and Marisa Radatz from the Ludwig Boltzmann Society; Michael Badics, Gerid Hager, Martin Honzik, Christopher Lindinger, Bianca Petscher, Manuela Naveau, and Gerfried Stocker from Ars Electronica; Reinhard Kannonier and Manfred Lechner from Kunstuniversität Linz; and Christa Sommerer and Laurent Mignonneau from the Kunstuniversität's Institute for Interface Studies. Working at the LBI also enabled me to conduct several extensive research projects, including those in cooperation with Gabriella Giannachi, Heike Helfert, Caitlin Jones, Lizzie Muller, and Ingrid Spörl, supported by the Daniel Langlois Foundation, Montreal (Alain Depocas) and the Mixed Reality Lab, Nottingham (Duncan Rowland, Steve Benford), whom I all thank for great cooperation and for making three of the case studies of this book possible.

From the huge new media (arts) and art history communities, I want to thank the following friends and colleagues: Marie-Luise Angerer, Keith Armstrong, Frauke Behrendt, Lars Blunck, Andreas Broeckmann, Söke Dinkla, Charlie Gere, Catherine d'Ignazio, Christian Drude, Annemarie Duguet, Zang Gha, Oliver Grau, Heidi

Grundmann, Kevin Hamilton, Günther Herzog, Erkki Huhtamo, Steven Kovats, Machiko Kusahara, Tobias Nagel, Michael Naimark, Christiane Paul, Simon Penny, Chris Salter, Bill Seaman, Edward Shanken, Mike Stubbs, and Noah Wardrip-Fruin.

Special thanks go to all the artists whose work I discuss in the book—especially Matt Adams, Susanne Berkenheger, Sonia Cillari, Jonah Brucker-Cohen, Holger Friese, Agnes Hegedüs, Lynn Hershman, Myron Krueger, Golan Levin, Olia Lialina, David Rokeby, Teri Rueb, Stefan Schemat, Scott Snibbe, Camille Utterback, Grahame Weinbren, and Robert Adrian X—for their work, their commitment and their willingness to be interviewed and to provide information and documentation.

This study also served as my Habilitationsschrift. I am therefore especially grateful to my habilitation committee—Hubertus Kohle, Dieter Daniels, Christopher Balme, and Ursula Frohne—for their confidence, support, and patience.

I owe a great debt to the Boltzmann Society and the partners of the LBI Media.Art. Research. who funded the translation. It was a pleasure to work with such a professional and committed translator as Niamh Warde. The final review of the manuscript took place while I was Visiting Professor at the Department of Art History and Visual Studies of Humboldt Universität zu Berlin. I therefore thank my Berlin colleagues for their support, and Nina Bergeest and Verena Straub for their help with formatting. I also wish to thank the staff members of the MIT Press for all their work in bringing the book to fruition, in particular Doug Sery, Paul Bethge, Katie Helke Dokshina, and Christopher Eyer.

I sincerely thank my parents, Heidi and Egon Kwastek, as well as my family, Sabine, Ute, Alexander, Titus, and Nike, for their endless (direct and indirect) support and confidence.

Finally, none of this would have been possible without Joachim Westphal, who not only supported my project from the very beginning but was also the greatest imaginable companion during conference trips and festival tours. Thank you!

Introduction

Since the beginning of the twentieth century, artists have increasingly sought to actively involve the recipient in their works and to stretch the boundaries of the traditional concept of the artwork. Since the 1960s—at the latest—this trend has been an object of extensive academic research. Nevertheless, art history still has difficulty acknowledging the specific (machine-based) invitations to participation that characterize interactive media art as a fully valid form of artistic expression. In this book, I argue that the particular aesthetic experience enabled by this category of art can open up new perspectives for art history, and not only with respect to the understanding of media art. In fact, a perspective founded on interaction aesthetics might inspire us to begin looking at other contemporary and historical art forms from new angles. Moreover, artistic presentations of media-based interactivity can be regarded as touchstones of a general media aesthetics.

Jonathan Crary has described the optical devices invented in the nineteenth century as techniques for the manipulation of attention that "codified and normalized the observer within rigidly defined systems of visual consumption."[1] In principle, this definition can also be applied to the media technology of the twentieth and twenty-first centuries, with the difference that such technology concerns not only visual consumption but also auditory and tactile activity on the part of the recipient. Moreover, media technology and the contexts in which it is used have become so complex that it is no longer appropriate to speak of "rigidly defined systems." Nevertheless, the manipulative capacity of media has grown enormously since the nineteenth century. The characteristic feature of media art is that it not only consciously orchestrates the manipulation of attention, it also often—self-referentially—makes such manipulation the theme of a work.

In this book I examine the aesthetics of interactive media art from a dual perspective. First, drawing on pertinent theories of process aesthetics and action analysis, I develop an aesthetic theory that can be used to describe and analyze interactive media art. Second, I present illustrative case studies that serve both as a basis for the theoretical considerations and as examples of their application. All the case studies

refer to interactive media artworks that have been produced within the last twenty years.

In the case of media art, especially, the institution of art can no longer be considered the only reference system, and perhaps not even the primary one. Media art reflects today's media society—either as interventionist practice or creative design, as a visionary model, or as a critical commentary. Consequently, it would be unsatisfactory if the only academic discipline to concern itself with media art were art history. Media art is also a topic for sociology, for media studies, and for philosophy, not to mention the other art sciences and the history of technology. This is not to say that art history can afford to ignore media art, however. On the contrary, art historians can contribute enormously to the scientific study and contextualization of media art activities, for their methods of description, comparison, and analysis of both form and content enable them to carry out in-depth examinations of the specific aesthetic configurations of individual works.

Although this study is motivated by the conceptual concerns of art history, it takes a cross-disciplinary approach. Because interactive art relies on action on the part of the recipient, it lies beyond the bounds of the traditional subject areas of art historians, as well as those of theater and music scholars. In 1998, Hans Belting noted that the boundaries between the visual arts and the performing arts had become blurred. Traditionally, according to Belting, what distinguished the visual from the performing arts was the conception of the former with a view to exhibition and observation, and of the latter with a view to performance and participation. The value of the traditional visual artwork, for Belting, was the fact that it existed "in the time of art, not in real time."[2] Now, however, Belting sees the boundary between the visual arts and the performing arts becoming blurred as the form taken on by the visual increasingly resembles spectacle. Belting is alluding here not to the "theatricalization" of the art object decried in the 1960s by Michael Fried (who was referring to minimal art's spatial and physical effects of presence) but to action art.[3] Ultimately, however, both Belting and Fried are concerned with the dissolution of the boundaries between the arts and the associated questioning of the traditional concept of "visual arts." This dissolution presents a challenge to the art sciences that has resulted in the formulation of essential theoretical viewpoints on twentieth-century art, including those of Umberto Eco, Lucy Lippard, and Peter Bürger.[4] That the aesthetic strategies these theorists examined are still important research topics today is demonstrated, for example, by two extensive interdisciplinary research programs on "Aesthetic Experience and the Dissolution of Artistic Limits" and "Cultures of the Performative" pursued in German academia in the 1990s and the 2000s. One of the goals of the present book is to relate this field of research to research in media art.

Up to now, most of the attempts to analyze the aesthetics of media art have been made by media theorists. Mark B. N. Hansen, for example, takes the perspective of

reception aesthetics to examine the digital age's new understanding of the image and its new concepts of the body, supporting his philosophical theories by thorough analyses of media art.[5] The present study, by contrast, puts the artistic work and the recipient's experience of the latter at center stage. This focus also distinguishes it from media theories such as Lev Manovich's.[6] Even if this study shares with Manovich an interest in the aesthetic structure and aesthetic effects of media-based processes, its theme is still not the contemporary media landscape in general. It specifically examines artistic strategies for staging interactivity not in order to make the case for a contrived differentiation between artistic and "other" cultural products but because works of interactive media art are often exemplary illustrators of both the characteristics and the implications of media-based processes. Interactive media art may thus inspire novel ways to apply, contextualize, and critically reflect on electronic media in general. It is often explicitly dedicated to new ways of "understanding media" (to quote the title of a famous book by Marshall McLuhan).[7]

Interactive art places the action of the recipient at the heart of its aesthetics. It is the recipient's activity that gives form and presence to the interactive artwork, and the recipient's activity is also the primary source of his aesthetic experience.[8] Thus, actions and processes, as opposed to (re)presentations, are the point of departure for this study. However, even though interactive art depends on action, there are still crucial differences between this genre and (other) performative practices. In performance art the recipient usually remains in the role of viewer, whereas in action art and happenings the recipient is often invited to join in the action of the artist or group of artists. Furthermore, in both performance art and action art, whether or not the recipient remains passive or becomes physically active, the actual co-presence of artist and recipient is usually required for the realization of the work; production and reception aesthetics coincide, and the work is conceived as an event experienced jointly by the artist and the audience. Interactive art, by contrast, presents an action proposition that is generally not modified by the artist while being exhibited. Production and reception are clearly distinguishable, although the work is implicated in both processes, but the interactive work—and this is what distinguishes it from traditional visual artworks—doesn't manifest its gestalt in the absence of reception.[9]

Thus, if interactive works are conceived with a view to action, which is enabled and to an extent orchestrated by but not performed by the artist, this characteristic differentiates interactive art from all other forms of art. In interactive art, the recipient becomes a performer. This is true not only for media-based works but also for many other forms of participatory and interactive art. In contrast to other forms of participatory art, however, recipients of interactive media art are mostly confronted with a "black box" situation—an apparatus whose workings are not self-evident. In fact, the exploration of the functionality of the work is an important component of

the aesthetic experience in interactive media art. The focus is not on face-to-face communication but on technically mediated feedback processes.

Interactive art is a hybrid combining elements of the visual arts, the time-based arts, and the performing arts. Each of the disciplines that study these art forms has its own methods for analyzing specific aspects of interactive art, but each of them also reaches its own disciplinary limits when dealing with this form of art, and not only because of its hybridity. The reason is that interactive art's predication on the physical activity of the recipient contradicts a fundamental condition to which the possibility of aesthetic experience of any art form is usually linked: that of aesthetic distance. The aesthetic object—according to the prevailing theory—is constituted only in the contemplative act of the viewer.[10] In interactive art, however, we are not faced with an artistic offering that requires straightforward observation; rather, the aesthetic object must first be made accessible through the action of the recipient before any act of contemplation (or reflection) is possible. This makes the requirement of aesthetic distance extremely difficult to satisfy. Physical action on the part of the recipient is indispensable for the materialization of the artistic concept, which the recipient must realize, experience, and reflect upon at the same time. An analysis of the aesthetic experience of interactive art must, therefore, not only do justice to its hybrid nature by following an approach that extends across the different disciplines, but also consult comparable constellations of experience, even those that are not primarily artistic in nature. One of these is play, which also strives for contemplation through action.

This study was written in a historical moment in which numerous doubts have been expressed about the legitimacy of the concept of media art. Some theorists are calling for greater differentiation within the domain of media art, whereas others believe it should be subsumed under the rubric of contemporary art.[11] This book is a contribution to both sides of the debate. It deals with a particular strategy used in media art (human-machine interactivity) from a clearly formulated perspective (aesthetic experience), and does so in the general context of the art of the last hundred years. At the same time, the aesthetics of interaction developed in this study should be considered an applied aesthetics. Rather than an abstract theory, I intend to provide a set of instruments for describing and analyzing interactive art that does justice to the variety of artistic strategies found in the field. This focus on applicability entails that the approach to interactive media art pursued in this book doesn't see itself as belonging to any particular discourse tradition (technically analytical, systems-theory, phenomenological, or deconstructivist). Theoretical positions will be discussed when they are useful to the analysis of particular characteristics of interactive art, but, to borrow a term from Barbara Büscher, there will be no "shadow-boxing" between theories that might cause us to lose sight of the real object of the study.[12]

The term "interactive media art" is used to refer to a broad spectrum of artistic forms of expression, ranging from Internet art through interactive sculptures to loca-

tive performances. This book takes account of this variety, but its specific focus is on artistic strategies that locate the aesthetic experience in the interaction between the recipient and the technical system. Media-based stagings of interaction between human beings are referred to on several occasions, but they are not the main theme of this book. Thus, the focus is on the very works that have drawn much of the criticism about interactive media art because their foundation in programmed processes calls into question the popular vision of the "openness" of interactive art, not to mention the role of the recipient as co-author. In this book, the fact that technological systems may actually substantially impede or curb interaction is seen as a distinguishing feature of interactive media art.

Interactivity is not celebrated here as an ideal way to configure aesthetic experience, nor is it presented as a counter-model to putatively passive contemplation. Jacques Rancière is entirely correct when he writes that every spectator is ultimately an actor in his own story, and that every man of action is also a spectator in the same story.[13] Contemplation and action should be seen not as mutually exclusive but as mutually dependent aspects of aesthetic experience. This is why it is so important to ask which specific forms of aesthetic experience are enabled by interaction within media-based systems and how they are related to (purely) cognitive perception.

My position as author is one of contemporaneity and historical distance. I became interested in media art only at the turn of the millennium, at a time when the avant-gardist visions of the 1990s and the sense of a dawning new era for art were already waning and the voices of the critics were becoming louder. From the point of view of art history, neither enthusiastic praise nor ill-defined criticism can do justice to media art, and so I began to examine the aesthetics that are specific to this type of art. In other words, I began to ask *how* this art, which is usually contextualized within the framework of socio-technological discourses, actually works. My intention is not to justify interactive media art to its critics, or to present a discourse analysis that historically contextualizes the avant-gardist ambitions of its pioneering works, but to scrutinize the aesthetic processes found operating in this category of art. Of course, even with this aspiration I remain a prisoner of my particular era, which has shaped my own perception of interactive media art, my focus on particular methods and theories, and my choice of certain guiding principles. In this sense, this study is also a personal "historical account" of the reception of interactive media art at the beginning of the twenty-first century. The task of identifying its blind spots naturally rests with others.

Studies that examine not only the processes of staging but also (or especially) the processes of reception of interaction propositions are faced with the problem of how aesthetic experiences based on individual realizations can be researched at all. The case studies on which the theoretical considerations are based rely on different types of individual or multi-perspectival analysis, made up of a combination of self-observation and third-party observation as well as interviews with recipients and artists. In the

other chapters, too, the theoretical models presented are supplemented, wherever possible, by statements and observations from artists and recipients. Thus, this study also illustrates the broad range of potential modes of access to interactive art, in order to demonstrate that research on reception aesthetics is ultimately always bound by the subjectivity of the individual perspectives of researchers and recipients. This applies to all analyses of artistic works, but especially to analyses of works that are rooted not in traditional sign systems but in open interpretability, and even more so to works that require activity on the part of a recipient in order to take on their actual form. Although it would thus be inappropriate to propose binding methods of exploration, general-purpose interpretations, or normative explanatory models, this doesn't mean that an aesthetic analysis of interactive art must be destined to fail from the outset. Quite simply, analyzing art in terms of process and reception aesthetics requires intensive observation of individual works "in use," comparative analyses, and theoretical contextualization from different perspectives. Only on the basis of such analyses can research in the field of process-based art forms be advanced in an interdisciplinary discourse.

Chapter 1 begins with a description of the basic notions and concepts of interactive media art and then analyzes processual strategies of twentieth-century art that can be considered an important backdrop for interactive media art. Artistic strategies that involve questions of chance and control, observer participation, instrumentalization of everyday objects, incorporation of rules and game structures, stagings of movement and feedback processes, active provocation of processes of perception and self-reflection (that is, a critical examination of one's own corporeity, behavior, and attitude), and the opening up of the spatial or temporal structures of a work were not invented by media art. On the contrary, these are predominant strategies employed by twentieth-century art. Their advent opened up a range of new artistic possibilities that not only shaped theory formation, but also prepared the ground for interactive media art.

If the gestalt of the interactive work ultimately reveals itself only when it is realized by the recipient, an aesthetic analysis of interactive art cannot limit itself to examining the formal structure and interpretability of the artifact or the interaction proposition presented by the artist. On the contrary, the aesthetic experience must be located in the process of realization of the work. For this reason, chapter 2 examines theories of aesthetic experience and process aesthetics in order to assess their relevance to an aesthetics of interaction. As will be shown, however, these approaches neglect the aspect of action—an essential facet of interactive art—as a potential source of aesthetic experience.

Chapter 3 investigates theories of play as a comparable mode of experience, for action and contemplation are closely linked in play, too. Play is understood here as a "boundary concept"—a transdisciplinary notion, with a variety of connotations, that nonetheless facilitates the discussion of the phenomena it denotes. The notion of play

includes both (free) play and (rule-based) games, as well as performances. Chapter 3 draws on theories of play and theories of performance for the purpose of identifying significant general characteristics of purposeless action and discussing their relevance to interactive media art.

The first three chapters, which provide historical and theoretical preambles, serve as the groundwork for the aesthetics of interaction presented in chapter 4, which aims to be both a theory and a set of tools for describing and analyzing interactive media art. An investigation of the roles and functions of the various actors involved in interaction processes is followed by a description of the ways in which interaction propositions can be staged and realized in space, with a particular focus on overlaps between real space and data space. The next topic is an analysis of the temporal structures of interactive media art regarding both interaction time and interaction duration as well as the systems of rhythms and processes implemented in the works. Proceeding from these descriptions, the actual interaction process can then be examined in more detail. Instrumental and phenomenological perspectives on interactivity are compared, different modes of experience of interaction are identified, and the significance of individual expectations and interpretations for the aesthetic experience of interaction is discussed. Finally, the relationship between materiality and interpretability is carefully examined. How can knowledge be produced by action? How can physical action inform the interpretability of art? How do multiple reference systems and potential frame collisions shape aesthetic experience? Chapter 4 concludes with a discussion of the ontological status of interactive art as a hybrid of an enduring artifact and an ephemeral action.

This study sees itself as an example of applied aesthetics in the sense that its theoretical considerations have been developed on the basis of case studies. As was mentioned above, the objective was not to produce abstract theories; it was to provide a set of tools for the analysis of interactive artworks. Chapter 5 consists of ten case studies in which the theory developed in chapter 4 is applied to typical examples of interactive media art. The first two works, Olia Lialina's *Agatha Appears* and Susanne Berkenheger's *Bubble Bath*, are Internet artworks; they are used here to analyze the staging of basic forms of narration through media technology. These are followed by another two narrative works, Stefan Schemat's *Wasser* and Teri Rueb's *Drift*, which, unlike the first two, are located not in the virtual space of the Internet but in real landscapes, so that they illustrate in an exemplary manner the potentials of interwoven real space and data space. The chapter then departs from the domain of narration in order to analyze interactions staged as real-time communication on the basis of a "classic" of media art: Lynn Hershman's interactive sculpture *Room of One's Own*. This interactive installation orchestrates a situation of reciprocal observation between the visitor, the artwork, and its narrative protagonist. The next work to be discussed is Agnes Hegedüs' *Fruit Machine*, an installation that invites the recipient to interact

simultaneously with a virtual sculpture and with other recipients and which explored the relationship between interactive media art and computer games at a very early stage in the development of media art. The next two case studies, of Tmema's *Manual Input Workstation* and David Rokeby's *Very Nervous System*, shift the focus to multimodal experience and the instrumentality of interactive art. Sonia Cillari's *Se Mi Sei Vicino* is similar to these works in that it, too, focuses on questions of physical activity and self-perception, but it goes further: By using a performer as interface, Cillari thematizes the relationship between human beings and machines in a very singular way. The final case study examines Blast Theory's *Rider Spoke*, which once again unites many of the aspects presented above, but goes beyond them by inviting recipients to partake in an action in public space that requires them to make spoken contributions.

The case studies are both the point of departure for a hermeneutic research process and its result. Because this book is bound to the linear medium of a printed text, the case studies that conclude the book exemplify how the features and categories identified in the previous chapters can be applied. However, readers who are less familiar with interactive media art may find that reading the case studies first will facilitate their understanding of the theoretical considerations. The conceptual dovetailing of work analysis and theory is central to this book, as is the methodological combination of art-historical analysis and reception research.

1 Interactive Art—Definitions and Origins

(New) Media Art, Computer Art, Digital Art, and Interactive Art

The designations in the subtitle above did not originate as provocative self-definitions by artists' groups (as did "futurism" and "Nouveau Réalisme") or as derisory labels (such as "Gothic" or "impressionism"). All were introduced as ostensibly objective classifications based on technical characteristics. Often, however, these terms have become equated with the debates sparked by the new art forms they designate, and they are consequently criticized in their place.

Since the 1980s, and increasingly since the 1990s, artistic works that make use of electronic media have been subsumed under the term "(new) media art."

If "media art" is regarded as an artistic category defined by technical or formal characteristics, then it is open to the common criticism that, in a broad sense, all art is media art, insofar as all art seeks to convey a message by means of a medium of some kind.[1] But even the narrower use of the term—according to which "(new) media art" refers only to forms of artistic expression that employ electronic media—fails to differentiate between analog and digital processes of image and sound production, or between participatory and representative works, or between performative projects and installations. "Media art" is, thus, an umbrella term for very different types of artistic expression, often also encompassing the field of video art. At the same time, many of the art forms designated as media art, as distinct from other types of visual art (visual art having established itself as the former's primary frame of reference), have something important and fundamental in common: their organization in time.[2] As a result, they are occasionally subsumed under the term "time-based art."[3] And yet it would be difficult to consider the processuality intended by this term to be a mandatory characteristic of media art, for that would exclude, for example, computer-generated images and graphics created using electronic processes without such processes being a characteristic of the works themselves.

"Media art," however, is often considered to be a genre or a trend in art, and thus understood in terms of common cultural or artistic goals. These goals are seen mostly

in the artistic reflection of the information society or in the creation of alternatives to the commercial media. In other words, these expectations represent a return—albeit in a new guise—to the avant-garde visions of the early twentieth century and the 1960s. In the 1990s, several authors made the euphoric claim, that media art was the trend-setting art form of the information age. Writing in 1997, Hans-Peter Schwarz— founding director of the Media Museum at the Zentrum für Kunst und Medientech- nologie (ZKM) in Karlsruhe—placed media art in the tradition of the "magnificent breakout scenarios of the intermedia art forms of the 1960s," which he saw moving to center stage in the 1990s "through a process of fundamental changes in our society" that earned them "a sudden and unexpected and perhaps not even welcome public interest."[4] Heinrich Klotz, founding director of the ZKM, wrote in 1995 that he believed a Second Modern Age had dawned: "The arrival of the media arts has changed all art."[5] In 1996, Gerfried Stocker, artistic director of the Ars Electronica festival in Linz, saw "artistic commitment as a model for navigation through a world in a state of mediamorphosis."[6] In the Ars Electronica 1998 festival catalog, the role of the media artist was described as a "prometeic battle of the self-sufficient and solitary subject against the perverse over-determination of society."[7]

Nowadays we no longer dream of such utopias, let alone believe we have achieved them. Accordingly, media art is at times considered a failure or at least a thing of the past—like so many avant-garde movements before it.[8] Furthermore, technologies that were once considered progressive are outdated today. Many innovative ideas of media art have long since been overtaken by developments of the mass media. Suffice it to mention Nam June Paik, who, in 1993, accused Bill Clinton of having stolen his 1974 concept of a "Data Highway" by promising an "Information Highway" during the 1992 presidential campaign. More recently, new game consoles like Nintendo's Wii and Microsoft's Xbox Kinect have revived models of embodied interaction that Myron Krueger proposed in the 1970s. But if we were to deduce from these facts a failure of media art, we would be ignoring the question as to whether, along with their social and technological utopias, the works designated as media art have also lost their pre- tension to reflect the world—in short, their claim to artistic validity.

It is not a coincidence that I have cited three people who in the 1990s played major roles in the founding and the development of important media-art institutions. The conceptualization and the evolution of media art have always been closely associated with its institutional environment, for it was only thanks to the institutionalization of media art in the 1990s that the sophisticated technology still essential then for such artistic practices could be made available to artists. As a consequence, however, the concept of media art was often associated by implication with the products of these institutions. This is evidenced by derogatory terms such as "SGI art," which mocks the dependence of many works from the 1990s on the computer systems of SGI (Silicon Graphics Incorporated).[9] Institutions and companies still have considerable

influence on the evolution of technically oriented art, but it is no longer appropriate to speak of a general relationship of dependency now that artists have much easier access to such technology. Thus, Inke Arns observes that "the interactive, immersive, and technically complex media art of the 1990s, which sharp-tongued polemicists liked to call 'ZKM art' and which was accused—to a degree justifiably—of reducing media art to mere interface development, no longer exists in this form today."[10] Arns describes the identification of media art with those particular forms of it that were shaped by institutional or technical influence as a "rhetorical ruse used by critics to discredit across the board the entire realm of practices in media art."[11] Arns and others thus call for the (re)integration of media-art practices into the general domain of contemporary art. In Stefan Heidenreich's view, "media art was an episode. . . . There is plenty of good art that uses media as a matter of course. But there is no such thing as media art."[12] And so these authors ultimately arrive at a conclusion similar to that of Rosalind Krauss and Lev Manovich, who level a general criticism against media-based definitions of art because they believe artistic works can no longer be adequately described in terms of the medium they use.[13] This view was anticipated in the 1960s by Dick Higgins, who coined the term "intermedia" (art) to denote artistic strategies that crossed media boundaries. However, as Dieter Daniels notes, the trend toward interdisciplinary art was initially succeeded in the 1980s by an emphasis on the nature of the particular medium used in the work, as evidenced by concepts such as "computer art."[14] The subsequent return to a conceptual union as "media art" was not unproblematic either, however, as is shown by the fact that the term "new media art" became common in the 1990s. As Beryl Graham and Sarah Cook recount, it had its peak at the beginning of the new millennium, whereas today there are renewed efforts to either differentiate the field or integrate it into the domain of contemporary art.[15]

Given the provenance of the designation "media art" in critical discourses on art and media, its dual use as the name of both a category and a genre, and its application as a generalizing umbrella term, it is no surprise that the meaning of the term is exceedingly vague. Nonetheless, it does seem appropriate for denoting the area of discourse with which it is associated, especially when its controversial connotations are acknowledged. Even if at least a partial integration of the works it denotes into the context of contemporary art would certainly be desirable, the term can still be used to underline those characteristics of technically oriented and processual forms of art that render their exclusive treatment in the context of the "visual arts" not very meaningful.

An older and at the same time a more specific term than "media art" is "computer art." Rather than referring vaguely to media in general, this term explicitly names a particular medium—the computer—and thus today might be considered a subcategory of media art. However, the term "computer art" was coined in the early days of digital

media to denote computer-generated graphics, and is still often used today as a historicizing label for these works.[16] This may be the reason why the term was increasingly replaced by "digital art" in the 1990s. Contrary to what the wording of the term may suggest, "digital art" is understood to refer not only to purely immaterial works expressed in code, software, or data—such as Internet art—but also to installations and performative works that use digital media. Moreover, the term is applied both to works that primarily use digital technology as part of their method of production (as in certain forms of digital photography) and to projects in which the processual qualities of digital technology are an elementary feature of the work; examples are generative software and works based on an interaction between the recipient and the digital systems. Such works are produced, stored, and presented in the digital medium.[17]

Digital artworks that require the viewer to engage in some kind of activity that goes beyond purely mental reception are commonly designated as "interactive art." In *Pioniere interaktiver Kunst* (Pioneers of Interactive Art), Söke Dinkla proposes the following definition: "The term 'interactive art' serves as a category-specific designation for computer-supported works in which an interaction takes place between digital computer systems and users."[18] The restriction of the label interactive art to the field of digital art is controversial, however. Some authors even ask whether computer-supported art should be called interactive at all, insofar as there are numerous art forms that activate the recipient to an even greater extent without the support of technical media.[19] These concerns are rooted in the fact that interactive art can be measured either in terms of criteria for human-machine communication or in terms of the sociological concept of interaction—in other words, on the basis of the ideal of face-to-face communication. The expectations of art forms labeled as interactive will always be determined by the particular system of reference used. Because the aesthetics of interactive art are substantially influenced by such expectations, the reference systems on which they may be based, as well as the historical development of these systems, will be briefly presented in the following subsection.

The concept of interaction

Around 1900, the concept of interaction was used to denote various different types of feedback process. The 1901 *Dictionary of Philosophy and Psychology* defined interaction as "the relation between two or more relatively independent things or systems of change which advance, hinder, limit, or otherwise affect one another," citing as examples both the body-mind relationship and the interaction of objects in and with the environment, which is also often called "reciprocity."[20]

When sociology became established as a scientific discipline, at the beginning of the twentieth century, the concept of interaction was applied to social and societal processes. Georg Simmel was the first to use the term in Germany to characterize interpersonal relationships.[21] In the English-speaking world, George Herbert Mead and

Edward Alsworth Ross discussed "social interaction" and "the interaction of human beings" as early as 1909.[22] Mead's student Herbert Blumer systematized Mead's research under the term "symbolic interactionism," setting it in contrast to the "stimulus-response theory" in 1937. The proponents of the latter theory, which was rooted in the social psychology of the early decades of the twentieth century, perceived interpersonal interaction as a complex process of cause and effect between the various sensory organs and muscle groups. They thus explained it primarily in physiological terms and studied it by means of statistics.[23] The symbolic interactionists, by contrast, saw "social interaction as primarily a communicative process in which people share experience, rather than a mere play back and forth of stimulation and response."[24] Whereas the stimulus-response theorists mainly studied reactions, the interactionists were interested in actions.[25] Thus, symbolic interactionism extends the concept of stimulus and response so as to include interpretation, which mediates between actions and reactions.

The emergence of cybernetic theory midway through the twentieth century opened up new perspectives on processes of interaction. Norbert Wiener—who in 1947 coined the word "cybernetics" (from the Greek *kybernetike* = "the art of the helmsman") to denote the science that studies the structure of complex dynamic systems—was less interested in interactions between human beings than in analogies between the self-organization of the human organism and that of feedback control systems. In *The Human Use of Human Beings: Cybernetics and Society*, published in 1950, he suggested, however, that one could also describe society by analyzing communication processes.[26] Although Wiener focused on processes that lent themselves to statistical analysis, as did the stimulus-response theory criticized by Blumer, his theory of feedback processes goes beyond the latter model by distinguishing different types of feedback, ranging from reflexive reactions to systems that are capable of learning.[27] It was therefore cybernetics that first focused research on the potential value of precise theoretical analysis and technical reproduction (by means of machines and later computers) of various interaction processes.

By the early 1960s, computer technology was so advanced that interaction between human beings and machines, in the sense of a real-time feedback process, began to seem possible. In 1960, the American psychologist J. C. R. Licklider, considered a pioneer of computer science, wrote in a groundbreaking essay that he planned to "foster the development of man-computer symbiosis by analyzing some problems of interaction between men and computing machines."[28] Only a few years later, the first systems that made real-time interaction between humans and machines practicable were built. In 1963, the electronics engineer Ivan Sutherland presented an invention he called Sketchpad as part of his doctoral thesis at the Massachusetts Institute of Technology. Sketchpad was a graphical user interface that allowed graphics to be manipulated on a display screen by means of a light pen. Sutherland explained that

the system permitted human beings and computers to communicate through the medium of line drawings. Previously, Sutherland wrote, interaction between human beings and computers had inevitably been slow because all communication had to be reduced to statements written in type: people had to write letters to the computers, as opposed to conferring with them. Thus, Sutherland declared that the Sketchpad system opened up "a new area of man-machine communication."[29]

A year earlier, Douglas Engelbart, the founder of the Augmentation Research Center at the Stanford Research Labs, had presented his concept for "augmenting human intellect," which employed new technology to improve human processing and analysis of information.[30] Around 1965, Engelbart created the "X-Y position indicator for a display system," nowadays universally known and used as the mouse. With the arrival of Sutherland's concept of the graphical user interface and Engelbart's mouse, fundamental elements of the human-computer interface were now available. Thus, the research field of Human-Computer Interaction (HCI), which is concerned with the development and study of user interfaces and input media, was born.[31] HCI research should by no means be considered only a subsection of computer science, for it also deals with themes from the human sciences. In fact, this research field is interested both in the utility of the computer for human beings and in communication between humans and computers.[32]

If, then, on the one hand, technological research is receptive to theories of social interaction, on the other, the human sciences have also always specified their concept of interaction in response to new technological and media-related fundamentals and in close exchange with the new fields of media and communication studies. As the communications theorist Christoph Neuberger explains, nowadays interaction is described either as a subset of communication or vice versa, depending on whether researchers are interested in the feedback processes themselves or in the cognitive elaboration of these processes.[33] Unlike many other authors, Neuberger doesn't consider the mere presence of the interaction partner a guarantee for successful interaction. He argues that such a view equates the potential of the communication situation with actual communication, for "not every communication between people who are present is interactive."[34] Inverting the argument, he also holds that interaction doesn't necessarily require the actual presence of the interaction partners. One cannot presume that indirect communication is in principle inferior to direct communication, Neuberger asserts, because certain aspects of face-to-face communication might even be obstructive, depending on the purpose of the exchange. The distinction between the potentiality and the actual realization of interaction processes is fundamental for Neuberger in another respect, too, for he sees a need to distinguish between interaction and interactivity, the first describing a process that actually happens and the second only a potential process. As we will see, this distinction is extremely rewarding when applied to interactive art, which is based on the realization of potentials that are built into systems.[35]

Thus, the concept of interaction—originally used to describe the reciprocal actions that take place in biological, chemical, and physiological processes—has undergone considerable diversification and differentiation over the last hundred years. While, on the one hand, sophisticated theories of social exchange have been formulated in various disciplines (sociology, psychology, communication studies), on the other, a brand-new science has been born in the form of cybernetics, which proclaims the importance of feedback processes as a general basis for life and technology. Moreover, advances in computer technology have made it possible to digitally control technical feedback processes and, in the context of the developments in HCI research, place them at the service of human beings. It is not surprising, therefore, that these developments have led to the emergence of extremely varied notions about interaction processes. The fundamental features of interaction that have been identified include real-time exchange and presence, control and feedback, and selection and interpretation processes.[36] An analysis of artistically configured interaction processes must take these various reference systems into account if a differentiated examination of their artistic aims and of the expectations of their recipients is to become possible.

The conscious incorporation of interactivity as a component of artworks initially took place more or less in parallel with its scientific exploration in the social sciences. Although the first artistic attempts to actively involve the public go back to the beginning of the twentieth century, the breakthrough of these new concepts in the context of action art did not occur until after World War II. Since then, the analysis of interrelations between artist, artwork, and the public has become established as a basic theme of artistic practice and art theory. However, artworks that actively involve the public—without the use of modern technology—are often not denoted as "interactive," but as "participatory" or "collaborative" works. Initially, the concept of interactive art had not yet been introduced, and later it was often consciously avoided so as to distinguish these works from projects that use digital technology.

The first art projects based on technical feedback processes initially employed analog electronic media and had close links with the ideas of cybernetics. As early as the 1950s, Nicolas Schöffer, James Seawright, Edward Ihnatowicz, and other artists were building apparatuses that interacted with the environment or the public, mostly by means of light or sound sensors. Nonetheless, these artists did not call their works "interactive"; instead they called them "cybernetic," "responsive," or "reactive."[37] Although the use of computers was already being imagined, very few artworks were actually based on processes controlled by computers.[38] In fact, cybernetic art soon entered a phase of disillusionment. In 1980 the art historian Jack Burnham expressed his disappointment unequivocally: "Why have the majority of artists spurned advanced technology, and why have others so bungled its use in producing new art forms?"[39]

The pioneers of interactive media art came from quite different geographical and professional backgrounds than the protagonists of cybernetic art. While most of the latter worked in Europe, the early computer-supported installations of the 1970s and

the 1980s were created in the United States. In 1969, artists and scientists from the University of Wisconsin built an installation they called *Glowflow*. It consisted of phosphorescent particles circulating in transparent tubes that were kept in a dark room. Visitors were able to make the particles glow by walking on touch-sensitive computer-controlled floor pads. It was the flyer accompanying this exhibition that contained the first use of the term "interactive art": "Glowflow is not an exhibit in the traditional sense, but a continuous experiment in interactive art."[40] One of the collaborators on the Glowflow project was Myron Krueger, a pioneer of interactive media art. Instead of devoting himself to the construction of cybernetic sculptures or robot-like creatures, Krueger took as his point of departure the idea of a responsive environment that would react to changes in its surroundings. He strengthened the environment's sensory capacities by installing video cameras, enhanced its operative processes through the use of computers as controlling devices, and extended its reactive options through projections of computer graphics. Nonetheless, Krueger used the term interactive art only rarely. The same is true for other artists who started working with digital interaction systems in the 1980s.[41]

And so, while social interactions were increasingly staged as artistic projects from the 1960s onward, and electronically controlled interactions were first used in art projects in the 1950s and the 1960s (followed by digitally controlled human-machine interactions from the 1970s on), it was not until the 1990s that "interactive art" became an important concept in media art.[42] The public perception of interactive (media) art as an independent genre was bolstered by its inclusion in 1990 as a category in the Prix Ars Electronica, which also established the restrictive use of the term to the areas of electronic and digital art. In the 1990s, interactive art was thus frequently celebrated as *the* groundbreaking manifestation of media art.[43]

However, the more artists used technological feedback processes in their work from the 1990s on, the more evident was the discrepancy between the restrictive use of the term "interactive art" for computer-supported installations for human-machine interactions and the numerous denotations of the word "interaction" itself, which is based on various concepts of social, biological, and technical exchange. Similar to the debates about the term "media art," the term "interactive art" is a constant source of debate, and definitions are still being conceived that seek to do justice to present-day artistic products. One example of these efforts is the "broader definition of interactivity" proposed by the jury of the Prix Ars Electronica in 2004. According to that definition, "mediation by computer" was no longer a "requirement" for this category. The jury called for "relaxation" of the constraints on "real-time interaction" and also allowed "passive interaction."[44] Such new definitions reflect the generally observable trend toward a relaxation of the rigid boundaries between digitally and analogically mediated interaction, and between active participation in feedback processes and their "passive" observation.[45]

In this study, I will use the term "interactive art" whenever generally interactive processes—which need not be digitally mediated—are discussed. Whenever the digitally mediated interactive artworks at the focus of the study are addressed exclusively, this will be specified by the use of the term "interactive media art."[46] Even if the theme of the study is the discussion of the specific aesthetic characteristics of digitally mediated interaction, this will not be carried out in terms of rigid distinctions. On the contrary, many of the concepts pursued in digital art are based on process-related strategies that were developed independently of the use of electronic media. Accordingly, the aesthetics of interaction developed throughout this book will also be relevant to art projects that are not electronically mediated. However, the main emphasis will be on the question as to whether digitally mediated interactivity creates new potentials for aesthetic experience.[47]

Aesthetic Strategies in Processual Art

It is not the aim of this study to present a history of interactive media art. This is not because the topic has already been dealt with in individual studies,[48] artists' monographs,[49] and overviews,[50] as well as in general works on media art,[51] but because the wisdom of such an undertaking seems dubious at this time. As Söke Dinkla points out, it would be misleading to speak of a causal history of interactive media art in the sense of a historical development whose logical conclusion was the emergence of a concretely definable art form with this name.[52] After all, the variety of terms and reference systems is matched by an equally heterogeneous collection of motivations and personal and theoretical incentives that have prompted artists to experiment with process-related and participatory strategies since the 1960s. Nonetheless, none of these strategies developed in a vacuum. In fact, we can observe both continuities that link back to the concepts of the classical avant-garde and numerous personal relations that were essential for the cross-linking and cross-influencing of different artistic genres and categories. Examples include Jean Tinguely's contacts with Yves Klein and Robert Rauschenberg, Rauschenberg's intensive collaboration with Merce Cunningham and John Cage, and the enormous influence of John Cage's teachings in the United States and of Roy Ascott's in Great Britain. There were also close interactions between artistic practice and art theory. Major figures such as Roy Ascott and Allan Kaprow worked at both the practical and the theoretical levels and thus directly supplied the relevant theoretical background to their artistic activities. The cross-disciplinary exchange between visual art, music, and performance, which was significantly shaped by Cage and his courses at the New School and at Black Mountain College, as well as the exchanges between artists and engineers made possible by the engineer Billy Klüver and others, were important impulses behind the development of artistic strategies that also served as a conceptual background for interactive media artworks. This doesn't

mean that all artists working in the area of interactive media art categorically draw on these developments or have their origins in these environments. While some of the "pioneers" had already carried out projects in the broader milieu of action art (for example, Jeffrey Shaw in the Expanded Cinema movement and Lynn Hershman in the field of performance art), others first underwent traditional training in painting and then switched to interactive media art (Mark Napier is an example). Nonetheless, many of the artists can be described as "lateral entrants" who came to interactive art from non-artistic disciplines such as computer science (Myron Krueger) or from other artistic fields such as architecture (Sonia Cillari) or film (Grahame Weinbren). Even if many of the artistic strategies described below are often treated as direct forerunners of interactive media art,[53] we should be careful about making casual generalizations about the category's relationship to social, cultural, or art-history contexts, and also about the motivations behind the use of interactive technology in art.[54]

What is needed first is a set of theoretical instruments that will permit an in-depth analysis of the aesthetic strategies underlying these artistic works so that a basis for their interpretation and comparison can be created. Of course, an analysis of this kind must not dispense entirely with historic contextualization. Though it doesn't seem useful to create a linear historical model of development, interactive media art can only be described within the context of the arts of the twentieth century and the early twenty-first century. The same applies to the aesthetic theories that were developed in direct response to the new process-based and participatory art forms. These theories will be discussed in chapter 2. In the remainder of the present chapter, I will describe twentieth-century artistic practices that are relevant to the field of interactive media art in one way or another.

Process and chance

The avant-gardists of the first half of the twentieth century had already questioned the classical object-oriented concept of the artwork, advocating instead a more process-oriented and event-oriented understanding. The futurists and the dadaists demonstrated their opposition to the traditional art system in provocative manifestos and performances and by relying on elements of chance during the genesis of the artistic work.[55] Marcel Duchamp's *3 Stoppages étalon* (1913–1914)—in which three threads were dropped from a height of one meter and then fixed to the canvas on which they fell—is celebrated as the "prototype of the aesthetics of chance."[56] Duchamp also saw his ready-mades primarily as manifestations of non-intentionality.[57] The surrealists also instrumentalized chance, both through the incorporation of everyday materials and through the psychic automatism of "écriture automatique."

Jackson Pollock was fascinated by the idea of automatism and developed it with a view to full-scale abstraction. His "drip paintings" definitively shifted the process of artistic creation to center stage. These paintings—consisting of abstract patterns of

color dripped onto the canvas—drew the following comment from the art critic Harold Rosenberg in 1952: "What was to go on the canvas was not a picture but an event."[58] It is important to note that Rosenberg did not tie the concept of event to spectator participation.[59] In fact, he used the term to denote an aesthetics of production that can be characterized as performative practice. (See chapter 3 below.) In 1998, Paul Schimmel observed that Pollock's "desire to maintain 'contact' (his word) with the canvas essentially transformed the artist's role from that of a bystander outside the canvas to that of an actor whose very actions were its subject."[60] The transformation into the role of actor thus doesn't apply here to the recipient (as in subsequent, participatory art forms), but initially applies only to the artist. The focus is on the process of production, not on reception.

Pollock's emphasis on action and his appeal for automatism suggest that he was interested in random processes within the framework of the genesis of the work. However, as Christian Janecke has noted, Pollock made rather contradictory pronouncements in this respect, emphatically acknowledging random processes on the one hand but claiming to have "as much control as possible over the painting process" on the other.[61] Pollock's ambivalent position might indicate that while he wanted to manifest random processes with his works, he did not want to relinquish his artistic influence over the result of these processes—the gestalt of the work. Thus, whereas Duchamp used random processes to challenge artistic composition by replacing it with non-intentional events, for Pollock random processes were a means of enhancing his artistic expressivity.

Pollock's activities received international recognition in a wide variety of artistic contexts. Art informel painters, as well as artists such as Yves Klein and Lucio Fontana, stretched the material boundaries of artworks but still remained attached to the art object. The Viennese actionists and the GUTAI group in Japan, by contrast, developed a kind of action painting that could almost be considered action art.[62] North America's action artists also claim Pollock as a forerunner. Although there are few stylistic parallels to abstract expressionism in their work, they consider the processuality of painting to be a source of inspiration for their actions. Allan Kaprow identified himself as belonging to this tradition in an essay titled "The Legacy of Jackson Pollock."[63] Nowadays, however, some feel that Pollock's role as a trailblazer has been exaggerated. Paul Schimmel suggests that an "overstating [of] the case for the performative qualities of Pollock's painting" has led to the construction of a myth around the artist, responsibility for which he believes is shared by Rosenberg and Kaprow.[64]

By contrast, the major role assigned to John Cage in the development of new artistic strategies in the 1960s doesn't seem exaggerated. Cage, who was a trained musician, attracted both performing artists and visual artists and thus played a decisive part in the dissolution of disciplinary boundaries. He worked intensively with random operators and also experimented with technological media. In his composition *Imaginary*

Landscape IV (1951), he used twelve radios "not for the purpose of shock or as a joke but rather to increase the unpredictability." Chance, Cage believed, offered the possibility of "a leap out of reach of one's own grasp of oneself."[65] George Brecht and Allan Kaprow, both of whom attended Cage's lectures, also highlighted the importance of random processes in their work.[66] Kaprow described chance as a vehicle of the spontaneous. He saw the planning and channeling of random processes by the artist as a form of control that nonetheless created an impression of something unplanned and uncontrolled.[67]

Thus, random processes can be employed to very different ends. Duchamp used them to show an absence of intentionality, Pollock was interested in enhancing spontaneous expressivity, and Cage was concerned with the unpredictability of processes that lie beyond the control of the artist.[68] Kaprow, meanwhile, emphasized that these processes were always implemented by the artist for his own purposes. The relationship between chance and control will prove, in the course of this study, to be central to the aesthetic experience of interactive art.

Random operations had a different function again in early computer graphics, where the aim was not to represent indeterminacy but to create variability. In the 1960s, Frieder Nake and Georg Nees, two mathematicians who were investigating Max Bense's theory of generative aesthetics, began to produce graphic images using algorithmic operations. The graphics were often in constant motion, the incorporation of random operators allowing for variability in their form and sequences of movement.[69] These processes can also be considered interactions, though only in the form of an intrasystem interaction between program components. Subsequently, the users, too, would be able to manipulate the dynamic shapes that had been generated. Today, computer graphics are primarily used in the applied field of visualization, for example in science and music, where they now usually visualize external data. Digitally programmed random processes continue to play a role in contemporary media art as generators more of variability than of unpredictability. They are used to create dynamic graphic images, but they are also used in software art, digital literature, and Internet art.[70] In interactive media art, unpredictability is usually embodied in the reactions of the recipient. Myron Krueger emphasizes these analogies between random operators built into systems and the unpredictability of the actions of recipients. He argues that random processes were implemented in computer art so as to generate complexity, because it is difficult to create complex stimuli by means of programming alone. In interactive media, by contrast, the participants are the source of the unpredictability.[71]

Thus, artists' desire to integrate elements of the unpredictable into the process of gestalt formation is one possible reason for their interest in actively involving the recipient in their works. Nam June Paik claimed in 1962 that "as the next step toward more indeterminacy, I wanted to let the audience act and play itself."[72] In fact, at his

groundbreaking *Exposition of Music* (1963), visitors were able to use a foot pedal and a microphone to operate two manipulated televisions, and other television sets had been prepared to react to radio programs and audio tapes. In connection with his fascination with intermedia interactions and their alienation effect on the information transmitted, Paik saw recipient participation as one of many means of processing visual and acoustic material. He continued to pursue these explorations in the different versions of his *Participation TV* (1963–1966) and *Magnet TV* (1965).[73]

Participation

The new artistic interest in the processual qualities of artworks, and in factors that could not be controlled by the artist, led to an exploration of the situation of presentation of artworks and of the role of the public and its receptive activity. As Lars Blunck shows, Duchamp's oft-quoted declarations from the 1950s that ultimately it was the observer who made the work are by no means the first of their kind. As early as 1851, Richard Wagner had called for the spectator to become co-creator of the artwork, and similar statements were made in the ambit of early twentieth-century avant-garde film and theater.[74] Whereas Wagner, like the avant-gardists, was concerned with observance as co-creation in the sense of interpretation and actualization, Duchamp questioned the meaning of artistic intentionality in general.[75] The American artists of the postwar years, by contrast, initially focused on heightening the sensitivity of the recipient to each unique reception situation. In 1951, on the occasion of the exhibition of his entirely monochromatic White Paintings, Robert Rauschenberg declared that the paintings were not passive but "hypersensitive." He was referring here to the fact that the shadows cast on them showed how many people were in the room, for example, and that each picture changed appearance depending on the time of day. It was irrelevant, he said, that he had created these paintings: "Today is their creator."[76] John Cage, who was also a close friend of Rauschenberg's, pursued the idea of incorporating the environment or the immediate exhibition situation into the concept of the musical work. The score of his renowned piece *4'33"*, composed in 1952, simply lays down time intervals that allow listeners to perceive the surrounding soundscape. The beginning and the end of each interval are indicated by closing and opening the piano's lid, the lid remaining closed for the duration of each of the three movements in the piece.

Thus, audience participation was first realized in terms of a presence of the recipient "in the work" with the aim of enhancing (self-)perception. The same applies to the early manifestations of action art, which were later called "happenings." At Black Mountain College in 1952, John Cage organized an action (featuring four of Rauschenberg's White Paintings) that was later titled *Theater Piece No. 1*. It consisted of music, dance, painting, poetry, readings, and projected images presented by different performers in an open time frame, and "not on a stage, but among the audience."[77] Ultimately,

however, the only people who were really active and therefore relatively free to compose their own actions were the performers themselves. It was only very gradually that the action art of the 1950s and the 1960s began to actively involve the public in actions, in addition to the performative activities of the artists.

The event *18 Happenings in 6 Parts*, staged in 1959, is usually referred to as the first happening in the history of art—because, thanks to Allan Kaprow, it was the first to bear this name. Kaprow defined the happening as a spatial conflation of public and performance in improvised situations that left much to chance.[78] He saw the involvement of the participants (Kaprow did not differentiate between performers and public or between artist and recipient; he used the inclusive personal pronoun "we") as the benchmark for the artistic status of the projects: "Whether it is art depends on how deeply involved we become with elements of the whole and how fresh these elements are."[79] Moreover, he made it clear that different kinds of participant behavior were possible: "In the present exhibition we do not come to look at things. We simply enter, are surrounded, and become part of what surrounds us, passively or actively, according to our talents for 'engagement.' . . . [We] will constantly change the 'meaning' of the work by doing so."[80] It is not easy to establish in hindsight how involved the public actually was in these happenings. The degree of participation probably varied significantly from one work to the next.[81] In the script that has survived from *18 Happenings in 6 Parts*, Kaprow listed the "visitors" among the "participants," but the script also shows that only the people referred to by name in the invitation actually became active (having rehearsed in advance), and that the only action reserved for the visitors was to change places according to precise instructions written on handouts.[82] Thus, in this case, too, the activity of the public only went slightly beyond a presence "in the work." According to Kaprow, he arrived at the concept of happenings by way of assemblages and environments. Looking back in 1965, he explained that he had first created environments and then observed the visitors to these works. When it became clear to him that the visitors, too, were part of the work, he gave them small tasks to carry out, such as moving something or turning on switches. He expanded this approach in 1957 and 1958, passing on "scored responsibility" to the visitors and allowing them more opportunities for action. This, as Kaprow tells it, is how the happening was born.[83]

According to Kaprow's definition, his work *Yard*—in which, as part of a 1961 group exhibition at the Martha Jackson Gallery in New York, he filled an interior courtyard with old car tires and invited the visitors to move freely among them—should be called an environment.[84] The same applies to *Push and Pull. A Furniture Comedy for Hans Hofmann* (1963), another environment installed in New York, in which the visitors were invited to arrange furniture in a room. Today we would tend to conclude that the visitors to these works had more opportunity for action than the visitors to *18 Happenings in 6 Parts* had, and thus would adjudge environments as offering greater

potential for audience participation than happenings. This distinction is essential for artistically configured (inter)action processes: In contrast with a happening, the artist is not present at the moment when a recipient encounters an environment; thus, if any action is to take place, it must emanate from the recipient, who is not able to retreat into the role of a spectator. In many happenings, by contrast, recipients were able to retreat, for the artists were evidently the principal actors. However, there are also records of happenings in which all the people present—both artists and audience members—played active roles. For example, in Kaprow's *Household*, staged on a garbage dump in New York State in 1964, stereotypical gender roles were acted out together by all the participants.[85]

The initial euphoria that had met the new art form of happenings had already fizzled out by the mid 1960s.[86] Nonetheless, it had become possible in the context of the visual arts both to fashion projects as actions and to incorporate the public as active participants.

Performance art developed as a hybrid of the visual arts and the performing arts. The role and the potential activation of the visitors were central to many performance projects, even if often all that was required was reaction. One well-known example is *Imponderabilia* (1977), in which Ulay and Marina Abramović positioned themselves naked in the narrow passageway entrance to a gallery in such a way that visitors had to actively squeeze their way past, and had to decide which of the two performers they would face.

Joseph Beuys took a different approach to activating the public with his concept of the social sculpture. Beuys called for an expansion of art into the realm of daily life, or rather an understanding of daily life as an artistically malleable material. According to Beuys, all members of society should actively participate in reshaping their environment and their living conditions.[87] These ideas find a direct echo in some forms of interactive media art, specifically in the Internet art of the 1990s. Many of the Internet artists of those years saw the Internet as a new means to artistically shape the information society, and their activities often invoked the concept of social sculpture.

From the 1960s on, active involvement by the public was required repeatedly in experimental and post-dramatic theater, too. In the late 1960s and the 1970s, Richard Schechner, in performances such as *Dionysus in 69* (1968) and *Commune* (1970–1972), transformed the viewers into actors, either as volunteers or even by means of repressive strategies. Schechner argued that participation took place when the play stopped being a play and became a social event. In the 1990s, participatory strategies were adopted by Christoph Schlingensief (*Chance 2000—Wahlkampfzirkus '98*) and by the Compagnie Felix Ruckert, albeit with very different objectives. Whereas in Schlingensief's work the spectators were often provoked in the extreme and left in the dark as to what kind of participation was expected of them, the Ruckert Company, whose

performances emphasized bodily participation, showed great sensitivity in handling emotions that emerged in the participants.[88] Those performances opened up spaces of possibility and opportunities for action and movement that could be embraced in relation to other participants, whether they were professional performers or fellow recipients.[89] Around the same time, Rirkrit Tiravanija and Felix Gonzalez-Torres devised situations in which the emphasis was on negotiating relationships between different recipients or between artists and recipients. Nicolas Bourriaud based his theory of relational aesthetics (discussed in the next chapter) on such projects.

Another approach to configuring interactions came about as a result of the debates of the 1970s and the 1980s on art in public spaces. In the 1990s, projects developed under titles such as Art in the Public Interest and New Genre Public Art presented alternatives to the artistic "furnishing" of the public space by means of permanent sculptural installations. Many such initiatives sought to engage the residents of a particular neighborhood or a specific social group in actively shaping their environment, or encouraging them to scrutinize their life situation, either by creatively changing the public space, organizing events, or carrying out social projects together.[90] Many of these public art projects are good examples of the fluid boundaries between "media art" and other forms of contemporary art that have led to the calls for (re)integration recorded above. In fact, nowadays electronic media are used as a matter of course in numerous projects of this kind. Artists who are normally not counted among the members of the media-art scene can be found organizing video workshops with young people or installing video conference systems in order to construct links between different population groups.[91] Vice versa, media artists can be seen organizing public interventions and social projects. For example, since 2006, the Graffiti Research Lab has been inviting participants to make their own "LED throwies." The group then arranges these simple magnetic LED lamps into provocative statements and displays them in urban environments with the help of passers-by. Since 2003, Jonah Brucker-Cohen and Katherine Moriwaki have been motivating participants in their *Scrapyard Challenge Workshops* to be creative with simple digital and electronic components. The potential strategies for artistic configuration of societal and social participation, collaboration, and interaction can thus be based to differing degrees on digital technology. However, this study focuses on artistic projects that use digital technology as the main interface for aesthetic experience. Social interaction—either with other recipients or in a system that simulates social forms of interaction—is one possible reference system, but not the only relevant one, in this context.

The material of everyday life
The public art projects described above lead us to another artistic strategy—that of challenging the boundaries between art and everyday life. This can occur through the quest for alternatives to established art institutions and exhibition venues, or through

the use of everyday objects. In the case of happenings, the events often took place either in public spaces or in locations that were not associated with art institutions and thus conveyed their own unique atmosphere.[92] According to Allan Kaprow, "the line between the Happening and daily life should be kept as fluid and perhaps indistinct as possible."[93]

In parallel to such boundary crossings, the use of everyday objects and materials became an established practice in art. This was true both for projects that were primarily object oriented and for projects that were largely action based. Once again, these are artistic practices that had forerunners in the first half of the twentieth century, such as Marcel Duchamp's ready-mades and Joseph Cornell's object boxes.[94] Whereas Duchamp's aim in declaring everyday objects to be objects of art was to challenge the concept of the artwork, Cornell pieced together old toys into surreal assemblages that could often be set into motion by the observer. Dadaist collages were followed in the second half of the century by the assemblages of the Nouveaux Réalistes, by the installations and environments of pop art, and by a variety of artistic practices that arranged, defamiliarized, archived, depicted, or celebrated everyday objects.[95] Objects from daily life were employed not only in the visual arts but also in the performing arts—for example, in the Merce Cunningham Dance Company's 1963 piece *Story* a number of everyday materials collected by Robert Rauschenberg were used as props and costumes.[96] Moreover, the kinds of everyday materials chosen were not limited to the visible or the tangible environment. Beginning with the classical avant-garde (as early as 1930, Walter Ruttmann had assembled everyday sounds into a composition for a radio piece titled *Weekend*), the sounds of everyday life were also discovered as potential material for artistic creativity. John Cage not only integrated actual sounds from the environment into his compositions; he also experimented with whistles, water sounds, and sounds of other everyday things. In the early 1960s, the Judson Dance Theater worked with "found movements."[97] Similar to what John Cage had done, Robert Rauschenberg and Tom Wesselmann incorporated radio receivers into their performances and installations so that the program being broadcast at that particular moment became part of the work.[98] A guiding principle of Nam June Paik's work was the instrumentalization of what was being broadcast by the mass media as raw material for his artistic projects. Thus, the decisive step toward the incorporation of set pieces from (mass) media communication into artistic projects was taken in the 1960s.

The use of everyday objects was initially aimed at provocatively challenging the idea of the artistic, and thus also the boundary between art and everyday life. George Brecht was the first to instrumentalize these boundary crossings in terms of an invitation to the audience. He created collections of objects that invited the viewers to take action. Brecht insisted that these be called "arrangements" (not "assemblages") because he was primarily interested in "the time element," which he believed emerged

more clearly in the concept of the arrangement than in that of the assemblage; he felt the latter was "more applicable to clusters in space."[99]

Because Brecht identified the gestalt of an artwork in its process, as opposed to its structure, it is not surprising that later he often dispensed entirely with the provision of objects and simply published scores that instructed viewers to act on their own. Whereas Duchamp, whom Brecht explicitly invoked,[100] chose his ready-mades himself (despite declaring them to be non-intentional), Brecht often left the selection of his objects up to visitors or exhibition curators. For example, when organizing the exhibition of his 1959 work *The Cabinet*, he specified that if parts of it were to be lost, broken, or even stolen, the curator should be "relaxed" and should do whatever he thought best: "When (if) parts disappear, replace them with parts that seem equivalent (able to substitute). If no equivalent parts are available, substitute something else, or nothing at all, if you'd rather."[101]

Just like the use of everyday materials, the reach into public space has become established as an artistic strategy. It is perceived as a provocative violation of the boundary between art and everyday life only when it emphatically challenges conventional standards of behavior or acknowledged systems of reference. And this is also true for media art. For example, Jenny Holzer's 1982 *Truisms*—statements displayed on commercial billboards in New York's Times Square—were clearly provocative, as are Holzer's more recent projection works and Krzysztof Wodiczko's monumental video projections. Julius von Bismarck, who in *Image Fulgurator* (2007) clandestinely manipulated people's photographs of tourist attractions by inscribing them with commercial icons or critical commentaries, reaches simultaneously both into public space and into the private space of the individual. Other works, such as Julian Opie's moving portraits and various media facade projects, may also aspire to stimulating reflection, but they do not do so in a way that provocatively challenges public practices and models.

The use of everyday objects is also not uncommon in media art. The material employed in the works must by no means be limited to technical equipment. In fact, everyday objects are often used as an interface for the very reason that their function, symbolism, or operation is familiar to the recipient. However, another aspect of the intersection between art and daily life is even more significant for the aesthetic experience of media art: Because the technical devices with which media art operates are increasingly becoming everyday objects themselves, new questions are now arising about the boundary between the artistically configured work and the everyday environment.

Rules and game structures

As has already been pointed out, the incorporation of participatory elements into artistic projects went hand in hand with considerations about how these processes could be controlled. Even though—or especially because—the new artistic strategies

were designed to leave room for chance and individual creativity, they still needed a structured scheme to channel the processes that would emerge. In the second half of the 1950s, various musical composers, including John Cage, had written pieces prescribing different types of arrangement that the interpreters were then free to flesh out as they pleased.[102] Cage's *Theater Piece No. 1*, for example, was based on clearly communicated rules that structured the improvisations of the performer. The rules, which were calculated in turn by random operators, were seen by Cage as a means to counteract intentional actions by the performer. The almost paradoxical situation that resulted was that the indeterminacy of the performance was supposed to be guaranteed by precise game rules.[103]

Allan Kaprow and George Brecht likewise experimented with different kinds of rule-setting, now also concerning the activity of the recipient. Before a performance of Kaprow's *18 Happenings in 6 Parts*, visitors were given handouts containing clear directions as to when to change places, whereas in *Yard* visitors received no instructions and had complete freedom in the participatory environment. In *Push and Pull*, printed cards specifying the rules of the work were made available to visitors, and in *Household* not only was a detailed script provided but the participants were asked to attend a preparatory meeting.[104] George Brecht also initially wrote instructions for his works. One of his arrangements was *The Case (Suitcase)* (1959)—a picnic basket filled with various everyday objects such as toys, musical instruments, and natural materials. The invitation to the exhibition contained the following instructions: "THE CASE is found on a table. It is approached by one to several people and opened. The contents are removed and used in ways appropriate to their nature. The case is repacked and closed. The event (which lasts possibly 10–30 minutes) comprises all sensible occurrences between approach and abandonment of the case."[105] These instructions are undeniably very general, leaving wide scope for individual elaboration and interpretation. Brecht emphasized elsewhere that his works "may open out into the participant's experience, literally involving him, greatly, or slightly, according to his nature."[106]

In his subsequent Fluxus activities, Brecht only distributed "event scores"—descriptions of actions that, similar to musical notations, could be carried out by anyone, anywhere.[107] Here, too, however, an evolution can be observed. Whereas the early event scores gave the recipients very precise instructions, the later ones are more like broad incentives. For example, an early Brecht score, *Three Colored Lights* (1958), gives the participant these instructions: "at red lite, count 3 and hit one of 3 gongs, at green lite count 7 and hit a piano key for same duration as the light."[108] In a subsequent interview with Michael Nyman, Brecht recalled that Cage, who had played the piano at the event, had complained that he felt utterly controlled. Brecht thus learned his lesson: "I realized that I was being dictatorial in that situation."[109] From then on, he wrote simpler scores, each time increasing the potential for indeterminacy.[110] Interestingly, Brecht's strategies were developing in the opposite direction to Kaprow's. Kaprow,

disappointed by many recipients' actions in his happenings and environments, gradu-
ally decided against extensive liberties for the public: "[W]hen people are told to
improvise, they become self-conscious and perform banal, stereotyped actions. . . .
Real freedom is a consequence of real limitations."[111] The evolutions undergone by
Brecht and Kaprow illustrate how the configuration of the relationship between liberty
and control represents a major challenge in interactive art. This is also made explicit
in some of the theater performances mentioned above. In Schechner's renowned
Commune performance, for example, the audience's refusal to comply with the invita-
tion to participate would elicit the following resolute response: "First, you can come
into the circle, and the performance will continue; second, you can go to anyone else
in the room and ask them to take your place, and if they do, the performance will
continue; third, you can stay where you are and the performance will remain stopped;
or fourth, you can go home, and the performance will continue in your absence."[112]
These rules do not specify how participants who have agreed to partake are guided
through the piece, but illustrate the fact that participants who insist on maintaining
their role as spectators are practically forced into an active role, such that the hierarchy
of power in theater is made explicit.

Another way to control actions within the context of artistic projects is to use game
strategies. However, the specification of a particular goal, as is usual in rule-based
games, is quite uncommon in artistic projects.[113] More common are analogies to free,
aimless play—for example, through the use or alienation of playthings or mechanical
toys, as in Joseph Cornell and Marcel Duchamp's work, or through the ludic organiza-
tion of artistic actions, for example by taking up different positions across a city as
part of an action day, as the Groupe de Recherche d'Art Visuel (a group of French
kinetic artists) did in Paris in 1966.[114]

Above all, however, as will be shown in chapter 3, numerous basic characteristics
of processual art can be identified through comparisons with games and play. This is
all the more true since the spread of digital technology has opened up new opportuni-
ties for comparisons between art and play. The availability of new ways to configure
processes has led to a completely new type of game: the computer game. Therefore,
in a study of digital interactive art there is good reason to specifically seek parallels
with computer games. However, in media art, too, goal-oriented processes are only
rarely at the focus of artistically staged interactivity.[115] Nonetheless, commercial com-
puter games are often referred to or manipulated by media artists in order to stimulate
reflection on their structures. This is true, for example, of Agnes Hegedüs' *Fruit
Machine*, one of the case studies presented in this volume.[116] Furthermore, the com-
mercial success of the computer game has led to the development of an active com-
munity of researchers and to various innovative approaches to the analysis of game
structures that inform the present study.

Movement and perception

Whereas action art located process in actions, in op(tical) art and kinetic art the focus was on motion and its perception. Op art invited the observer to move in front of the image, whereas kinetic art set images, reliefs, and sculptures themselves into motion.[117] Op art, which is most famously represented by Victor Vasarely, sought to heighten the sensitivity of the observer to processes of human perception, working, for example, with line structures that created illusionistic flicker effects and thus an apparent dynamic in the image. Op artworks were based on a scientific exploration of colors and forms that was reminiscent of the Bauhaus tradition.[118]

Kinetic art, which was made famous by Jean Tinguely's machines and Alexander Calder's mobiles, again echoes back to pioneering works of the classical avant-garde, such as Duchamp's *Bicycle Wheel* (1913) and *Roto-Reliefs* (1935), Naum Gabo's *Kinetic Construction* (1920), and László Moholy-Nagy's *Light-Space Modulator* (1922–1930). László Moholy-Nagy and Alfred Kemény made the following claim in their *Manifesto of the Dynamic-Constructive Power System*: "Carried further, the dynamic single-construction leads to the DYNAMIC-CONSTRUCTIVE ENERGY-SYSTEM, with the beholder, hitherto receptive in his contemplation of art-works, undergoing a greater heightening of his powers than ever before and actually becoming an active factor in the play of forces."[119] Thus, even in constructivism, movement was discussed in terms of its effect on the observer: what was being sought was not just a new concept of the artwork but a new role for the observer.

It is interesting to note that the representatives of kinetic art and op art presented themselves as stark opponents of abstract expressionism. The Groupe de Recherche d'Art Visuel, after Nicolas Schöffer had already defended the Bauhaus tradition against the École de Paris, declared that they had "really put an end to the dominance of the École."[120] This is notable because, as I pointed out above, American action artists consciously identified themselves as belonging to the tradition of abstract expressionism, and especially to the art of Jackson Pollock. We can see here again that it is not possible to trace one linear development for processual art forms, but that processual strategies can be associated with a great variety of aims and modes of expression.

As Frank Popper—one of the first art historians to study processual art—concludes, kinetic art was primarily interested in a formal enrichment or reform of the arts by means of the introduction of movement into visual art, but the accompanying exploration of perception almost inevitably required a more in-depth examination of the role of the observer.[121] Yaacov Agam, for example, made *"tableaux transformables"*— images that could be transformed by the observer. These works, exhibited at the Galerie Craven in Paris in 1953, were geometric shapes that could be arranged in different ways or rotated (e.g., on mounting devices). In the invitation to the exhibition, the visitors were encouraged to participate in the works. It was explained that these

were subject to continual transformation depending on the angle of observation and that they could also be rearranged by the visitor: "aesthetically ever more perfect, concerning the forms and colors in an indefinite variety of rhythms and shapes."[122] Agam wanted to create an image that existed not only in space but also in time, procuring "a foreseeable infinity of plastic situations flowing out of one another whose successive apparitions and disappearances provide ever-renewed revelations."[123] Agam initially created images and wall objects, then later also created wall and ceiling decorations for specific locations and reliefs with movable parts that could be arranged and manipulated by recipients. In 1967, at a Paris exhibition titled Lumière et Mouvement, he invited visitors to turn on a light bulb by raising or lowering their voices.[124] Roy Ascott had visitors experiment with geometric objects (1963), Gilles Larrain installed play areas made out of air cushions (1969), and Claude Parent sent visitors walking across sloping surfaces in the French pavilion at the Venice Biennale of 1970.[125]

Ascott claims that as soon as an observer relates to an artwork, he can become totally involved in it—physically, intellectually, and emotionally. But even though the observer in this way becomes an active participant in the production process, it is still the artist who defines the boundaries within which the recipient can act: "In response to behavioural clues in a construction (to push, pull, slide back, open, peg, for example) the participant becomes responsible for the extension of the artwork's meaning. He becomes a decision-maker in the symbolic world that confronts him."[126] Ascott compares his own pictures and kinetic works to ideas, seeing them as structures that can be equally subject to human interventions and transformations. The writings of the Groupe de Recherche d'Art Visuel also often emphasize the importance of actively involving the observer so as to heighten his perception. Indeed, in the catalog for a group exhibition held in 1968, François Morellet, one of the co-founders of the group, encourages further research into polysensual activation: "Take heat: nobody has ever really studied its effect on aesthetic perception."[127]

Artists were drawn to op art and kinetic art for various reasons. Some, following the tradition of the classical avant-garde, saw their art as an opportunity to realize social utopias; others were interested in ironically disrupting such utopias. Victor Vasarely can be taken as a representative of the utopian group. He was in search of a universal aesthetics that bordered on totalitarianism. His aim was "the improvement of our entire artificial environment."[128] He believed that "a library of images consisting of 'immaterial multiples' was the surest means for perfecting the culture of the happy inhabitants of the future Colored City."[129] For Vasarely this implied the need to activate the observer: Whereas previously the artwork had been the object of passive contemplation, now observers were participants and actors, he claimed.[130] Frank Popper supported such demands in his publications of the 1970s, celebrating the social visions that accompanied these art forms—from transferring art projects onto the street to artistically shaping entire cities.[131]

On the other side stood the artists who assumed a distanced and critical stance toward such visions. Jean Tinguely's art machines, which Pontus Hultén describes as "metamechanics," were interpreted as an ironic criticism of humans' faith in and fascination with machines, as well as an ironic reflection of avant-garde art.[132] For example, Tinguely created a series of drawing machines, titled Méta-matic, that can be viewed as a commentary on the automatic painting of the surrealists. These devices allow observers who have inserted a coin to switch on and off a machine that basically rotates automatically. While the machine carries out the actual act of drawing (in the surrealists' case, this was controlled by the subconscious), the recipient's possibilities for action (in addition to the action of payment) are limited to activating and deactivating the machine. However, because the recipient carries out all the actions that are deemed conscious artistic acts in surrealist automatism, it seems reasonable for Tinguely to advertise the machine as a do-it-yourself affair, claiming that anyone can use it to create his own abstract drawing.[133] On the other hand, Tinguely is, of course, contradicting the idea of observer participation here, because in automatic drawing there is no longer any concept of a consciously creative act.

Other representatives of kinetic art turned to scientific methods in order to make the effect of their works part of their theme. These artists used a questionnaire to examine the ways in which observers responded to their action propositions. Enzo Mari, for example, gave the recipients of his participatory sculpture Modulo 856 (exhibited at the San Marino Biennale in 1967) a questionnaire, designed by Umberto Eco, that was aimed at "stimulating reflection and awareness by means of a series of questions."[134] The Groupe de Recherche d'Art Visuel also often used questionnaires to obtain detailed feedback from the public. Not only were they interested in ascertaining whether the viewers accepted their works as art; they also asked for information about the recipients' aesthetic and emotional reactions to the works.[135]

Similar to action art, kinetic art can be seen, on the one hand, as an art movement that was limited to the 1950s and the 1960s; on the other hand, it can be seen as having established new forms of artistic activity that remain relevant today. As early as 1967, Jean Clay described the movement's achievements as a reflection of modern physics: "Kineticism is the awareness of the instability of reality."[136] She argued that whereas traditional painting presents things in the past tense—the artist represents emotions that he has experienced—kinetic art is located in the present tense. Today, the use of mobile elements in the visual arts and the thematization of perceptual phenomena are still important artistic means of emphasizing the emergence of gestalt in the actual moment of perception. Artists continue to create installations that are surprising, threatening, or irritating so as to stimulate the recipient's spatial (self-) perception. Works that deserve mention in this context are Bruce Nauman's corridors, Richard Serra and Vito Acconci's space-filling installations, and Ilya Kabakov's staged interiors. Serra, Nauman, and Acconci wanted to convey an overall impression that

was physical and emotional at the same time, whereas Kabakov's multi-part installations (based on everyday objects and alienated everyday situations) sought to create a new, poetic view of everyday phenomena through a "continual switching of [our attention] from the general to the details, then back again to the general."[137] Recently, Tomàs Saraceno, Antony Gormley, and Bill Viola have constructed inflatable or floating architectures to be experienced bodily by visitors. Other contemporary artists, including James Turrell and Olafur Eliasson, work primarily with visual phenomena of perception, focusing in particular on sensitizing the recipient to the physical characteristics of the elements (fire, water, earth, and air). At the same time, Eliasson—like Rebecca Horn and Roman Signer—incorporates dynamic elements in his works as a matter of course.

Even though the aforementioned works are mostly based on mechanical rather than electronic processes, the boundaries remain fluid between kinetic art and the narrower definition of media art, insofar as mechanical elements can often be found in media art—for example, in robotic projects. The desire to facilitate multisensory perception was an important motive behind many media art projects, too, beginning with the Evenstructure Research Group's experiments in Expanded Cinema and with the Pepsi Pavilion that was built in 1970 for the Osaka World's Fair. The Pepsi Pavilion—one of the cooperative projects involving artists and engineers organized by Robert Rauschenberg and Billy Klüver under the name E.A.T. (standing for Experiments in Art and Technology)—was a temporary architectural structure that incorporated many projections and light and sound effects and was intended to function as an audiovisual *Gesamtkunstwerk*.[138]

As will become clear, the heightening of perceptual sensitivity, which can be characterized as the primary goal of kinetic art but which was also extremely important for artists such as Cage, Kaprow, and Brecht, is another important aspect of aesthetic experience in digitally mediated interaction. It would thus be inadequate to assess interactivity in media art exclusively against the benchmark of social interaction, for often the mechanical interactions between bodies and machines are equally important. But there is also an ontological reason why kinetic art should be seen as an important reference scheme for interactive media art: Unlike happenings and action art, which involve the participation of the artists, kinetic art offers opportunities for action that can be realized in the absence of the artist.

Self-perception and self-observation

Action art and performance art have put bodily action—of the artist or the recipient—at center stage, and kinetic art aims primarily at heightening perception. In the 1970s, video art not only aimed at recording action, but focused emphatically on staging self-perception and self-observation, especially when closed-circuit video installations recorded a recipient by means of a camera and then directly reproduced the image on

a monitor. This image was often subject to interventions programmed by the artist, such as selection of specific components, time lags, or distortions.[139] The aim, therefore, was not primarily to record actions, but to use media to support the observation and staging of actions in real time—up to and including an ironic questioning of the epistemic potential found in passive contemplation, as illustrated by Nam June Paik's *TV Buddhas* (since 1974).

The most frequent aim of such works, however, is the mediatization of the recipient's own image, temporal or spatial distancing often being used to stimulate self-reflection. An example of spatial distancing focusing on the perception of one's own body is Bruce Nauman's *Live-Taped Video Corridor* (1970), the media-supported version of the same artist's *Corridors* (mentioned above), in which the recipient only sees himself from behind, his image moving further and further away the closer he gets to the monitor. The recipient thus becomes an external observer who is systematically denied the possibility of approaching himself. Nauman was interested here in the tension that arises when physical and mediated perception cannot be reconciled.[140] Another reason Nauman's work is interesting is that it is often cited as an example of extreme recipient conditioning. The recipient is simultaneously controlled and kept under surveillance by means of spatial structures and media-based strategies, as explicitly acknowledged by Nauman in his celebrated declaration "I mistrust audience participation."[141]

Other works have used media-supported time lags to enable new forms of self-perception. An example is Frank Gillette and Ira Schneider's *Wipe Cycle* (1969), a work consisting of nine monitors, four of which show the television program currently on air while the other five display the observer's image after various time lags. Gillette was convinced that video technology enabled such entirely new kinds of relationship between observer and object that it was not possible to explain its aesthetic potential on the basis of existing models of interaction. In fact, the artist, in Gillette's words, could use this new medium to evoke and transmit "states of awareness, sensations, perceptions, compulsions, affects, and thoughts."[142] Probably the best-known closed-circuit video installation to use time lags is Dan Graham's *Present Continuous Past(s)* (1974), in which a time-delayed (eight seconds) video image of the recipient is repeatedly reflected in a mirrored room, thus creating a multiple layering of temporal states. Dan Graham's aim with this kind of installation was to create a link between the recipient's self-perception and neuronal and cognitive processes of awareness. He believed that the possibilities offered by time effects evoked "the subjective sense of an endlessly extendible present time in flux."[143]

But is it acceptable to call this kind of feedback interaction? Closed-circuit installations based on video technology do not stage social interactions, nor do they enable technological interaction (in the sense of a possible reaction by the technical system to input). Nonetheless, they confront the observer with his own reactions and thus

involve him in the work in a new way. The observer is both a live performer and his own public as an interaction arises between self-portrayal and self-observation, for his movements simultaneously give rise to and respond to their reproduction on screen. Rosalind Krauss thus ascribes to video art a narcissistic aesthetic: "[T]he medium of video art is the psychological condition of the self split and doubled by the mirror reflection of synchronous feedback."[144] This leads, Krauss argues, to the illusion of a blending between subject and object, so that the reflection amounts to an appropriation of one's own image.[145] In other words, what is staged is the interaction of the recipient with himself, as conveyed by his media-transformed likeness. Krauss nevertheless acknowledges the existence of artistic video that "exploit(s) the medium in order to criticize it from within."[146] Reinhard Braun describes this situation as a "relay of spaces of perception, meaning, and imagination" and as a "place in which the media system (video in this case) in a way becomes intertwined with real space and real time and also draws the observers into this feedback effect."[147] The closed-circuit video installation thus destabilizes the recipient with respect to the boundary between real and mediated perceptions, and with respect to his own corporeity and its place in time and space.[148]

Many interactive artworks are also based on the principle of real-time reproduction of an image portraying the recipient, although it is usually digitally enhanced or distorted. The principles of self-portrayal and self-observation are maintained, but transmission and alienation through the medium are given greater significance. The spectrum of works in this category ranges from actual integration of a closed-circuit video system in Lynn Hershman's *Room of One's Own* (case study 5), to a precise reflection of body movements by means of a computer-generated silhouette in Myron Krueger's *Videoplace* and others, to total abstraction in Sonia Cillari's *Se Mi Sei Vicino* (case study 9), and to the transposition into the medium of sound in David Rokeby's *Very Nervous System* (case study 8).[149]

From cybernetics to artificial reality

As I mentioned above, cybernetics researchers eventually devoted themselves to theoretical and practical studies on (electronic) control systems. In this area, especially, the boundary between apparatuses built for scientific experiments and works presented explicitly as artworks was very fluid.[150] The first artist to be fascinated by the ideas of cybernetics was the Hungarian sculptor Nicolas Schöffer. In 1956, he designed a "cybernetic spatiodynamic sculpture," called *CYSP 1*, whose movements were controlled by external light and sound pulses.[151] In many of his works, Schöffer used a cybernetic apparatus called a homeostat, which controlled different forces with the aim of attaining a stable equilibrium. As early as 1954, Schöffer celebrated the nature of this apparatus in his publication "Le Spatiodynamisme": "It is . . . a homeostat that will control these sounds, always in an unpredictable way. This will create a total

synthesis between the sculpture and the sound . . . with a maximum of flexibility because it immediately adapts to any change in the environment."[152] Schöffer's interest in interactivity was thus primarily focused on interaction with the environment, and, in particular, with light and sounds. However, he also had dancers perform with his sculptures. Furthermore, in 1973 he staged an opera, titled *Kyldex*, in which the audience was able to influence the course of events by holding up colored signs.[153]

Similar to Vasarely, what Schöffer sought in his art was a total, almost totalitarian, aesthetic innovation of society. He espoused an evolutionary model that described the battle for dominion between natural form (*nature plastique*) and human form (*plasticité humaine*). Schöffer termed his all-encompassing ideology of innovation "aesthetic hygiene," envisioning rooms in which "the consumer will be surrounded by audiovisual (olfactory, tactile) programs" and will "bathe in a truly, consistently aesthetic climate he is able to dose, reassemble, and program according to his own wishes. This bath will put him in a position to continually advance and perfect himself, to sensitize, concentrate, and express himself; it will lead to a new notion of human hygiene."[154]

Schöffer's works, like Tinguely's, were exhibited in the 1960s. It was not until toward the end of the decade, however, that a whole wave of events celebrated kinetic and cybernetic art as groundbreaking art movements accompanying the rapid technological advances of the era. These included performance series like 9 Evenings (New York, 1966, staged by the Experiments in Art and Technology Group[155]) and exhibitions like Cybernetic Serendipity (London, 1968). Jasia Reichardt, the curator of the latter, explained that she particularly wished to examine the parallels between creativity and technology, and that the exhibition was about the links between scientific or mathematical approaches and the "more irrational and oblique urges associated with the making of music, art and poetry."[156] Thus, the exhibition was dedicated not only to the use of computers in different categories of art, but also to displaying them alongside scientific research and theories. As a result, Cybernetic Serendipity, in addition to presenting state-of-the-art computer science research, exhibited works from computer music, computer literature, and computer graphics, as well as kinetic and cybernetic sculptures (including works by Tinguely and Schöffer). However, it was not the works of these two well-known artists that attracted the most attention, but two other exhibits—one by a scientist, the other by an artist. The English cyberneticist Gordon Pask presented his *Colloquy of Mobiles*—apparatuses hung freely from the ceiling in two variants that, he explained, were the male and the female of the species. The male, consisting of geometric shapes, emitted light that could be reflected by the organically and anthropomorphically shaped female objects. If it was reflected back to the "right" place, the communication was "successful" and an audio signal was emitted. Pask described the group dynamics as follows: "Whereas males compete amongst themselves and so do females, a male may cooperate with a female and vice-versa."[157] Here, a technically complex feedback system is represented by means of an

emotionally loaded attribution of meaning—in the form of simplistic gender imagery—
with the signification of the behavioral level also being alluded to at the formal level
(anthropomorphic vs. mechanistic). This work thus illustrates the fact that interac-
tions that are primarily technical can also be measured in terms of social interaction
if appropriate metaphors are used. Instrumentally, moreover, the installation also
allowed two different types of interaction. Interaction could take place between the
technical components, but visitors to the exhibition were also invited to actively
participate using mirrors or flashlights. Pask describes the installation as an "aestheti-
cally potent environment," for "the trick is that if you find them interesting then you
can join in the discourse as well and bring your influence to bear by participating in
what goes on."[158]

In comparison with the complex system architecture of Pask's *Colloquy of Mobiles*,
a work by the Polish artist Edward Ihnatowicz seemed almost simplistic in its effect.
Ihnatowicz presented *SAM*, the *Sound Activated Mobile*—a small, flower-like sculpture
that used a hydraulic system to bend forward and backward and to turn to either side.
The four "petals" were fitted with microphones that localized sounds from different
directions. The sculpture reacted to quiet but sustained sound by bending toward it.[159]
The reason for *SAM*'s huge success with the visitors might have been that it explicitly
invited recipients to interact with it, while at the same time its reactions were not
immediately comprehensible (it preferred certain types of noises over others).

The Philips company subsequently commissioned Ihnatowicz to create a sculpture
for its new technology center (Evoluon) in Eindhoven, which led to the birth of *Senster*
(1970). This metal construction, more than four meters high and often likened to a
lobster claw, was able to perceive its environment by means of both a microphone
and radar and could thus distinguish between sounds coming from different direc-
tions, toward which it would then move its enormous arm using a visible hydraulic
system. Very loud noises and rapid movements made it shy away, however.[160] There
are video recordings showing how fascinated the public was by this creature. Evidently
the fascination was primarily based not on the visual appearance of *Senster* but on its
behavior.[161] Jasia Reichardt pointed out that the very fact that *Senster* reacted simulta-
neously to different impulses made its reactions more lifelike and less easy to predict
than if only the intensity of the environmental sounds had influenced the speed of
movement.[162] Jack Burnham, who in 1968 was the first art historian to provide a
comprehensive contextualization for cybernetic apparatuses and art projects, had
a similar view, pointing out that it was the very unpredictability of many of these
apparatuses that represented the main analogy to living beings.[163] Unlike the effects
of indeterminacy created by random operators, here the unpredictability lies in the
fact that the recipient cannot anticipate the system's behavior, which ultimately is
the result of the lack of transparency of the technical processes. This brings us to a
further issue that has great significance for an aesthetics of interaction: The interaction

and thus the aesthetic experience are determined not only by the actual potentials of the interaction system but also by their interpretation and by the meanings ascribed to them by the recipient. Already emphasized by the symbolic interactionism approaches described at the beginning of this chapter, this becomes even more important when the interaction processes are no longer immediately transparent to the recipient (as is still the case in action art and kinetic art). Technical mediation turns part of the interaction process into a kind of "black box," and the recipient has to rely on his own suppositions regarding these processes. The role of expectations and individual interpretations for the aesthetic experience of interactivity will be discussed at length in chapter 4.

The first person to systematically explore the potential of digital technology for interactive art was the computer scientist Myron Krueger, in the 1970s. He coined the term "artificial reality" to denote an art form resulting from a blend between aesthetics and technology, and provided a detailed description of his work and visions in a publication of the same name.[164] Krueger expected the possibilities of digital technology that he described and illustrated in his works to lead to the emergence of a new movement that would influence culture in general: "[A]rtificial reality offers a new aesthetic option, an important new way of thinking about art."[165] Although he conceded that the expressiveness of this art form could not yet compare with the visual agency of film, the narrative potential of the novel, or the complexity of music, he still believed that it would ultimately catch up with those genres. Krueger's ambitions were by no means limited to the realm of art. He wanted to found an interdisciplinary institution devoted to the development of interactive media and systems, which would guarantee that they would be used in equal measure for aesthetic, scientific, and practical purposes.[166]

In 1971, Krueger created an interaction environment, called *Psychic Space*, that detected the movements of the recipient by means of a touch-sensitive floor.[167] In *Maze*, an application designed for that environment, the recipient could use his own movements to steer a square through a labyrinth displayed on a vertical projection screen.[168] As he did so, he had to deal with a complex and occasionally bizarre set of rules. Krueger's aim in this project and in subsequent projects was to explore and reveal the laws and conventions of interaction. He believed that in *Maze* the use of an abstract symbol (the square) to represent the recipient, as well as the translation of his horizontal movements into a vertical projection, created a feeling of distance that would support the stereotypical idea of the computer as an inhuman technology. And yet the recipient would be entranced by the labyrinth, the visual minimalism enabling him to concentrate entirely on the interaction. Although the recipients initially tried to solve the problem (i.e., exit the maze), they realized in the course of the interaction that the labyrinth was really a "vehicle for whimsy" that queried the willingness of the recipient to subordinate himself to rule systems.[169]

In *Videoplace*, a system that Krueger developed subsequently and for which he created numerous applications between the 1970s and the 1990s, the recipient's silhouette was recorded on video camera, then digitally manipulated and projected. The visitor could, at the same time, elicit and manipulate the output created by the computer graphics via his own movements. Krueger argued that the active role of the recipients enabled them to experience the work in a way that in traditional types of art is reserved for the artist: "Thus, within the framework of the artist's exhibit, the participants also become creators."[170] Krueger also wanted to heighten the sensitivity of recipients for their physical interaction with the environment. He felt that such a new perspective of reality would not only open the door to a new quality of aesthetic experience, but also amounted to an exciting step forward in human evolution.[171] Krueger did not want to shape human-computer interaction as something different to interactions in real life; he wanted to use his "artificial reality" to make new types of social interaction possible.[172]

Krueger envisioned systems with different levels of interactivity ("second-strike capability"). He imagined exhibits that could actively arouse and maintain the attention of passers-by by recognizing them and reacting in order to incite them to interact. Such exhibits would also be able to measure the level of involvement of the recipient over the course of the interaction and adapt their behavior accordingly. Visitors who spent only a brief amount of time with a work would thus have an entirely different experience to those who lingered. Such adaptive systems would be able to evolve with each interaction, even in ways that the artist had not foreseen, and would surprise him.[173] These ideas about the adaptability or evolutionary capacity of systems already touch on the visions of artificial life and artificial intelligence that will be dealt with in the following section.

Myron Krueger is significant for the development of interactive digital installations for two reasons. First, his work introduced a basic "vocabulary" of digitally mediated interaction on which the structures of many subsequent works were based, whether consciously or unconsciously. Andy Cameron, a younger media artist, expresses the inevitable acknowledgment of Krueger's importance succinctly: "Myron did it first."[174] Krueger himself has the following to say, presumably not without some pride: "I am shocked that the formats that I happened to pick have turned out to be so canonical."[175] The formats in question, in addition to the design of interactivity as an interplay between video recordings of the recipient and computer-graphic feedback, are his work with silhouettes and artificial creatures, the critical references to established rule systems (including invitations to violate them), the use of loops, repetitions, and fade-outs, the possibility of creating one's own figurations, the staging of communication situations, and his work with interconnected interaction partners.

In addition to the significance of his practical work, many of the ideas and theories on interactive art that Krueger formulated in the 1970s are still valid today. This is

true, for example, of his analysis of the relationship between technical interaction processes and their interpretation by the recipient, and of his explorations of methods for increasing recipients' willingness to deal critically with interaction processes.

Artificial intelligence and artificial life

Krueger's idea of sensitizing the recipient to the potentials of new media by inviting him to manipulate artificial figures or transform his own likeness was not the only possible approach to interactive media art, however. In fact, there were many attempts to revive the ideas of cybernetic art with a view to developing systems that truly imitated biological feedback or human thought processes.

In both artistic and scientific research on artificial intelligence, the technical system usually becomes a communication partner with whom the recipient can enter into contact through the spoken word or written text. The system's reactions are based either on pre-programmed structures guided by grammatical rules or on a stored vocabulary that can be matched with, and sometimes can learn from, the recipient's input. Although the motivation behind the artistic projects in this field is often simply a fascination with artificial intelligence itself, they also often incorporate disruptions that challenge scientific wisdom. For instance, since the 1990s Ken Feingold has been creating puppet heads that communicate among themselves or with the public, at the same time displaying their artificiality in their rudimentary, bodiless forms. Another example is Peter Dittmer's *Amme* (1992–2006), an enormous robotic installation that embarks on a complicated procedure to knock over a glass of milk any time it is confused by a recipient's communications. Dittmer makes no secret of his critical stance with respect to artificial intelligence: "The *Amme* is not an attempt at machine intelligence but more of a work about the phenomenon of artificially generated expression and about the place of the usually modestly silent thing in the domain of knowledge and meaning." Dittmer views communication with the machine as a kind of absurd exchange that he describes as "tactics of stupidity whose brusque appearance creates melancholic confusion in the public lawnmower."[176]

Lynn Hershman's *Agent Ruby* (2002) and Stelarc's *Prosthetic Head* (2002–2003) come across as somewhat less critical artificial intelligence projects with a more positive attitude toward technology. Artistic explorations of artificial intelligence may thus be intended either as critical commentaries or as visionary models.[177] At any rate, these are examples of interactive media art that provoke comparisons with face-to-face communication. Nonetheless, in these cases, too, as in cybernetic art, the attraction lies less in the actual possibility of complex communication (or even an interesting "exchange of ideas") than in the exploration of the potentials of the system.[178]

Other artists focus not on visions of artificial intelligence but on visions of artificial life.[179] Since the 1990s, Christa Sommerer and Laurent Mignonneau have been creating projects that imitate and represent natural processes of evolution. The aim is to

render such processes comprehensible for the recipient by allowing him to intervene in them by selecting or changing certain parameters. In the installation *A-Volve* (1994), which was developed in collaboration with the biologist Tom Ray, recipients design artificial creatures which are projected onto the bottom of a basin of water and then interact with one another in searching for food and for opportunities to reproduce. Depending on their fitness, their energy, their speed, and their reproductive capacity (these parameters are partly calculated based on the shape of the creatures produced by the recipient but can also be inherited as a kind of "genetic code" through "pro-creation"), an artificial biosystem develops that the recipient can influence by creating new creatures. Sommerer and Mignonneau are interested in understanding art as a process and, at the same time, in challenging the artist's role by confronting his sovereignty over creation with programmed processes of gestalt formation.[180]

Artists who explore the potential conditions for artificial life also simulate everyday interactions, albeit in terms of biological interaction as opposed to human communication.[181] They create models to represent certain processes that can be better perceived when they are dissociated from the complexity of real life.[182] The representation and simulation of (unmediated) everyday interactions by means of digital media is, therefore, one possible form of interactive art. These works are rare, however; many more projects critically engage with the specific characteristics of mediated processes.

Collaborative networks and telepresence

As electronic communication and information networks became increasingly widespread within the past century, these too became a theme, location, and medium for artistic projects. On the one hand, artists were interested in artistically configuring, visualizing, and reflecting data networks and the flows of information they enabled; on the other hand, they used them for long-distance collaborative activities. As early as 1932, Bertolt Brecht had called for radio to be transformed from an apparatus of distribution into one of communication, so as to allow every participant not only to receive but also to transmit messages.[183] In their futurist manifesto of 1933, Filippo Tommaso Marinetti and Pino Masnata had championed radio as a new art—as "a pure organism of radiophonic sensations," as "reception, amplification, and transfiguration of vibrations emitted by living beings, or living or dead spirits," and as "art without time or space, without yesterday or tomorrow."[184] The realization that invisible electromagnetic waves could carry information in space and transmit it worldwide at the same moment in time engendered such enthusiasm in artists that they envisioned a wholesale reform of the arts.

Again, it was not until the second half of the twentieth century that at least a partial realization of these social and artistic visions became possible. In addition to radio and television, artists used satellites, fax machines, BTX systems, mailboxes, the Internet, and mobile data networks as media and material for their work.[185] In 1980, Robert

Adrian X, a Canadian-Austrian artist who was interested in rendering visible the power structures behind communication networks, founded the Artists' Electronic Exchange Network (ARTEX),[186] which became the basis for Roy Ascott's project *La Plissure du Texte*. In that project, initiated in 1983, a story was jointly composed by an international network of writers.[187] In 1985, at the Centre Pompidou in Paris, Jean-François Lyotard presented an exhibition, titled Les Immateriaux, that was dedicated to the aesthetic qualities of the information space,[188] and included a project of twenty French intellectuals debating via Minitel. Generally speaking, the first people to explore the new communication media for social and cultural purposes were members of closed circles of artists and intellectuals. They were primarily interested in new forms of collective creativity and in a collaborative aesthetics of production.[189] As Fred Forest explains, the focus in these actions was often not so much on the content of the information as on the form of transmission. Forest sees a paradoxical space emerging that simultaneously becomes "felt reality" and a "common imaginary." In Forest's view, this imaginary draws on "invisibility, immediacy, ubiquity, presence, and action at a distance," all of which are based on aesthetically sensitized perception.[190] The notion of a concrete configuration of communication is surprisingly closely associated here with an almost sculptural conception of the communication space. The appeal of the "immaterial materiality" of the communication space, which had already characterized the visions of the futurists and which had been a central motif for Lyotard, still endures today and is characteristic of contemporary works in so-called locative art.

With the triumphant advance of the World Wide Web and the growing ease of access to the new communication networks, the vision of the Internet as a communication platform for the general public gradually took hold.[191] The mid 1990s saw the birth of network platforms, such as *De Digitale Stad* (Digital City), in which there were "cafés" for communication, a "graveyard" for former members, and other metaphorically denoted information nodes. Numerous social groups such as schools and retirement homes participated in this projects.[192] Many of the early Internet artists drew on Beuys' concept of the social sculpture.[193] They saw their Internet artworks primarily as a "basis for exchange,"[194] and they hoped to raise awareness of the power relations in the public sphere by actively involving the users.[195] Wolfgang Staehle, the founder of a network platform titled *The Thing*, likewise makes the connection to Beuys, but he also sees Bourriaud's theory of relational aesthetics as applicable in retrospect to many network activities.[196] Although Helmut Mark, who founded *The Thing Vienna*, also sees his work as sculptural and thus unmistakably related to aesthetic categories, he is predominantly interested in developing alternatives to the art scene.[197] Mark refers to Gene Youngblood's concept of meta-design, developed in the 1980s, which includes the idea that art should create environments rather than content.[198] It is thus not surprising that many Internet artists are in close contact with the hacker scene, which endeavors to reveal the power structures of digital networks

and to advocate alternative uses by carrying out targeted attacks on commercial and political networks and systems.

Accordingly, many of these artists harbor great skepticism toward forms of interactivity that allow the recipient to activate only prescribed choices. For instance, the artist duo 0100101110101101.org criticizes the fact that by clicking around on websites one is only responding to the artistic defaults: "It is not the artwork itself that is interactive, rather the observer can use it in an interactive way. Interaction is when one uses something in a way that was not foreseen by its creator."[199] This provocative proposition to interpret interaction as creative misuse can be taken as a reaction to the failed fulfillment of the vision of media art as something that could change society.

In relation to Internet art, too, one has to agree with Dieter Daniels that many of the avant-gardist visions of the early Internet artists and Web activists have long been caught up in the commercial mainstream.[200] Nonetheless, this doesn't mean that the communication space has lost its appeal as an artistic medium and material. Today, more data networks can be configured and used by artists than ever before. The continued spread of mobile communication technology has led to an abundance of digital networks that are closely connected to real space through their site-specific services. Artistic projects dedicated to mobile media and their possibilities for tracking data are generally designated as locative art.[201] The case studies presented in this volume analyze three such projects. Their aim is to illustrate new forms of asynchronous, collaborative exchange of ideas (Blast Theory), the possibilities of site-specific narration (Stefan Schemat), and the ephemeral character of data networks (Teri Rueb).

Not only did network technologies inspire artists to engage with issues of networked communication; they also brought about visions of telepresence (in the sense of a virtual presence in a separate place). Artists began exploring this subject as soon as television and video technology began to become widespread. As early as the 1970s, Douglas Davis—in live-broadcast television performances—invited viewers to "break through the TV screen" in an effort to establish direct contact between the artist and the public.[202] Ultimately, of course, Davis' theme was the impossibility of interaction in the classical mass medium of television. The first artistic satellite performance took place in New York and San Francisco in 1977; in the same year, at the opening of documenta VI, performances by Joseph Beuys, Nam June Paik, and Douglas Davis were broadcast by satellite.[203] In 1980, Kit Galloway and Sherrie Rabinowitz presented *Hole in Space*, the first project that transmitted images and audio recordings of recipients between two different locations. Galloway and Rabinowitz installed video systems in two display windows, one in New York and one in Los Angeles, enabling real-time communication between passers-by in the two cities. Their goal was to provide a new communication space that could be used as the recipients themselves saw fit.

Digital technology then provided the means for remote control of technical systems and for distributed processuality that went beyond real-time human communication.

In Ken Goldberg's installation *Telegarden* (1996), Internet users were able to control a machine that tended a real indoor garden. In his installation *Telezone* (1999), a collaborative effort was required to use remote control to make a robot build a house in a model city. The aim of Goldberg's projects was to heighten people's sensitivity to the potentials offered by digital technology. He was particularly fascinated by the idea that Internet participants cannot know for sure whether the distant components of the project actually exist or are only being simulated.[204] Whereas traditional technologies that bridge distances (such as the telescope, the telephone, and the television) only transmit information, telerobots allow long-distance action.[205]

Paul Sermon, by contrast, is mainly interested in telepresence because of its potential for social interaction. He has created various projects that involve a joint virtual presence of recipients who are actually located in different places. In his installation *Telematic Dreaming* (1992), he invited visitors to lie on a bed. A projector was then used to beam the image of a partner—another visitor lying on an identical bed in another room—onto the bed beside the first visitor. Sermon's aim was to stimulate reflection on the relationship between bodily presence and representability.[206] He later created entire apartments in which the recipients were able to meet telepresent partners in different communication situations—for example, on a sofa or at a kitchen table.[207] Telepresence concepts are still being realized in artistic projects today. For example, external actors may be incorporated into theater pieces, or recipients may be invited to exert remote control over digital presentations in public places.[208]

Virtual reality

Although one of the goals of modern and contemporary art has been to challenge its traditional restriction to representation, the representation of spatial situations and the representation of temporal processes will always remain possible fields of interest of the arts. By means of interactive technology, spatial and temporal representations can be newly organized—through immersive space illusions and alinear forms of narrative.

The illusionistic integration of the observer into a simulated space is, as Oliver Grau has shown, an aesthetic strategy that has been practiced repeatedly in the history of art and architecture since antiquity.[209] However, that approach declined in the twentieth century as part of the general shift away from representative and illusionistic artistic strategies and toward abstract art and an emphasis on materiality.[210] It was thanks to the possibilities offered by digital media that interest in realistic simulation was rekindled, so that media art gave birth to a counter-trend to twentieth century art's tendency toward alienation and abstraction. By the early 1990s, advances in computer graphics had made it possible to create realistic three-dimensional simulations in the digital medium. Two new developments (relative to traditional illusionistic representations) were, first, the possibility of accentuating the immersive effects and, second, the processuality of the simulated spaces, which allowed the recipient to

actively explore them. The computer scientists Howard Rheingold and Jaron Lanier saw "virtual reality" as the future of the information society, and people are still working intensively today on these technologies—and not only to create spectacular 3D effects for movies.[211] Artists, too, were fascinated by these new media-based potentials. Jeffrey Shaw, another pioneer of interactive art, saw virtual reality as the defining criterion of interactive art. In 1989 he described interactive art as a "virtual space of images, sounds, and texts" that the user can experience either entirely or in part and whose aesthetics "is incorporated into the coordinates of its hidden potential forms." Shaw saw every user as a "narrator and autobiographer of one of these possible scenarios."[212] In his interactive installations, he presented computer-generated three-dimensional worlds that could be explored by the recipient via different interfaces.

Heinrich Klotz recognized the potentials of digitally simulated spaces as an opportunity to recover the strategies of illusion that had always been central to art.[213] Now artists could return to the creation of "credible fictions, spaces of illusion, and artificial worlds in which something is played out that we can believe once again of the arts and can convey." Klotz felt that the avant-gardist program had rejected these potentials of illusion in favor of identifying art with life. Media art, he wrote, offers a new opportunity for "art per se, which creates distance to life" and allows us to understand "art as a world of fictions."[214]

Once again we see how broad the spectrum of real and apparent goals and intentions in interactive art forms is. While some artists champion the activation of the recipient as enabling a new form of self-reflection, and others see the creation of new forms of communication as a means of changing the information society, in this case the aim is no less than to reclaim illusion as a central characteristic of the arts. Today there are still artists exploring the potentials of visual illusionistic immersion that were popular in the 1990s. Also Jeffrey Shaw continues to create simulated spaces. Nowadays he constructs them as huge, high-resolution 360-degree panoramas that feature fascinating three-dimensional effects.[215]

Nonetheless, simulation and illusionism have by no means established themselves as the chief objectives of media art, and certainly not as the chief objectives of interactive art. If mimetic representations are created at all, or fictitious worlds are constructed, then these often make an explicit theme of their own fictionality, or else feature superimpositions between digital and physical, or fictitious and real, situations. The relationship between real-world physical materiality, on the one hand, and illusion and fiction, on the other, will constitute an important aspect of the aesthetics of interaction to be developed in this book.

Alinearity

In addition to new ways of reproducing spatiality, interactive technology also offers new approaches to organizing temporal processes. Alinear narration allows the recipi-

ent to potentially influence the plot, usually by choosing between alternatives or by organizing their chronological sequence. Alinear narration is often celebrated as a fulfillment of the post-structuralist demand that traditional forms of narration should be renounced. The first types of alinear narration were created using analog means. The best-known example of parallel alternative plot lines presented in traditional book form is Jorge Luis Borges' short story "El jardin de senderos que se bifurcan," published in 1941. In music, Karlheinz Stockhausen, Luciano Berio, and John Cage were already writing pieces that left the selection or arrangement of segments up to the interpreter in the 1950s.[216] But music was never primarily a medium for descriptive narration requiring linear composition. In theater, on the contrary, the move away from texts requiring linear execution was one of the main innovations of the intermedia movement. As Barbara Büscher recounts, Dick Higgins worked with guidelines that contained no more than "agreements about time frames, lines of movement, and arrangements," which, however, could be interpreted variably in the performance.[217] In this context, the artists were often seeking to displace the traditional narrative structures with presentations that Michael Kirby calls "non-matrixed performances."[218] By this Kirby means dispensing with a fixed performance structure of time, place, and characters, and even using flexible notation systems that allowed simultaneity, on the one hand, and a variable sequence of processes, on the other, which again were often determined by means of random operators.

As regards alinearity based on technical media, again Nam June Paik must be considered a pioneer. As early as the 1960s, his *Random Access* works allowed recipients freedom to choose positions on magnetic tapes or phonograph records, in that the artist simply removed the pickup and gave it to the recipient for placing. As the name suggests, this choice was guided by chance insofar as it was practically impossible to foresee which succession of notes would be activated by which recipient. A similar example is *Variations V* (1965) by John Cage and Merce Cunningham. In this dance performance, the dancers activated the sound mix by means of sensors distributed throughout the room, without, however, being able to intentionally select particular sequences of sounds.[219]

Interestingly, the manipulation of alinear narrations in real time (rendered possible by the arrival of digital media) was first used not in literary texts but in the medium of film. As early as the 1980s, Grahame Weinbren began to shape collages of images, texts, and films into associative, alinear narratives that could be activated by a recipient operating a touch screen or using other input media. Weinbren called this art form "interactive cinema." Although recipients could navigate within the material, the works were nonetheless finished products. Weinbren emphasizes that he has never understood interactivity as meaning "power to the people" and is not interested in the emancipation of the observer.[220] He uses interactivity to intensify the immersive potentials of cinema. At the same time, according to Weinbren, the observer's freedom

to explore the work and to arrange its parts invalidates traditional narrative struc-
tures.[221] Weinbren distinguishes between two epistemological states that determine
the relationship between viewer and interactive film. The first state (the "active") cor-
responds to the viewer's action of selecting an image; the second state (the "subjunc-
tive") arises from the viewer's recognition that a different action would have led to a
different image on the screen. "While the first might encourage the viewer to invest
the image with meaning—it is, in a sense, 'his' image, 'her' image—the second should
lead him to question its inevitability."[222] Weinbren wants the viewer to realize that
images are replaceable and to see the screen as a container of possible images. He
believes that this attitude can enable an intensification of cinematographic expression.
Weinbren considers interactive cinema to be an important development in the history
of communication specifically because of its capacity to intensify cinematic expression
in this way. In order to maintain cinematic continuity, an equilibrium must emerge
"between program continuity and viewer interruption" so that "a sense of continuing
logic and cinematic development should remain."[223]

Scott Snibbe, a media artist from San Francisco, is also convinced that interactive
media art still has much to learn from cinematic concepts, for he thinks the medium
of film is still more emotionally powerful than interaction systems. As a result, he
gradually develops a "vocabulary of interactivity" in his projects so as to be able to
create increasingly more complex narrative structures in interaction systems. Two
works that explicitly engage with cinematic storytelling (*Visceral Cinema: Chien*, 2005,
and *Falling Girl*, 2008) insert the recipient's silhouette into a pre-recorded linear story.
Snibbe is interested both in narrations in the narrow sense and in the meditative
approaches that were pursued in structuralist cinema. He uses narrative strategies both
to stimulate the social interaction of the recipients among themselves and to convey
an intensive experience of bodily presence.[224]

Other forms of alinear narration in the digital medium focus on the multi-
perspectival documentation of events (Paul Sermon, *Think about the People Now*, 1991;
Sarai Media Lab, *Network of No_des*, 2004) or on the staging of communication situa-
tions with optional communication partners (Jill Scott, *Paradise Tossed*, 1993; Michael
Mateas and Andi Stern, *Facade*, 2005). In these works, the transitions between interac-
tive narration strategies and the creation or simulation of communication situations
are often fluid. Thus, for example, in Lynn Hershman's early installation *Lorna* (1979–
1984), the recipient sits in a living-room-like environment and uses an everyday
remote control to select and activate the video monologues of a suicidal woman.
Although the only action of the recipient in this case is the choice of the film seg-
ments, Hershman still emphasizes the dialogical potential of the work: "It is about a
conversation and a dialogue and having an audience participate."[225] Hershman recalls
that she felt her work with interactive media was a political act "because it allowed
the viewer to really have some input into how they saw things."[226] She adds that she

tried over the course of her career to intensify the involvement of the recipient, so that the works evolved from narrative strategies into the presentation of communication situations. Her more recent Internet-based works are even supported by the "intelligent agents" mentioned above.[227]

The first fictional hypertext, in the sense of a primarily text-centered, digital, and alinear narration, did not appear until 1987. Michael Joyce's *Afternoon, a Story* is a complex relationship drama consisting of 538 multiply interconnected text segments that the reader can follow using the classical hyperlink structure or can explore using a drop-down menu. Subsequently, numerous texts of this kind were composed using different types of cross-linking and ramification.[228] With the success of the World Wide Web and its possibilities for graphical configuration, an increasing number of digital texts used this platform. Multi-media interactive stories were born. Often, however, as the case studies of Olia Lialina's *Agatha Appears* and Susanne Berkenheger's *Bubble Bath* will show, the aim was not so much maximum freedom for the reader as a self-referential presentation of the possibilities offered by digital media, or in other cases the emotional involvement or destabilization of the reader. Locative art projects that combine strategies of interactive narration with the intertwining of data space and real space (see the case studies of Stefan Schemat's *Wasser*, Teri Rueb's *Drift*, and Blast Theory's *Rider Spoke*) also have much in common with digital literature and hypertext strategies.

However, hypermedia systems for exploration by a single recipient are by no means the only possible form of narration as structured by digital media. There are projects that continue to adhere to the classical audience situation of cinema or theater but also allow the audience to decide by voting how the plot should progress. This method was used back in 1973 by Nicolas Schöffer in the opera *Kyldex*. More recently Michael Mateas, Paul Vanouse, and Steffi Domike presented the film *Terminal Time*, the plot of which was repeatedly determined by means of measurement of applause levels.[229]

Art, Technology, and Society

Artistically configured interactivity can be viewed in the overall social context as a kind of "extracted sample." In other words, insofar as it represents only a fraction of the media-based interaction systems that characterize modern society but still draws on them in numerous ways, it functions as an analytical, critical, or deconstructive model of interactivity. Just as interactivity is often considered a fundamental feature of media art, it is also a fundamental feature of electronic media and thus of the information society as a whole. As a result, aesthetic perspectives on interactivity are ultimately also relevant to many areas of contemporary behavior. One of the reasons this study focuses on artistically configured interactivity is that it can be used as an ideal basis for the extraction of aesthetic experiences of interaction, allowing us to explore phenomena that resonate at least peripherally in many areas of everyday life.

Furthermore, it is practically impossible to draw a clear line between artistically orchestrated and "everyday" aesthetic experiences. Media art especially, because it relies on technologies that are increasingly becoming common elements of our every-day lives, constantly challenges its own boundaries to commercial, social, political, and technical interactions. It does so not necessarily as an artistic strategy of con-sciously breaking down borders, but as an aesthetic staging or contextualization of interaction processes in many areas of daily culture, whether from a critical or an affirmative standpoint.[230]

The discourse on media art has been accompanied since its inception by questions as to the relationship between art, technology, and society. The questions can refer to media art's roots in military research, to the fluid boundaries between artistic creation and innovative research, to its role as a model of collaboration between artists and engineers, or to its place in "artistic research" or the "creative industries."[231] Contrari-wise, Stephen Wilson points out that scientific and technological research should be seen not only as purposeful activities but also as "cultural creativity and commentary"—much like art: "It can be appreciated for its imaginative reach as well its disciplinary or utilitarian purposes."[232] At the institutional level, too, artistic and commercial applications are often developed in close proximity to each other. Examples are the applications for the CAVE installation at the Ars Electronica Center (Linz, Austria) the projects of the MIT Media Lab (Cambridge, Massachusetts), and the concept of the LABoral Art and Industrial Creation Centre (Gijon, Spain). The following four paragraphs will briefly illustrate what the intersections between art, technology, and society can look like in practice.

Myron Krueger saw a huge potential in his systems for use in schools and in physi-cal and cognitive rehabilitation. Both he and David Rokeby have reported on the experiences of disabled recipients with their work.[233] In 2010, the *Eye-Writer Project*, described as collaborative research on improving the quality of life of the physically disabled, won the Golden Nica Award in the "Interactive Art" category of the Prix Ars Electronica. In addition to applications in rehabilitation, curators and scientists have also highlighted the numerous opportunities for using digital simulations for learning and planning purposes.[234] One example of didactic interaction environments—in addition to the traditional area of E-learning—are the many commissioned works by Scott Snibbe exhibited in natural science museums, which allow recipients to actively explore biological and physical processes.

Anthony Dunne and Fiona Raby attend to critical reflections on commercial prod-ucts and systems, denoting their works as "Design Noir" or "post-optimal objects." According to Dunne, the classical task of the designer of electronic objects is to create semiotic surfaces for incomprehensible technologies—transparent interfaces that render the use of devices simple and understandable. Dunne cites Paul Virilio, who views interactive user-friendliness as a metaphor for the enslavement of humans to

supposedly intelligent machines insofar as it unconditionally accepts the functioning of and the need for such machines.[235] Dunne thus defines post-optimal objects as those that reveal the great difference between humans and machines and emphasize aspects of incompatibility between the two.[236] Dunne and Raby have constructed car radios that, instead of receiving the radio stations of the locality one is driving through, pick up radio networks, including baby intercoms. They have also made a *Faraday Chair* (1998) that protects users against electromagnetic radiation, and a series of *Placebo Objects* (2000) that react to electromagnetic fields or profess to protect against them but actually, more than anything else, investigate people's fears and their lack of understanding of technology.[237]

The overlaps between art and the entertainment industry are particularly evident in Asian culture. Thus, a group of researchers led by Machiko Kusahara at Waseda University in Tokyo has coined the term "device art" to characterize a form of media art in which a concept is realized as a device. The deliberately provocative term "device art" is designed to question where the dividing lines between art, design, entertainment, and technology should be drawn. A demarcation of this kind has not been customary in Japan, and many contemporary artists, Kusahara notes, also consciously refuse to accept such a "Western" delimitation. The research group examines both the critical potential of numerous design projects in the area of new media and the ludic element in artistic projects. Aware that projects designed for commercial marketing must have a "positive quality" (whereas museum visitors are also willing to come to grips with harsh or very negative art projects), the researchers ask what is so objectionable about the idea of artists marketing their works as commercial products and thus making them available to a large number of users.[238]

Furthermore, exerting a creative influence on the information society is still often seen as the primary task of media art. It is contextualized as part of a network culture or as an organ of network criticism. Media art can propose concrete models with the aim of establishing them as everyday practice or as critical modes of intervention. These models range from the communication platforms for grassroots democracy created in the early years of Internet art to the possibility of expressing opinions in public by means of *LED throwies*, whose harmlessness can persuade even the very reticent to take part in public actions. Such strategies also include the exposure of social and political conditions by means of (interactive) visualizations (as in Josh On's 2004 project *They Rule*) and the issuing of invitations to express one's opinions in public by means of Web 2.0 technologies (as practiced by the ubermorgen.com group). Though generalizing theories that see all actors in interaction systems as co-authors are justly criticized, these projects often genuinely seek to motivate their participants to take social, political, or socially relevant action, which inevitably leads to a withdrawal from authorial roles in favor of the desired manifestation of collaborative agency.

This study is not concerned with how interactive projects should be contextualized in artistic, technological, or social discourses. Nonetheless, media-based constellations like those mentioned just above, which blur the boundaries of art, technology, and society (or at least challenge the existence of these boundaries), also enable and instrumentalize aesthetic experiences. Each of the borderline areas named above—which must be viewed from the perspective of the art system in order to appear as borderline areas at all—operates within specific aesthetic contexts that cannot be addressed within the confines of this study. Nonetheless, the fundamental aspects of the aesthetic experience of mediated interaction that are identified here are also relevant for these spheres of activity, whether with respect to the role of the body in interaction, the relationship between artistically configured interactivity and digital game structures, or the relationship between materiality and signification. This volume can thus also be seen as a contribution to network criticism's call for a "distributed aesthetics" to deal with the transformation of aesthetic processes resulting from our actions in digital networks.[239]

2 Interaction as an Aesthetic Experience

This book presents an "aesthetics of interaction." The word "aesthetics" is consciously applied as an ambivalent term whose meanings can range from "perception mediated by the senses" (aisthesis) to "theory of art" (aesthetics).[1] Although the aim of the study is to contribute to the formulation of a theory of interactive media art, this will not entail reopening a discussion of the concept of art itself. Instead, the focus is on describing and analyzing the actions and the processes of perception and knowledge acquisition that are made possible through engagement with interactive media art.

Digital technology fundamentally alters the conditions in which sensory perception takes place. Interactive media art reflects not only digital technology's functionality and symbolism, but also the ways in which we deal with such technology and our (self-)perceptions when engaging with it. At the same time, interactive art presents a challenge to aesthetic theory because it calls fundamental aesthetic categories into question: the work as the primary object of an aesthetics understood as a theory of art, aesthetic distance as a necessary condition of aesthetic experience, and the distinction between sensory perception, cognitive knowledge, and purposeful action that underlies most aesthetic theories.

The Artwork as the Object of Aesthetics

The primary object of aesthetics as a theory of art is the artwork. The integrity of the concept of the artwork as an amalgamation of art and work is still often seen as a prerequisite for a philosophical aesthetics. While, on the one hand, the claim to artistic status is defined as the principal characteristic of the artwork, on the other, its "workliness" is seen as indispensable to its essence as art.[2] The theoretical consequences of the reciprocal dependency between artistic status and workliness implied by the term "artwork" have not been sufficiently discussed, however.[3] Concerns about the validity and meaningfulness of the concept of the artwork are compounded by the fact that its interpretation is in constant flux, both in artistic creation (which often deliberately

strives to elude definition) and in academic research. This applies to both of the concepts united in the term—that of art and that of the work.

The artwork is traditionally viewed as an individual creation that expresses an idea "in sensuous form" (Hegel). More recent definitions take into account twentieth-century criticism of the traditional conception of the artwork as being based on originality, creation by the artist's own hand, and representativeness, and now define the artwork as "any thing which is performed or chosen in the context of the art discourse."[4] The reference to the art discourse basically describes the communicative intention of the artwork, combined with its detachment from the constraints of daily life. The artwork relies on an intentional distancing that seeks to mirror or critically comment on everyday life or, as is often the case in music, to create ever new aesthetic compositions. The description of the artwork as a "thing" demonstrates an adherence to its conception as formal entity, even if it no longer lays claim to integrity or originality. Interactive art challenges two characteristics of this complex concept of "work": its fixed location in time and its formal manifestation.

Contextualizing the artwork in time

The manner in which an artwork is contextualized in time depends on whether it is understood primarily as the final product of a creative process, as an historical artifact, or as an reception proposition to be experienced in the here and now. In art history, dating an artwork is usually considered just as important as attributing it to an author. An artwork always requires a location in time. There may be debate in individual cases as to whether the date assigned should refer to the moment when the work was begun or to the moment when it was concluded (or even the period between these two moments), but the crucial issue in the visual arts is still always the "moment of creation." In the performing arts, however, the various moments in which a work has been presented are also relevant, and these moments may likewise be significant in cases of site-specific installations in the visual arts.

Historically oriented art history, which examines artistic products as rooted within their historical and geographical contexts, treats the artifacts as "primary sources," seeking (whether practically or theoretically) to reconstruct their original state to the greatest possible extent. Traditionally, art history was mainly interested in iconographic and stylistic analysis and contextualization of the reconstructed artifact, whereas sociohistorical research analyzes the artifact as a testament to the society from which it emerged, or indeed uses it to gain new insights about this society. Lorenz Dittmann argues, by contrast, that a purely historically oriented history of art inevitably neglects the here-and-now presence of the artifact. He asserts that the work becomes manifest only in the moment in which it is experienced, and thus calls for a concept of art that places the intuitive presence of the artwork at center stage.[5] Dittmann argues that the necessary condition for aesthetic experience is the individual

perception of art within the cultural and social context of the moment of reception. However, in contrast to this distinction between the artwork's function as a historical source and its expressive function in the present, Walter Benjamin had previously insisted that it was impossible to separate historical context, event of tradition, and present-day impact. He held that the aura of an artwork relies specifically on the fact that its material uniqueness is embedded in the context of tradition, but that this uniqueness is able to manifest itself only in the "here and now of the artwork."[6] For Benjamin, therefore, the work is always present as a testament to its own history and, as such, is an object of aesthetic experience in the here and now.

Other theories see the work primarily as a testament to its own creative process (as opposed to its historical tradition). Matthias Bleyl opposes the idea of the recipient acquiring an intuitive understanding that results automatically from the work's presence in the here and now. After all, he argues, such a presence can only be experienced from the point of view of the observer, whereas intuitability is inseparable from the creative process. He thus contraposes the "concept of the artwork" with an "artistic concept of the work." Bleyl sees the concept of the artwork as being based on the hypothetical external view of an interpreter, whereas an artistic concept of work always entails "drawing near to the internal view, seeing it from the point of view of the creator."[7] Thus, an art-historical analysis requires knowledge of and, as the case may be, an understanding of or empathy with the process of creation. Bleyl reasons that the recipient is not necessarily in an inferior position to the creator, insofar as he can compensate shortfalls in his knowledge about the details of the creative process with greater objectivity, provided that he engages with the internal view of these processes.[8] The somewhat paradoxical thesis of objective empathy touches on a general issue to which I will return later: To what extent does the aesthetic experience of an artwork require objectivizing distance, and to what extent does it benefit, by contrast, from the greatest possible proximity to the process of the work's realization? When it comes to interactive art, the possibility of the recipient having an internal view must also be posed in another way. Because the recipient is actively involved in the formal realization of the work, some authors argue that he should be considered a co-creator. Even though, as we will see, this thesis is rightly criticized, the recipient's active role does, nonetheless, suggest that the development of the work is by no means concluded once the artist has produced the interaction proposition. Insofar as the interactive work's presence in the here and now is a necessary condition for its realization, and that the original and unique experience of each recipient in the interaction process is considered the primary impulse behind the aesthetic experience, this must be considered the principal basis for the definition of the work in interactive art.

On the other hand, it would be inadequate to analyze interactive artworks with an exclusive view to the moment of their realization by a recipient. Notwithstanding interactive media art's relatively short history (in terms of general time frames in art

history, one could reasonably claim that all the existing works in this category still count as "contemporary art" today), many of these works have already undergone substantial modifications in the form of technical updates, productions of new versions, or adaptations for different presentation situations. Endeavors to contextualize interactive artworks in time must, therefore, bear in mind not only that a necessary component and feature of this type of art is its realization through different recipients (potentially separated by lengthy time intervals) but also that the interaction system and its material manifestations may change.

The material integrity of the work

If locating an artwork in time can be a tricky endeavor, verifying its material integrity (which is understood here as a completed gestalt that can be clearly indicated) can be even trickier. Until the second half of the twentieth century, it was beyond dispute that the artwork, as an intentionally created artifact, had definable spatial, temporal, and conceptual boundaries. Musical works and texts had a linear structure with a clear-cut beginning and end; paintings, sculptures, and architecture were bound by frames or materials; performances had a designated course of action and a duration that varied only marginally from one presentation to another. This view changed as a result of the neo-avant-garde movements of the second half of the twentieth century. Whereas the classical avant-garde had leveled criticism at the late-bourgeois art system and its cultic exaltation of the artwork, the neo-avant-garde of the 1950s and the 1960s sought to demolish the concept of the artwork from within. Thus, the classical avant-garde focused on criticizing autonomy, authorship, and originality, whereas the ideas of the neo-avant-garde led to the practical realization of fundamentally new designs and disintegrations of the structural form of the work, which challenged its material integrity.[9]

The processual strategies discussed in chapter 1 should be seen in the broader context of this trend, which advocated a dissolution of the boundaries between work and artist (in performance art), between work and idea (in Brecht's event scores and also in concept art), and between work and public (in participatory art). The integrity of the work was challenged by the dissolution of its boundaries with space (in installations and in minimal art), with everyday commodities (in collage and object art), and, finally, with life itself (in social sculpture).[10] As part of a general criticism of authorship, post-structuralist theories also call into question the existence of the self-contained work. These theories use the term "intertextuality" to describe cross-linking between different texts which creates a literary fabric than can be interpreted associatively by the reader. Texts or text fragments are addressed as integral components of the social and societal fabric.[11]

However, as early as the 1970s, Peter Bürger observed that art had entered into a post-avant-garde phase. He saw this new phase as characterized by the restoration of

the category of the work of art, "procedures invented by the avant-garde with antiartistic intent" now being used for "artistic ends."[12] This view is supported by the production side of art, for works in the various arts are still being presented as compositions that can be clearly referenced. Insofar as their authors no longer feel bound by the premodern criteria of autonomy, originality, and integrity, these works incorporate avant-garde criticism of the concept of the artwork.[13]

Other authors believe in the possibility of art without a work, however. Dieter Mersch, who uses the term "post-avant-garde" to refer to the art produced around the turn of the millennium, doesn't observe a restoration of the category "work," but does observe "art without an artwork." He describes this kind of art as performative, referring not only to the traditional performing arts but also to visual artworks: "Performative art is art without an artwork. It takes place—'in the middle of art.' It is simply the once-only deed, the plain gesture, the unique act, the event." Mersch sees this type of art as focusing on the open process, not on the self-referential strategies of the avant-gardists, who had viewed art as meta-art. "Art becomes a celebration of pure emptiness and fullness. It appears as a master of nothingness; its task is to evoke 'effectiveness.'"[14] The idea suggested here of the artwork being absorbed by its own presence appears ontologically problematic in view of the fact that contemporary artists are still producing intentional compositions and structures. Nonetheless, it does introduce the alluring concept of aesthetic experience as something that goes beyond the realization of material and symbolic structures. Although I will show below that media art cannot be said to be altogether lacking in workliness, Mersch's thesis still represents an interesting theoretical position, toward which an aesthetics of interaction in digital art should rightly take a stance.

Although interactive media art was celebrated by many in the 1990s as the new avant-garde, today it should really be defined as post-avant-garde—along with many other artistic movements belonging to the end of the twentieth century and the beginning of the twenty-first. In fact, its primary concern is not opposition to the art scene or criticism of institutions or of the concept of the artwork.[15] Interactive media art does use aesthetic strategies that have evident similarities with those of the (neo-) avant-garde; however, its intricate and occasionally ambiguous workliness is in many cases no longer an intended objective but, rather, simply a means to heighten the sensitivity of the recipient for the complexity deriving from the use of media. The work's processuality is not longer designed to call the work into question but is the basis for the aesthetic experience of realizing an artistic interaction proposition. This doesn't render the concept of the artwork obsolete; on the contrary, it challenges art historians to find ways to describe the processual gestalt that characterizes interactive art. Thus, my working hypothesis is to define the interactive artwork as an artistically configured interaction proposition that concretizes its gestalt only through each new realization by a recipient. What remains to be explored is the interplay, in the process of gestalt

formation, between the definition of the parameters of the work by the artist and its active realization by the recipient.

Aesthetic Experience

If the gestalt of the interactive artwork only emerges each time it is realized anew by a recipient, then an aesthetic analysis of interactive art must look beyond the formal structure and interpretability of the interaction proposition produced by the artist, for the aesthetic experience lies in the action of realizing the work. Several artists working with new media explicitly declare that they are primarily interested in an aesthetics based on action and process. Once again, Myron Krueger deserves quotation: "It is the composition of the relationship between action and response that is important. The beauty of the visual and aural response is secondary. Response is the medium!"[16] Roy Ascott has a similar view regarding the potentials of digital art: "The aesthetics in this transformative work lies in the behavior of the observer."[17] And David Rokeby's renowned declaration demonstrates how such a perspective can shape the artist's self-conception: "I am an interactive artist. I construct experiences."[18] In 1990, Myron Krueger observed that an aesthetics that could do justice to such concepts (he used the term "responsive aesthetic") still had to be developed, and that remains the case today.[19] This study is intended as a contribution to filling this gap, insofar as it treats the action-related experience of the recipient as a basic component of an aesthetics of interactive art. Although it draws on existing theories of aesthetic experience, it will become clear that these ultimately cannot do justice to the purposeless—though action-based—experience of interactive art.

When Immanuel Kant declared aesthetic experience to be based on subjective feelings, he was already paving the way for aesthetic theorists' exploration of the meaning of the receptive act, but not until the twentieth century did the receptive act become one of the central themes of aesthetics.[20]

In his 1934 book *Art as Experience*, John Dewey discussed which characteristics of artworks enable aesthetic experience. Dewey assumed that aesthetic experience could be distinguished only in a qualitative sense—and not categorically—from everyday experience, and that it could also occur as a result of everyday actions or encounters with nature. He saw the qualitative difference as depending both on the intensity of the individual experience and on its tendency to strive for a conclusion.[21] In Dewey's view, imagination is used to construct current experience against the background of past interactions, so that objects of experience are perceived as integral, formed wholes.[22] In order to enable such a holistic conclusion, the aesthetic form must adhere to structures that Dewey described using terms such as "preparation" and "continuity." Above all, however, according to Dewey, resistance is required, because ordered development with the aim of completion depends on the presence of an inner tension.[23]

Dewey saw aesthetic experience as being part of the general experience of one's surroundings, on the one hand, and as an essential property of the artwork, on the other, arguing that the artwork only becomes artwork—in the sense of an aesthetic object—in present experience.[24] However, he also noted that aesthetic experience requires a particular type of observation on the part of the recipient. Specifically, he argued that the artwork is experienced aesthetically only when the recipient permits and actively produces that kind of experience. At the same time, the experience evoked by the artwork is different for each recipient.[25] Thus, Dewey saw aesthetic experience as relying on an aesthetic form that motivated it and also on a corresponding disposition on the part of the observer.

The treatise *Aesthetics of Appearing* published by Martin Seel in 2002 illustrates clearly how topical Dewey's theses are today. Like Dewey before him, Seel believes that the necessary condition for aesthetic experience is an appropriate disposition on the part of the recipient. He describes specifically aesthetic perception as being "always distinguishable by not being an exclusively purposeful activity and by being alert to a dysfunctional presence of phenomena."[26] According to Seel, when perception is sensitized in this way, it is able to detect a "multitude of sensuous contrasts, interferences, and transitions" that elude a conceptual definition and can only be felt in the here and now.[27] Seel attributes greater importance than Dewey to the epistemic potential of aesthetic experience. Dewey had pointed out that previous experiences, especially when they concern "collateral channels" of perception, can sharpen current experiences because they focus attention accordingly.[28] Seel makes a similar argument but clearly identifies understanding as the aim of this experience: In order for artworks to be perceived as such, they must be "followed and understood in their modus operandi or construction." This, in Seel's view, often requires reflection, which is not a companion to aesthetic perception but an "essential form of executing the intuition of art objects."[29] Seel therefore makes a distinction between mere appearing (contemplative aesthetic perception), atmospheric appearing (corresponsive aesthetic perception), and artistic appearing of an intentional presentation, which requires a comprehending, articulating (constellational) perception, in other words, it relies on "implicit or explicit understanding."[30] Seel's aesthetic theory thus incorporates a problem found at the heart of hermeneutic research, namely whether knowledge can be said to transpire through aesthetic experience.

In order to describe the process of aesthetic reception itself, Wilhelm Dilthey, seeking to distinguish the research objects of the human sciences from those of the natural sciences, introduced the concept of experience (*Erlebnis*) as the root of (humanistic) understanding—as opposed to observation (*Beobachtung*) as the basis of (scientific) explanation. Hans-Georg Gadamer draws on Dilthey when he explains that "the work of art would seem almost by definition to be an aesthetic experience [*ästhetisches Erlebnis*]: that means, however, that the power of the work of art suddenly tears the

person experiencing it out of the context of his life, and yet relates him back to the whole of his existence."[31] He emphasizes the historical relativity of aesthetic consciousness and defends his belief in a general possibility of knowledge acquisition through aesthetic behavior. He even wants to define "truth" in humanities research via the concept of experience (*Erfahrung*). Gadamer believes that the recipient meets the artwork in the world and also encounters a world in the artwork.[32] The work of art is not "some alien universe"; rather, the recipient undergoes a process of understanding that has a lasting effect: "Art is knowledge and experiencing an artwork means sharing in that knowledge."[33] Moreover, the artwork "has its true being in the fact that it becomes an experience that changes the person who experiences it."[34] The knowledge attained through aesthetic experience is thus distinguished from logical judgment as a transformation that can be controlled only partially. Gadamer uses the word "transformation" in two ways here. The recipient himself is transformed, but so is the work of art. Gadamer describes the latter process as transformation into structure, which enables reality to be raised up "into its truth."[35] Gadamer compares the artwork with drama, which "is experienced properly by . . . one who is not acting in the play but watching it."[36] Gadamer is thus primarily interested in the differentiation between performer and performance, and especially in the process of gestalt formation as a manifestation that can be witnessed by the spectator. However, the spectator's experience must not be equated with a distanced judgment; in Gadamer's view, experience is interrupted if the spectator "reflects about the conception behind a performance or about the proficiency of the actors."[37] Though he goes on to say that aesthetic reflection has its own value, Gadamer doesn't consider it essential to aesthetic knowledge. For him, aesthetic knowledge is primarily based not on reflective judgment but on the process of transformation described above.

By contrast, the literary scholar Hans Robert Jauß, the founder of reception aesthetics, regards aesthetic distance—in other words, the detachment of the reception situation from normal, everyday behavior—as a fundamental condition of aesthetic experience. However, for Jauß the constitution of the aesthetic object also depends on the contemplative act of the viewer.[38] It is this act of constitution, he asserts, that distinguishes aesthetic experience from a theoretical position: the observer is involved in the creation of what is being experienced.

It becomes clear that the question of aesthetic distance presents a fundamental challenge for theories of aesthetic experience. It is here that the possibility of direct absorption in the aesthetic experience comes into conflict with the possibility of knowledge acquisition. We will see below that this tension is accentuated in interactive art by the merging of action and experience. In this category of art, not only the relationship between aesthetic experience and knowledge but also that between aesthetic experience and action must be reconceived. For if contemporary art is usually considered to be autonomous because the recipient can experience it without any

compulsion to take action,[39] in interactive art the observer's own actions are a condition of aesthetic experience.

Although Jauß regards action as a central component of the act of reception, he doesn't see it as essential to enabling aesthetic experiences; rather, he sees it as part of a transformation made possible by aesthetic experience and thus as a possible consequence of the epistemic process. According to Jauß, the attitude of aesthetic enjoyment "frees both from and for something." He distinguishes three different functions of aesthetic experience: the act of production of world in the form of a work ("poiesis"), pleasurable reception and discerning seeing that allows renewal of one's perception of both "outer and inner reality" ("aisthesis"), and judgment and behavior ("catharsis"). Jauß describes catharsis as the observer's pleasure in the emotions aroused in him by the artwork, which can lead to a change in opinion or mood and at the same time can open up subjective experience to intersubjective experience: "In the assent to a judgment demanded by the work, or in the identification with sketched and further-to-be-defined norms of action."[40] Thus, action is viewed as an element of aesthetic experience, but rather as something that may ultimately follow perception—a result of perception that has an effect beyond the artistic context. In interactive art, however, action is a precondition for perception. On the one hand, it occurs at the same time as the experience; on the other, it is not purposeful. Thus, non-purposeful action as a condition of aesthetic experience is a characteristic of interactive art that is not encompassed by existing theories of aesthetic experience.

At this point, we can identify three main touchstones of any aesthetics of interactive art. When discussing the *workliness* of artworks in this category, we must ask how their complex gestalt emerges in each realization of the interaction proposition. We must also discuss the question of *aesthetic distance*. If aesthetic distance is a condition of aesthetic experience, can the realization of an interaction proposition that requires action on the part of the recipient convey an aesthetic experience at all? Finally, we must ask whether and to what extent interactive art seeks to, or can, convey knowledge, and in what way this can take place. The question as to the *epistemic potential* of art must be posed anew with respect to interactive art because in this category knowledge no longer arises only from a contemplative or cognitive process of perception but also arises in the context of an active realization.

The possibility of acquiring knowledge through aesthetic experience has already been discussed at length in hermeneutics research, so we must now ask whether action can be reincorporated into aesthetic theory through interactive forms of art. Heinrich Klotz identified the basis in action as the defining criterion of interactive art because "the contemplative concentration of the observer gives way to purposeful behavior, which, as such, can no longer be disinterested."[41] But even if action in interactive art may be materially or physically effectual, it has no practical impact on the everyday life of the recipient and therefore still must be considered purposeless. Furthermore,

as Erika Fischer-Lichte has pointed out, it is no longer appropriate to tie the possibility of aesthetic experience to the condition of indifference.[42] The discussion of theories of play in chapter 3 will help us to further scrutinize the aesthetic experience of purposeless behavior.

Aesthetics of Response

For the purpose of the present study, theories of aesthetic response[43] (which were initially developed to analyze literary texts with a view to eliciting their potential effect on the reader) should be seen within the broader context of various theories that focus on the structure of the work as the motivator of aesthetic experience. These range from Umberto Eco's semiotically oriented theory of the artwork through the philosophical perspectives of (post)structuralism to Wolfgang Iser's phenomenological approaches to reading processes.

The open work of art

Umberto Eco was the first to research the active role played by the recipient in the realization of the artwork. In *Opera aperta* (The Open Work), published in 1962, he examined works of literature, music, and the visual arts that afforded the reader, the interpreter, or the observer new latitude in the realization of the work. He proposed three levels of intensity, ranked according to the recipient's degree of influence. First, for Eco, all artworks are "effectively open to a virtually unlimited range of possible readings," each reading giving the work a new vitality, depending on personal taste, perspective, and type of reception.[44] Elsewhere, Eco defines this receptive activity as a theoretical or mental collaboration on the part of the recipient, "who must freely interpret an artistic datum."[45] However, he distinguishes these works from others which, albeit organically complete, "are 'open' to continuous generation of internal relations which the addressee must uncover and select in his act of perceiving the totality of incoming stimuli."[46] The important word here is "must," which makes the way the artist consciously plays with the possibilities for interpretation the crucial criterion. Eco argues that the recipient becomes most involved in works that are not only open but also "works in movement," characterized "by the invitation to *make the work* together with the author."[47] Elsewhere, he describes such works more clearly as those that "characteristically consist of unplanned or physically incomplete structural units."[48] Thus, the listener, for example, structures and organizes the musical discourse: "He collaborates with the composer in *making* the composition."[49] Although Eco formulates his distinctions mainly on the basis of musical works, he explicitly also includes the visual arts. However, his examples are limited to kinetic artworks such as Alexander Calder's mobiles—in other words, to works that are literally mobile in the mechanical sense.[50]

In addition to these rather general ontological distinctions, which represent the first theoretical response to the new artistic concepts of the work, Eco also deals with the consequences of these developments for the potential interpretability of artworks. Drawing on information theory, he distinguishes between meaning and information, defining the latter as an "unchecked abundance of possible meanings": the simpler the structure, the clearer the ordering of the information and the plainer (less ambiguous) the meaning; the more complex the structure, the greater the content of information and the more numerous the possible meanings. Because art always seeks to organize the available material in novel ways, Eco argues, it offers the recipient a greater amount of information.[51] However, there must be some degree of organization, for otherwise one would be faced with an "undifferentiated sum of all frequencies," which would, at one and the same time, convey both the most information possible and no information at all: "For there is a limit beyond which wealth of information becomes mere noise."[52] Thus, Eco uses the perspective of information theory to identify the challenge I discussed above in the presentation of different artistic strategies. There it was described as the balance between chance and control; here it is posed as the relationship between openness and predetermination. In both cases, it touches on an issue that has been a frequent point of attack for many critics of interactive art: How can the recipient be offered opportunities for action without risking randomness, on the one hand, and auctorial control, on the other?

The blank space

The literary scholar Wolfgang Iser also uses terminology borrowed from information theory in his argument that "contingency" is the factor that induces interaction. He believes that contingency arises in face-to-face communication when behavioral programs are not attuned to one another and require interpretation on the part of the communicating partners. "The more it [contingency] is reduced, the more ritualized becomes the interplay between partners; the more it is increased, the less consistent will be the sequence of reactions, culminating in an extreme case, with the annihilation of the whole structure of interaction."[53] The partners do, however, adapt to the course of the conversation by constantly revising their interpretations. Iser distinguishes the relationship between text and reader from face-to-face situations on the basis of the fact that texts cannot adapt themselves to each new reader, while the reader receives no indication that his interpretation is accurate. Moreover, the contextual framework and the purposefulness of normal communication situations, which provide further aids to interpretation, are also lacking. At the same time, the very basis of face-to-face communication is abiding contingency between behavioral programs, not the factors that limit such contingency. Both face-to-face communication and the text-reader relationship are thus based on a "fundamental asymmetry." In both cases, Iser considers the gap a stimulant, so that "asymmetry, contingency,

the no-thing—these are all different forms of an indeterminate, constitutive blank which underlies all processes of interaction."[54] Iser believes that this constitutive blank is filled by projections that must be modifiable in the course of the interaction. However, guiding devices are required in the text, for only if the communication between text and reader is controlled can it be successful.[55] Iser sees one possibility for control in intentional gaps in the text, that is, conscious omissions that the reader can fill; however, these gaps are not open to any possible meaning, for what is used to fill them must be appropriate to the context of what is being represented.

Although, as I will show below, the concepts of contingency and asymmetry are more helpful with respect to interactive art than the model of the blank space, art historians have promoted the latter as the paradigm of an aesthetics of reception and as a benchmark for the critical examination of interactive art.

In the 1980s, Wolfgang Kemp applied the concept of the blank to the visual arts.[56] Kemp argues that the blank space induces the reception of an artwork through postponement or obstruction of the connectivity between work and observer, through disruptions of perception, or through the use of narrative constellations in which a gap in information becomes apparent between the observer and what is being presented or in which there is an allusion to either temporal or spatial secondary arenas.[57] Most of Kemp's examples are taken from nineteenth-century art, but he also deals briefly with contemporary art. However, he doesn't see interactive media art as an ideal example of the type of art that activates the recipient; rather, he sees its structures as tending to represent an obstacle to an open, dialogic relationship with the observer. He criticizes that interactivity seeks to optimize the relationship between humans and machines instead of "placing technology at the service of communication between people. . . . The chief commitment of this art, which seeks to liberate the observer, is to the program." Kemp argues that freedom of choice can be simulated but not programmed: "Only bogus alternatives can be programmed."[58] Hans Belting adopts a similarly categorical position when he states that electronics, as a substitute for the observer participation called for at the time, introduced "a new automatism that . . . did away with experimental freedom . . . in favor of a preprogrammed game."[59] As recently as 2004, Dieter Mersch criticized "computer art" for being constrained by the determinism of the system. He holds that in this kind of art even the unpredictable requires a rule, which renders it predictable.[60]

Such criticisms should be understood as reactions to the visions of the 1990s that expected media art to have a constructive effect on the media society and counted on interactive art to liberate the recipient, transforming him from observer into co-creator.[61] These criticisms assumed that interactive media art would seek to transpose the participatory objectives of the (neo-)avant-garde one-to-one into the digital medium. Some authors did in fact draw such parallels—for example, Peter Weibel saw an evolution from "participatory practices of the avant-garde toward a technology of interactivity."[62]

Some media artists took exception to this view early on.[63] For instance, Mona Sarkis likened the recipient to a puppet reacting to the artist's planned vision. She argued that the interactive artwork was not liberating, as many maintained, and could not replace face-to-face communication: "No meaningful communication—in the sense of a true exchange of ideas, thoughts, opinions, or discussion . . . can ever emerge from a programmed technology."[64] Alexei Shulgin adopted a similar position in 1999, describing interactivity as a simple and blatant form of manipulation: "'Oh, it's very democratic! Participate! Create your own world! Click this button, and you are as much the author of the piece as I am.' But it is never true. There are always authors with a name and a career behind it, and they just seduce people to click buttons in their own name."[65]

These criticisms are also ultimately a response to the assessment of interactive media art as an open artwork that, by enabling the recipient to contribute substantially to the creation of the work, goes beyond the interpretive scope left open by the blank spaces in literature or painting. As we will see, interactive media art is primarily based not on systems of meaning that the recipient must complete or even create by means of associations but on processual invitations to which the recipient must respond through his own actions. Though processes of associative completion or co-authorship may play a role in some interactive artworks, they cannot be considered a prime characteristic of this type of art. As a result, this study makes no effort to justify interactive art by defending the thesis that it liberates the recipient. On the contrary, it criticizes the fact that interactive media art is still often judged either in terms of avant-gardist objectives or in terms of a technological euphoria that is by no means shared by all artists working with new media. Instead, as Dieter Mersch emphasizes, what must be examined is the potential of the works to deconstruct media: "The task of art, when it makes use of media, . . . is to reveal fractures. Thus, if media are used in art and, vice versa, artistic experiences are induced via media, then this is always as a reflection of the tension existing in the relationship."[66]

The thesis of this study is that the aesthetic attraction of interactive art is based on the restriction of its processes through manifest control mechanisms and rules. The new types of aesthetic experience offered by interactive media art are not primarily based on a simulation of face-to-face communication, or on the recipient's becoming a co-author, or on symbolic systems' being opened up for associative completion, but are mainly based on uncovering the structures and control mechanisms used in digital media and the related perceptual processes.

A critique of hypertext

Interactive art based on hypertext is mainly discussed in literary studies. I will dedicate a brief excursus to hypertext here, not only because it represents an important variant of interactive art as a favored medium for interactive narratives (see the case studies of Olia Lialina's *Agatha Appears* and Susanne Berkenheger's *Bubble Bath*) but also

because it offers a good opportunity for illustrating once again the shortcomings of exploiting common (mis)conceptions of interactive art within discourses of reception aesthetics and post-structuralism.

The term "hypertext" was coined in 1967 by Ted Nelson to denote non-sequential, branching writing that allows the reader to make choices.[67] In the early 1990s, various authors drew parallels between electronic hypertext and the post-structuralist theories of Roland Barthes, Michel Foucault, and Jacques Derrida. The literary scholar George Landow has called hypertext the fulfillment in two respects of post-structuralist notions about textuality.[68] On the one hand, he writes, hypertext allows the alinearity described by Barthes to be transformed into a dynamic structure within a self-contained text. On the other, hypertextual systems can be used to realize as actual connections the structures of intertextuality (reciprocal references between different texts) emphasized by Derrida.[69]

This comparison between hypertext and post-structuralist ideology is often criticized, however.[70] Not only, as Roberto Simanowski points out, does the structure of the links require that text units be short, self-contained, and comprehensible (which means they cannot be used to transmit complex chains of thought); in addition, both the production and the reception of hypertexts are "occasionally prematurely celebrated as an instrument of critical thought."[71] Simanowski believes this is based on two misunderstandings: the supposed openness of the text and the apparent death of the author. In hypertext theory, too, belief in the openness of the text is usually based on the model of the blank space. Simanowski argues that the blank space is meant to stimulate the imaginative power of the reader, whereas the openness of hypertext offers freedom only in choosing the order of text units. He distinguishes between combinatorial and connotative freedom, adding that combinatorial activity is unfortunately detrimental to connotative interpretation because the hypertext constructs a "hierarchy of associations . . . in which the connections actually made by the author enjoy a more dominant presence than those created virtually by the reader."[72]

Critiques of hypertextual literature thus follow a similar pattern to critiques of interactive media art in general. First, a form of art is associated with certain ideological or avant-gardist expectations; then it is criticized for not fulfilling these expectations.[73] As has already been mentioned, the present book suggests that we not assess interactive media art in terms of the various liberation utopias with which it has been associated, and that instead we deduce its ontological status and aesthetics from its own specific media-based structures.[74]

Aesthetics of Process

The approaches based on an aesthetics of response which I have described above still ultimately remain committed to the analysis of the work as a referenceable entity. By

contrast, analyses of process-based art which are explicitly concerned with describing processes and action-based experiences require a truly new perspective on artistic works. In what follows, I will present those few approaches that have emerged from the context of the visual arts before moving on (in the next chapter) to discuss theories of play and performativity, which are much more comprehensive in this respect.

Systems aesthetics and relational aesthetics

Back in the 1960s, Jack Burnham coined the term "systems aesthetics" when calling for an analysis of art based on its processuality. Fascinated by the possibilities offered by the new technologies and confident of the potential of kinetic and cybernetic art, Burnham believed that society was in transition "from an object-oriented to a systems-oriented culture."[75]

Burnham felt that art had an educational duty to demonstrate that it resided not in material entities but in relations between different people or between people and their environment. He argued that the concept of systems aesthetics, which transcends the boundary between art and technology, made it possible to treat the artist as a critical observer of technological and social systems. Drawing on the system theorist Ludwig von Bertalanffy, Burnham described a system as an interaction between material, energy, and information in various degrees of organization. He believed that the task of the artist was to configure the "goals, boundaries, structure, input, output and related activity inside and outside the system."[76] The focus should no longer be on a visually perceptible final product: "[H]ere behavior is controlled in an esthetic situation with no primary reference to visual circumstances."[77] Burnham explained that the value of the abstract concept of systems lay in its applicability to "kinetic situations" and, in particular, to "connecting structures of evolving events."[78] However, he soon had to revise the high hopes for art he had built up on the basis of cybernetic theory. Although he regarded the use of negative feedback as a prerequisite for enabling a truly flexible interaction between the work and the observer,[79] in the light of the works that were actually produced he had to satisfy himself with the finding that kinetic and cybernetic artworks constructed patterns of behavior that were not purely random products but were not entirely predictable either.[80] In a later essay, referring to the growing mechanization of society, Burnham repeated his aspiration that there would one day be an "aesthetics of intelligent systems."[81] In such a society, Burnham wrote, an art object would no longer offer predefined information for reception; rather, a dialog would evolve between two systems, with both systems in a constant state of change. He believed that this process constituted an evolutionary step in the field of aesthetic responsiveness. In Burnham's view, the computer dissolved the boundary between art and the environment and that between the observer and the observed. Form would no longer be definable in geometric terms, but it would be definable in terms of process and system.

Burnham's systemic perspective on aesthetics was, thus, primarily formulated as a vision of a new art. Yet it found few adherents, probably because, as Burnham admitted in 1980, the reformation of art through cybernetics never came about. Burnham was referring to Jean Tinguely when, in resignation, he asked "Why should the only successful art in the realm of twentieth century technology deal with the absurdity and fallibility of the machine?"[82] Even though some of Burnham's visions (especially those concerning the dissolution of boundaries) seem to have been fulfilled in contemporary media art, even today few projects actually use negative feedback methods, i.e., the flexible adaptation of system processes to recipient input.[83] This doesn't categorically rule out a systems-aesthetics analysis of interactive art, insofar as systems theory by no means deals only with complex technical feedback processes. The main reason why more recent systems theories touch on questions of aesthetic experience only rarely[84] is that systems theory, as a theory of social systems based on Niklas Luhmann's thinking, is primarily interested in the social function of art, not in its modes of aesthetic operation.[85]

In a broader sense, the concept of relational aesthetics, developed by Nicolas Bourriaud in the mid 1990s, can also be considered a systems-theory approach (albeit not of the Luhmann school). Bourriaud is concerned with the analysis of artistic strategies that invite the recipient to engage in social interactions and to reflect on their meanings and contexts. Examples include Rirkrit Tiravanija's transformations of art galleries into temporary kitchens, Felix González-Torres' consumable art multiples, and Christine Hill's service art. Bourriaud distinguishes the intentions of these artists from those of the classical avant-garde as follows: "[T]he role of artworks is no longer to form imaginary and utopian realties [sic], but to actually be ways of living and models of action within the existing real, whatever the scale chosen by the artist."[86] Nowadays, in Bourriaud's view, it is not utopias that matter, but real spaces, "cultural do-it-yourself" and recycling, the invention of the everyday, and the configuration of time lived. Bourriaud sees such art projects as functioning as "social interstices"—that is, as interspaces that fit more or less harmoniously into the social system but open up other possibilities for interaction than those traditionally offered by the system. What are developed here, in his eyes, are "critical models and moments of constructed conviviality."[87]

Although Bourriaud studies social interactions, not technically mediated interactivity, his ideas are interesting for the present study because he suggests that analyses should focus on the formal or structural characteristics of interactions. These "arenas of exchange" should, he argues, be assessed on the basis of aesthetic criteria—that is, by analyzing the coherency of their formal configuration, the symbolism of the systems they propose, and their nature as reflections or models of human relations. Bourriaud asserts that form is no longer defined by an object's style and signature, and that we should speak instead of "formations," which only exist in the intersubjec-

tive encounter and in the exchange between the artistic concept and the social con-
stellations in which it intervenes.[88] Art should be differentiated from other human
activities on the basis, for example, of its transparency, defined as the disclosure of its
production process and its mode of functioning.[89] In this respect, however, interactive
media art has little in common with Bourriaud's examples. As we will see, the media-
based approach often leads to the recipients' being confronted with a "black box"—a
mediating apparatus whose workings are not immediately transparent.

Nonetheless, both Burnham's visionary model and Bourriaud's analysis of actual
projects constitute endeavors to define interaction processes themselves as something
that can be configured artistically. Within these processes, the actions of the various
actors combine to create their own formal, though constantly modifiable, structures.
Because they are related to, though differentiated from, processes of everyday life, they
provide opportunities for sensitized perception and awareness.

The configuration of experience

Alongside efforts to carry out a general systemic analysis of processual art, other
approaches have sought to examine the physical relationship between the observer
and the work. They investigate its effect on the process of a work's realization and
explore it as the point of departure for emotional and cognitive experiences. Probably
the best-known discussion of this viewpoint was a trenchant critique by Michael Fried.
In an essay titled "Art and Objecthood," Fried criticized minimal art (he called it "lit-
eralist art") for its focus on the real (spatial) conditions of its perception, which he
believed reduced the work to an object trying to affect the observer in a theatrical
relational situation that actually distanced him.[90] Fried's essay, although it was con-
ceived as a negative outlook on minimal art, was often received as a positive descrip-
tion of the new strategies being used in art.[91] However, neither Fried nor the other
authors taking issue with the Greenbergian formalism that was dominant in the
United States in the 1950s truly articulated the new relationships between work and
recipient in aesthetic terms.[92] In the German-speaking world, the first attempt to do
so was Gerhard Graulich's doctoral thesis, published in the late 1980s, which exam-
ined the sculptural art of the twentieth century (from Auguste Rodin to body art) from
the perspective of the "corporeal self-experience of the recipient" and traced a path
from object aesthetics to process aesthetics, which Graulich defined primarily in phe-
nomenological terms. Graulich used works by Franz Erhard Walther, Bruce Nauman,
and Richard Serra to illustrate how tactile impulses and invitations to take action
facilitate "corporeal self-understanding" and provide "models for experiencing social
processes."[93]

This view correlates with Oskar Bätschmann's analysis of the artworks as "configu-
rations of experience" (Erfahrungsgestaltungen)—a topic that has been pursued further
in various recent publications on the question of corporeity in the arts. Bätschmann

superbly describes walk-in installations of the 1970s and the 1980s (by Rebecca Horn, Bruce Nauman, and Richard Serra) which are deliberately conceived as configurations that trigger and control experiences. According to Bätschmann, they construct and facilitate strange or threatening situations, ritual processes, and (apparently) transcendental experiences by means of effects that induce feelings of isolation, aggression, destabilization, surprise, temptation, and intimidation. In the light of such projects, Bätschmann argues that not only the roles and functions in the artist-work-beholder triangle but also the processual relationships between these entities should be reassessed, insofar as the work remains incomplete without the activity (not only the presence) of the observer.[94] Even if Bätschmann doesn't provide a detailed theoretical formulation of these relationships, his exemplary descriptions show that he sees a possible point of entry in an analysis of the intended and actual emotional effects of the works. One example of an application of this perspective is Anne Hamker's "cognitivistic reception analysis" of Bill Viola's video installation *Secrets* (1995). Hamker illustrates how the media-based structures of this installation "channel its reception into particular avenues and thus motivate the complex and occasionally ambivalent emotional reactions."[95] She identifies the emotional reactions (which include surprise, interest, curiosity, uncertainty, fear, mistrust, compassion, frustration, shock, panic, and relief) by drawing on a model of a reconstructed ideal-typical recipient.[96] According to Hamker, in *Secrets* knowledge can be acquired through the recipient's encounter with "conflicting self-perceptions and self-experiences," which induce "active identity work."[97]

Another important element of experience-based research is a careful analysis of physical relationships. In addition to Graulich's work, this approach is also illustrated by Felix Thürlemann's analysis of Bruce Nauman's corridor piece *Dream Passage* (1983), which he characterizes as "experience architecture."[98] Thürlemann uses semiotic categories (and, like Hamker, a reconstructed ideal-typical recipient) to analyze how Nauman's installation activates the "topological competences" of the recipient by contrasting physical and cognitive perception and prompting the recipient to reflect on these.

In the early years of the new millennium, this focus on the recipient's corporeity as a basis of reference attracted renewed interest under the term "embodiment." For example, Mark B. N. Hansen shows how bodily (self-)perception can also be a central theme in interactive media art. He holds that only bodily perception can really transform the general appearance of an artwork into a rich and unique experience.[99] Drawing on Henri Bergson, Hansen points out that the body configures individual perception by means of "affection"—that is, by means of activating impulses that originate in a perception without having to be manifested as an action.[100] Hansen asserts that the body can "experience its own intensity, its own margin of indeterminacy," and that this is an experience that goes beyond "the habit-driven, associational logic governing perception."[101] The focus shifts, he writes elsewhere, from ocular-

centric concepts of virtual reality to the enrichment of real space through technology and data in "mixed realities."[102] As a result, the virtual becomes one domain among others that can be rendered perceptible through bodily sensitized action.[103] Drawing on Merleau-Ponty's concept of the body scheme (the action-oriented, environmentally based self-perception of the active body), Hansen coins the term "body in code" to denote a technical mediation of the body scheme, which is accompanied by a dissolution of the boundaries between body, real space, and data space. He reminds the reader that Myron Krueger had already described the "enactive" potentials of the new media—the possibility of using new media to activate the recipient's bodily capacity to acquire knowledge.[104] According to Hansen, new technologies create new possibilities for body awareness by working directly with bodily data. Hansen believes that the human body doesn't end (any longer) at the boundary of its own skin. He illustrates his thesis of the technically mediated fusion of the boundaries between the individual and the collective by reference to Rafael Lozano-Hemmer's installation *Re:Positioning Fear* (1997), which projected online discussions on the topic of fear onto the facade of the historical Zeughaus building in Graz in such a way that the words became legible only when struck by shadows cast by the recipients' bodies. The physical actions of the recipients thus rendered digital data visible, while the facade displayed a manifestation of the spatially distant body (its shadow) together with a manifestation of data that had been produced at a spatial distance. Because, according to Hansen, the human potential for embodiment no longer coincides with the boundaries of the human body, disembodiment is the condition that can enable collective embodiment through technology.[105] Hansen thus suggests that the experience of interactive art should be interpreted as mediated by the body and as transforming body awareness. Although this view is pertinent with respect to Hansen's chosen case studies, it must be pointed out that the chain he constructs from embodiment to disembodiment to renewed collective embodiment doesn't constitute a structural description of these installations, but rather is one possible interpretation within the context of the self-referential interpretability of these works.[106]

Thus, while an aesthetics of response deals with the work as the central object of the analysis and sees the activation of the recipient as consisting in the invitation to associatively complete or further develop a given work, process aesthetics emphasizes either systemic processes and social relations, or emotional or physical processes and their cognitive elaboration. Whereas in theories of aesthetic response the epistemic potential is ultimately identified in the recipient's associative and interpretive involvement with the work, theories of process aesthetics have a different focus. Similarly to Jauß and Gadamer, both Hamker and Bätschmann locate the work's epistemic potential in a (cathartic) transformation, which they analyze by constructing an ideal-typical recipient.[107] Thürlemann and Hansen's body-centered approaches, by contrast, offer interpretations, centered on particular issues (semiotics and disembodiment), at

which one arrives not through cathartic transformation but through cognitive reflection and subsequent interpretation of the artistic projects—in other words, what is expected in this case is a reflective distancing, even if it may come about only after the actual experience.

Methodology

In this book I do not want to present an aesthetics of interaction as a purely theoretical model. Rather, I want to elaborate criteria—based on the concrete observation of exemplary artistic projects—that facilitate the description and analysis of interactive art. The combination of theoretical deliberations with case studies opens up the question as to how the object of investigation can be accessed. Descriptive and analytical tools, even if they rest on carefully constructed theoretical foundations, still tell us nothing about how the object of study can be encountered in practice. How can an artwork based on innumerable new realizations of an interaction proposition be pinned down in a written description?

Some artists evidently choose to produce interactive art specifically because it resists scholarly analysis. Myron Krueger has criticized both art history and art criticism as barriers to the experience of art. He holds that visitors to installations are aware of the experts' compulsion to interpret, and therefore expect to be able to immediately express the purpose or meaning of a work in words. In Krueger's view, interactive art, as a "medium that can resist interpretation," can counteract this tendency.[108] Krueger is convinced that the art form he calls "artificial reality" thwarts all attempts at analysis because it individualizes the way the visitor deals with the system. If every visitor has a different experience, then the quest for the supposedly correct interpretation loses significance. This kind of approach, labeled "flight from interpretation" by Susan Sontag as early as 1964, can be seen as symptomatic for that era.[109] However, it seems fair to claim today that contemporary art historians are able to accept open-ended meanings for artworks and carry out analyses of artistic production without falling back on reductive and normalizing interpretations. Among others, Susan Sontag, in the past, and Brian Massumi, more recently, have thus advocated a stronger focus on the *form* of artistic creations—in other words, an analysis that reveals the complex fabric of formal structures and their possible meanings without seeking to unlock them. Of course it is difficult, Massumi concedes, to speak of form when what actually happens in such types of art is determined only through realization by a recipient, or when there are potentially infinite variations of a single work, or when the artwork "proliferates" or disseminates across networks. However, it is also true that form is never stable, even in traditional aesthetics: "The idea that there is such a thing as fixed form is actually as much an assumption about perception as it is an assumption about art."[110] This makes the need to resolve the problem of exactly how to access the object

of study even more urgent. On what should its description be based, and how can it be meaningfully and comprehensibly verbalized?

First of all, the description will not concern static artifacts or simple actions but interactions. Even describing a single or a consistently repeated interaction process would be difficult enough, insofar as what must be described are relationships between system processes and recipient reactions—in other words, between invisible and visible procedures. But the description must also take into account the huge number of possible interactions that might take place—that is, the relationship between interactivity (the work's potential for interaction, i.e., the reception intended by the artist) and actual interaction.

Consequently, accessing and describing these processes is much more difficult than simply describing a static artifact. However, a converse argument is also possible. If we shift the perspective from the artifact to its reception, then access becomes easier in interactive art because the reception manifests itself at least partially in observable behavior, which, moreover, is channeled in particular directions by the technical systems involved. Whereas the individual reception of a static artifact (or a stage performance) is purely visual or cognitive, and therefore virtually incomprehensible for an outside observer, it is at least partially observable in interactive art. Decisions and selection processes cannot be observed in the reception of static artifacts, but they are manifested at least to some extent in the form of actions in the case of interactive art.

There are several reasons why a description might tend to distinguish between the interaction proposition itself and its realizations. The art historian is more familiar with the task of describing the interaction proposition as an artistic product than with describing its active realization by the recipient, even if what requires description concerning the interaction proposition is not only what can be directly perceived but also how the system motivates the recipient to act and how it channels these acts. Such a description identifies the set parameters of processes of experience, that is the parameters that will restrict the possible range of subjective experience within the context of the realization. In other words, what we are dealing with here is an aesthetics of response, as described above. However, the structures of an interaction proposition cannot be grasped only by looking at it. To be able to describe the artistic configuration of a work, we have to see it being actively realized (in some cases repeatedly); otherwise we would be forced to rely on the artist's explanations of its composition and structure. Thus, the interaction proposition and its realization, and, respectively, the aesthetics of response and the aesthetics of process, cannot be separated in practice.

The (physical) activity involved in the realization is, in principle, open to observation. If we then want to proceed from these observable actions to issues of associative and interpretive reception, we must conduct surveys (unless we are content to limit ourselves to our own individual experiences).

Self-observation

There is one principle that can justifiably be considered an unwritten law of studies of interactive media art—at least as regards the frequency and vehemence with which it is expressed by scholars in the field: "Never write about a work that you have not experienced yourself!"

Art historians have been describing works on the basis of their own perceptions for centuries, and this practice has seldom been called into question. The art historian draws on his extensive experience with visual perception and cognitive appreciation of artworks, and also on his training in the use of specialist vocabulary and the verbalization of his observations. As John Dewey and Martin Seel observed, the art historian's sensitivity to the specific characteristics of a work feeds on his knowledge of other artworks, which can be used for comparison or to contextualize the current perception. The fact that an observation based on these premises will still be subjective—notwithstanding all the prior knowledge and scholarly background possible—is either tacitly accepted or (as in hermeneutics) openly discussed.

Thus, the above imperative of personal experience of interactive art refers not only to individual access to the work, but also and especially to the need for an active, physical realization. The art historian should experience the interaction process in person, rather than only observing it or even acquiring an impression of the work only through documentation. However, this requirement is problematic for two reasons, one pragmatic and the other methodological. First of all, it can be expected that, as time passes, older interactive media artworks will become less available for personal experience. If we were to take the premise to the letter, scientific studies on works that can no longer be presented or are no longer accessible would become inadmissible, with the result that it would be impossible to conduct research on interactive art that looks back over a longer period. Most interactive projects are exhibited only briefly, usually in the context of a festival. And most of the interactive artworks that have ever been created are not installed anywhere today, if they still exist and are functional. Thus, it is extremely important that they be documented, which nowadays is usually done using videos, technical drawings, and other material. Documentation must, nonetheless, be clearly distinguished from personal observation or third-party observation of a realization in the here and now. In the ideal case, observation should be supplemented by the consultation of documentation. Though describing works exclusively on the basis of documentation is not ideal, sometimes it is unavoidable.[111]

The second methodological problem with the above premise also concerns works that are (still) accessible for personal realization. Once again, the difficulty is one of aesthetic distance. Is it possible that the price of personal experience is a loss of aesthetic distance, which would be guaranteed, by contrast, if the art historian were to consult good-quality documentation or simply observe other recipients?

The anthropologist Colin Turnbull compares the researcher to a performer who adopts different roles so as to facilitate particular communication situations. Turnbull argues that liminal phenomena—such as threshold situations between different states of consciousness in ritual behaviors—cannot be studied objectively and must be experienced through participation. Though an external perspective is not entirely impossible, according to Turnbull a real understanding of the behavior in question can only be achieved by means of an inside view.[112] The ethnologist Dwight Conquergood deals in even greater detail with different possible research perspectives in ethnographic studies. Of the five possible research attitudes he identifies, he criticizes the "archivist," the "skeptic," and the "curator" as too distant. But he sees excessively enthusiastic identification as equally misguided because it fails to do justice to the complexity of cultural differences. Conquergood calls instead for a dialogical approach that seeks to bring different opinions, world views, and value systems together in a single conversation.[113] Without entering in any more detail into the different viewpoints expressed in anthropological and sociological research, it is already evident that human (inter)action is studied in these fields in acknowledgment of the fact that objectivity is impossible; such studies include critical reflection on the researcher's unavoidable balancing act between involvement with and distancing from the object of examination.

The analysis of interactive media art on the basis of participatory (self-)observation is actually less problematic than the study of social interactions because, unlike human actors, technical systems are not influenced by the fact that their interaction partner is a scientific observer rather than a normal participant. However, the researcher still has the task of reconciling his own involvement in the action with the goal of scientific observation. This question of the possibility of (or necessity for) aesthetic distance equally concerns the aesthetic experience of the recipient, however. In any case, self-observation is an important component of the description and analysis of interactive art. But even the description of a work exclusively on the basis of self-observation will not content itself with the description of a single encounter with the work. A detailed description requires a certain amount of time spent dealing with the work, at the very least a repeated experience with the particular interaction proposition.[114] In this way, any description becomes a cumulative construct consisting of different experiences—which in the ideal case should include not only the scholar's own experiences but also those of other recipients.

Recipient observation and recipient interviews

If we take the concept of dialogical research seriously, then (and especially because in interactive art the gestalt of the work is realized anew with every new recipient) we would have to formulate a second premise: "Never write about a work only on the basis of your own experience!"

But how can a scientific study take other realizations and experiences of a work into consideration? To what extent can empirical studies meaningfully support scientific research on art? The answers to these questions will differ depending on the aim of the study in question, for what might be beneficial to a study in sociology of art will not necessarily be meaningful at all in a study with an aesthetic focus. For example, art sociologists are very interested in knowing what share of the visitors to an exhibition of interactive art are willing to interact with a work at all, or—as a subsequent step—willing to take the time to actually intensively experience a work. But such knowledge is less relevant for an aesthetics of interaction, which is interested in the experience of art and therefore requires at least a minimal degree of engagement with the interaction proposition. The relevance of statistical surveys is also questionable when it comes to the interactions that actually take place. Though receptive experiences or interpretations may be considered more significant when they are supported by a representative number of similar reports, a single "original" interpretation or experience might be considered particularly interesting. We must also ask whether in fact all the possible encounters with the work are relevant, in principle, for an aesthetic analysis. For example, recipients can, of course, behave entirely differently than the artist expected them to, the spectrum of behaviors ranging from ignoring the invitation to interact to attempts to destroy the work. As Dewey and Seel have pointed out, an aesthetic experience requires a certain degree of willingness to enter into the experience itself. But it also requires the ability to consciously reflect on one's own behavior or at least perceive it. Furthermore, not all recipients, by any means, are either able or willing to comment on their behavior.

As a result, this study gives a higher priority to examples of reception by people whose willingness to participate in the research was ascertained in advance. It accepts that the behavior of the subjects in the interaction is influenced by their awareness of being documented. After all, as ethnographic theories explicitly point out, when the object of study are subjective experiences, objectivity is not only impossible to achieve but is also ultimately irrelevant. On the one hand, each interaction is unique; on the other, both the perception and verbalization of interactions are influenced by numerous factors.

Bearing these caveats in mind, the dialogical method—which seeks to mitigate the impact of personal viewpoints and research-related limitations by using a multiperspectival approach and by eschewing the ideal of putative objectivity—appears to be a suitable means to gain access to the object of study and to its aesthetic experience. I was able to make extensive use of such a dialogical method for three of the case studies presented here (those of Blast Theory, David Rokeby, and Tmema). Thanks to the collaboration of three colleagues (Lizzie Muller, Caitlin Jones, and Gabriella Giannachi), it was possible to design and create comprehensive multi-perspectival documentation (including data from visitor observations, visitor surveys, and in-depth

artist interviews). In particular, a method called video-cued recall (VCR), which had been applied in the past by Muller and Jones, was used. In VCR, the recipient is filmed during the interaction and is subsequently asked to comment on his actions and perceptions while watching the video recording of himself interacting with the work. An in-depth interview with the recipient is carried out only after this procedure.[115] One reason this form of self-commentary proved very informative was that the video-supported self-observation allowed pauses in the conversation, which gave the recipients the opportunity to recall details and enough time to verbalize their experiences.

The artist as a source of information

The work's author is an excellent though not unproblematic source of information for a multi-perspective approach. We can acquire his input by means of interviews, but also by consulting the texts and pictorial and video documentation he provides, which will help us not only to understand the design of the interactive work but also to gain an impression of the receptive behavior he expects. However, works are rarely constructed exactly as they have been described in drawings or texts, and they may vary from one exhibition to another. Moreover, artists' videos of their work in operation may depict an ideal or intended realization, rather than actual realizations occurring in exhibition contexts.[116]

The artist can also provide important information regarding the actual realizations of his project by the recipient; however, he is anything but unbiased. He probably will adapt a requested description of an ideal recipient to his own experiences as the first recipient of his installation and as an observer of its visitors. He will thus describe processes of interaction that are actually (or can be) realized, even if he had other actions in mind during the conceptual phase. Oskar Bätschmann illustrates the possible discrepancy between intended and realized reception using the example of Richard Serra's installation *Delineator* (1974–1975). Serra himself wanted the installation to stimulate reflections about spatial (self-)perception, but the visitors mainly found the installation frightening. Bätschmann criticizes the exhibition catalog for publishing statements by and instructions from the artist, which probably influenced the discussion of these experiences and predetermined their interpretation.[117] Rafael Lozano-Hemmer's installation *Body Movies* (2001) is a good example of the same problem in interactive media art. In that work, the artist projected life-sized photographic portraits onto the facades of public buildings. Thanks to special lighting, the portraits became visible only when passers-by cast shadows on them. As soon as all the portraits had been "shadowed" and had become visible, new photographs were projected. But as the documentation records, most of the recipients were not particularly interested in revealing the portraits, using the installation instead for lengthy and extremely original shadow plays.[118] The installation was very successful in this respect, even if few visitors appreciated the artist's original intention.

Projects of interactive art come into being through an iterative process that includes conception, production, realizations, evaluations, and adaptations. The artist is too deeply involved in this process to be able to serve as an unbiased witness. However, the artist's perspective still represents an important component of the researcher's access to the object of investigation, and this study, too, gives great importance to incorporating the views of the artist—not only in the case studies.

Approval of subjectivity

As has become clear, even if this study strives to take a multi-perspectival approach, it still remains shaped by subjective factors, beginning with my own horizon of experience, interests, and research style, continuing with the selection of the works taken as examples, and ending with the subjective perceptions of the recipients and artists. Just as the aesthetic theory presented in this book is not aimed at a categorical fixation of potential experiences of interactive art, the aim of the case studies cannot be objectivization. The only possible goal is to collect information from different sources and perspectives that will enable a multi-dimensional description, not an objective one. Any description will remain fragmentary for the simple reason that the observations made can only ever record specific instances in the history of a work's exhibition and reception.

Furthermore, no matter how the information about the interaction and its interpretation is obtained, its translation into the medium of descriptive text represents a challenge all of its own. In anthropology, the subjectivity of experience is often reciprocated through a performative style of reporting.[119] Such attempts at "performative writing" can also occasionally be found in art history. For instance, reporting on his visit to the *Spiral Jetty* (a Land Art project by Robert Smithson), Philip Ursprung writes that he wants to "convey to the reader the relativity and the changes of the author's perspective, not so as to promote a new subjectivism, but so as to keep in mind the fiction and contingency of historical description."[120] Ursprung presents his perception of *Spiral Jetty* as such a momentous experience that he is practically forced to adopt this style: "As if I were at the eye of a hurricane, my ideas of art were swept away. I would never be able to write about art again without saying 'I.'"[121]

Although this study expressly recognizes the subjective basis of the case studies, nonetheless the actual description of the works follows an approach that best reflects the mode of access to them. A first-person description would suggest that priority is given to my particular personal experience of the work. Thus, I opted for third-person descriptions, so as to indicate that these are constructs made out of different realizations, whether carried out by myself or by other recipients. However, this by no means suggests that the descriptions have generalizable validity.

A common way to describe interactions is to construct a typical recipient who engages in the interaction behavior (or single action) intended by the artist. The

concept of constructing an ideal observer was adopted from ethics into aesthetics research as a way of objectivizing aesthetic judgments. The idea is to construct an ideal observer who fulfills all the prerequisites of aesthetic experience in an ideal manner—if this observer likes a work, then its aesthetic quality is ensured.[122] This study doesn't agree either with the aim of such a construction (the establishment of aesthetic quality) or its premise (the idea of the ideal observer). Even if basing the case studies on different observations and sources means that in some sense a recipient is constructed for the description, I make no claim that this description reproduces the only "correct" reception or interpretation.

3 The Aesthetics of Play

Play as a form of action—not only among human beings—was first studied by Friedrich Schiller and has been explored since then within a range of different scientific disciplines: biology, physiology, psychology, sociology, philosophy, cultural studies, media studies, and economics.[1] Building on the seminal studies produced in the first half of the twentieth century by Johan Huizinga, Roger Caillois, Gregory Bateson, Ludwig Wittgenstein, and Frederik J. J. Buytendijk, each of these fields has developed its own approach to the phenomenon of play. While scholars of pedagogy and sociology have continued to explore the didactic and culture-shaping potentials of play, performance researchers, starting with the anthropologist Victor Turner and the theater theorist Richard Schechner, have been specifically interested in performative play in its many forms. In the 1990s, partly thanks to Erika Fischer-Lichte's theses on semiotic and performative aesthetics, the approaches of the latter two scholars were also disseminated beyond the realms of anthropology and theater studies.[2] Furthermore, since around the turn of the millennium the new and vibrant discipline of ludology has emerged; by studying the structures of computer games, it has given fresh impetus to the theories of rule-based play.[3]

"Play" can be defined in this context as a "boundary concept"—that is, a concept useful for defining research questions that pertain to a variety of disciplines—and for identifying the characteristics that unite or differentiate their individual perspectives.[4] In fact, the ambivalence of the German word for play—*Spiel*—is beneficial to the interdisciplinary view. Whereas the English language uses the word "game" to describe a special kind of rule-based play, in German the word *Spiel* is used to denote free and purposeless play, play in the sense of performing or role playing, and also rule-based strategic play (i.e., games). As Wittgenstein explains, the concept of *Spiel* is not founded on a single, clear-cut definition; rather, it refers to "a complicated network of similarities, overlapping and criss-crossing."[5] It seems both reasonable and conducive to the aims of this study to unite these various types of action under one generic term as a "boundary concept" that can further the discussion via its different interpretations. In fact, it is possible to find common characteristics in many different

forms of play—above all else, the foundation of an experience on an activity that is not primarily purposeful, which applies both to rule-based games and to free play. Since this is a fundamental characteristic of interactive art as well, play is an important reference system for this study.

Art and Play from Schiller to Scheuerl

Schiller was the first scholar to discuss play outside the context of child development. In *On the Aesthetic Education of Man* (1793), he coined the term "play impulse" (*Spieltrieb*) to describe an instinct that mediated between man's physical and sensuous impulse (*Stofftrieb*) and his rational or formal impulse (*Formtrieb*). Schiller argued that the object of the play impulse was the "living shape" that characterized the aesthetic semblance. Thus, he not only recognized play as a philosophically relevant category but also discussed it in relation to aesthetic theory.[6] However, Schiller did not specify whether "living shape," as the object of the play impulse, could also be achieved through perceptive and cognitive play, or only through constitutive and creative play. Subsequent nineteenth-century theories of play did not address this question either. The philosopher Julius Schaller simply compared the person at play to the creative artist. He did, however, point out that the difference between art and play was that art was oriented toward an enduring result, whereas "in play, the work is never detached from the subjective activity of the player, it does not acquire an objective, independent meaning."[7] The psychologist Moritz Lazarus followed the same line of thought, which is clearly based on the premodern concept of the artwork. Lazarus believed that play equaled movement, whereas the artwork remained static, so that in the realm of the arts only performances of literature or of music were related to play.[8] It was not until the beginning of the twentieth century that another psychologist, Karl Groos, shifted the emphasis to the moment of reception and identified "active aesthetic presence" in art and play as an important element of aesthetic behavior.[9] This shift demonstrates that even early theories of play were concerned with the problem (mentioned in chapter 2 above) of finding an ontological definition of the artwork that was located somewhere between artistic product and object of experience.

Even if the two most renowned play theorists of the twentieth century, Frederik Buytendijk and Johan Huizinga, did not make any direct comparisons between art and play, each of them left a fundamental legacy of thought about the cultural significance of play. Buytendijk highlighted the figurativeness of play objects. He argued that play's stimulative nature and indeterminacy could open up new realms of possibility and fantasy.[10] He used the term *Beeldachtigkheid* (meaning "figurativeness") to refer to the interpretability of play, since he saw the play experience as lending itself to interpretations and associations.

Huizinga sought to trace all forms of cultural expression back to play, and also to formulate the most concrete possible definition of play. Because his definition remains as topical as ever today, I will quote it here in full:

Summing up the formal characteristic of play, we might call it a free activity standing quite consciously outside "ordinary" life as being "not serious" but at the same time absorbing the player intensely and utterly. It is an activity connected with no material interest, and no profit can be gained by it. It proceeds within its own proper boundaries of time and space according to fixed rules and in an orderly manner.[11]

Regarding the relationship between play and aesthetics, Huizinga pointed out that play is characterized by the impulse to create orderly form, which animates the activity. He believed this was the reason why play is often found to be beautiful.[12] These deliberations have much in common with theories of aesthetic experience of the same era, for example John Dewey's description of the object of experience as a form striving toward completion. As we will see below, however, this view is a point of controversy in present-day research.

Around the middle of the twentieth century, the education researcher Hans Scheuerl drew on the ideas of Karl Groos in noting parallels in the processual natures of art and play, insofar as the two "obey comparable structural laws in the purely formal interrelations between form and process."[13] According to Scheuerl, the real phenomenon of play was the playing itself, not the player or the context of the play. The fact that play was "accomplished only in the given moment" didn't differentiate it from the artwork; rather, it was something that the two had in common.[14] Hans-Georg Gadamer, who was the first to incorporate the notion of play in a theory of aesthetic experience, made a similar point. According to Gadamer, play is the mode of being of the artwork. Like Scheuerl before him, Gadamer saw play as characterized not by the player as a subject but by the playing itself—by the to and fro: "In analyzing aesthetic consciousness we recognized that conceiving aesthetic consciousness as something that confronts an object does not do justice to the real situation. This is why the concept of play is important in my exposition."[15] Gadamer also pointed out that the structural framework of play "absorbs the player into itself" by relieving him of the burden of taking the initiative, "which constitutes the actual strain of existence."[16]

Significantly, these theories coincided with the era of the postwar avant-gardists, who called into question the strict separation of the work from the processes of its production and reception. The disruption of traditional conceptions of the work in postwar art and its reflection in scholarly texts thus revealed new parallels between aesthetics and theories of play. In particular, the increasing rejection of object orientation in art, the dematerialization of the artwork, and the growing consideration given to the recipient in the concept of art led to new parallels between art and play. The

difference between them was now no longer perceived in the ephemeral nature of play, but, to quote Scheuerl, in "value . . . that can glow in artworks."[17] Thus, two central aspects of the comparison between art and play have been defined. Whereas the traditional object orientation of the visual arts was originally a barrier to comparisons with processual play, the growing interest in processes of artistic production and reception now facilitated associations between the two. However, one possible divergence is seen in the question as to whether, and to what extent, artistic statements are founded on an inherent idea or intentionality—Scheuerl's "value"—that would differentiate them from play.

Characteristics of Play

The fundamental characteristics of play had thus already been outlined by the end of the 1950s.[18] Play is characterized by the *freedom* of the activity (Buytendijk, Caillois, Scheuerl) and by its *unproductiveness* (Caillois, Huizinga), as well as by *self-containedness* in the sense of being an activity with fixed spatial and temporal limits which is distinct from "real life" (Caillois, Scheuerl, Huizinga). Play *does not have a predictable course* or outcome and is based on *inner infinitude* (Buytendijk, Caillois, Scheuerl). It is *based on rules* (Buytendijk, Caillois, Scheuerl, Huizinga), and it resides in an *artificial* realm (Buytendijk, Huizinga, Caillois, Scheuerl).

Subsequent authors—such as Brian Sutton-Smith[19]—have further differentiated these classifications. Researchers' growing interest in computer games and the rise of the discipline of ludology have led to the formulation of additional characteristics since the turn of the millennium, which were excellently summarized in 2004 by Katie Salen and Eric Zimmerman.[20] These characteristics mainly refer to rule-based games, however, and thus address specific structures of play, which I will return to later.

Freedom: Voluntariness and unproductiveness

The free nature of play is comparable to the concept of autonomy in art and vacillates, like the latter, between the poles of cognitive and material independence. According to Scheuerl, one of the basic conditions of play is that it pursues "only its own self-sustaining purpose."[21] Huizinga, as cited above, defines play as a free activity, associated with no material interest, with which no profit can be gained. Caillois explicitly articulates the dual significance of freedom for the realization of play. On the one hand, he emphasizes the condition of voluntary participation in play; on the other, he emphasizes its lack of material productivity.[22] This dual condition of freedom is a constituent component of play, for at issue is not only whether an action is linked to a purpose or not, but also whether it is voluntary. This distinction is necessary because play (as well as interactive art) is based not only on contemplative perception but also

on action. For the voluntariness of an action is not the same thing as the voluntariness of perception; it cannot simply be equated with the Kantian conception of appreciation without interest. Perceptions and observations may be either disinterested or knowledge serving, but they can never be compelled, whereas an action may be carried out either voluntarily or under coercion. Thus, not until the condition of voluntariness has been fulfilled can the intentionality of an action be explored. The action may have the materially effectual and observable goal of changing one's personal environment, or it may be purposeless. Play is both voluntarily performed and materially unproductive.

These conditions can also be applied to interactive art, but they are not sufficient. I will explore the epistemic potential of action later in the book, but the question as to the symbolic productivity of actions can be posed here. For in addition to possible material purposes, actions can also serve to create social realities—for example, when a gesture is used to make a greeting. An action of this kind is not motivated by a material interest, and is not purposeful in this sense, but it does "constitute reality" (to anticipate a term used in performativity theory, which will be discussed in more detail below). The tension that arises when purposelessness and constitution of reality are confronted has been actively deployed in action art, too. Here, actions are carried out that may even be materially productive, but their function is ultimately as models or symbols. This applies to actions such as Beuys' tree planting and also to more recent projects in the sphere of Art in the Public Interest, in which, for example, the joint production and marketing of a chocolate bar by the artists Simon Grennan and Christopher Sperandio and factory workers was presented as an art project under the title *We Got It!* (1993).

Self-containedness

Scheuerl, referring to the structure of play that emerges as a result of temporal or spatial boundaries and is responsible for the fact that games can continue to exist beyond the moment in which they are played, described the self-containedness of play as a form or a gestalt.[23] Caillois too discussed predefined temporal and spatial boundaries. Huizinga defined play as an action carried out within a specifically determined time and space. Thus, self-containedness pertains to the rules and the location of play that separate play from everyday life and, above all, give form to the activity. Unlike the material self-containedness of a traditional visual artwork or the temporal structure of a stage performance, play doesn't necessarily involve clear-cut boundaries, although it may; the materiality of a chess board and the duration of a football game are examples. The space in which the game is played need not be materially separate from the everyday environment. In fact, it becomes a playing space when it acquires new meaning through an idea for or a process of play, or through rules and actions.

Its boundaries are often defined only by self-imposed regulations and then realized through the action that takes place, as when adjoining streets are used to define the territory of a game of Hide and Seek or when players agree to end a game as soon as one participant has achieved a particular aim. Salen and Zimmerman, borrowing a term from Huizinga, thus characterize the self-containedness of play as a "magic circle."[24]

However, the characteristic of self-containedness is called into question by certain types of play. A recent example is provided by "pervasive games"—games that actively reach into daily life, such as treasure hunts or stealth games staged as actions in public places.[25] Interactive art uses similar staging strategies, but also challenges the boundaries of playing spaces. The spatial and temporal extension of interactive artworks—their action space—often isn't evident at first sight or is difficult to distinguish from our living space. Just as in play, it is the rules of the interaction that define a radius of action for the realization of the work. The realization gives the work a distinct, ephemeral gestalt that has its basis in the interaction proposition but at the same time is individually constructed and perceived by the recipient. This is all the more true because the rules of action in interactive art are often less binding than those of play, which makes the boundaries of the interactive artwork potentially permeable, evanescent, and fragile. And yet the fragility is not an inevitable effect; rather, it is a conscious component of the staging of the work. The irritation provoked by the clash between different rule systems forms part of the aesthetic experience of interactive art.

Inner infinitude

Scheuerl used the term "inner infinitude" to describe the endless repetitions and variations found in play. Although a game may end, its conclusion is not the real motive behind the play. What fascinates the player is play's inherent "circling, oscillating, ambivalent state of suspense, which arises as a result of the reciprocal relativization of forces and in itself is not oriented toward a conclusion."[26] Scheuerl argued that this also applied to goal-oriented games, and that in such games, too, the fascination with playing itself was not extinguished by the achievement of the goal being sought. This phenomenon is related to the unpredictability of play that Caillois characterized as "uncertainty"—neither the course nor the result of this type of action is defined in advance.[27]

In the arts, too, each new observation of a work makes new perceptual experiences possible. "Just as one cannot become 'satiated' but at most tired of viewing an artwork," Scheuerl wrote, "one cannot be 'satiated' by a game, rather only tired of playing."[28] However, that view contradicts Huizinga and Dewey's theses that aesthetic experience is oriented toward a conclusion. Dewey argued that "every integral experience moves toward a close, an ending, since it ceases only when the energies active in it have done their proper work."[29] This contradiction is also evident in Gadamer, who on the one hand points out that the movement of play has "no goal that brings

it to an end; rather, it renews itself in constant repetition"[30] but on the other hand describes aesthetic experience in terms of transformation into structure.

Traditional works of visual art—as material objects—do not in any way predetermine the process of reception. A traditional stage play (with a linear progression) follows a predefined course. Interactive art, on the other hand, has a variety of options for guiding the process of reception or leaving it open. The work is often structurally based on potential variations that can be experienced only through repetition. The recipient of such a work can be satisfied by one course of interaction he has realized more or less by chance or, alternatively, can discover other possible courses by repeating the process.

Artificiality

Scheuerl defined artificiality (*Scheinhaftigkeit*) as the moment that distinguishes play from reality, describing it as a floating, independent state and a separate level of being. According to Scheuerl, artificiality may be based on the presentation of illusory worlds that imitate reality or may simply denote the onset of a ludic moment: "Thus, play—like art—can be either representational or 'abstract' and in both cases still remain on an 'imaginative level.' It is a kind of 'a second life' . . . that sometimes shines forth as an archetype, sometimes as a reflection of reality."[31] Caillois also emphasized these two possibilities of otherness, calling them a "second reality" and a "free unreality."[32] Huizinga, as I noted above, explained that the action of play is experienced as "not serious." Thus, whereas the characteristic of freedom emphasizes voluntariness and purposelessness, the issue here is the perception of the action as distinct from real life. It is not essential that there be a symbolic level that transcends materiality. What is essential is that an action, even if it is not necessarily symbolic, doesn't constitute reality. At first sight, it may seem tempting to equate this state of artificiality with the requirement of aesthetic distance discussed in chapter 2. However, we should be cautious here, since artificiality doesn't refer to the conscious distancing of the recipient from the object of aesthetic experience, but rather to a separation of the experience from everyday life. In fact, artificiality corresponds almost exactly to what Gadamer describes as "aesthetic differentiation": the suspension of the link between the work and the original life nexus. However, Gadamer further contrasts aesthetic differentiation with aesthetic non-differentiation, which doesn't refer to the relationship between the work and the life nexus but rather to the relationship between the work and what it represents. Gadamer's point is that what is represented merges with its own representation and remains in some way anchored to reality as a result of its embeddedness in the act of presentation. Thus, whereas aesthetic non-differentiation concerns the relationship between materiality and signification, aesthetic differentiation—like artificiality—concerns the recipient's contextualization of the presentation as separate from the original life context.

Rules

Rules are not uniformly considered a principal characteristic of play. Many authors do not believe that rules are a necessary condition for play in general, but rather that they are only an essential feature of "games."[33] Indeed, Caillois even argued that artificiality and rules were mutually exclusive: "Thus games are not ruled and make-believe. Rather, they are ruled *or* make-believe."[34] However, by drawing a sharp distinction between "ruled" and "make-believe" games, Caillois ignored role-playing games, many forms of which enjoyed a renaissance in the final quarter of the twentieth century with the emergence of board, card, and computer fantasy games.[35] Though Caillois was certainly correct that a representation based on fiction (for example, a drama) must not be subject to strict rules of play, rule-based systems certainly can draw on fiction.

The importance of rules for all forms of play becomes clear, however, once all the possible types of rule systems are taken into consideration. Salen and Zimmerman identify three different categories of rules: operational rules, constitutive rules, and implicit rules. Whereas Scheuerl and Huizinga evidently considered only operational rules (the instructions of the game or the agreements between the players), constitutive rules concern the underlying system of logic, while implicit rules implicate the broad domain of social norms. If we follow this categorization, it becomes almost impossible to deny the importance of rule systems for all kinds of play, since it is rule systems that constitute play's characteristics of freedom, self-containedness, and artificiality. Even in drama, norms are constitutive—as scripts and stagings, on the one hand, and as behavioral norms during the performance, on the other. Even the reception of traditional forms of art, although it is not subject to binding rules of any nature, complies with a great number of conventions.

Interactive art is affected by all three types of rules. On the one hand, like other types of art, it is subject to the norms and conventions of the art system or of other systems of reference, and it is received within the context of certain expectations and behavioral norms. On the other hand, because of its processuality, it is also shaped by constitutive rules and operational processes. Because interactive art highlights processual characteristics, a close examination of the various existing rule systems and the interplay between them is extremely important for this study. For an analysis of interactive art, theories of play thus represent an important complement to aesthetic theories. The latter usually don't look beyond the structures that become manifest in the gestalt of the work, whereas an analysis of the underlying rule systems can also reveal the structures that shape the processes of gestalt formation.

Ambivalence and flow

Scheuerl used the concept of ambivalence to explain that play cannot be pinned down in terms of fixed characteristics, but rather constantly oscillates between material and

form, seriousness and pleasure, reality and artificiality, rules and chance, nature and intellect: "Play is always a 'playing-between.' If we say that an entity, a thing, or an event 'is playing,' we are formally saying only that it is not firmly fixed—neither toward a definitive goal, nor toward a one-dimensional channel of action—but that with respect to all poles it finds itself in a circling, oscillating, ambivalent state of 'in between.'"[36] In Scheuerl's view, ambivalence is a fundamental characteristic of play that also emerges in other features, such as artificiality and inner infinitude.

Gadamer's considerations on the "to and fro" of play point in a similar direction. He described the movement inherent in play as a separate entity that is "independent of the consciousness of those who play." He saw this oscillating mode of being, which is located precisely in the process of change, as also applying to the artwork: "But this was precisely the experience of the work of art that I maintained in opposition to the leveling process of aesthetic consciousness: namely that the work of art is not an object that stands over against a subject for itself."[37] Whereas Gadamer located the ambivalence of play in the inseparability of the player and the play, Brian Sutton-Smith uses the word "ambiguity" to describe the general indeterminability of play. Drawing on Stephen Jay Gould's theory of evolution, Sutton-Smith argues that play is characterized by shifts and its latencies: "[V]ariability is the key to play, and . . . structurally play is characterized by quirkiness, redundancy, and flexibility."[38] Just as player and play are inseparable, these processes of play, which cannot be fully controlled by rational means, make it impossible to define play clearly.

A further feature of play concerns the idea that the player is absorbed by his play. This aspect was mentioned explicitly only by Huizinga, but it also is implicit in many other theories of play. In the 1980s, the psychologist Mihály Csíkszentmihályi coined the term "flow" to denote the phenomenon of total involvement in the process of an activity. The potential of being absorbed in behavior is closely related to the phenomenon of ambivalence mentioned above. Flow is likewise not a stable state; it represents one pole—the opposite to reflective distancing—within the complex processes of aesthetic experience. Once again, even if traditional art forms likewise enable different types of attention and identification, these ambivalences really only manifest themselves in interactive art as a result of the tension that arises between action and reception—as a vacillation between carrying out or refusing to carry out an act, between adherence to the rules and an uninhibited approach to the interaction proposition, between identification and reflection.

Classifications of play
Alongside the various attempts to find the unifying characteristics of the phenomenon of "play," there are also those that seek to make an internal differentiation. Caillois identified four different types of play, distinguishing between competitive games (*agôn*), games of chance (*alea*), simulation (*mimicry*), and the pursuit of vertigo (*ilinx*).

Competitive games are characterized by a clearly formulated goal that competing players attempt to achieve within the framework of a regulated system. The course of a game of chance doesn't depend on the abilities of the player, but on random processes. The player is more or less passive, although he still strives to achieve a particular result to the game. In many games, elements of competition and chance are present at the same time: certain aspects may be determined by chance, while others can be influenced by the player. There are clear parallels here with the way that processual art forms are based on an interplay between chance and control, as was pointed out in chapter 1.

Caillois recognized both in competition and in games of chance "an attempt to substitute perfect situations for the normal confusion of contemporary life. . . . In one way or another, one escapes the real world and creates another."[39] Here Caillois was alluding once again to the artificiality of play, which he interpreted here as a model world. Artistic projects are likewise often described as stagings of model worlds. However, their aim cannot be said to be perfection; rather, such models encourage a sensitized perception of, or a critical reflection on, the situations that are referenced. Here, once again, the comparison between art and play comes up against its limits, which ultimately always become manifest when it comes to the question of the epistemic potential of art.

Caillois also described the two remaining types of play, mimicry and ilinx, as means of escaping the world. He defined mimicry, or simulation, as anything ranging from children's games of imitation to theater performances. However, the characteristic feature is not the act of presentation, but the creation of a fictitious world, which for Caillois excluded a basis in rules. Games of vertigo (ilinx), according to Caillois, "momentarily destroy the stability of perception" in order to "inflict a kind of voluptuous panic upon an otherwise lucid mind."[40] What is sought in these games, therefore, is a physical or mental unsteadiness that the player finds exhilarating.

Caillois argued that each of these types of games could be located at different points on a continuum ranging from paidia to ludus. He defined paidia as joy in free improvisation, which derived from a desire for freedom and relaxation. However, he saw paidia as correlated with a "taste for gratuitous difficulty," which he called ludus.[41] According to Caillois, the above-mentioned categories developed gradually from the general joy of play, namely paidia. The more they were systematized and controlled, the more significant became the component of ludus. Thus, ludic activities, according to Caillois, have substantial affinity with agônal activities. However, the priority is not necessarily the struggle against a competitor; rather, the aim is to overcome obstacles in general—in other words, the player submits to rules to engage with "what to begin with seems to be a situation susceptible to indefinite repetition" that then "turns out to be capable of producing ever new combinations."[42] The distinction between paidia and ludus is thus similar to the distinction between free play and rule-based games.

Salen and Zimmerman define free play as "free movement within a more rigid structure," whereas rule-based games are "a system in which players engage in an artificial conflict, defined by rules, that results in a quantifiable outcome."[43]

Because of the many analogies between interactive art and play, theories of play can provide important contributions to an analysis of interactive art.[44] However, recent research on play often disregards its performative aspects. Thus, we must also consult theories of performance that examine the moment of performance and, consequently, the relationship between the actor and the audience, as these are central components of any study of interactive art.

Performance and Performativity

Performance

Theories of performance and performativity focus on the relationship between action and reception; thus, they analyze acting or "playing" in front of an audience.

The concept of performance, like the concept of play, is extraordinarily complex. Indeed, it is studied in such diverse disciplines as anthropology, ethnography, sociology, psychology, linguistics, and literature studies. The term "performance" is used to denote public presentations of exceptional abilities (such as artistic skills), to describe representational behavior that is separate from daily life, and also to characterize the quality of the execution of an activity.[45] But the concept of performance—like that of play—also implies general features that apply to many of the actions denoted by this term. The first of these features is the "consciousness of a doubleness," which sets the execution of an action in comparison with a potential, an ideal, or a remembered original model of that action.[46] This concept of doubleness corresponds very closely to the concept of artificiality (described above). The second feature concerns performance as a type of play whose distinguishing characteristic is that it is addressed to an audience. Richard Schechner defines performance as "an activity done by an individual or group in the presence of and for another individual or group,"[47] specifying that this characteristic remains relevant even when there is no actual public present. Even then, according to Schechner, it is still a presentation or a statement that, at the very least, is being observed by the performer himself, or is addressed to a higher entity (e.g., God).

Although the concept of performance is applied to an extremely broad spectrum of activities, performance research is still primarily dedicated to actions that are distinct from everyday life, such as drama, rituals, sporting events, and ceremonies. Performance theory extends the ambit of theater studies insofar as it enables comparative analysis of theater performances in the broader context of all types of spectacle. At the same time, its focus on single performances as one-off events provides an additional perspective to analyses of theatrical mise-en-scènes. Above all, however, the

scope of performance theory extends beyond actions based on a script so as to include activities that may be rooted in a huge variety of traditions and are primarily characterized by the fact that they are in some way separate from everyday life.

Although performance has important characteristics in common with play, not all of the characteristics of play discussed above are found in all types of performance. We have already seen that doubleness in performance corresponds to artificiality in play, but also that performance differs from other types of play because it is explicitly staged as presentation. What about the other characteristics—freedom, self-containedness, inner infinitude, and regulation? Although it is true that performances, like other types of play, are on principle materially unproductive and voluntary, the criterion of lack of purpose applies only to the artistic performance, whereas religious and social rituals are anything but purposeless. There is no doubt that such events constitute social reality in the sense of the symbolic actions discussed above. Initiation rites are used to admit individuals to particular groups, and leaders are confirmed in inauguration ceremonies. Nonetheless, such actions adhere to established norms and take place within a domain of reality that is separate from everyday life, even if the boundaries can't always be clearly defined. It is, therefore, not always possible to view performances as self-contained.

The criterion of inner infinitude also doesn't apply to all types of performance. For instance, dramatic theater is based on a clear sequence of events that rarely features repetition. Although a piece may be performed several times, it is usually assumed that each performance is offered to a new audience. By contrast, repetition is an important component of many rituals; examples are recitals of the rosary and repetitive sequences of movement in ritual dances. Thus, the more a performance is scripted, the less scope it leaves for repetitions, variations, and improvisations. Moreover, the mise-en-scène takes the place of constitutive and operational rules (unless these terms are construed as the director's instructions to the actors). Rituals and liturgies, by contrast, are often primarily based on traditions—ordered patterns of action with built-in repetitions and variations.

Theories of performance are particularly relevant to an aesthetics of interaction because they help us to analyze the complex relationships between action models and structures and their realization and interpretation. As a complement to structural analyses of rule-based games, such theories provide models that allow us to also take into account scripts and notations, roles and characters, and frameworks and norms. In the analysis of classical stage plays, theater studies differentiate between drama or theater text, mise-en-scène, and performance in the narrower sense of a one-off event lasting from the moment the audience arrives until the discussion of the performance afterwards.[48] This corresponds to a differentiation of four different actors: the author, who elaborates the concept of a work and records it in a text; the director, who stages the work; the actor, who realizes it; and the spectator, who receives it. The same dif-

ferentiation applies to musical performances, which are brought into existence by a composer, a conductor, a musician, and a listener, although in this type of performance the conductor and the musician are active at the same time. However, what applies to theater plays and musical symphonies doesn't apply to all types of performances. In performance art, the author, the director, and the actor are often the same person, as are the composer, the conductor, and the musician in musical improvisation. In the following discussion, the basic constellations found in interactive art will be outlined in comparison with the differentiated constellation of actors found in the traditional theater play.

A drama text composed by an author consists of a written formulation of the plot, usually in dialog form and also featuring stage directions.[49] A director then stages the material provided in the drama text—in other words, he carries out an interpretive translation from the medium of writing into those of speech, action, and materiality. Although the drama text provides stage directions, the director has some latitude for his own ideas, especially since he is often staging the text many years after it was written. Popular plays, moreover, are staged numerous times by different directors. Interactive art is also based on a concept developed by an artist which is then "staged" as an interaction proposition. This "staging" usually is carried out by the author of the concept and thus takes place in close temporal proximity to the conception of the work.[50] In fact, the concept is not recorded in the same way as the written text of a play and also doesn't call for the representation of a plot. The text is replaced by rules or processes which are inscribed, as it were, in the interaction proposition. These rules or processes channel the course of events, sometimes with the help of pre-recorded assets (sound, film, or text files).

The actor in a classical stage play is bound by the text to be recited (even if the original text has been altered by the director) and by the director's instructions. Although the recital requires a personal incarnation of the action on the part of the actor, it is simultaneously under the control of the director. Moreover, the actor doesn't simply execute an instruction; rather, he "plays a role." As Christopher Balme explains, it is possible to identify three different basic approaches to acting: The actor can try to project himself into the role by drawing on his own emotional memory (as suggested by Constantin Stanislavski); or he can approach acting as a precise technique, showing an aloofness that creates an effect of alienation through the conscious execution of symbolic behaviors (as favored by Bertolt Brecht or Vsevolod Meyerhold); or he can be encouraged to express himself by anchoring the performance as much as possible in his own individuality, thus exclusively representing himself in direct interaction with the public (as recommended by Jerzy Grotovski).[51] In interactive art, the recipient assumes the function of the actor. He too can be guided into a fictitious role and can either seek to fill it or distance himself from it. However, often he is simply addressed as an individual and is asked only to be himself.

In classical theater, the darkening of the auditoriums reinforced the passivity of the public, but that changed with the performative revolution of the 1960s and with the establishment of the so-called post-dramatic theater. Since then the spectator has been considered an important actor in theater performances. Erika Fischer-Lichte argues that actors and spectators, through their actions and behavior, are in an ultimately mysterious "reciprocal relationship of influence," and that the relationship between them is negotiated during the course of the performance. At the same time, "performance provides the opportunity to explore the specific function, condition, and course of this interaction," so that the mise-en-scène becomes an experimental arrangement.[52] This interaction, which Fischer-Lichte calls an "autopoietic feedback loop," has very different characteristics in interactive art. In fact, the detachment of the artist from the interaction proposition is accompanied by a fusion between the performer and the spectator.

Performativity

The concept of performance must be distinguished from that of the performative. The latter term is used to describe a type of behavior characterized by ambivalence between symbolic representation and actual execution. The concept of doubleness, aimed at making a clear distinction between performance and real life, is replaced here by ambivalence, which emerges at the point where artificiality and reality meet.

The concept of the performative was first developed in linguistics and then adopted both by cultural and theater studies. John Langshaw Austin, in his speech-act theory of 1955, distinguished between constative or descriptive utterances and performative utterances, whose fundamental feature, he asserted, was that they constituted reality. As examples he cited marriage rites and ship-naming ceremonies in which the ship is addressed with the words "I hereby name thee xy." According to Austin, these speech acts constitute reality insofar as they also create the social reality that they denote.[53] Austin did acknowledge later, however, that it isn't possible to make a clear distinction between constative and performative utterances, because all linguistic expressions may have the capacity to change reality. As a consequence, subsequent speech-act theories no longer focused on Austin's model of the performative and instead on the general behavioral dimension of speech (illocution).

Nonetheless, interest in the relationship between performance and constitution of reality did not fade. On the contrary, the relationship between performance and constitution of reality developed into an important topic in various scientific disciplines in subsequent decades. While sociologists and anthropologists such as Erving Goffman and Victor Turner argued that all social behaviors were ultimately performances, theories of the performative analyzed performances specifically with respect to their capacity to constitute reality. At the end of the 1980s, Judith Butler made fruitful use of the concept of the performative in feminist theory.[54] As early as the 1960s, Richard Schech-

ner's analysis of ambivalent forms of performance and behavior became the corner-stone for subsequent research on performativity. On the one hand, Schechner repeatedly emphasized the artificial and purposeless nature of performances. He saw performances as "make-believe, in play, for fun,"[55] and he viewed "non-productivity in terms of goods"—in addition to particular temporal and spatial configurations, and rules—as an important characteristic of performances.[56] On the other hand, Schechner first addressed the topic of reality constitution in an essay written as early as 1970. The concept of "actuals" introduced in that essay corresponds almost exactly to what have been characterized ever since Austin as "performative" forms of expression.[57]

However, performance theories since Schechner have used the concept of the performative to analyze types of performance that traditionally do not, in fact, constitute reality, but rather are symbolic and fictional—in other words, artistic performances. Erika Fischer-Lichte has applied the concept of performativity to the analysis of contemporary performance practices in performance art and in postdramatic theater. She is not interested in analyzing the performance of drama texts, but in analyzing artistic performances in which the action itself is at the forefront. Fischer-Lichte interprets Austin's writings as meaning that performative acts are characterized not only by their constitution of reality but also by their self-referentiality.[58] She applies these two characteristics to contemporary performance practices in order to show that the traditional figurativeness of artistic performances is gradually giving way to a reality or materiality of the action itself.[59]

The constitution of reality

In the normal course of events, actions always produce reality. Fischer-Lichte also argues on this assumption, as is evident from statements such as the following: "Abramović performed self-referential acts that constituted reality (as all actions finally do)."[60] Only in the case of artistic performances is it necessary to explicitly highlight this fact, because artistic performances usually don't constitute reality but rather remain confined in their own artificiality. Performances that constitute reality can no longer be said to be representational—a characteristic that is normally applied to performances.[61] In the realm of the performative, the constitution of reality is based on the fact that such performances create a presence without necessarily seeking to represent something.

The shift away from representation and toward presentation or even presence also plays an important role in interactive art. Similar to artistic performances, interactions in the context of art normally do not (directly) constitute social reality, but rather are perceived as purposeless. However, again similar to artistic performances, this perception, which constitutes the artificiality of the experience, can be called into question by the works themselves, especially when they involve bodily actions or violate taboos. Fischer-Lichte illustrates this point with respect to performance art on the basis of

Marina Abramović's 1975 project *Lips of Thomas*, in which the artist deliberately injured herself, provoking the intervention of the audience (who finally stopped the performance). Similar strategies can be found in interactive art, with the important difference that in these cases the (self-)injury is provoked in the recipient. For example, *Pain Station* (2001), created by the artist group //////////fur////, consists of a modified version of the early arcade video game Pong in which each mistake is punished by an electric shock on the palm of the player's hand. *Knife.Hand.Chop.Bot* (2007), by the 5voltcore group, converts the traditional knife game Five Finger Fillet into an interactive installation that plays with the recipient's concern about his own physical integrity. The constitution of reality in an artistic context becomes particularly evident when actual injury is involved, but the boundary with social reality can also be challenged by less provocative means—for example, by transcending institutional boundaries in public spaces (as in Schemat's *Wasser*) or digital space (as in *BumpList* by Brucker-Cohen), or by incorporating real face-to-face communications (as in Hegedüs' *Fruit Machine* and Blast Theory's *Rider Spoke*). Ultimately, the constitution of reality requires breaking through the "magic circle." It calls into question traditional rule systems and frameworks, leading to an ambivalent perception of the action being staged.

Self-referentiality

Austin doesn't draw on the concept of self-referentiality, which is central to John Searle's theory of performativity.[62] Searle bases the self-referentiality of performative utterances on the concept of "hereby." In Searle's view, as soon as "hereby" is explicitly formulated or implicitly intended, the performative utterance is stating something about itself. He argues that the utterance "I hereby order you to leave" is no less self-referential than the utterance "this statement is being made in English."[63] However, the two utterances clearly represent different types of self-reference. Whereas the latter remains entirely confined to the system of language, in the former two different systems—language and world—are set in relation to one another. Ultimately, the notion of reality constitution is thus inconsistent with self-reference (or at least exclusive self-reference). Although performative speech acts like "I hereby order you to leave" may also be self-referential insofar as they make statements about themselves, that is by no means their chief intention. Thus, it appears more reasonable to describe performative speech acts, as many authors do, as self-confirming, self-fulfilling, or self-witnessing, since what is at issue is primarily the statement's claim to validity, not the referent.[64] According to Sybille Krämer and Marco Stahlhut, the relationship between the performative speech act and the referent is based "not on the form of the language, but on the fact that this utterance is embedded in non-linguistic practices; it is endowed by the form of the culture. . . . A performative utterance is thus only 'self-confirming,' or 'true' when there are social practices in a culture that cor-

roborate this utterance, inasmuch as they conform with it."[65] Owing to their necessary reference to culture, statements that seek to constitute reality thus cannot be exclusively self-referential.

Fischer-Lichte doesn't analyze statements; she analyzes actions. She is interested in self-referential actions—those that have "signified what they accomplished."[66] Usually, signification is not by any means the main criterion for the evaluation of actions. Simple actions usually mean nothing in themselves; they constitute reality and are thereby neither self-referential nor hetero-referential. But this is not true of the whole domain of symbolic acts, such as raising one's hat to another person, which certainly has the purpose of conveying meaning. However, such acts also do not embody their signification; rather, they can be interpreted within a system of signs—in the case of raising one's hat, as a greeting. But Fischer-Lichte deals explicitly with performances that do not seek to be interpreted via sign systems, but rather really embody their signification; that is, they mean no more than what they do and have no aspiration to further interpretation. Thus, the difference between exclusive and inclusive self-reference is crucial for the present study. Fischer-Lichte is interested in exclusive self-reference of actions (for which referentiality is normally a secondary criterion). She wants to emphasize that in the context of art actions that normally mean nothing can become presentations offering themselves for interpretation, albeit an interpretation that is mainly based upon a heightened sensitivity for the action itself. Thus, the observation that actions are self-referential really makes sense only in the context of art. What is at issue in the area of artistic performances dealt with by Fischer-Lichte is not the (incompatible) systems of speech and world, but the systems of art and world, whose intertwinement she is seeking to demonstrate. When art breaks out of the realm of representation and artificiality into that of action and reality constitution, its aim is often simply to raise awareness of the processes and materials it presents, opening them up to interpretation. This is what is meant by the concept of self-referentiality of actions. These are self-referential not by dint of their action but by dint of their presentation in the context of art. This clarification is important for the present study because interactive art also stages actions that often simply emphasize or enhance sensitivity to everyday behaviors or to our everyday dealings with technology.[67]

The preceding discussion can be summed up as follows: Austin introduced the concept of performativity to denote an action that can also be understood as an execution, applying that notion to language. Butler added the level of identity construction to that of action. Performance theory since Schechner has extended the concept of performativity to the sphere of artistic performance.

Sybille Krämer constructs a development that progresses from Austin's "universalizing performativity" (a theory of communication based on a universal system of signs) through Derrida and Butler's "iterable performativity" (uses and transformations

of sign systems characterized by repetition and difference) to Fischer-Lichte's "body-centered performativity."[68] This last is characterized by an emphasis on the unique, individual expressive interaction between the actor and the spectator. Although Krämer's genealogy neglects the fact that the significance of the body was already emphasized by Butler, she is correct in saying that it is only the embodiment phase that calls into question the possibility of clearly differentiating between the signifier and the signified.[69]

Fischer-Lichte gives the fluid relationship between materiality and signification a central role in her explorations. She points out that the performances she describes do not demonstrate a paradigmatic replacement of signification and illusionism by materiality and reality constitution; rather, she sees its oscillation between these aspects as the truly characteristic feature of the performative.[70] In individual experience, she argues, the perception of a performance can switch between "representation" and "presence," as there are constant shifts in the relationship between subject and object and materiality and signification. Ultimately, what is at issue here is, once again, an ambivalent perception, which emerges as a connecting link between play and performance. This perspective allows us to make fruitful use of the concept of performativity, going beyond the normative definition of certain modes of action and instead analyzing variable relations between action and reality constitution.

Let us look at one more aspect of the performative as it has been studied by the media theorist Dieter Mersch. He understands performativity in terms of "positing" and thus ascribes it not to actions but to events, which he differentiates from actions on the basis of their non-intentionality: "Thus, an aesthetics of the performative should be understood as an aesthetics of events which is rooted not so much in the medial (in the processes of staging and representation) as in occurrences that take place."[71] Nonetheless, Mersch returns to the ambivalence between reality constitution and signification when he points out that "the performance of an action . . . [encompasses] . . . not only its implementation but likewise its recitation, its presentation. . . . Then we would have to understand 'performative art' as those practices and processes that make themselves explicit in their 'self-demonstration.'"[72] Thus, sometimes the emphasis is on action and staging and sometimes it is on passive occurring, though Mersch asserts that these categories represent tendencies and are not mutually exclusive.[73]

Both Fischer-Lichte and Mersch thus highlight ambivalences in perception as characteristic of aesthetic experience. Knowledge doesn't arise through successful comprehension of sign systems designed to be interpreted in a specific way, but through the interplay between transformative experience and its reflection. In interactive art, too, the recipient's activity oscillates between physical experience and cognitive interpretation.

4 The Aesthetics of Interaction in Digital Art

In the previous chapters, I discussed both strategies used in processual art and theoretical perspectives on associated qualities of aesthetic experience. In addition, comparisons with play have helped to identify basic parameters of non-purposeful activities. I will now turn to the main objective of the book, which is to develop a theory that can be used to analyze interactive art and determine its distinctive aesthetic potential.

The first step in an academic analysis of an artwork is usually to identify the object of study and the genre to which it belongs. Is the work we are dealing with an image, a sculpture, or an installation? Is it a text, a piece of music, or a play? Even such a basic classification as this is anything but simple with respect to the artworks under discussion here, however. As was pointed out in chapter 2, interactive artworks often do not manifest themselves in self-contained, material form, but as structures or systems. They may have been produced in different versions and have a large number of (sometimes variable) components, or they may run on different media. Above all, however, they are consciously conceived with a view to being realized by recipients in a multitude of ways.

As early as the 1960s, in reaction to the efforts of the neo-avant-garde to shatter the boundaries of the traditional forms and concepts of the artwork, various new classifications were proposed to replace the established categories. As regards the processual forms of art discussed in this study, these included (in addition to Umberto Eco's analysis of the "open work") an approach proposed by Stroud Cornock and Ernest Edmonds, who suggested differentiating between static and dynamic art systems,[1] and one proposed by Roy Ascott, who distinguished between deterministic and behavioral works.[2] However, dualistic distinctions of this kind were quickly displaced by more variegated spectrums. Eco had already introduced the subcategory of the "work in movement" to denote another stage of variability within the category of open works. Cornock und Edmonds further subdivided dynamic works into dynamic, reciprocal, participatory, and interactive systems.[3] Both proposals are thus based on the idea of a ranking scale reflecting the degree of activation of the recipient. However, such an approach can be problematic, especially when it comes to analyzing artistic projects.

A more complex proposal was developed by the Variable Media Network between 2001 and 2004. That North American research network created a model that takes into account specific characteristics of ephemeral, time-based, and media-supported projects, and can be used to describe artistic works without assigning them to any particular genre. Artworks are differentiated on the basis of process-related qualities (behaviors), which may also appear in different combinations. The model distinguishes between contained, installed, performed, interactive, reproduced, duplicated, encoded, and networked behaviors. Different criteria can then be applied so as to achieve a more precise description of each of these behaviors. The majority of works in the traditional visual arts (paintings and sculptures, for example) are meaningfully described as contained by their own materiality and as having clear physical boundaries. Consequently, the options for describing this type of work are based on standard characteristics related to matter, such as the type of surface and the support material. Installed artworks, by contrast, are characterized in terms of their location, their boundaries, and the associated lighting directions and sound elements, whereas in the case of performed works information about props, stages, costumes, performers, and time frames is collected. The options for describing code-based works include the recommended screen resolution and the data sources and fonts used. Interactivity is characterized by defining the input options and the interaction partners.[4] This kind of approach makes it practicable to compile a classificatory description of artistic activities (including media art)—while taking into account close intermeshing of material and processual characteristics.

In this chapter I will deal first with the main actors and parameters found in interactive media art. I will then analyze the spatial and temporal structures within with the actors stage and realize the processes of interaction. Only on this basis will it be possible to describe the processes of interaction themselves and discuss their aesthetic potential in terms of gestalt, aesthetic distance, and epistemic potential. Toward the end of the chapter, I will return to the question as to whether and to what extent it is possible to define the ontological status of interactive art.

Actors

A meaningful description of interactive art must begin with the active entities involved. Human actors are addressed here as individual subjects—as opposed to mere operators of the interaction system—because an aesthetics of interaction must give priority to individual perceptions and interpretations. Perceptions and interpretations arise subjectively and cannot be generalized.

The creator(s) of a work must be addressed as the first actor(s), if only because they are the first, chronologically speaking, to be involved in the project. In most cases,

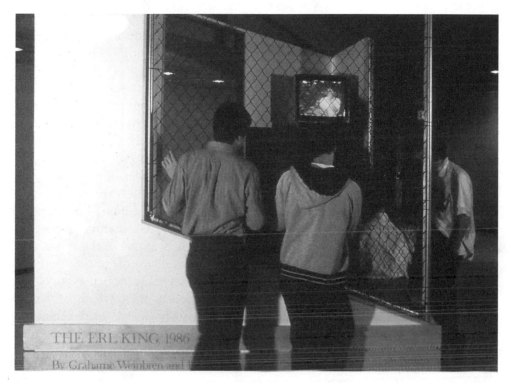

Figure 4.1
Actors of interactive art. Roberta Friedman and Grahame Weinbren, *The Erl King* (1983–1986/2004), installation view, Los Angeles Museum of Contemporary Art, 1986.

the creators still maintain their authorial role (in the sense that they have a significant influence on the aesthetics of the work in question), even if this role changes substantially as a result of the recipients' opportunities to take action. In the following discussion, the actors who initiate the project and who construct the interaction system will be referred to as "the artist(s)" regardless of whether these actors consider themselves to be artists, authors, or producers of a project. In the performing arts, these actors are flanked by interpreters and/or performers. Both in the performing arts and in the visual arts, the public traditionally has the task of contemplative or cognitive reception. Whereas in the traditional arts it is unusual for recipients to play a physically active role, that is the rule in interactive art.[5] The artist conceives of a process that awaits realization by a recipient, for only through the action of the latter can the processual presence of the work take shape. Nonetheless, both the construction of the work's interactivity and its realization depend on technical systems, which are thus also regarded as actors in this study.

The artist

The activity of the artist generally consists in conceiving of and then facilitating the interaction process, and therefore takes place before the actual moment of interaction. Several different people may be involved in the conception and creation of an interactive work, especially when different skills—e.g., sound design, interface design, programming—are required. As author of the work, the artist(s) create(s) the interaction proposition by designing, programming, or implementing the underlying system, by constructing, selecting, or assembling its digital assets and material components, and often also by selecting or configuring the required setting. In this context, digital media provide a means for structuring interactivity, in the sense of processes that can potentially be activated. The games researcher Noah Wardrip-Fruin uses the term "expressive processing" to highlight the creative potential of programming as a medium of expression.[6]

The production process is guided by visions or mental representations of possible interactions, or by assumptions about how the recipient will realize the interaction proposition. Many artists, however, also emphasize the need for openness or willingness to relinquish total control. This applies to media art just as much as it does to participatory works outside media art. In reference to the latter, the artist Yvonne Dröge Wendel has stated that "the beautiful thing about interactive work is that the moment you let go the unthinkable occurs and unknown situations arise beyond your own pre-conceptions. . . . I have to suppress my tendency to intervene or impose my intentions as to how the work is used or experienced."[7] Such declarations illustrate once again how the interest in random processes that informed art in the years after World War II is related to the strategy of open works, in which indeterminability was achieved through the active involvement of the recipient. However, Dröge Wendel is referring to circumstances where the artist himself may well be present in order to propose a situation within which recipients can act, so that the outcome results from a joint elaboration of the initial situation and the main focus is on a collaborative aesthetics of production. Such open invitations to collaborate are also found in the media arts, especially in Internet art. However, in this book I am not focusing on collaborative works. I am interested specifically in the aesthetics of projects within which the reactions of the systems to the decisions of the recipients are defined in advance. Nevertheless, the processes of realization can still occasionally surprise the artist. For example, as was mentioned above, Rafael Lozano-Hemmer experienced surprise in relation to his work *Body Movies* when the recipients were so fascinated by playing with their own shadows that they lost interest in using them to reveal the portraits the artist had projected onto a building facade. Likewise, Agnes Hegedüs is unlikely to have imagined that a recipient attempting to assemble the interactive *Fruit Machine* puzzle—which is designed to inspire cooperative behavior—would take over the work and manage to operate all three control stations on his own. David Rokeby, who cites Myron Krueger as sharing this view, sees the possibility of the artist being surprised

by his own works as an important feature of interactive art. In his view, the evident contradiction between the desire for surprise and the desire for control is a characteristic of interactive art.[8]

Although the absence of the artist from the interaction process has been identified as an important characteristic of interactive art, this criterion should be qualified here because it actually only applies to his role as author. The artist can certainly be present in other roles, for example as recipient, observer, mediator, or fellow player. Most interactive projects are developed in an iterative process in which the artist tests the possibilities for interaction he has envisaged in order to verify them and perhaps modify them. Thus, the artist is often the first recipient of his own work. The potential problems deriving from this practice are illustrated by an episode recounted by David Rokeby. At the first public presentation of *Very Nervous System*, he was astonished to see the system reacting only weakly to the actions of the recipients. Seeking to understand why, he realized that he had only ever tested the system himself—that he had internalized certain sequences of movements and then configured the system to react to these specific actions.[9] In order to avoid such pitfalls, most creators of interaction systems try to present their project as soon as is possible to the public or to a small group of interested people, so that they can observe how others engage with it.[10] But artists can also act as mediators of their own work by encouraging potential recipients to interact or by describing the way the system might potentially behave. The boundaries are fluid here—mediation will often follow observation, and the artist might take on the role of ideal recipient and perform possible interactions in order to encourage the public to follow suit. Thus, many artists exhibiting at the Ars Electronica Festival can be found in the close proximity to their works, ensuring that they are functioning properly, making themselves available for conversation, observing the public, providing suggestions, and perhaps interacting with the work themselves so as to present it or break the ice. The media artist Teri Rueb jokingly called this activity "babysitting a work."[11]

In a project that requires several human interaction partners, an artist may take on the role of a participant, and so may make contact with other recipients. Nonetheless, the artist is always in a special situation—even if he is subject to the same rules as the other recipients—because of his familiarity with the possibilities offered by the interaction proposition. Thus, when an artist assumes the role of co-participant (and whether or not he acts noticeably differently than the other recipients), he should be designated as a performer, because his primary intention is not to behave in the interest of his own experience, but rather to enrich the interactions of the other recipients. However, it would be wrong to draw too fixed a boundary here, for some of the other recipients may have figured out the system and its possibilities, perhaps because they already know the work or because they are familiar with similar projects. Thus, a recipient, too, can function as a mediating actor.

The assistant

Artists occasionally appoint third parties to assist in the presentation of interactive works. Such assistants may act as performers, as in Sonia Cillari's *Se Mi Sei Vicino*, which involves a female performer as a permanent interaction partner. Assistants also often play a mediating role when the input required of the recipient must be explained, supported, or supervised, and may be asked to distribute equipment. However, it is difficult to make a clear distinction between assisting functions that are a constituent element of the realization of the work and those that belong to the external setting. Matt Adams of the group Blast Theory, for example, sees the briefing phase in *Rider Spoke*—in which recipients must borrow a bicycle from a supply point—as extremely important for the success of the subsequent activity phase. According to Adams, the interaction is immediately preceded by a "particularly rich moment for us because people are thinking 'this hasn't started yet,' and so they are still relaxed and . . . our ability then to stage the experience and give them subtle cues is very strong."[12] Thus, overlapping roles are possible in this case, too: assistants can simultaneously be performers, and performers can act as or be perceived as recipients.

The recipient

The task of the recipient in interactive art is to realize the artwork. This means that the recipient actively responds to the interaction proposition (although not in the sense of "correctly" executing a prescribed concept, for recipients' behavior will not necessarily always correspond to the artist's expectations).[13] The scope for action offered by different works varies considerably, starting with the question as to precisely how the possible or expected actions are communicated. Written or verbal instructions may be provided, but most works are constructed and configured in such a way that the possibilities for action can be deduced from the installation itself. In many cases, one of the central components of the interaction is the recipient's exploration of the actual possibilities for interaction offered by the work.

As was mentioned in chapter 2, the recipient's activity depends to a large extent on his experience with similar works, his resulting expectations, and his willingness to take action. This is also confirmed by the results of the research projects carried out in the context of this study. For example, a recipient of Tmema's *Manual Input Workstation* recounted that his behavior was shaped by the fact that, as a teacher, he was accustomed to operating the kind of overhead projector presented in the work.[14] A recipient of *Rider Spoke* explained that the project went too far for her sometimes because she was not the kind of person who was inclined to speak openly about her feelings.[15] In order to counteract such contextualizations, David Rokeby sought specifically in *Very Nervous System* to ensure that recipients would not be able to draw on similar experiences in their interactions: "[I]t doesn't automatically register something that's familiar."[16] In addition to depending on the possibility (or impossibility) of

drawing on familiar behavioral patterns, the recipient's actions also depend on his interests—for example, in the type of technology used, or in its aesthetic effects. Likewise, the recipient's willingness to engage with the possible interpretability or intentionality of a work will vary.

Recipients may limit their activity to observing others interacting with a project, thereby taking a distanced position relative to the work. However, sensual or cognitive comprehension can still take place in these cases. Golan Levin defines such situations as "vicarious interaction"—a term, borrowed from educational science, that denotes a cognitive comprehension of others' interactions.[17] If an observer can understand the interaction taking place, he can also see relations between action and effect, even if he is not actively involved. Although the passive bystander doesn't have the same experience as an active recipient, he may be able to observe and understand interaction processes that he would not have carried out. As a result, the designs of many interactive installations reserve space for vicarious interaction. For instance, Grahame Weinbren often presented his early onscreen interactive narratives in cage-like constructions that contained a protected seating area for the interacting recipients. But he also built—either outside the cage or behind a metal construction—an area for spectators, which sometimes was even equipped with a monitor that replayed the screen recording of the active user for the onlookers.

Jeffrey Shaw also sees the advantages of vicarious interaction: "For the non-active spectator who only observes this interactive artwork being manipulated by a user, there is the unique experience of seeing it being illuminated through the eyes of another—his manifestation is a performance."[18] A recipient of *The Manual Input Workstation* recounted in the follow-up interview that observing other recipients was like witnessing an intimate act that revealed something about the person in question.[19] Observation may also be the first step toward active participation in that it gives the onlooker an initial glimpse of the system processes and reactions and also reduces inhibition. Observation often substantially influences the observer's own actions, for previously observed behavior is often followed by imitation or by deliberate modification.

The foregoing discussion leads us once again to the possibility of an interaction proposition being activated by the artist himself. In addition to explanatory demonstrations as an ideal recipient, it is also common for artists to stage performances using the systems they have created. Golan Levin and Zachary Lieberman invite the public to their own stage performances of their audiovisual systems.[20] Masaki Fujihata's *Small Fish* (1998–1999) and Toshio Iwai's *Piano—As Image Media* (1995) have been presented in public performances.[21] Levin regards his performances with *The Manual Input Workstation* as potential catalysts for vicarious interaction. In these performances, changes in the program mode are controlled by placing cardboard numbers on an overhead projector. This is clearly understandable for the public and takes place according to

the same principle as the subsequent interaction with the different modes themselves. For Levin this is an ideal way to demonstrate the functionality of the system to spectators.

The concept of vicarious interaction once again addresses the question of aesthetic distance. Is it really essential that the recipient be active in order to enjoy the aesthetic experience of an interactive artwork, or do forms of experience such as vicarious interaction actually create the distance to the object of experience often required by theories of aesthetics?

Robert Pfaller has been acclaimed for coining the term "interpassivity," which he uses to question the ostensible omnipotence of interactive media.[22] Pfaller suggests "denoting those media that already provide the process of their reception and consumption in ready-made form as interpassive media." The example he uses for such media is the video recorder, which, Pfaller claims, watches the films in place of the observer, so that the recording of films replaces their consumption. Pfaller explains the use of the prefix "inter" in terms of the transfer of roles that occurs: "[J]ust as interactive media transfer the activity to the observers, interpassive media transfer the passivity of the observers to the artwork."[23] Although the term "interpassivity" is admirably thought-provoking, it seems fair to ask whether it is really "passivity" that is being transferred in Pfaller's example or, in reality, actual or potential activity. What is certain is that the interaction propositions at the focus of the present study are neither (inter)passive nor vicariously active; rather, they are bearers of a processual potential that can be activated by a third party (the recipient).

Although Pfaller's concept of interpassivity thus appears less suitable for analyzing the aesthetic experience of interactive art, the broader context of his ideas certainly deserves consideration, insofar as they are based on a general mistrust of the view that activity is positive on principle and that activating observers is thus always "aesthetically rewarding and politically liberating." As Pfaller argues, many of the emancipation movements since 1968 have presupposed that "active is better than passive, subjective is better than objective, personal is better than other, changeable is better than fixed, immaterial is better than material, constructed is better than elemental, etc."[24] We must therefore ask critically which particular forms of aesthetic experience are specifically enabled by the activity of the recipient, whether a recipient's activity may also potentially prevent aesthetic experience, and to what extent contemplative observation of actions in the form of vicarious interaction should be taken into consideration as a distinct form of aesthetic experience of interactive art. Lars Blunck deals with this question in detail in his discussion of participatory art forms. In his study of (non-electronic) works that invite audience participation (e.g., the action art of the 1960s), Blunck doesn't discuss vicarious interaction so much as the possibility of mental anticipation of interactions. He asks whether actively responding to an invitation to participate is even necessary: "Is the theoretical possibility of participation not enough

to initiate an aesthetic fantasy centered on imagining using the work?"[25] Referring to works by George Brecht, Erwin Wurm, Joseph Beuys, and Franz Erhard Walther, he suggests that a particular form of aesthetic experience may be possible if we experience a situation not by actually experiencing "its sensual presence" but by "imagining it in its absence, imagining it sensually and in such a way as to lead it to its own aesthetic emergence."[26] Blunck argues that aesthetic sensuality is by no means sacrificed in this way to non-sensual reflexivity. He therefore suggests recognizing a range of different means of reception, and viewing sensuality and reflexivity not as alternatives but as components that can have different degrees of influence in determining the process of reception. However, the precondition for such an attitude—denoted by Blunck as reflexive imagination—is the accessibility of the potential actions. In the works on which Blunck's study focuses, the intended interaction is clearly identifiable and the course it may take can be anticipated. This is true both of Brecht's event scores and of Wurm's *One Minute Sculptures*, for example. In interactive media art, by contrast, we are usually dealing with a black box that conceals its own workings. In such cases, processes can be understood only if they are activated. This doesn't necessarily exclude an aesthetic experience through the observation of activation through others, but it does exclude Blunck's reflexive imagination. As my case studies will show, even vicarious interaction is not always possible in interactive media art. In particular, works that operate with mobile devices, works that are staged over large areas, and works that are based on audio files (played to the recipient on headphones) do not allow vicarious interaction.

Nonetheless, the possibility of aesthetic experience through vicarious interaction or reflexive imagination should be kept in mind as a potential mode of receiving interactive art, insofar as it touches on issues that have already been addressed as central to aesthetic experience—the relationship between active realization and distanced observation, and that between action and reflection. In the interaction with an artwork, shifts in the recipient's perspective between engaged realization and distanced (self-)observation are not only possible, but also essential for the epistemic processes at stake in the aesthetic experience of interactive art.[27]

The technical system

The technical system supporting the interaction proposition and the material components of that system must be considered actors in their own right, and not only when the system is configured as a virtual person. On principle, interaction systems not only enable actions; they also have their own processuality, which, although designed or programmed by the artist, acts independently of him. "Actor-network theory," for example, proceeds on the assumption that objects should be considered actors. Objects not only serve as a backdrop for human action; according to Bruno Latour, they can also "authorize, allow, afford, encourage, permit, suggest, influence, block, render

possible, forbid, and so on."[28] The proponents of actor-network theory are not primarily interested in processual entities, however, but in static objects. Donald Norman uses the term "affordance" to describe the action potential of objects. "Affordance" refers to the actual and perceived characteristics of things, especially those that determine how things can be used.[29] In the area of HCI research, especially, the concept of affordance has become established as a means to describe the stimulative nature of computer interfaces.[30] The present study, however, doesn't deal only with the perceived stimulative nature of systems; it also deals with their processuality. Although many interaction systems become active only after an input (in the form of human activity or incoming data from other systems) and otherwise remain in wait mode, some systems run their own processes while waiting for input. Thus, we must ask how processuality is triggered in each individual work, and what actually characterizes the processuality. Is it based on the activation of pre-stored playable assets, or on real-time processing of code? In the following, I will be looking at the processuality of technical systems especially with regard to the temporal structures of interactions and in the context of instrumental and phenomenological perspectives on interactivity.

It is important to note, in this context, that this study seeks to abstract the processuality from the actual technology used in works. In other words, the aim is to describe general qualities of processuality, not specific hardware or software functionalities. Of course, interaction systems are characterized by technology—for example, by the type of software and hardware that is available at the time a work is created or is familiar to the artist. The artist's decision in favor of a particular technology or system architecture may be based on the concept of the work itself, but can just as easily be determined by external factors. These include not only access to technology or the means for funding it, but also the roles played by sponsoring institutions, commissioners of works, and cooperation partners. For example, Ashok Sukumaran reports that the idea for his work *Park View Hotel* (2006) came to him during his stint as an artist-in-residence at Sun Microsystems, where he was required to work with Sun-SPOT technology.[31] Similarly, Matt Adams relates that Blast Theory would unquestionably have used GPS technology for *Rider Spoke* if the group's cooperation partner, the Mixed Reality Lab in Nottingham, had not proposed WiFi fingerprinting.[32] But although the underlying technology influences the aesthetics of a work, the latter is still ultimately based on abstractable procedures and structures. These will be described here not primarily in terms of their technical causality, but with a focus on the effects they enable. First, however, it is necessary to discuss the spatial and temporal structures within which the actors operate.

Regarding the actors, it can be said in summary that interactive media art differs from other forms of participatory art in that the authorial role of the artist is usually restricted to the phase before the actual interaction. At the same time, the interaction process is already embedded in the system as a potential, which leaves the recipient

different degrees of freedom to configure the interaction himself. Thus, the kind of interaction at stake in interactive media art differs substantially from a face-to-face interaction. As Erika Fischer-Lichte explains, in the performing arts, interaction is based on the principle of the "autopoietic feedback loop."[33] As was discussed in chapter 2, this term denotes the joint negotiation of the course of the performance, which can be controlled neither by the performers nor by the public alone. However, according to Fischer-Lichte, the feedback loop requires face-to-face interaction, which is not possible in mediatized performances.[34] In actual fact, the feedback processes in interactive media art are not the same as those that Fischer-Lichte draws on from performance art. Even if some projects also induce interpersonal negotiations, the focus is still on the interaction between a human being and a technical system.

Space

Each and every interaction proposition and act of interaction is tied to particular spatial situations. This is always true, regardless of whether the activity takes place in a public, institutional, or private space, whether it occurs in a physical place or within a data network, or whether it is based on mobile or stationary devices.

A "place" is understood to be a point, usually on the Earth's surface, that can be located using a system of reference (e.g., geographical coordinates), whereas "space" refers to an area with boundaries that can either be perceived or imagined. Recent theories of space are particularly interested in imagined boundaries, which are both subjective and variable. The sociologist Martina Löw defines space as a more or less fluid individual or collective construction, which may be material or may exist only in perception, in ideation, or in recall.[35] According to Löw, who sees space as "a relational ordering of living entities and social goods,"[36] the ordering comes about as a result of processes of "spacing" and "synthesis." Löw defines spacing as the placing of things, people, or markings, as in the alignment of items in shops, of groups of people, of architectures, or even of the components of computer networks. By contrast, she defines synthesis as the cognitive part of spatial construction: "[G]oods and people are connected to form spaces through processes of perception, ideation, or recall."[37] In Löw's model, spacing and synthesis should be understood not as consecutive but as mutually conditioning processes.

Löw's interpretation of spatial parameters as including not only materially fixed characteristics but also mutable designations that can be subjectively configured is also crucial for an aesthetics of interaction. However, we must distinguish between two different moments in the construction of space—on the one hand, the selection or staging of spatiality during the configuration of the interaction proposition and, on the other, the realization of spatiality during the moment of interaction. The distinction is not at all the same as that between spacing and synthesis, for the latter

Figure 4.2
Spaces of interaction. Scott Snibbe, *Boundary Functions* (1998), installation view (© Scott Snibbe).

two processes are involved both in the configuration of the system and in its realization. The author of an interactive work not only arranges objects and data (spacing), but also combines them so as to create a real or potential spatial structure (synthesis). In exactly the same way, the recipient not only constructs spatial structures within his own perception (synthesis), but also actively configures them by means of his own movement (spacing). Spacing and synthesis are thus relevant in equal measure for the configuration of the interaction proposition and for its realization.

The configuration of interaction spaces
The spaces that accommodate interactive works can be either man-made constructions or natural environments. Fischer-Lichte uses the term "performative spaces" to denote the spaces used for staging artistic performances. She writes that these spaces are intentionally created or selected in order to organize and structure the relationship between the actors and spectators and to enable specific forms of movement and

perception. Accordingly, performative spaces can be configured by the artist or they can build on the possibilities offered by pre-existing spaces (chosen by the artist).[38]

In interactive art, spaces of interaction are often subject to different premises than the performative spaces described above. Despite its hybrid status between visual and performing art, interactive art is mostly presented in exhibition situations, whether during festivals or as classical museum exhibits. This institutional context establishes certain spatial parameters. Because an exhibition usually runs for at least several days, interactive projects are rarely housed in architectonic spaces normally used for other purposes—unless the institutional situation is similar to an exhibition in that it is open to public access and is constantly supervised, such as the foyer of a trade show or an airport terminal.[39] Occasionally, an exhibition will display only one large-scale work, or a group of interrelated works by one artist that may be conceived as a single spatial arrangement. Two examples are the exhibition *Es, das Wesen der Maschine* held in Osnabrück in 2002, which featured robotic installations by Louis-Philippe Demers and Bill Vorn,[40] and the exhibition of works by Rafael Lozano-Hemmer that represented Mexico at the 2007 Venice Biennale.[41] Both of those exhibitions were held in historic locations, the former in Osnabrück's Dominikanerkirche and the latter in Venice's Palazzo Soranzo van Axel. Indeed, curators often make use of vacant historic buildings that still evoke a special atmosphere associated with their original function or their age. Among the other media-art shows that have benefited from exposition spaces with an interesting atmosphere are the exhibitions held by the Hartware MedienKunstVerein in Dortmund's Phönix Halle (part of a former steel mill), the presentation of the ZKM's exhibitions in a former weapons and ammunitions factory, and the guest appearance by Ars Electronica 2010 in the former Tabakfabrik (tobacco factory) in Linz.

Often however, exhibitions are held in neutral venues where the artist is assigned a site, or a white or black cube, for his installation. Unlike the theatrical stage, which is designed so as to accommodate a constant succession of new and individual productions, the spaces allotted to special exhibitions in exhibition venues often are neutral containers that offer only limited possibilities for modification. An interactive work must then be adapted to the space provided, be it by simply placing the necessary hardware in view, by assembling a sculptural installation, or by mounting hidden technical devices, sensors, or effectors.[42]

Whereas interactive media art of the 1990s often eschewed physical space in favor of simulations of virtual reality, active configuration of the actual spatial situation became more common over time. In the 1990s, the hardware used in media art was often seen as no more than a necessary interface to a projected artificial world. Myron Krueger called explicitly for the real-world space to be as neutral as is possible so that recipients could close their eyes to its materiality: "The empty rectangle has the advantage of being so familiar that physical space is eliminated as a concern and response

is the only focus."[43] This statement is consistent with Krueger's vision of an artificial reality that should be considered distinct to the spatiality of the here and now. The focus of Krueger's *Videoplace*, which he produced in the 1970s and the 1980s, is clearly on the effect of the computer-generated graphic feedback conveyed by the projection, whereas the real interaction space is darkened. However, the spatiality of Krueger's computer graphics is not particularly complex, either. Though his intention may have been to allow the recipient to concentrate entirely on the actual interaction, the technical possibilities available at the time the work was created limited the scope for complex graphical solutions from the outset. The 1990s saw the production of various projects that staged computer-generated graphic feedback as a visually illusionary virtual reality. Examples range from Jeffrey Shaw's *Legible City* (1998–1991), which sought to create the illusion of a bicycle ride through a city,[44] to Peter Kogler and Franz Pomassl's 1999 *Cave* (produced for the Linz Ars Electronica Center's CAVE environment[45]), which invited the recipient to immerse himself in a labyrinth of graphically patterned tubes, pipes, and passageways.

In more recent installations, by contrast, physical space is understood by many artists to be a fundamental component of the work and is configured accordingly. This may take the form of complex sculptural settings, such as *Web of Life* (2002) by Jeffrey Shaw and collaborators. Visitors to this installation must traverse an artificially curved floor and pass through a web of taut wires before arriving in an inner space that houses the interaction system. However, space may also be structured simply by means of a coordinated interplay between dimensions and lighting.[46] Spatial structures can also interconnect different components of a project. For example, Sonia Cillari's *Se Mi Sei Vicino* stages the spatial relationship between interface and visual feedback by means of multiple projections onto the walls surrounding a clearly marked touch-sensitive area of floor in the center of the room. David Rokeby's installation *n-Cha(n)t* (2001) features several monitor towers that communicate both with one another and with the recipient, inviting him to wander around the space delineated by the work. In other cases, spatial structures may be used to clarify the possible roles of the actors. As has already been mentioned, Grahame Weinbren, in his interactive installations, constructed one area for the active realization of the work and another for the observers of the interaction. In this case, action and observation—two possible functions of the recipient as actor—are presented as spatially separated roles. At the same time, they are distinguished from another possible actor function—that of the passer-by who is involved neither in the active realization nor in the observation. Thus, this artist uses material means to suggest different possible forms of reception. The spatial arrangement illustrates that the interaction is part of the work but is also a possible object of observation and reflection.

Visual art has always (also) been a spatial art, and twentieth-century installation art placed the spotlight on spatial configuration. I have already mentioned the action

art of Allan Kaprow, the Groupe de Recherche d'Art Visuel, and Claude Parent, the experiential environments of Bruce Nauman and Rebecca Horn, and the live stages of Rirkrit Tiravanija, all of which are based on spatial organization. But interactive media art offers much wider scope for spatial configuration. As was discussed in chapter 3 in relation to the self-contained nature of play, in interactive media art both the materially configured space and the interaction space are important, and these two spaces will not necessarily always coincide. A project's potential radius of interaction is usually determined by technical factors, be it simply the length of a mouse cord or the need for proximity to a monitor used as a touch screen, the angle of a camera observing the recipient, or the range of a sensor. However, the radius of interaction is often not visible from the outset—especially in works that operate with wireless sensor technology. In various manifestations of her installation *Untitled 5* (2004), Camille Utterback used a panel, lighting, or simple markings to indicate the margins of the touch-sensitive floor area. David Rokeby has recounted that every time he installs *Very Nervous System*, he asks himself whether and how he should specify the work's radius of interaction. In some versions he has used ropes to define the interaction space, in others lighting. However, often he has decided not to mark out the radius of interaction at all, so that it can be experienced only through interaction.[47]

As has already been pointed out, the spatial staging also concerns the space surrounding the immediate area of interaction. Does the artist leave room for vicarious participation or does he exclude potential observers? And if he includes them, does he allot them a specific place? Besides Grahame Weinbren's configuration of different areas for different types of reception, the Austrian artist group Time's Up's *Sensory Circus* deserves mention in this regard. This environment, installed numerous times in 2004–2006, offered various possibilities for individual and collaborative physical activity, including a recreation area that functioned as a transitional zone between the interaction space and everyday space.

Locative art has its own possibilities for spatial configuration. The use of portable devices (cell phones, GPS navigators, laptop computers) as interfaces enables the spatial extension of art projects across entire cities or landscapes and at the same time allows for a potentially infinite spatial dynamic of actions. This is all the more true when the project can be realized on everyday devices. Often these are not even provided by the artists and the recipients are expected to use their own, which means that the spatial (and temporal) confines of the project are ultimately determined in technical terms only by the mobility of the recipients.[48] However, having to rent out devices at supply stations is not necessarily a disadvantage, for it necessitates an institutional starting point. The significance of a related briefing phase has already been discussed in reference to Blast Theory's *Rider Spoke*. Furthermore, because the supply station will be both the starting point and the final destination of the recipients' activity, the spatial structure of the project usually takes its location into account;

levels of representation (e.g., fictional texts) refer to it, and its historical, social, or atmospheric implications are taken into consideration in the staging of the work. Also generally, locative artworks are characterized by a close nexus between their spatial structure and the public space, because GPS technology or some other location-tracking technique can be used to directly link information to specific coordination points.

The realization of spatiality

The recipient has the task of realizing spatiality within the structures provided by the system. When such a realization takes on manifest, physical form, it immediately acquires the quality of a performance. This was pointed out as early as 1980 by Michel de Certeau. When de Certeau observed that spaces are realized by walking through them, he was drawing clear parallels to performative acts. He believed that, owing to a "triple enunciative function," the act of walking was to the urban system what the speech act was to language. First, it served as a "process of appropriation of the topographical system on the part of the pedestrian"; second, it served as "a spatial acting-out of the place"; third, it implied "relations among differentiated positions, that is, among pragmatic 'contracts' in the form of movements." Walking, for de Certeau, was thus a "space of enunciation."[49] It was not just a question of subjective construction and perception of space, but also a perceptible performing. De Certeau was interested in physical and cognitive perception, in the active utilization of the environment, in the activation of certain places by means of presence, and in the construction of relationships between places and spaces through one's own movement.

In the performing arts, such active realizations of spatiality are primarily reserved for the performers (who may be following stage directions), whereas the recipient's contribution is mainly cognitive in nature.[50] In interactive art, by contrast, the recipient may be assigned an active role, or even the main role, in the material realization and manifestation of spatiality. Observations of recipients interacting with Rokeby's *Very Nervous System*, as well as interviews with them afterward, showed that many recipients first explored the motion-sensitive area and generally perceived their movements as an acting-out of space or as a way of finding the spatial boundaries of the work. In Cillari's *Se Mi Sei Vicino*, the material configuration of space functions as a foil for the negotiation of the spatial relations between the actors, especially with respect to the recipient's distance from or proximity to the performer. In these cases, then, we can concur with Martina Löw that spatiality can also characterize a relationship between people. In fact, the presentation of space as interpersonal relationship is a central theme of Scott Snibbe's *Boundary Functions* (1998). As soon as more than one visitor enters a demarcated area, lines are projected onto the floor so as to partition the area in such a way that each recipient is assigned a section of equal size. As the recipients move, the partitioning lines shift to adapt to the new situation.[51]

The realization of spatiality on the part of the recipient can, therefore, be manifested through self-positioning with respect to certain spatial constructs (as in Rokeby's work) or through a spatial acting-out of social relations (as in Cillari's and Snibbe's works). The realization of space tends to be on a much larger scale in locative art projects, which also require positioning with respect to everyday public space. In Schemat's *Wasser* and Rueb's *Drift*, the location and the boundaries of the works were determined by the artists, but each recipient created a version of the project that was unique in terms of its (internal) spatial structure. In both of these projects, everyday space acquires a metaphorical or atmospheric function and becomes a central element of the work's interpretability. In Blast Theory's *Rider Spoke*, by contrast, the participants have complete liberty to define their own radius of action. They can cycle in any direction they please, and their radius of movement is subject only to a time limit equal to the maximum duration of interaction allowed by the system. What all of these projects have in common, however, is the significance of personal movement for the construction or realization of the spatiality of the interactive work. This may take the form of physical activity or positioning, inclusion or exclusion of others, or even extensive locomotion. The gestalt of the work is realized in the course of these individual activities. Such gestalts are often fleeting and processual and ultimately endure only in the perception or memory of each individual recipient.

Digital and virtual spaces

In interactive media art physical space and digital data space can enter into complex interrelations. On the one hand, space can be simulated in the digital medium; on the other, digital information flows and networks create their own forms of spatiality.

When space is simulated by means of digital media, this simulation is not restricted to creating the visual illusion of space behind the picture plane or of interpreting an image as a window (as has been practiced in painting since the invention of central perspective). Digitally simulated space can be presented as both processual and modifiable, which opens up various possibilities of action for the recipient.[52] The simulation may present an enclosed space, like the cube in Perry Hoberman's *Bar Code Hotel* (1994), which is constructed from a central perspective and within which objects either move or can be moved. Space might also be presented as an infinite space into which the recipient can gaze, as if through a large window, or within which he is invited to move virtually, as in Shaw's *Legible City*. Hegedüs' *Fruit Machine* has such a dark background that the interactive object the recipients must assemble seems to float within the actual exhibition space, or at least this is the intended impression.[53] The same impression is even more effective in the CAVE, in which virtual objects are projected directly into physical space so as to create the illusion that the recipient finds himself in a virtual world. *Home of the Brain* (1992), by Monika Fleischmann and Wolfgang Strauss, was explicitly designed to feature an overlap between virtual and

physical space. Recipients were given head-mounted displays and were invited to move around the foyer of Berlin's Neue Nationalgalerie so as to explore a virtual space whose boundaries and dimensions corresponded to those of the actual foyer. Within this space, the virtual homes of famous philosophers could be visited.

In addition to using forms of visual illusion, artworks may represent social structures by means of spatial metaphors. For example, the original interface of the early network platform *De Digitale Stad* was a mixture of a city map and a subway plan, whereas a more recent and more abstract version showed a web-like structure. In this work, urban space was seen as a network of social, societal, and political institutions and relationships, and was staged as an online communication space. Ingo Günther went even further with his project *refugee republic* (1995), which presented a republic without a location in the real world and characterized by independence from all existing political and geographical systems.[54] These last projects address yet another form of digital spatiality, for they not only represent a place but also instrumentalize a digital communication network. Local and global data and communication networks are also spatially structured, manifesting themselves as such by means of access points, information flows, and entry requirements. Manuel Castells coined the term "space of flows" to describe this feature. As a counterpart to the "space of places," it denotes global economic, social, and political communication flows and relationships organized around various nodal points.[55] Anthony Dunne and Fiona Raby use the term "Hertzian space" to describe the immaterial spatiality of information carried by electromagnetic waves.[56]

Internet art is never located primarily in physical space; rather, it is based on HTML code stored on a server whose location usually seems to be of no relevance for the recipient. When the appropriate address is accessed, the code is temporarily transmitted via an Internet connection and can be displayed on any computer. Nonetheless, these works involve spatiality both in the staging and in the realization. The realization is shaped significantly by the location of the reception—the public or private space in which the project is activated. It makes a great difference whether I interact with an Internet artwork alone or in company, and whether I am positioned directly in front of a large screen or am incidentally clicking through a work on a laptop computer. The staging, by contrast, concerns the technical location of the work in digital data space. If the work in question consists of Web pages that the recipient is simply invited to explore, where the work is stored usually isn't relevant. One exception is Olia Lialina's *Agatha Appears*, which is not just stored on but also narrated across multiple servers spread around the world. The network nodes also acquire substantial importance when a work links up different recipients, whether synchronically or asynchronically, as is the case in *refugee republic*. But then again, it is not so much the location of the server as that of the recipients that determines the individual spatial construction of the work. Even if I am not exactly aware of where my interaction partners are, I still create the idea of a communication network, which is shaped by

my mental image of the interconnected space of the World Wide Web. This imagined spatiality may have parallels in the actual technical paths of transmission, but need not coincide with them.

Again, the most complex form of superimposition between data space and real space happens in public space. This is clearly illustrated by *Blinkenlights*, a project presented by the Chaos Computer Club in 2001. The Berlin-based hackers' club transformed the facade of Berlin's Haus des Lehrers into a computer screen, using the windows as pixels. Recipients were invited to send their self-designed graphics to a server, and these were reproduced in large scale from the illuminated windows of the high-rise building. Moreover, it was also possible to play the computer game Pong on the facade.[57] Phoning a number that had been publicized in advance turned the recipient's cell phone into a joystick that he could use to control the Pong paddle depicted on the facade. The action became especially exciting when a second player joined in, for then the recipient was not playing against a computer but against another person whom he knew must have been somewhere within sight of the playing field (the facade of the building). Now the recipient's perception of the space around the high-rise building changed, for somewhere in the immediate area there had to be a person with a cell phone controlling the second Pong paddle. So the recipient tried literally to trace the incoming radio waves back to their transmitter. The path of the Pong ball and the path of the transmission became mixed in the recipient's perception, even if, technically speaking, the information did not follow a direct path from the player to the playing field. Now space was suddenly defined in terms of information flows, and a network of connections was superimposed on the physical urban location—a network of mobile transmitters and receivers, visible pixels, and invisible information flows. Such close linking of real space and data space is typical of many interactive artworks. It may, as in *Blinkenlights* and *Se Mi Sei Vicino*, be supported by appropriate visualizations, or, as in *Wasser* and *Drift*, be based on linking real space and acoustic information space.

In the locative projects chosen for the case studies presented in this volume, the artists selected specific locations for the works to be realized. Other projects, by contrast, leave the actual location of their realization completely open. The location then corresponds to the action radius of the recipient, for the work is delivered to the recipient, wherever he is, by cell phone. In *FLIRT* (1998), Anthony Dunne and Fiona Raby sent a virtual cat into the network to dart across the cell phones of the recipients. In *Operation CNTRCPY*™ (2003/2004), the Viennese artist group CNTRCPY™ organized a game that used text messages to yank recipients out of their daily life at all hours of the day and night—they were obliged to respond immediately if they wanted to win a virtual race to Mars. In these cases, spatiality is no longer determined by the consistency of physical spaces, but by blending these with imagined worlds and, in Martina Löw's words, with the "non-continuous and only intermittently connected moving realms of cyberspace."[58]

Regardless of whether the conjunction of real space and data space is staged in the public space or is a theme of a Internet artwork, and regardless of whether the artist designates locations within these spaces or simply initiates locative processes, the realization of such hybrid spatial constructs is central to the aesthetic experience of interactive art. Often it is in these mutually overlapping spatial layers that the boundary between interaction space and everyday space is challenged. The resulting irritation of the recipients is explicitly desired. In addition to a constant questioning of aesthetic distance, here a challenging of the boundary between the artwork and everyday life (addressed by Gadamer as "aesthetic differentiation") is also particularly evident. When real space and data space, and interaction space and everyday space, overlap to varying degrees, does it still make sense to refer to an artwork as a self-contained entity?

Presence
The observations made above about individual and ephemeral constructions of spatiality indicate that spatial phenomena are increasingly viewed in processual terms. Spatiality thus acquires relevance not so much as an objective condition as in terms of a perceived situation. If, on the one hand, interactive art relies on the absence of the artist during the process of interaction, on the other hand it requires not only the existence of a system and a recipient, but also the readiness of these to become active—in other words, their "presence." The *Oxford English Dictionary* defines "presence" as "the state of being before, in front of, or in the same place with a person or thing," and specifies that "being present" is also used to denote non-human phenomena, such as things that are ready at hand, immediately accessible, or available. This last meaning of the term is also applied to traditional artworks, which are ascribed the quality of presence on the basis of their material effect or impression on the observer. This spatial impact of art—criticized by Michael Fried as amounting to theatricality—has gradually become a significant issue in art since the middle of the twentieth century.[59]

Dieter Mersch relates his concept of presence to non-human entities, describing their active qualities as "ekstasis" and "positing."[60] Even Erika Fischer-Lichte, who considers presence to be the defining characteristic of the performative ("an aesthetics of the performative is . . . an aesthetics of presence"),[61] recognizes the active qualities of objects, although she would prefer to reserve the concept of presence for the physical presence of human beings. Fischer-Lichte proposes a ranking scale of concepts of presence ranging from weak to strong to radical—from pure physical presence, to presence that dominates space and seizes attention, to the self-experience of recipients as "embodied minds" kept in a state of constant flux by the circulating energy.[62] Fischer-Lichte believes that the third type of presence is the exclusive prerogative of human beings, whereas the first two can also apply to objects. Nonetheless, for objects she prefers to use Gernot Böhme's notion of the "ecstasy of things."[63]

Thus, media studies and performance theory emphasize physical being there and active qualities as criteria of presence. They use the word "presence" in a way that is related, but not identical, to the concept of affordance, which generally entails an invitation to take action. In 1992, Thomas Sheridan introduced the concept of presence to HCI research, specifically in relation to behavior in media-based environments. Sheridan differentiates between telepresence as a sense of presence in another, physical place, and virtual presence as a sense of presence in a simulated place. What is important to note is that he defines presence as a subjective feeling. Thus, according to Sheridan, one can only perceive one's own presence. This is determined, on the one hand, by the degree of sensory information that can be obtained and, on the other, by the potential of the individual to modify his environment.[64] Matthew Lombard and Theresa Ditton illustrate succinctly how in information technology the concept of presence is based on illusion and mediatization when they define presence as "an illusion that a mediated experience is not mediated."[65] The conception of "presence" as an illusion is, of course, diametrically opposed to a definition of presence as actual "being there." Fischer-Lichte, especially, defends her conviction that presence can be simulated, but not generated, by media. In her view, presence requires actual (co-) presence in one place, because otherwise the autopoietic feedback loop—the ongoing negotiation of the relationship between actor and public—cannot take place.[66]

However, these divergent definitions of presence—in performance studies and in HCI research—can be used to create a productive concept of presence for this study. If presence can be applied both to objects (including technical systems) and to people, then although the quality of presence can only be ascribed to an entity that can be activated in the here and now, this entity need not be human. Presence can thus be understood as potentiality for action which is specific to a particular location. When such potentiality results in a factual activity, however, usually the word "liveness" is used instead of "presence."

Time

The processuality of interactive art is not limited to a linear, preconfigured, and structured duration; rather, it is the result of interrelations between different levels of time. As John Dewey emphasizes, time is relevant to all forms of art: "[T]here is the same compression from accumulation in time" in the visual arts and architecture, and also in music, literature, and theater.[67] Nonetheless, the different conditions of reception as well as the structure of the works offered for reception in the different genres have a significant influence on the temporal course of the works.

Whereas a performance is usually defined by a temporally fixed beginning and end, and thus by a fixed duration, in interactive art questions of duration are equally relevant, although (in most cases) they are not determined in advance. Interactive projects are comparable to visual artworks in that they generally are presented in the

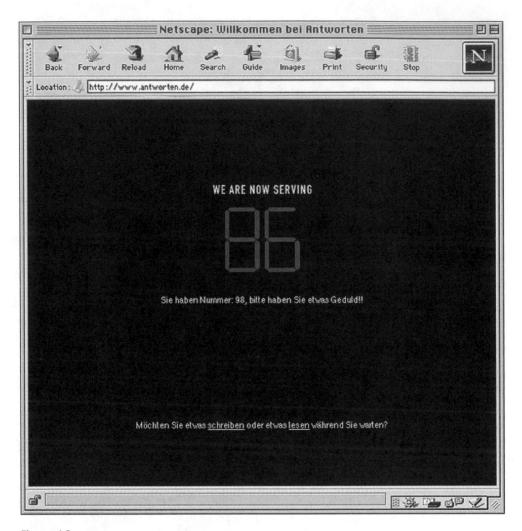

Figure 4.3
Interaction time. Holger Friese and Max Kossatz, *antworten.de* (1997), screenshot.

context of an exhibition and can be accessed at any given time (during the venue's opening hours) and for any given duration. This also applies to Internet artworks (which are not subject to opening hours) and to projects presented in public spaces (where the opening hours of distribution points for devices may have to be respected).

Interactive art and visual art may have the same degree of openness regarding the moment and duration of a reception, but this doesn't hold for the structural preset-tings of the reception itself. Visual artworks impose no conditions in this respect either, whereas in interactive media art the temporal structures of the realization phase are designed in the form of potential processes. This potentiality, rendered possible by the use of electronic media, is seen by modern philosophers of time as a fundamental revolution with respect to our experience of time.[68] In fact, electronic media are increasingly calling into question our model of a linear progression of time. In 1766, using the examples of painting and poetry, Gotthold Ephraim Lessing noted that the principal difference between visual and time-based art was that "signs arranged side by side can represent only objects existing side by side," whereas "consecutive signs can express only objects which succeed each other."[69] This, Lessing argued, was why bodies were the objects of painting and actions were the objects of poetry. Friedrich Kittler still basically agrees with Lessing when he points out that "on the time axis, however, manipulating the notions of ordering and analyzing seems to be different and more complex than in space," because time is from the outset a "successor rela-tion."[70] Kittler argues that it is only thanks to the tools that electronic media provide for storing information as a time flow that such information can be arbitrarily orga-nized, played faster or slower, or processed in what is regarded as real time.[71] Paul Virilio also observes that the traditional tenses of past, presence, and future have been replaced by two tenses: real time and delayed time. Virilio uses the term "real time" to refer to the natural flow of time, and "delayed time" to refer to represented or potential (virtual) events that can be accessed or realized at any time through a medium.[72] Thus, by making temporal structures available for activation, electronic media, and with them interactive media art, create a new potentiality for time. The issue here is not the representation of a course of events, as in literature, but the potential activation of concrete units of time and of programmed processes.

The technical possibilities for structuring time are not the only aspect that informs the time structures of interactive media art, however. These also rely on the perception and contextualization of such structures, which are based on collective agreements and symbolic attributions.[73] Mike Sandbothe argues that the socially informed con-cepts of past, present, and future represent a "dimensioned time" that differs from the time model of "earlier, simultaneously, and later."[74] However, both models are char-acterized by a linear understanding of time, which (like the idea of continuous space) is a modern construct. In fact, the anthropologist Edward T. Hall labels this conception of time characteristically Northern European. From this point of view, Hall writes,

actions are primarily perceived and organized as succeeding one another, whereas other cultures live according to the polychronic model of time, in which there is a stronger focus on the simultaneity of different chains of action.[75] Also Hall observes, however, that the information society is inducing a general trend toward polychronic models of time, and that cultural differences are being gradually broken down by the new potentiality of time engendered by electronic media.

Different concepts are used to describe this new potentiality. Paul Virilio uses the term "simulation time," whereas Helga Nowotny examines "laboratory time." Following the ideas of Karin Knorr Cetina, Nowotny sees the laboratory as an interactional environment—a "temporally structured environment capable of acceleration."[76] She argues that laboratory time is characterized by the "continuous presence" and the constant "temporal availability" of technical objects, which allows temporal sequences to be controlled and programmed. Moreover, it is possible both to accelerate processes and to slow them down under laboratory conditions, and events can be repeated several times—with variations, if so desired.[77] This brings us back to a topic we already encountered in the context of play: the inner infinitude of processes that can be repeatedly activated and replicated within a set framework or rule system. In interactive media art, the repetition of actions is not only possible, it is often specifically desired. Examples are the invitation to play further rounds in Berkenheger's *Bubble Bath* and recipients' tendency to repeat sequences of physical movements, either with the aim of exploring the reactions of the system in more detail or simply of enjoying the processes in question, in Rokeby's *Very Nervous System* and in Cillari's *Se Mi Sei Vicino*.

Interaction time

The time required for an interaction with artistic systems can also be described as laboratory time in the sense that the point in dimensioned time at which short-term interactions take place is not particularly important.[78] We do not contextualize such interactions as temporally relevant segments of the life course. In the configured temporal structures on which this study focuses, the interactions are usually integrated into societal time structures only at the level of representation—that is, they may represent past or future events. The interaction itself, however, can only take place in the present, but the context is generally not that of everyday life. The exceptions are works aimed specifically at calling into question the boundary between the artwork and the everyday, such as *Operation CNTRCPY*[TM], which, as mentioned above, involves the recipient for a number of weeks in a virtual race to Mars. In this work, the recipients' contact with their virtual spaceship is created via cell phone, so that they can be alerted at any time of the day or night that they must intervene immediately, via an Internet connection, to prevent imminent danger (collisions, attacks by enemies, fuel shortages). Owing to the lengthy duration of this project and the instrumentalization of the participants' personal appliances, the interactions with

the system interfere with the recipients' everyday lives, so that the time spent inter-acting with the artistic project becomes intermingled with the time spent in social reality. In most projects, however, the duration of the interaction is separated, via its artistic contextualization, from the everyday sense of time. Although it cannot be entirely detached from the conventions of social time management—a recipient will devote less time to a work if he is in a hurry, for example—other time structures still dominate.

Narration time and narrated time

Literary, film, and art scholars have primarily been interested in the relationship between narration time and narrated time.[79] In other words, their consideration of temporal structures relies on the basic assumption that works have a representational function. Research is dedicated to the historical context of the situation or activity being represented and to the relationship between the course of the narrated time and the duration of its representation or reception. Literature operates with flashbacks and previews to structure the representation of time, and film may use slow motion and fast motion, in addition. Represented time can even play a role in the visual arts, for example when a sculpture evokes a sequence of movements or a single painting com-bines different scenes that succeed one another chronologically.

But of course the arts don't always represent something, let alone something that could be contextualized in temporal terms. Richard Schechner points out that action art is not based on the representation of symbolic time, and Erika Fischer-Lichte's analysis of performance art likewise doesn't place the focus on represented time. The performances Fischer-Lichte examines are not primarily geared toward representation, but emphasize reality and thus the actual time of action. In interactive art, too, the main focus is on the actual moment of interaction. Nonetheless, the category of rep-resented time is by no means irrelevant here. For example, when a project uses assets that have been stored in advance, actions or processes performed in the past are replayed. Although the chronological order of the actions represented in alinear nar-ratives may be variable, the process of reception nonetheless produces a chronological progression that orders the different fragments of represented time. Such works often create the illusion that the represented actions are happening in the real time of the individual realization—for example, when the recipient is addressed directly, as in *Rider Spoke*, *Wasser*, and *Room of One's Own*. In such cases, the storage of data gives a potential to communication that is aptly described by Paul Virilio's concept of delayed time. Of course, this doesn't exclude the possibility that actions stored on media may also be presented as past actions. Both *Wasser* and *Rider Spoke* thematize memories and past events, whereas in *Room of One's Own* we find references to past episodes in the life of the protagonist (for example, she greets a fictitious telephone caller with the words "Finally, it's about time you called. It's been two weeks . . . ").

In interactive art, narration time corresponds to the duration of the interaction. In a game, a conclusion is usually reached either after a certain amount of time has elapsed or after a certain result has been achieved.[80] Because of the open-ended nature of interactive art, such predefined conclusions are rarely imposed; most projects allow interactions of different durations.[81] Nonetheless, the duration of interaction is largely determined by the pre-established structure of the project. In this context, the difference between projects based primarily on stored assets and projects that focus on the processing of code becomes relevant again. In order to differentiate between these two features, Chris Crawford introduced the concepts of "data intensity" and "process intensity."[82] Crawford writes that data-intensive projects are based primarily on pre-recorded sound and/or image sequences, or on static texts or images that are selected or arranged during the interaction. In these cases, processuality serves mainly to structure, select, or compose the assets. In data-intensive projects, a time length may be computed by adding up the duration of all the included assets, although this calculation by no means determines the duration of each individual realization. In such projects, recipients may seek to activate all the available assets. Just as we are used to watching a movie from beginning to end, we are inclined to want to experience the "whole" of a work—that is, all available assets. If a work has mainly been programmed in a process-intensive manner, then the sound and image data we can experience will be generated in real time according to algorithms that are activated and influenced by the input of the recipient. In these cases, the duration of the interaction may be determined by the desire to exhaust the underlying algorithms and the possibilities for interaction offered.

The important point in both cases is, however, that the interaction will not necessarily end when all the assets have been accessed or when the workings of the system have been understood. If the interaction process is in itself aesthetically appealing, exciting, or pleasurable, the recipient will seek to reactivate specific assets, repeat individual processes, or try out alternative patterns of interaction. On the one hand, the desire to fully realize or comprehend a project may thus replace the pursuit of a goal in a rule-based game—that is, the recipient will define a conclusion that can be justified within the framework of the interactive work. On the other hand, the recipient might just as easily—as Scheuerl and Gadamer pointed out—find pleasure in the repetition and the inner infinitude of the movement of play.

The temporal structure given to narrative systems is often closely linked to the storyline. For example, most hypertexts have a starting point that represents the beginning of the story. However, it is rare for such texts to have a defined end, for that would hardly be appropriate for their alinear structure. Nonetheless, every individual reception will, of course, conclude at a particular moment. Michael Joyce wrote the following in relation to his hypertext *Afternoon* (1990): "When the story no longer progresses, or when it cycles, or when you tire of the paths, the experience of reading it [the hypertext] ends."[83] This applies to the experience of Schemat's *Wasser*. By con-

trast, the plot of Lialina's *Agatha Appears*, which has an almost entirely linear structure, has an evident end, even though it leaves the outcome of the story open and thus doesn't provide a conclusion to the arc of suspense. Berkenheger's *Bubble Bath*, by contrast, clearly moves toward a climax, but then loses itself—at least in my experience—in tiresome loops, which are obviously aimed at ultimately provoking the withdrawal of the recipient.

Structure, rhythm, and processed time

Interactions are, by definition, reciprocal actions. Accordingly, the course of time of an interaction cannot be conceived or realized as a seamless continuum; rather, it manifests itself in the form of rhythms or structures.

In both data-intensive and process-intensive projects, the course of the interaction depends on whether all the data can be accessed (on principle) at any time, whether all the processes can be initiated at any time, or whether sequences or actions are available or can be activated only at certain points in time. It is also determined by whether it is mandatory for the recipient to be always active for the process to continue. Jesper Juul introduced a distinction between real-time and turn-based games in the context of play. Whereas in "real-time" games the fictitious gameplay proceeds continuously, turn-based games stagnate in the absence of input from users.[84] And hybrid forms in which such moments of stagnation trigger system-internal processes can often be found. Instead of simply hovering in a waiting state, the system then reverts to a standard procedure that signals that it is waiting for input. Alexander Galloway distinguishes in this regard between "ambience acts," which are activated to bridge pauses determined by the players, and "cinematic interludes," during which input from users is precluded.[85] Interactive media art also operates with different forms of reactivity and autonomy on the part of the system processes. Agnes Hegedüs' *Fruit Machine* remains entirely static when no input is registered. So does David Rokeby's *Very Nervous System*, which is entirely inactive until a recipient enters the room and moves within the work's radius of action. Whenever there is an absence of interaction in Sonia Cillari's *Se Mi Sei Vicino*, the grid reverts to a gentle billowing movement as it registers the variations in voltage that are latently present in the room. By contrast, Lynn Hershman's *Room of One's Own* emits singing and laughter when no recipient is interacting with it, as if the interactive sculpture were involved with itself. At the See This Sound exhibition, *The Manual Input Workstation* indicated its readiness for action by means of the request "Please Interact," which was projected onto the otherwise empty screen. In this work, the audiovisual formations, once generated and activated by the recipient, can also run independently as loops before they gradually fade.

The technical processes underlying such effects are not primarily based on time in the sense of a progression which is perceived, remembered, or anticipated, but on frequencies and pulses that structure a sequence of predefined units and steps—determined to different extents by external input. Even though the feedback processes

of the technically mediated interaction are ultimately always based on a chronological succession, "real-time interaction" is said to take place when feedback is made possible within the normal limits of human reaction time.

Often the transition between sequences follows a conscious design. For example, Grahame Weinbren was particularly proud of having developed a system for his early work *The Erl King* (1983–1986) in which the cinematic assets could be interactively selected and varied, whereas the sound remained unchanged and thus suggested a continuity that Weinbren considered an important aesthetic element of his vision of interactive cinema.[86] Lynn Hershman recorded specific film sequences to accompany the transition from one position to the next in *Room of One's Own*. In *Drift*, Teri Rueb used the sound of footsteps to indicate that the recipient was approaching a zone containing text. However, she also left long pauses between these zones in which the recipient received no feedback whatsoever on his movement. These examples show that, in some works of interactive media art, the transition between selectable information units may be deliberately indistinct; in others it may be staged as an evident interruption. Whereas in the past it was often technically impossible to avoid a waiting period before the system reacted, nowadays one can assume that delays have probably been deliberately programmed. An exception from the past, as Jesper Juul recounts, is Space Invaders, an early computer game that halted briefly when a player had hit an opponent so as to allow him time to celebrate his achievement. Juul compares this approach, which takes account of subjective perception of time, to slow-motion sequences in film, which often mark moments of great emotional significance.[87] Interactive art also uses such deliberately staged delays. For example, in *Bar Code Hotel*, Perry Hoberman programmed objects to react after a time lag when they had reached a certain age. During the restoration of *The Erl King*, delays in feedback found in the original system were artificially simulated in order to preserve the experience of the original process speed.[88] The influence of the system's response time on aesthetic experience is also illustrated by the observations of the visitors to Tmema's *Manual Input Workstation*. Whereas one visitor explained his perseverance in waiting for something to happen after he had placed a number on the projector by saying that in interactive projects one must always first learn to appreciate the latency of the system, the recordings of other visitors showed that they didn't wait long enough to allow the system to recognize the numbers placed on the projector. The Internet artwork *antworten.de* (1997) by Holger Friese and Max Kossatz uses irony to disrupt expectations regarding real-time communication in interactive art. Recipients who access this work's Web page are greeted by a friendly message announcing "We are now serving 13. Your number is 97. Please be patient!" This is accompanied by a musical jingle of the kind that typically signals that one is on hold on the telephone. Even though the number is regularly updated, the recipient finds himself in an endless waiting loop; when his turn arrives, his number is skipped.[89]

At the opposite end to technically determined, aesthetically generated, or ironically disrupted real-time interaction are projects that stage asynchronic feedback processes. Such works invite users to store data that other recipients can then access in different forms. Jonah Brucker-Cohen's *BumpList* (2004) is a mailing list that uses particular rule systems to self-referentially question the mechanisms of such communication. Although the list allows users to refer to one another, it prevents meaningful communication by admitting only a limited amount of subscribers. When a new person joins, the first person to subscribe is "bumped"—that is, unsubscribed—from the list. In other works, including *Rider Spoke* and the archive project *The File Room* by Antonio Muntadas, data can be stored for other, anonymous recipients.

Liveness

One of the main characteristics of interactive art is the fact that it can—indeed must—be experienced in the form of actual and individual realization. However, I have already identified a contradiction between this process-based actuality of interaction and the material or informational permanence of the programmed interactivity. Every work was conceived at a particular moment in time and, unless it has since been updated or adapted for exhibition purposes, it is presented on each new occasion with the same original structure. In this subsection, the concept of liveness will be used to examine the relationship between the action potential ("interactivity") of the interaction proposition and the moments of its realization or actualization ("interaction") by a recipient in more detail.

The adjective "live" is documented in the English language since the early modern period and denotes such different states as "alive," "of current relevance," "full of energy," and even—in the terminology of mineralogy—"untreated." With the coming of the Industrial Revolution, "live" also came to be used to describe machine parts that moved, especially when induced to do so by other parts. The noun form "liveness" has been in use since the nineteenth century, both in the literal sense of an organic body's being alive and in the metaphorical sense (for example, denoting an active area of research).[90] Similar to "presence," "liveness" can thus be applied both to living things and to objects.

The word "liveness" was adopted into the context of media in the 1930s, when radio broadcasting had become widespread. Although storage media such as the phonograph record had already allowed aural performances to be recorded and later played back for many years, it was only with the arrival of radio that listeners were no longer able to distinguish between direct broadcasting of a performance and broadcasting of a recording. Consequently, direct broadcasting was now designated as "live broadcasting."[91] Thus, the concept of liveness found its way into the media context the moment it became possible to simulate "here and now" communication using new storage and broadcasting technology. The word "live" was intended to distinguish

a here and now communication from newly emerging methods that called its liveness into question. The concept of liveness can apply to different areas of the communication model, however. "Live recording" places the focus on the production of data, "live broadcasting" emphasizes the process of transmission, and the "live concert" prioritizes the moment of performance and reception. In the context of the present study, I propose defining liveness in terms of actual processuality. Whereas presence is understood to be a potential of objects, systems, and living beings, liveness will be used to denote a processual activity.[92] In the remainder of this book, the concept of liveness will be applied to the analysis of interactive art when the focus is on processes that are currently taking place. These processes may comprise the realization of the interaction proposition on the part of one or more recipients, but they may also be internal system processes. Moreover, drawing on Jesper Juul's distinction between real-time games and turn-based games, we must also distinguish between system-internal liveness and the reactive liveness that develops on the basis of the reciprocal responses of the system and the recipient.

Philip Auslander has pointed out that the meaning of liveness has changed once again as a result of the growing diffusion of interactive media technology. Now, according to Auslander, the ontological status of the performer—which may be either human or non-human—is under discussion.[93] For example, Auslander views chatterbots such as Stelarc's *Prosthetic Head* as processing entities that perform live. Thus, in his view, the most significant challenge to traditional concepts of interaction is now posed by digital entities that autonomously run processes and respond to the input of performers and spectators.[94] Margaret Morse makes a similar argument: "A machine that thus 'interacts' with the user even at a minimal level can produce a feeling of 'liveness' and a sense of the machine's agency."[95] Auslander and Morse discuss systems that imitate face-to-face communication, but in the present study I will not tie liveness to the idea of simulated human communication. On the contrary, I will also characterize as live technical processes occurring in the here and now that do not necessarily follow communication models, thereby applying the original usage of the term. The liveness of a system must be determined by its processuality, not by its similarity to face-to-face communication.

Processing entities can be individual actors, software or hardware components, or complex networked systems. Manuel Castells describes the entire communication space as a "space of flows" characterized by a continuous real-time interaction. Nick Couldry, by contrast, is interested specifically in online communities, which are based on the potential to link up different social groups or entities and thus enable a social co-presence.[96] Membership in such networks, and constant (even if only potential) connection by means of a cell phone, convey a feeling of being present, whether or not an exchange of information is taking place at the moment.[97] Because communication in these networks often takes place asynchronically (e.g., via chat rooms or text messages), the question arises as to when these represent actual processuality and

when they represent only potential processuality. Liveness and presence thus cannot be effectively separated here. In these cases, interconnectedness is a phenomenon that is equally spatial and temporal.

Further, concerning interactive media art, often different levels of liveness must be taken into account. In addition to the technical liveness of a system and the possible liveness of interaction processes between a human being and a system, liveness can be simulated at the representational level.

Interactivity and Interaction

Having examined the various actors and their possible roles, as well as basic spatial and temporal parameters of interactive art, we can now focus on the interaction processes themselves. Here we must distinguish between instrumental characteristics and phenomenological characteristics.

The instrumental perspective

Descriptions of interaction systems often concentrate on the technical parameters and the structural conditions of the feedback processes taking place. Martin Lister and colleagues classify attempts to describe interaction processes in such formal terms as an instrumental view of interactivity.[98] The project Capturing Unstable Media, for example, focuses on the compilation of a formal meta-database for describing recipient interactions (with the explicit caveat that metadata alone are not sufficient for describing the subjective characteristics of interaction processes, for which a detailed documentation of the experience of reception is also required).[99] The authors of that project seek to record—in addition to the temporal and spatial parameters—the role and the minimum and maximum number of users, as well as the sensory modes of each work (visual, auditory, olfactory, tactile, gustatory).[100] The observed interaction processes are differentiated by their degrees of intensity, which range from observation and navigation to participation, co-authoring, and intercommunication. Thus, similar to Cornock and Edmonds' classification, which was outlined at the beginning of this chapter, Capturing Unstable Media uses a ranking scale ranging from weaker to stronger interactions. In her early study on the reception of interactive art, the artist and curator Beryl Graham also took this approach by comparing interactions to different forms of communication. In Graham's study, an exchange that is equivalent to a real conversation guarantees the highest degree of interaction: "a category which is a possibly unobtainable end point but remains as a possible future aim."[101]

The media theorist Lutz Goertz describes interaction propositions in terms of their degree of optional selection, degree of modifiability, number of available selection options and modifications, and degree of (a)linearity. However, Goertz's ultimate aim is a ranking scale of interactivity, too: "The following rule should apply: The greater the quantity or degree of a factor, the greater the interactivity."[102] This tendency to

Figure 4.4
Interactivity and interaction. Lynn Hershman, *Lorna* (1983–1984), installation view (© Lynn Hershman Leeson and Paule Anglim Gallery, San Francisco).

create ranking scales, which is particularly widespread in media and communication studies and often goes hand in hand with a view of face-to-face communication as the ideal form of interaction, is not suitable for studying the aesthetics of interactive art, however,[103] because it encourages an evaluation of the quality of a work on the basis of its level of interactivity. As a result, interactive media art is measured by the criteria that apply in artificial intelligence research, where the more similar an interaction is to face-to-face communication the more successful it is generally considered to be. But this analogy ignores the fact that many artists deliberately choose to work with digital media because they want to scrutinize specifically how mediated interac-

tion deviates from face-to-face communication.[104] An aesthetic theory of interactive media art must help to identify and describe the various interaction processes that artists have conceived and implemented through the technical systems. It must specifically focus on the tension between media-based potentials and limits, on the one hand, and the expectations and interpretations guiding both the design and each individual realization of the work, on the other.[105]

Other approaches that take an instrumental perspective attempt to describe interactions or interaction systems by means of identifying patterns of action or of individual processes. For instance, Katie Salen and Erik Zimmermann use the term "core mechanics" to denote the basic activities that define computer games. Typical core mechanics are movements such as running or jumping, discursive processes such as answering questions, and goal-oriented actions such as shooting or catching.[106] Ian Bogost's concept of "unit operations" describes in a more general way those individual processes of games that represent particular actions and can reappear in different contexts.[107] However, single operations are not the focus of the descriptions of interaction provided in this study. The reason is that it is questionable from an aesthetic point of view to differentiate between clearly referenceable units, especially in the context of artistic configurations of action.

Above all, however, an aesthetic analysis of interactive art must go beyond instrumental categorizations in general. It will become clear in the following that there is no necessarily causal relationship between the experiences and epistemic processes brought about by interactive art and the instrumental characteristics of interactivity. For example, a hyperlink system may present a non-linear narrative, but can just as easily involve the recipient in a question-and-answer game. The storage of a user's input may be perceived as a means of control, but also as an invitation to become co-author. Nonetheless, an instrumental view of interactive art can be helpful when it comes to analyzing the incongruous relationship existing between technical parameters and aesthetic experience. Thus, I will first take an "instrumental" look at interaction processes in digital art, also to identify the limits of such a perspective.

One could view as the technically simplest form of interaction the activation of a work which is organized as a linear succession of assets. An example of this kind of work is Olia Lialina's Internet-based work *Agatha Appears*, in which the recipient must click on the two schematically depicted protagonists in order to make their dialogue—and thus the story—progress. Masaki Fujihata's installation *Beyond Pages* (1995) is also based on simple activation options. In this work, a picture book is projected onto a table. By touching the pages of the virtual book with a light pen, the user can turn the pages and animate the images that appear. The animations include a stone that can be moved, leaves that begin to rustle, and an apple that can be bitten into. In both *Agatha Appears* and *Beyond Pages*, the recipient's task is limited to activating a pre-programmed sequence of data with minimal possibilities for variation. Nonetheless,

the aesthetic experiences of the two works will be very dissimilar. *Agatha Appears* invites the recipient to follow the narrative of a story. Participating requires no more than clicking on the figures. The recipient becomes a kind of puppeteer, even though he has no power whatsoever to influence the development of the plot. Also, the linearity of the chronological evolution of the narrative is felt much more clearly than in *Beyond Pages*. This is because, on the one hand, Fujihata's picture book doesn't present a story, but depicts independent symbols and objects. On the other hand, the fact that the metaphor used is that of a book seems, curiously enough, to counteract the perception of linearity. The reference to a book, usually considered the linear medium par excellence, gives the impression that all the options are available at the same time (even if, technically speaking, the pages must be turned consecutively), whereas in *Agatha Appears* the traditional hyperlink system, whose alinearity usually represents the antithesis to a book, highlights the linearity of the narrative.[108]

Other projects may offer a simultaneous choice of clearly defined options that can be activated in a non-linear process. They may be constructed in a relatively simple manner (concerning instrumentality), offering a range of options that always remains the same; in other words, after each interaction the same options will still be available as previously. This is the case, for example, in Schemat's *Wasser*, in which the recipient activates acoustic texts by moving through the landscape, and in a similar way in Ken Feingold's *JCJ Junkman* (1995), a screen-based work that invites the recipient to "catch" rapidly moving icons with a mouse in order to influence an audio composition.[109] Both of these works are based on simple selection options presented simultaneously by means of their spatial arrangement. Nonetheless, here again the realization and the aesthetic experience of the two works will have very little in common. Whereas *JCJ Junkman* is concerned with reaction speed on a standard interface and can be viewed as an ironic comment on the consumer society, *Wasser* deals with movement in real space, inviting a poetic experience that results from a combination of fiction and personal associations.

There is a higher level of technical complexity in works that feature a tree structure or a network structure, because different selection options are made available at different moments of the interaction process. This applies to many Internet artworks, such as Berkenheger's *Bubble Bath* (a mystery story in which the recipient influences the course of the narrative by activating hyperlinks). Lynn Hershman's early interactive installation *Lorna* is also based on a tree structure that allows recipients to activate pre-recorded film sequences by choosing numbers on a remote control.

Both *Bubble Bath* and *Lorna* create fictitious worlds, but they differ in the media they employ, the required modes of action, and the involvement of the recipient. Activating a film sequence by selecting a number on a remote-control device is very different from clicking directly on a word on the screen, which itself is a syntactical element of a primarily text-based narrative. Whereas *Lorna* involves the recipient in

the story through the installational configuration of the exhibition space as a kind of stage for the film scenes, *Bubble Bath* encourages involvement not only through the complex semantics of the links, but also by assigning a fictitious role to the recipient.

In addition to various forms of selection, interactive works can offer possibilities to modify something. For example, when recipients use a joystick to piece the segments of a virtual object together in Hegedüs' *Fruit Machine*, this is not a simple matter of selection, but implies a free movement of the virtual object in three dimensions, as well as its rotation. Similarly, in Jeffrey Shaw's *Legible City*, riding the bicycle controls not only the direction, but also the speed of movement in virtual space. Although both projects allow recipients to control a graphic animation through free operation of a steering device, once again there is little to compare between the potential interactions and experiences of the recipients. This is not only because *Fruit Machine* invites several recipients to participate at the same time and presents them with a clear goal. The main disparity is that the two works, although they are both based on the control of (virtual) movement in (simulated) space, provide completely different contexts for the recipient's actions. Whereas *Fruit Machine* challenges the motor and cognitive abilities of the recipients, who have to maneuver a virtual object into a precise position, *Legible City* seeks to convince the recipient that he is using his handlebars and pedals to move through virtual space. Moreover, the ultimate aim of the activity is not motor precision, but the act of reading and exploration, which the recipient can experience through direct spatial and bodily involvement.

Another possibility for designing interaction systems is the integration of a recipient's likeness into an interactive installation. In *Room of One's Own* and *America's Finest* (1993–1995), Lynn Hershman uses closed-circuit systems that reflect the real-time image of the recipient back into the installation so as to orchestrate processes of (self-) observation. In other works, the recipient is only reproduced in shadow form, either to encourage him to make performative movements (as in Snibbe's *Deep Walls*) or to enable interaction with graphically generated creatures (Myron Krueger's *Critter*) or objects (Tmema's *Manual Input Workstation*). Other works (for example, Utterback's *Untitled 5*, Cillari's *Se Mi Sei Vicino*, and Rokeby's *Very Nervous System*) may record recipients' body movements without creating a mimetic image; instead they use the movements as a trigger for abstract formations of a visual or acoustic nature.

Some projects not only reproduce the actions of the recipients in real time, but also record them and store them briefly or even permanently. A comparison between Scott Snibbe's *Deep Walls* (2002) and Camille Utterback's *Untitled 5* (2004) shows how such recordings can inform the experience of the interaction in different ways. Utterback creates abstract generative graphics in which the recipient's movements leave traces that evolve and grow as formal compositions, then interact with one another and mutate, then gradually fade. In *Untitled 5*, the recipient becomes a kind of painting implement, although he cannot use his own creative imagination, but rather steers

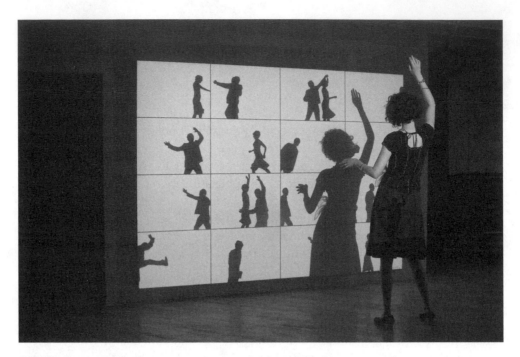

Figure 4.5
Self-representation of the recipient. Scott Snibbe, *Deep Walls* (2002), installation view.

and activates processes built into the system that recall natural processes of growth and decay. *Deep Walls*, by contrast, records a sequence of movements by a recipient and then plays back a silhouette version of the sequence in just one segment of a wall projection, with other segments containing recordings of previous recipients. The projection is repeated in a loop until all the segments have been filled with new recordings; the oldest recording is then deleted. In one work, therefore, the recordings function as an abstract index and an element of the process of gestalt formation, and in the other they are a means of iconic self-representation on the part of the recipient. Nonetheless, in both works recordings are presented as fleeting traces that fade as the time since the actual interaction passes. The aim is thus not permanent storage, but the staging of a time-limited process that begins with the real-time interaction and ends in dissolution.

Whereas some projects record visual traces of a recipient, others involve the recipient in a dialogue, in which case his input is more likely to be stored on a long-term basis. Discursive interaction can be staged as asynchronic communication (Jonah Brucker-Cohen's *BumpList*), as an anonymous exchange of ideas (Blast Theory's *Rider Spoke*), or as contributions to a meta-data archive (Antonio Muntadas' *File Room*). In all three of the aforementioned projects, the participants provide input in the knowl-

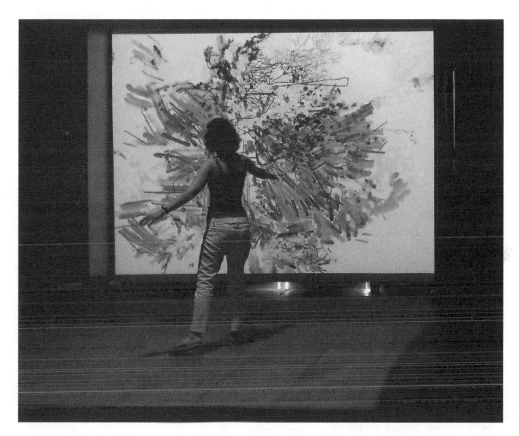

Figure 4.6
Visualizing a recipient's movements. Camille Utterback, *Untitled 5* (2004), from External Measures Series (© Camille Utterback).

edge that it will be recorded and stored. The perception of the communication situation is shaped not only by the specific context, but also by the person or people to whom the statements are addressed. Both *BumpList* and *Rider Spoke* are based on the idea of mutual consent. The recipients must first reveal something about themselves in order to gain access to the contributions of others. Thus, a community is created, but its behavioral norms are challenged in both projects. Muntadas' archive, by contrast, is made available to the public via the Internet. Thus, whereas *BumpList* and *Rider Spoke* have a limited number of participants, making active contributions to Muntadas' archive amounts to publishing something in the mass media. Once again, however, the specific design of the communication is a fundamental component of the work, insofar as *File room* is designed to publicize cases of censorship, which would be incongruously perpetuated if access to the archive were limited in any way.

Projects that encourage discursive communication in real time, whether between several human participants or with an artificially intelligent system, are usually considered to offer the highest degree of technically mediated interaction. Communication between several different participants is often staged in interconnected systems that offer opportunities for input in different locations. The spectrum of these works ranges from Paul Sermon's telepresence installations, which create intimate communication situations, to Blast Theory's mobile game projects, which stage communication in the form of competition.[110] Discursive real-time communication is thus usually ranked at the upper end of the instrumental continuum of interactivity.

Together with other instrumental criteria, such as differentiation between system-internal and reactive liveness and differentiation between process-intensive and data-intensive projects, this continuum offers one possible point of departure for describing interaction processes. However, by comparing and contrasting works with similar instrumentality but very different aesthetic potentials it has been shown that an exclusively instrumental view of interactive art is not sufficient for an aesthetic analysis. The aesthetic experience of interactive art is based on the interplay between instrumental constellations, their processual activation, their material staging, and their contextualization within different possible systems of reference and individual horizons of experience. These aspects will therefore constitute the focus of the observations that follow, beginning with the rule systems of interactive art, which mediate between the processuality and the interpretability of the interaction systems and thus serve as a link between instrumental conditions and their individual perception.

The interplay between constitutive and operational rules

As was noted in chapter 3 above, Salen and Zimmerman differentiate between constitutive, operational, and implicit rules of play. *Constitutive rules* are the formal structures on which games are based—their logical or mathematical principles. They exist independently of the here-and-now action of play as abstract, logical relations that may not necessarily be discernible from the gameplay or from the operational rules. The algorithms on which artistic interaction propositions are based can also be seen as constitutive rules. Constitutive rules determine the principles according to which the interplay between input and output is organized; they also determine which calculations or transformations take place. For example, when in Cillari's *Se Mi Sei Vicino* the projected grid structure is set into motion by the performer's movements, the constitutive rules not only make that happen; they also determine exactly how the grid changes and moves. When in Rokeby's *Very Nervous System* a recipient's movement triggers a sound, the constitutive rules define the threshold value at which a movement is interpreted as such; they also define which sounds (or sequences or combinations of sounds) are emitted as a result. The recipient doesn't have to understand exactly how the algorithms work, although many projects—particularly process-

intensive works—emphatically prompt recipients to examine the underlying constitutive rules.

Operational rules are what we normally call the rules of the game—the guidelines or instructions that players need in order to play and to which they are supposed to feel obliged to adhere.[111] The operational rules describe the activities and procedures that may or must be carried out in a game. In interactive media art, however, operational rules are rarely communicated explicitly to the participants, though they may be outlined by assistants or in written information. Whether it is necessary to communicate the rules is determined not only by the nature of the project in question, but also by the context in which it is presented. Tmema's *Manual Input Workstation* illustrates this point particularly well. When the work was presented at the See This Sound exhibition in Linz, Golan Levin decided to spell out the fundamental operational rule underlying all interactive art by means of a projection requesting visitors to "please interact." Because only a few interactive works were being exhibited, Levin felt that visitors could not be expected to know automatically that they were expected to interact with the work. The fact that he called this decision a capitulation demonstrates that instructions to interact are often felt to be inappropriate in interactive art—the recipient is expected to grasp the operational rules intuitively. For example, the structure of Hegedüs' *Fruit Machine* (three seats equipped with joysticks to control the three free-floating parts of the projected puzzle) unequivocally indicates the objective of the installation and the fact that this can ideally be achieved through collaboration between three players. In this work, the operational rules are self-explanatory. On the other hand, explicitly formulated rules need not have a negative connotation. For example, Blast Theory deliberately uses the introductory phase to its interactive projects as an opportunity to emotionally and aesthetically attune the recipients to the work.

When a work represents a fictitious world, the explicit formulation of operational rules can be rendered superfluous by the fact that these rules are presumed to be the usual standards of behavior of the world that has been staged.[112] On the other hand, the representational level also offers the possibility of communicating the rules as part of the narrative. For example, in Schemat's *Wasser*, when the recipient is addressed as a detective during the course of the narrative and is instructed to look for a woman, the operational rules are contextualized within the story. The detailed analysis in the case study on *Wasser* will show, however, that this doesn't mean that the recipient must acknowledge these rules as binding. The relationship between operational rules and constitutive rules must thus be examined separately for each individual case. We must ask if there are any clear instructions regarding behavior, or if the recipient is encouraged to play freely within the framework of the system structured by the constitutive rules. And if operational rules exist, do they help the recipient to understand the system and its constitutive rules, or do they actually impede such

understanding? How is the relationship between openness and control structured by the system of rules?

Play theorists believe that operational and constitutive rules are ideally combined when they allow for emergence—that is, for interesting variations to emerge from the rule systems. Play theory sees emergent systems as differing from fixed, constantly self-repeating, or chaotic game structures,[113] on the one hand, and from progressive systems, which are based on the successive presentation of challenges, on the other.[114] Salen and Zimmerman believe that only emergent systems allow intensive and persistently engaging exploration of the relationships between game elements and gaming possibilities. The system's emergence corresponds to the player's "agency"—his personal feeling of empowerment, his scope to exert meaningful, logical, and relevant influence on the way the game is progressing.[115] Janet Murray describes this experience as "aesthetic pleasure." She argues that in games "we have a chance to enact our most basic relationship to the world, our desire to prevail over adversity, to survive our inevitable defeats, to shape our environment, to master complexity, and to make our lives fit together like the pieces of a jigsaw puzzle."[116] However, Murray also points out that adopting a creative role within a constructed system is not the same thing as filling the role of author: "The interactor is not the author of the digital narrative, although the interactor can experience one of the most exciting aspects of artistic creation—the thrill of exerting power over enticing and plastic materials." For Murray, this is not authorship; it is agency.[117] Emergence and agency are thus important factors concerning the player's willingness to take action in the non-purposeful circumstances of play. However, Ian Bogost objects that prioritizing emergence privileges the formal qualities of games over their expressive potential.[118] In order to determine the relevance of the concepts of emergence and agency for an aesthetics of interactive art, we must examine more closely the modes of experience and action that characterize interaction with artistic systems.

Phenomenology of interaction: Modes of experience

The recipient's realization of an interaction proposition usually begins with procedures of *experimental exploration*. The recipient wishes to investigate the system presented to him, both with respect to its constitutive rules and with respect to the assets that may be available. He wants to acquire an idea of the actions that are possible within the framework of the interaction system and of the results to which they may lead.[119] David Rokeby closely observed this approach in exhibitions of his installation *Very Nervous System* (see case study 8) describing it as an attempt to verify the predictability of the system. He noted that recipients initially repeated a particular action with a questioning attitude and subsequently (when they believed they knew how the system would respond) repeated the same action with a commanding attitude—which, however, because of the system's sensitivity, led to a different response.

Often the observation of recipients conveys the impression that the reception amounts to no more than an attempt to fully grasp the work, its assets, or its functional principles—an attitude that many artists view very critically. Ken Feingold notes that "the circuit described between the desire to get something from an artwork and the expectations of a return informs the basic drive in the interactive encounter."[120] He reports that many recipients of his *Surprising Spiral* (1991) expressed disappointment that they were unable to achieve their objective: to control the work. In fact, the structure of *The Surprising Spiral* denies the recipient an understanding of the effects his actions elicit. Feingold comes to the conclusion that "interactivity is, in many ways, about affirmation of the human action by a non-human object, a narcissistic 'it sees me.' But beyond that, there is the desire for control, for mastery over the non-human entity."[121] He relates that, in his experience, very few recipients felt comfortable in the role of public participant in an interactive artwork that had no clear goal. Most of them wanted to find out how the work was structured, whether they were approaching it "correctly," whether it responded purely randomly, or how one could achieve a certain outcome.[122] Myron Krueger has also dealt in depth with recipients' efforts to explore interactive works, describing the artist's position as an interactive dilemma. He recounts that the individual artists who co-designed *Glowflow* had very different ideas about which interactions should be made possible. Although feedback was considered conceptually interesting, some of the artists did not believe the recipients should necessarily be made aware of it. They were concerned that the visitors might become entirely absorbed by playing with the evident interdependencies: "This active involvement would conflict with the quieter mood established by the softly glowing walls."[123] Thus, although in *Glowflow* the feedback processes were not rendered explicit, Krueger decided that the design of his own works would place the focus on interactivity, instead of seeking to use interactivity to convey other themes: "Interactive art is a potentially rich medium in its own right. Since it is new, interactivity should be the focus of the work, rather than a peripheral concern."[124] However, Krueger also pointed out that one could consciously foil recipients' expectations, "leading to a startled awareness of previously unquestioned assumptions."[125] Such strategies of disruption thus elicit epistemic processes from the act of exploration. Ultimately, disruptive strategies are at odds with the primacy of agency, for the recipient is deliberately not given a sense of empowerment; instead he is intentionally irritated. The recipient cannot fully control the system and instead is encouraged to grapple with its mediality.

However, the use of such disruptions is not the only way to induce epistemic processes. As Rokeby's example showed, another way to heighten awareness during the process of experimental exploration is to invite the recipient to repeat interaction processes. Repetition not only furthers the exploration of the workings of the system, but also creates distance to one's own actions by contextualizing them as just one of

many possible behaviors. Repetitions may be merely made possible by the structure of a system, or they may be explicitly prescribed. For example, the authors of *Terminal Time* (the interactive film, mentioned in chapter 1, that involved viewers by asking them to vote on the plot) decided to show the film twice to the same audience. They observed that the viewers responded to the questions in a completely different way the second time around: In the second screening, they had a more playful approach, trying out different responses to see how this would influence the plot.[126] Noah Wardrip-Fruin analyzes such forms of gradual understanding in relation to computer games. He cites Will Wright, the author of the game SimCity, who has observed attempts at "reverse engineering" in which players try to infer the constituative rules by exploring the different processes that can be carried out.[127]

Thus, a recipient may repeat an action in order to achieve a particular objective or to understand something specific about the system, but he may do so also because he is fascinated by the action itself. The latter possibility is addressed by the concept of "inner infinitude" in classical theories of play. The process of experimentally exploring a work's interactivity thus provides opportunities for knowledge, be it in the form of critical reflection or in the form of intensified (self-)experience.

Moreover, the recipient can be encouraged to elicit something new from a system— as soon as he is more familiar with its workings—and thus to become consciously creative himself. For example, Tmema's *Manual Input Workstation* invites the recipient to create and manipulate audiovisual formations. As soon as a recipient has become more familiar with the constituative rules of a system, he can explicitly use these for *expressive creation*, grasping his own actions as a creative activity. This will be all the more true the more scope for creativity the recipient is given by the system. It seems appropriate to see this as a form of agency, insofar as the recipient can intentionally use the system to achieve a particular result. However, as Murray has emphasized, agency in this sense is not the same thing as co-authorship if the recipient has no influence on the predefined systemic parameters of the interaction. Furthermore, agency need not be based on an emergent system. Thus, for example, *The Manual Input Workstation* allows numerous different types of action without these becoming more complex or leading to more sophisticated processes over the course of the interaction.

When interaction processes are connoted on a representational level, then, in addition to exploring or making creative use of the potentials for interaction, the exploration or configuration of the symbolic level also becomes relevant. I will denote this form of interaction as *constructive comprehension*. Not only can the rule systems of the work be explored; so too can the chosen, configured, or represented elements that contextualize the action in question and give it another level of interpretability. This is already true when the interaction system is spatially configured, either through the representation of spaces that can be explored using a mouse or other input device or

through the direct location of projects in a public space—in both of these cases, the represented or configured space contextualizes the interaction. Often, the representational level is presented to the recipient as a narrative for constructive comprehension, in the sense of arranging or performing the narrative. We can distinguish between such interactions as either diegetic processes (located within the fictional world of the narrative) or extradiegetic processes (located externally to the narrative) that, in different ways, further, control, or comment on the actions that are presented. The recipient may then activate the assets stored in the system, which are connected to one another in some way—usually flexibly, as in a hypermedia structure. The basis may be textual assets (as in Schemat's *Wasser*) or a classical hypertext linked through words (as in Berkenheger's *Bubble Bath*), but the system may also primarily link images or film excerpts (as in Weinbren's *Erl King*).

In commercial media, the reception of hypermedia-based structures is usually contextualized as freedom of choice, because the available links contain clues to what is hidden behind them and thus enable the recipient to consciously decide whether or not to retrieve more information or assets.[128] In many artistic projects, however, the recipient may be offered no information, or only misleading information, about the possible effects of his choices. As George Landow explains, the hierarchical tree-like or rhizomatic structures of hypertext must also be interpreted at the semantic level not only as links but equally as disruptions[129] Roberto Simanowski explains the many possibilities for intelligent semantization, which is often configured as a "deliberate . . . contradiction between the expectation built up by the link text and what is represented by the node which is linked." It is not just a question of deciding in favor of a particular link, Simanowski writes, but also a question of making of guesses as to whether "link A is A only because, or also because, or despite, or instead of."[130] For example, links may lead to pages that use a different sign system to comment on the linked term or text passage. In the case studies presented in this volume, such references are created in *Agatha Appears* through the use of system-internal error messages as diegetic elements, and in *Bubble Bath* in the numerous passages that first explicitly offer a link and then criticize the recipient for having made the mistake of clicking on it. Such hypermedia systems thus elicit actions that must be decided upon on the basis of hypothetical expectations and interpretive strategies. Not only the actual (technical) potentials for action call for exploration, but also (and even more so) the actions and processes that are represented.

Often the recipient becomes the protagonist in the processes that are portrayed. Assigning a diegetic role to the recipient of a fictitious plot is also common practice in computer games and constitutes the point of departure for Brenda Laurel's theory of interactive drama. Drawing on Aristotle's theory of drama, Laurel describes interaction in technically mediated narrative systems as an interplay between material and formal causes.[131] Elaborating on this theory, Michael Mateas differentiates between the

position of the recipient in classical theater and in interaction systems. He argues that in theater the actual performance is the material cause that the audience uses to draw conclusions about the formal cause—that is, about the intentions of the author. The recipient of an interactive narrative, by contrast, becomes active himself, guided by the material resources and possibilities for variation that are available to him and also by his own desire for the plot to follow a meaningful course. Thus, by using the material resources, the player develops an increasingly concrete idea of the plot and consequently a meaningful version of the story, which can generate a sense of agency.[132] Such theories are based on the premise that—within computer games—the technical system should be as transparent as is possible and the fictional context should be logical. The player should be absorbed by the game and should identify with his diegetic role as fully as is possible.[133]

When the recipient of interactive art is assigned an active role in a narrative, his possibilities for action and the resulting potential for experience are usually significantly different from those found in games. The recipient of interactive art may also be invited to activate the plots that are presented and, if he has been assigned a diegetic role, must adopt a position with respect to it. However, at least in the case studies dealt with here, he is not offered any possibilities for action that will decisively influence the progress of the narrative on the basis of logical inferences. Although plots can be activated or selected, very often the actions of the recipient will be ironically disrupted. Thus, the recipient in *Bubble Bath* is more likely to feel powerless, whereas the recipient in *Agatha Appears* will feel like an uninvolved provider of simple impulses.

Artistic strategies that counteract the seamless absorption of the recipient into a plot find parallels in modern critiques of Aristotelian poetics. Arguing that under the Aristotelian model the recipients' immersion in the stories leads to their losing all critical distance, the game researcher Gonzalo Frasca refers to Bertolt Brecht and Augusto Boal, whose solution was to create strategies of alienation that required a distanced attitude on the part of the actors but at the same time spelled out to the spectators the artificial nature of the performance.[134] Thus, the use of alienation and disruption demands aesthetic distance from the actors and renders aesthetic distance possible for the recipients. The interactive narratives discussed in this study use comparable means to provoke reflection. However, in interactive art the recipient is in the ambivalent situation of having to advance the narrative and at the same time perhaps being involved in it himself, all without stage directions. Theoretically, the recipient can choose among the basic approaches to acting discussed in chapter 3: distancing, projecting himself into the story, and pure self-expression. Although his self-positioning with respect to the interaction proposition will certainly be influenced by provocations or disruptions that are incorporated into the work, nothing can be imposed.

The possibilities for involving the recipient diegetically, as well as the question as to his agency within the context of fictitious roles, lead us to another mode of experience: *communication*. For the purposes of this study, any feedback process that addresses the recipient as a reasoning actor and involves him in an expressed or sensed intercommunion is defined as communication. This applies not only to cases that allow a real-time exchange of information with the system or other actors, but also to asynchronic or asymmetrical forms of communication.[135]

Thus, many interactive artworks present the technical system primarily as an observer, often with reference to or as a critique of modern surveillance technology. They explicitly deny the recipient the possibility of discursive communication, although they address him as a thinking individual whose reaction to this form of one-sided contact is being provoked. Two examples of such projects are Golan Levin's *Double Taker* (2008) and *Opto Isolator* (2007), both of which consist of artificial eyes that appear to observe the recipient. Although these eyes can register no more than the presence and position of a person, their behaviors are associated with living creatures and fascinate their viewers. Several early interactive apparatuses, including Edward Ihnatowicz's *SAM* and *Senster*, were based on this phenomenon. Another example is Simon Penny's amiable robot *Petit Mal* (1993), which approaches observers inquisitively but shrinks back, apparently frightened, if they get too close.[136]

Other projects use closed-circuit systems to address the recipient. In David Rokeby's *Taken* (2002), the recipient is not only filmed and replayed on screen but also classified by the system. In *Border Patrol* (2003), a collaboration between Rokeby and Paul Garrin, visitors are shown their heads in crosshairs and simultaneously hear the sound of machine-gun fire. *Access* (2003), by Marie Sester, takes a different approach by giving Internet users control of a spotlight with which they can follow unsuspecting passers-by. Although none of these works allow discursive real-time communication in the instrumental sense, they are still perceived as establishing moments of contact and as inviting the recipient to engage in the situation. On the other hand, even interactive works that use discursive elements can generate unbalanced communication. For example, in Hershman's *Room of One's Own* the recipient is addressed but is given no possibility to respond. Or recipients may be asked to reply to questions, as in Blast Theory's *Rider Spoke*, but receive no feedback on their answers. Cillari's *Se Mi Sei Vicino* illustrates that even manifest interpersonal communication (non-linguistic in this case) can be based on such an imbalance. The recipient uses body language and touch to enter into contact with the performer, but the performer shows no directly perceptible reactions; instead, the recipient sees a visualization and sonification of the surrounding electromagnetic field.

Thus, communication (including observation) is another relevant mode of experience in addition to experimental exploration, expressive creation, and constructive

comprehension. On no account should these modes of experience be thought to be mutually exclusive. On the contrary, the aesthetic experience of interactive art is based on superimpositions or successions of different modes of experience that may supplement or counteract one another.

As has been shown, these modes of experience only rarely give the recipient a sense of agency. Often they deliberately frustrate his desire for agency. Very often, neither the assumption of a role in diegetic systems or staged communication nor attempts to explore system processes give the recipient the feeling that he is able to consciously exert influence on the further evolution of the interaction process through his own decisions, or that his own input can represent an important stimulus within an emergent system. The aesthetic experience is found to a much greater extent in the course of interaction itself, which may often be shaped by the encounter with artistically configured and symbolic disruptions and irritations.

Expectations and implicit rules

The various potential modes of experiencing interactive art are shaped by individual interpretations and attributions of meaning. The individual expectations of the actors, the explanatory models they have constructed, and the associated strategies of interaction play major roles in the aesthetic experience of interactive art. As was mentioned in chapter 1, communication studies and the social sciences have long emphasized the significance in interactions of the expectations of the interaction partners. Encounters and communications between people are profoundly influenced by their prior knowledge about one another and by their attempts to find out more. Erving Goffman writes that actors interpret the behavior or the appearance of a person they do not know on the basis of their experiences of similar situations, but also on the basis of stereotyped ideas.[137] In interactive art, processes of this kind are relevant for all the actors. The artist may allow assumptions about his audience to inform the configuration of the interaction proposition, and may design the possible reactions of the system in accordance with these ideas. The recipients will develop individual expectations on the basis of previous experiences with interactive art (or with everyday interactions) and shape their behavior accordingly. As was noted in chapter 2, Wolfgang Iser made fruitful use of the recipients' interpretive role in his theory of the blank space. Referring to literature, Iser argued that, in contrast with the contingency of face-to-face communication, art is based on a fundamental asymmetry because it cannot address a single, concrete recipient. As a result, the artist's prior assumptions and the situations he configures, as well as the recipients' individual interpretations of these, become all the more important. At issue here are interpretations at the symbolic level and role expectations, as well as the exploration of technical processes. One of the central claims of actor-network theory is that not only humans but also objects and systems actively shape interaction processes. As the sociologist Ingo Schulz-

Schaeffer has pointed out, "the reciprocal attributions of behavior and expectations are . . . exchanged in such a way between human and nonhuman protagonists that it becomes impossible to make a tidy distinction between social and technical factors."[138]

Noah Wardrip-Fruin analyzes more closely how these overlaps function. He examines the extent to which technically mediated interaction requires, enables, or facilitates insight into system processes. To this end, he differentiates three effects: the "Eliza effect," the "Tale-Spin effect," and the "SimCity effect." "The Eliza effect" refers to the program Eliza, created in 1966 by Joseph Weizenbaum, which invites the recipient to engage in a written conversation with a computer. Despite the quite simple constitutive rules of the system (often a statement by the user is simply repeated as a question), users extolled the system's apparent intelligence. Thus, Wardrip-Fruin uses the term "Eliza effect" to denote the phenomenon whereby a recipient's high expectations regarding the intelligence or complexity of a system will make the system appear to be much more complex than it actually is at the programming level: "When a system is presented as intelligent and appears to exhibit intelligent behavior, people have a disturbingly strong tendency to regard it as such."[139] Myron Krueger had the same experience with the *Glowflow* environment. Because the publicity had mentioned that the system would respond to visitors, many visitors assumed that any visual or acoustic phenomenon was a reaction to their individual actions, and visitors "would leave convinced that the room had responded to them in ways that it simply had not."[140]

The "Tale-Spin effect" denotes the converse situation. A very complex programming process is reproduced in such a simplified form that the complexity remains concealed from the recipient. Wardrip-Fruin's name for this effect refers to a 1970s story-generating computer program whose highly complex algorithms could not be discerned by the users. Many interactive artworks, among them David Rokeby's *Very Nervous System* and Teri Rueb's *Drift*, are likewise based on constitutive rules that will not be understood by many recipients. Rokeby uses the complexity of the algorithms to inhibit conscious control of the system and to engender a state of flow. Rueb explains the principles underlying the system's reactions in an animated diagram that allows interested visitors to understand the constitutive rules.

Wardrip-Fruin calls the third effect the "SimCity effect" after the well-known computer game of the same name, using the term to denote systems that allow recipients to acquire a broad and growing understanding of the underlying processes via the interaction itself.[141] Game researchers would see only the SimCity effect as indicative of an emergent system that can convey a sense of agency. This is the only case in which the interplay between constitutive and operational rules leads each time to new and logically comprehensible courses for the game. However, those who experimented with the Eliza system also felt empowered, although Eliza only feigned emergence.

Likewise, one could characterize Tale-Spin as structurally emergent, but because this emergence is not perceived by recipients, they do not feel their options for action to be satisfying in the long term. In interactive art, the irritation caused by the gap between the logic of the system and the interpretation of processes is an important element of the aesthetic experience. Just as a sense of agency cannot be considered a decisive factor in aesthetic experience, neither is aesthetic experience usually based on systemic emergence. If there is any emergence at all, it is not manifested in a coherent system that becomes increasingly complex, but in an epistemic process that specifically requires disappointed expectations, irritations, and disruptions in order to arise.

The significance of possible expectations for the experience of interactive art leads us to the last type of rule identified by play theory: implicit rules. Implicit rules are the unwritten laws of everyday (inter)personal behavior and of standard behavior in play. Examples include fair play, avoiding cheating, and the behavioral rules that are normal for the societal and social situations (or reference systems) in which actions are contextualized.

The first reference system for interactive art can be said to be the art system itself. What is contextualized in this framework is usually considered to be non-purposeful and separate from everyday life; appreciation of art is subject to its own criteria, and reception of art is subject to its own behavioral norms. However, as we have already seen, the art system is constantly called into question by artists themselves. And, even more important, it is not the only relevant reference system for interactive art, nor can its implicit rules be applied readily to interactive art. Not only can interactive art also be seen as belonging to other reference systems, such as politics and education, media culture, and interaction design[142]; the fact that interactive art requires action on the part of the recipient fundamentally challenges the standards of the art system.

Marco Evaristti's installation *Helena* (2000) highlighted the instability of interactive art's systems of reference. Evaristti exhibited ten commercially available kitchen blenders, each containing a live goldfish, in Denmark's Trapholt Art Museum. The blenders were in working order, and visitors could see that they were plugged in. Several visitors activated the blenders nonetheless. Two goldfish lost their lives on the opening evening, fourteen the following day. Evaristti responded to the public outcry with the laconic declaration that everybody knows that nothing should ever be touched in a museum, so he had never expected the goldfish to come to any harm. The artist thus invoked the implicit rules of the art system, whereas the visitors either responded to the affordance of the kitchen appliances or identified the work as interactive art and inferred that they were expected to activate it.[143] Evaristti's *Helena* thus explicitly thematizes the instability of the reference systems of interactive art and vividly demonstrates how this very instability significantly shapes the aesthetic experience of this type of art. Myron Krueger reports about a much less dramatic but nonetheless inter-

esting clash between the implicit rules of the art system and those of other systems of reference. The recipients of Krueger's project *Maze* were invited to guide a symbol through a labyrinth using their own movements on a floor space covered with sensor mats. Krueger observed that at first the recipients followed the prescribed paths and thus adhered to the usual game rules pertaining to mazes. After a while, however, they began to investigate what would happen if they ignored the apparent boundaries. In other words, the change in their behavior was justified by the reference system of art, according to which a probing questioning of the exhibit is usually welcome. Because the maze in question was a computer-graphic simulation and the activity took place within this simulation, recipients were able to cross boundaries in a way that a material maze would not have permitted. Rule systems that in a real maze are given solidity by the spatial arrangements were only represented here in a digital model and, moreover, were rendered open to explorative violation by the fact that they could be contextualized within the art system.[144]

Phenomenology of interaction: Frames

Implicit rules are similar to what are known as "frames" in sociology. Drawing on Gregory Bateson, Erving Goffman uses the term "frame" to denote the natural, social, institutional, or individual conditions within which an action is perceived or interpreted.[145] According to Goffman, the perception and interpretation of an action depends on the evaluation of its relationship to reality. Thus, frames, for Goffman, are definitions of situations which are established individually in accordance with "principles of organization which govern events."[146] Goffman is particularly interested in what he calls "keys," that is, "the set of conventions by which a given activity, one already meaningful in terms of some primary framework, is transformed into something patterned on this activity but seen by the participants to be something quite else."[147] He cites as examples play fights and religious rituals that always refer back to an original model.[148]

Thus, if the possibility of contextualizing interactive art within different reference systems has substantial influence on its aesthetic experience, we must also ask how interactive art relates to systems of social interaction. Does the realization of an artistic interaction proposition imitate interactions in everyday life and draw on the relevant conventions? As already noted, there is little point in measuring artistically staged interactivity against the benchmark of face-to-face communication, because artistic projects often specifically seek to reflect on the mediality of technically mediated interactions. However, this doesn't mean that they do not make reference to interpersonal communications in different ways. Though it is true that in a work that creates a technologically mediated discursive communication situation the recipient's behavior clearly differs from real-time communication with a human partner, the recipient's behavior can nonetheless draw on face-to-face communication, for example through

the use of common communication patterns (question-and-answer exchanges, courtesy phrases, eye contact, and so on). But even if the interactivity is based less on discourse and more on action, the project can still evoke an original model of real actions—for example, by means of the interface, which can refer to familiar patterns of action by inviting the recipient to ride a bicycle or sit on a garden swing. Figurative representations can also refer to everyday situations—for instance, in the form of virtual soap bubbles that must be burst, computer-graphic creatures that flee from the recipient's shadow, or a three-dimensional puzzle that must be compiled. In these cases, the recipient is encouraged to behave in the way that is familiar to him in such situations, even if that behavior may ultimately be counteracted by the interactive work. But whereas these examples imitate or modify actions using different media, frame analysis assumes that keying takes place in the same medium as its original model. The representation of actions or situations in another medium, as is usual in the visual arts and literature, renders the keying evident from the outset. Moreover, different keyings can take effect at different levels of (re)presentation. Therefore, in literature studies narrative theory differentiates between diegetic levels of narration (which are localized within the narrated world) and extradiegetic levels (for example, that of an uninvolved narrator who is nonetheless also described as part of the narration or within the frame of the literary work). In analyzing computer games, Alexander Galloway differentiates between diegetic and non-diegetic actions, both of which can be carried out by the user or by the system. In digital media, Galloway shows, actions and processes can be contextualized both within and outside the fictional world of the game, and both within and outside the medium of representation. For example, the control panels of a computer game can be external devices, but they can also be displayed directly on the screen, as part of the games' visual design.[149]

In interactive media art, actions are framed by media, and plots and actions are represented in other media or are presented as keyed through contextualization in new reference systems. These actions may be staged within the frame of fictitious worlds or narratives, although this is not imperative. In chapter 3 I introduced the term "artificiality" to denote these different means of removal from reality. In the context of this study, this term is preferable to the concept of keying because it doesn't exclude levels of alienation that, as purely abstract formations, do not make any reference to an original model of "real" action.

Interfaces, which mark the transitions between different frames, or the entry into and exit from the interaction, have particular importance in this context. In stage performances, Goffman points out, transcription practices that "render stage interaction systematically different from its real-life model" are used.[150] Here Goffman is referring to the placing of spatial and temporal limits, and to the fact that natural forms of interaction are distorted in order to facilitate perception—for instance, when all the people participating in a dialogue are allowed to express themselves without

interrupting one another, or when significant details are emphasized. Marvin Carlson uses the concept of "marking" to describe these practices. Janet Murray uses the term "threshold markers," which she sees as taking on the role of the fourth wall of the theater.[151]

Marking of this kind is necessary when the keying is not conveyed medially, for otherwise the medium is evidence of the artificiality of the presentation. However, such markings can become relevant in interactive art when the intention is for actions to be distinguished from everyday life.

The frames within which interactions are contextualized are constitutive for the perception—or the questioning—of their artificiality. As explained regarding the spatial configuration of interactions, clear-cut markings are by no means always present. Just as the recipient is often left in the dark about the spatial boundaries of a work, the system of reference that should be applied is often far from clear. Erika Fischer-Lichte calls the conflicts that can arise a "collision of frames." If an action can potentially be ascribed to different framing systems of reference, that represents a challenge to its perception and interpretation.[152] Whereas one feels safe in familiar frames (Goffman speaks of "well-framed realms"), frame collisions lead to irritation. Whether one breaks out of a frame on one's own initiative or a change of frame is brought about by the interaction system, the destabilization leads to a conscious awareness of the reference system and, according to Goffman, to vulnerability: "[The individual] is thrust immediately into his predicament without the usual defenses."[153] Goffman demonstrates this using the example of everyday interpersonal encounters, but such frame collisions are equally important in art. Especially in art, they are consciously provoked; in fact, to a certain extent they are actually expected. When interactive art operates simultaneously in several different reference systems, as it often does, the recipient finds himself confronted with multiple rule systems. Thus, Lino Hellings emphasizes that the potential of interactive art lies in evidencing and challenging its implicit agendas and rule systems: "I look for a process of dismantling rules, of derailing the codes and protocols so those who come into contact with the work become aware of their own rules and structures."[154]

Materiality and Interpretability

Up to this point I have dealt with the different actors, parameters, reference systems, and processes of interaction that are constitutive factors of any aesthetics of interaction. The exploration of the temporal and spatial parameters of interaction has demonstrated clearly that although the gestalt of interactive art is set out by the interaction proposition, it becomes manifest only in individual realizations. The gestalt of a work is not found in a determinable materiality or temporal structure; rather, spatial and temporal structures emerge in the process of interaction. Thus, if the traditional category

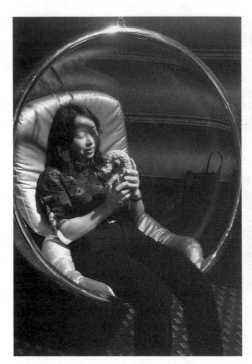

Figure 4.7
Materiality and interpretability. Christa Sommerer & Laurent Mignonneau, *Mobile Feelings* (2003), installation view (© 2003 Christa Sommerer & Laurent Mignonneau, supported by France Telekom Studio Créatif, Paris and IAMAS Gifu, Japan).

of form is replaced in interactive art by a processual gestalt, the next task is to deter-mine the latter's relationship to other two basic categories of aesthetics: materiality and interpretability. This also brings us back to the main touchstones of an aesthetics of interaction which have been identified in the opening chapters: the requirement of aesthetic distance as a condition of aesthetic experience, interactive art's specific potential for giving rise to knowledge, and its ontological status or "workliness."

The interplay between form and signification is a guiding principle of the arts. This is reflected—with different focuses in the different artistic genres—in the traditional distinctions between style and iconography (in the visual arts), between form and content (in literature), between text and production (in drama), and between structure and expression (in music). Indeed, as differentiation between the signifier and the signified, it even constitutes the central topic of semiotics. However, the importance of the configurable substance underlying both form and signification was only recog-nized relatively recently. As Monika Wagner explains, material substance was for a

long time considered to be no more than the medium of form in the visual arts. Since World War II, however, material has acquired an increasingly significant role as a constituent element of meaning. This has led, according to Wagner, to the "need to not only view material as a technical circumstance, but also to value it as an aesthetic category"[155] and to take into account everything from raw materials to processed materials, products, and objects. Similarly, Dieter Mersch points out that signs assert "their own presence . . . chiefly through their materiality, through the sound of language, through the trace left by the material . . . or through its substantiality, as used by the artist."[156] As a media philosopher, Mersch is less interested in materiality or substantiality in the physical sense than in its here-and-now effect, which he denotes as an event that should be given more weight in relation to semiotic theories: "The process of significance cannot be separated from the uniqueness of its manifestation—what we try to single out in two ways as the 'ekstasis of materiality' and the 'intensity of performance.'"[157] Although both Mersch and Wagner call for a rehabilitation of the material within aesthetics, their arguments are based on opposite perspectives. Mersch seeks to reassign materiality to signs and specifically examines their capacity to transcend signification, whereas Wagner is interested in the symbolic potential of material, which she sees not only as a medium awaiting processing, but as something that conveys meaning itself.

Thus, materiality is understood in different ways, depending on the perspective of the researcher, and also depending on the artistic genre in question. Whereas Wagner looks at materiality in the visual arts in terms of substance, Fischer-Lichte analyzes materiality in the performing arts from the perspective of corporeity, focusing on its role in the constitution of reality. In music, sound events can be considered to be material, whereas in literature it is difficult to find any kind of comparable material condition. Interactive art operates with both physical matter and objects, but also with light and sound events and the corporeity of the recipient, all of which are activated through actions and processes. The materiality of interactive art is dynamic and modifiable; it can vary substantially from one version, manifestation, or individual realization of an interaction proposition to the next. Thus, Mersch's view that materiality need not precede form, but may also only manifest itself as a "here-and-now effect" in the moment when the gestalt of a work emerges, must be highlighted. Moreover, as Fischer-Lichte's emphasis on the constitution of reality makes clear, what is at issue here is the active creation of situations in the context of interactions. Nonetheless, the reason the concept of materiality is preferred in the following to that of reality is that the existence of an absolute reality becomes increasingly questionable in the light of the media-based phenomena that are at the focus of this study.

Like materiality, signification can also manifest itself in different ways. In music, expression has always been the primary category of interpretation, whereas literature, drama, and the visual arts have usually required a semiotic reading in the sense of an

iconographic analysis or symbolic interpretation. It is only since the twentieth century that in these genres, too, the potentials of open, associative interpretation have become more evident. While the concept of signification suggests the existence of an unambiguous relationship between the sign and the signified, this fixed relationship has been increasingly called into question since modernism—and not only by what is known as abstract art. Indeed, Mersch argues that art can exist "outside the realms of signification and interpretability."[158] Gernot Böhme has also noted a disintegration of the mimetic and semiotic concept of the image: "We are dealing with images that represent nothing, say nothing, and mean nothing." Nonetheless, Böhme adds, such images can lead to "significant and occasionally dramatic experiences."[159] Mersch also points out elsewhere that he in no way means to deny the possibility of any kind of referential interpretability, rather he wants to emphasize that between the known systems of meaning something else is always happening too, "which perpetually pours out of them."[160]

Arthur Danto used the more general concept of "aboutness" to describe the production of meaning through art. He sees artworks as actually transcending their semiotic nature because, unlike pure representations, they also express something about their own content.[161] He argues that such expressions have a metaphorical character in that they refer to a third, non-identical something, which must be deduced by the recipient. In Danto's view, therefore, what is expressed by an artwork demands a cognitive response and a complex act of understanding that is "wholly different from those basic encounters between simple properties and us."[162] Danto is already alluding here to the importance of reflective processes: on the one hand, in the sense of a self-referentiality of the work which is intended by the artist, and, on the other, as a requirement on the recipient to adopt a reflective attitude. The lack of unequivocal signification should thus not be seen as a loss, but rather as a gain in the complexity of possible epistemic processes whose goal is not conclusive decodification. The more general concept of interpretability will be used in the following to denote this epistemic potential. Any work of art can, in principle, be subject to interpretability. For when instead of signification (in the sense of clear-cut reference systems) the general epistemic potential of the experience of art shifts to center stage, the question is not whether an artwork can be interpreted at all, but to what extent processes of interpretation are facilitated by the artwork or possibly hampered or thwarted by it.[163] This is all the more true in view of the fact that interpretability can be manifested at different levels of the artwork, starting with the material chosen by the artist and proceeding with its configuration or style. In addition, the work may be open to a symbolic reading referring to known sign systems. The term "representation" is used in this study only when the symbolic level becomes relevant and denotes a representative, illustrative, or narrative allusion to a referenceable original archetype. When the term "presentation" is used, by contrast, it refers to all kinds of manifestations conceived

for an audience—configurations which are open to interpretation without requiring explicit referents.

As the following analysis will show, materiality and interpretability should be understood as complementary components of aesthetic experience. The analysis will proceed systematically, beginning with the physical materiality of hardware and objects, then examining the immaterial materiality of images and sounds, and concluding with the atmospheric efficacy of reception processes.

Interface and hardware

Even though interactive art may, of course, use traditional, objectual, sculptural, or installational elements, the materiality of the interaction proposition is primarily manifested in its technical components—especially the user interface. The interface is the direct point of contact between the human being and the system, and comprises both input and output media (keyboard, mouse, microphone, sensors, screen, projection, loudspeaker, and so on). It is part of and connected to the hardware that processes, transmits, and stores data. However, especially when standardized, commercially available devices are used, it is debatable to what extent these belong to the aesthetically relevant materiality of a work. This is especially true when a recipient uses his own laptop computer to access Internet art, or his own cell phone to participate in a locative art project.

Nonetheless, even if the interface is presented as a purely functional medium that makes information perceivable and enables actions, it still must be addressed as a potential bearer of meaning. Even when material components appear to be carrier media that are peripheral to the work (like the frame of a painting), they can still play an important role in the process of aesthetic experience.[164] Media theory differentiates between transparency and opacity, or between the "immediacy" and the "hypermediacy" of a medium—in other words, between media that seek to transport data as inconspicuously as is possible and media that make their mediating function explicit.[165] However, complete media transparency is considered impossible. A medium may be blanked out in individual perception, but it can always come back into play.

As the technical component that mediates between the system and the recipient, the interface is usually expected to manifest its functionality overtly. It should display its usability and even actively encourage interaction—a feature that has been addressed above as affordance. However, the input and output media used in interactive art are by no means always visible. Loudspeakers and projectors may be built into existing walls, and the actions of recipients may be recorded by hidden sensors and cameras instead of keyboards and computer mouses. For instance, the only evidence of the technical system in Rokeby's *Very Nervous System* are a tiny camera and standard-issue loudspeakers in an otherwise empty room, and Rokeby considers this to be crucial for the work itself: "I want you to forget about the technology."[166] The recipient's possibilities

for action cannot be deduced through the materiality of the interface but only through explorative actions. Unlike commercial systems, interactive art doesn't necessarily seek to provide interfaces that are as intuitive as is possible. On the contrary, the exploration of the system's functionality often plays a significant role in the aesthetic experience.

Apart from questions of usability, interfaces may also convey meaning incidentally, or they may be employed explicitly as bearers of meaning. For example, Daniel Dion insists that his video work *The Moment of Truth* (1991) be played on a portable video player, although it is conceived as a museum exhibition piece. Dion considers both the mobility and the size of this device to be means of expression.[167] Standard media configurations (mouse/keyboard and projector/screen), because they are familiar, replaceable, and purely functional elements, are usually not perceived as aesthetically effective components of a work. Nonetheless, they convey a subtext that enters into the overall configuration of the aesthetic experience. Thus, while one visitor may feel intimidated by ultra-modern technology, another may be interested in the particular workings or design of a new device. Whether an artist has used a PC or a Macintosh may lead to conclusions about his disciplinary context. Valuable materials or well-known brands can be testimony to quality requirements and can provide information about the financial background of the project. At the same time, medium opacity of this kind can be either lost or can increase when an artifact ages. Devices that come across as novel and spectacular when a work is first presented become affordable and ordinary over time. Vice versa, aging can draw more attention to a medium when, for example, components that were originally ignored as standard devices are perceived as having historical value after a number of years. In most cases, such interpretability is not explicitly intended by the artist; instead, it develops incidentally or as a consequence of an aging process. Nonetheless, technological characteristics may also be highlighted by curators. For example, in Hershman's *Lorna*, old hardware (a laser disc player) has been exhibited as part of the installation, although technically the work had already been installed on a more modern system.

Like standard devices, individually constructed systems can serve purely functional purposes or can be carefully configured, either to satisfy contemporary design concepts or to make an installation appear amateur, old fashioned, or simple. For instance, Bernie Lubell almost entirely eschews electronics in his large interactive installations, controlling or letting the recipients control all the functions using clearly visible wooden mechanical constructions and pneumatic equipment, so that the focus of the works is their materiality, which then shapes the way they are interpreted. Karl Heinz Jeron, in his project *Will Work for Food* (2007), and Jonah Brucker-Cohen and Katherine Moriwaki, in their *Scrapyard Challenge Workshops* (since 2003), use the simplest of materials to build improvised mini-robots, and this pieced-together functionality also becomes an expression of artistic intentionality. At the opposite end to such "low-tech approaches" are efforts to achieve perfection. For example, the Japanese artist Toshio

Iwai collaborated intensively with the instrument manufacturer Yamaha in creating *Tenori-on* (2007)—an artistic musical instrument—in order to achieve a perfect design and at the same time produce an instrument that could be launched on the commercial market.

Even if individual constructions are more likely to be perceived as aesthetically effective elements than (replaceable) serially produced devices, intentional significa-tion or "only" contextual interpretability is possible in both cases. The boundary between the framing context of a work and its aesthetically effective gestalt is thus negotiable. This applies not only to the hardware, but also to the software, which becomes particularly evident in the case of Internet art. Every Internet browser has its own framing elements and is thus not entirely neutral. Even if some Internet artworks recommend the use of a certain type of browser, many can be accessed using different browsers, so that one is inclined to see them as external to the work. However, when I asked Holger Friese, one of the artists behind *antworten.de*, for permission to publish a screenshot of that Internet artwork, he happily complied, but also asked me to use a screenshot taken in the year the work was created (1997), which showed the work in a version of Netscape in use at that time.[168] Should a request of this nature be understood simply as a wish to contextualize a work historically, or is the browser also given importance as aesthetically relevant part of the work?

As early as 1998, in an essay on the materiality of Internet art, Hans Dieter Huber differentiated between the framing borders (which depend on the operating system), the version of HTML code being used, and the materiality of the browser. He pointed out that although browsers all have a central window, a status bar, and an address bar, the look and feel can vary substantially from one make to another. Huber compared HTML data to a score which is performed or interpreted in whichever browser it is activated.[169] However, in contrast with a performer of music, a browser has no interpretive freedom; it depends on its own algorithms. Rather than an artistic, interpretive performance, it performs a technical execution, which nonetheless can substantially influence the effect of a work. But this can be planned by the artist only to the extent that he can program the code with known browser versions in mind; he cannot know how future browsers will present his work. Susanne Berkenheger comments ironically on the problems presented by this situation: Internet artists are for-ever in danger of physical collapse "as they constantly revise works that aren't even fin-ished yet."[170] This "power of the browser" results in Internet art often self-referentially exploring its media-based context.

Interactive object art

Even if media art only rarely produces traditional sculptural formations, everyday objects—in the tradition of ready-mades, assemblages, and installation art—are often incorporated or converted into interfaces. In *America's Finest*, Lynn Hershman

alienated a rifle from its intended use, capitalizing on the fact that all firearms are interactive devices. Hershman remodeled the weapon in such a way that when the trigger is pulled, historical war images are superimposed on the real surroundings that appear in the viewfinder. In addition, the recipient periodically sees a picture of himself and is thus staged as his own victim. The presentation of a firearm has two purposes here. First, the visitor confronted with the device can imagine what he is expected to do and how the interface should be operated—he deduces the operational rules of the work from what he knows about weapons. Furthermore, firing a weapon provokes associations that can become aesthetically effective through the very invitation to engage in physical action. The recipient enters into a conflict between perceiving his action as a context-free interaction with an artwork and perceiving it as the active representation of a potentially violent undertaking.

Paul DeMarinis' *Rain Dance* (1998) represents a more harmless form of instrumentalization of everyday objects as bearers of meaning. It invites visitors to take an umbrella and walk under streams of water that are modulated with audio signals so that musical tunes are created every time the water hits the umbrellas. The operational rules of the work can be deduced from the normal, everyday use of umbrellas. However, everyday objects can also be used as bearers of meaning independently of issues regarding their usability. In his installation *The Messenger* (1998), whose theme is early methods of communication, DeMarinis uses old enamel basins as resonance bodies and canning jars as signaling devices. He thus characterizes the technology he presents as historical, but at the same time shows how communication systems can be constructed using simple, everyday objects.[171] In his installation *Giver of Names* (1990), David Rokeby uses children's toys that the visitors can scan and classify with a computer. This system could, in principle, analyze any object at all, but Rokeby uses toys, which are available in many different forms and which tend to evoke associations, emotions, and memories.[172] Christa Sommerer and Laurent Mignonneau use bottle gourds as interaction objects in their project *Mobile Feelings* (2003), which explores new forms of multisensory telecommunication by transmitting smells, gusts of air, and movements. The bottle gourds not only contrast with the technological appeal of commercial cell phones, but also open up an associative radius that ranges from erotic accessory to the feel of toad skin. Whatever the association, however, the objects provoke a strong desire in the users to touch them, which again is to the benefit of their usability.[173]

Immaterial materiality and atmosphere

In addition to components that can be considered material in the physical sense, interactive art is substantially based on "immaterial materiality"—visual or acoustic information transmitted via screens, projections, loudspeakers, or headphones. Such elements are anything but imperceptible—they are simply either visible or audible,

but not tangible. Even if they are immaterial, their form can still be shaped and perceived. However, there is considerable dispute as to whether such kinds of perceivable information can be deemed to have materiality. Dieter Mersch ties his thesis of the "anaesthetics of the digital" to this very issue. He believes that the digital medium not only erases the memory of material but also doesn't bow to "the aisthetic sensoriality of its presence."[174] When Mersch, as discussed above, describes presence as ekstasis, he thus suggests that such ekstasis requires a materially tangible corporeity. But why should the phenomenon of presence be bound to physically concrete materiality? In reality, a luminous surface or a light space (such as in Diana Thater's projections or Olafur Eliasson's environments) or a spatially staged sound (as in Jan-Peter Sonntag or Bernhard Leitner's works) can emanate just as strong a presence. Interactive media art also works with the spatiality of such effects, already denoted by Jean-François Lyotard as "immaterial."[175] Teri Rueb's sound islands not only roam with the tides, but are also broken down into inner areas that contain text and external zones, within which footsteps can be heard. David Rokeby describes the movement-sensitive space of *Very Nervous System* as sculpturally explorable. Thus, in interactive media art, (im)materiality should be understood above all as a perceivable spatial quality of the works, regardless of whether this manifests itself through solid matter or immaterial materiality, through static form or fluid motion. As we have already seen with respect to the spatial qualities of interaction, such (im)materiality is, moreover, often only activated and realized in the moment when the work is received by the recipient, whereas otherwise it only exists as a potential.

We must furthermore distinguish between referenceable forms of (im)materiality, on the one hand, and perceptions or appreciations of atmospheres, on the other. According to Gernot Böhme, the primary object of perception—and thus a central theme of aesthetics—is atmospheres, which Böhme defines as an "indeterminate quality of feeling poured out into space."[176] Böhme believes that what are first perceived are not human beings or objects or their arrangements, but atmospheres "against whose background the analytical view then distinguishes such things as objects, forms, colors, etc."[177] According to Böhme, atmospheres are thus always spatial. He uses the term "spheres of presence" to refer to the presence of things or human beings that radiate a "thereness." He believes that atmospheres are tinged by the ekstasis of the people who are present. His point is that atmospheres contribute both to the ontology of the people present and to the phenomenology of perception.[178]

Atmospheres are central to the aesthetic experience of interactive art. Works presented in the public space partake of the atmosphere of the chosen location, be it the raw climate of the German North Sea coast (as in the cases of *Wasser* and *Drift*) or the tranquil mood of a city at dusk (as in the case of *Rider Spoke*). Atmospheres can also characterize exhibition spaces: Consider the calm, white, empty room of *Very Nervous System* and the mysterious mood of the dark entry area to the *Web of Life*, which is

traversed by wires and has an uneven floor. However, in many other works, moods are created by elements that cannot easily be characterized as spatial. As was discussed in chapter 2, emotions can be evoked by visual and especially acoustic presentations, as Anne Hamker has illustrated with respect to the aesthetic experience of Bill Viola's video installations.[179] The music chosen by Blast Theory for *Rider Spoke* is described by visitors as relaxing, whereas the sonar noises underlying the texts in Schemat's *Wasser* have the purpose of creating suspense. The voice of the female narrator in *Rider Spoke* is intended to exude calm and generate trust; the voice of the female protagonist in Hershman's *Room of One's Own* invokes an erotic mood but also expresses anger. However, moods can also emerge during the course of the interaction. Whereas most of the recipients of Berkenheger's *Bubble Bath* probably quickly slip into a tense and perhaps even slightly aggressive mood, the combination of cycling and recollection in *Rider Spoke* has a relaxing effect on many recipients. Feingold's *JCJ Junkman* can evoke a harried mood. The recipients of Hegedüs' *Fruit Machine* often show signs of annoyance (with other recipients) or impatience. Whether emotional effects are evoked by spatial atmospheres or by interaction processes, Böhme's observation still always applies—that atmospheres (and, we should add, the resulting moods) are not represented mimetically or semiotically, but are actually created by the work.[180] Atmospheres and moods thus represent a hybrid link between materiality and interpretability.

Representations

We have seen that interpretability starts with the usability of the interface and the potential contextualizing interpretation of the technology or material used. In addition, sculptural and objectual elements, as well as the "immaterial materiality" of acoustic and visual presentations, convey atmospheric qualities. But, of course, traditional means of signification can also come into play.[181] A work can evoke associations or create atmospheres through abstract configuration or localization in specific environments, but it can also intimate interpretations through references to traditional sign systems. Objects may be chosen to this end, but items and events can also be represented by means of traditional signifiers in texts or images. Interactive film projects such as Weinbren's *Erl King* and Hershman's *Room of One's Own* use pre-recorded video sequences or film excerpts whose scenic representations can be interpreted as sign systems. The same applies to the use of images, such as the comic-style illustrations on the tablet computer used for *Rider Spoke* or the objects found in the picture book in Masaki Fujihata's *Beyond Pages*. Many projects use language—in the form of superimposed or spoken texts—or clearly identifiable sounds. Language and text make use of discursive sign systems, which, in addition to being a means of narrative representation, may also serve the purpose of directly addressing the recipient with diegetic communications or extradiegetic prompts to take action.

Figure 4.8

Interacting with animations. Myron Krueger, *Videoplace* (1972–1990s), screenshots from 1990 video footage.

However, representative strategies do not necessarily require recourse to prefabricated assets. Myron Krueger's figurative computer animation *Critter* uses programmed modes of behavior to interact in real time with the recipient's shadow; the artificial creatures that interact with one another in Sommerer and Mignonneau's work *A-Volve* (1994) are created anew each time on the basis of the recipients' input. Even when process-based works produce exclusively abstract graphics or sounds, clearly referenceable relationships are not excluded. Tmema's *Manual Input Workstation* enables the creation of simple, abstract forms, which, because they are closely associated with corresponding acoustic data, can be understood as representations of these, albeit in another medium. In Cillari's *Se Mi Sei Vicino*, even though the animated grid structures and metallic sounds that are generated are entirely abstract, they can still be interpreted as a representation of an encounter between the recipient and the performer.

Interactive art thus also operates with traditional relationships between the materiality and interpretability of the artifact or the performance. In contrast with other art forms, however, the purpose of these is usually to activate, motivate, control, or channel action. And the action is characterized, in turn, by its own kinds of materiality and interpretability. The materiality of an action is manifested in movement, be

it the physical movement of the recipients or the dynamics of processes and configu-
rations.[182] However not only physical corporeity and mechanics but also immaterial
configurations, animated forms, roaming sound islands, or pulsating light spaces are
set in motion.

Traditional means of signification are likewise anything but irrelevant for the inter-
pretability of actions. Discursive communications and narrations are staged over time
in interactive art, but visual symbolism also plays a role, for example when the recipi-
ent's mimicry or gesturality draw on familiar sign systems or when he acts symbolically
in a representative role. Above all, however, the dynamics of the actions also evoke
atmospheres and emotions that can substantially influence the aesthetic experience
of interactive art. They can trigger both cognitive interpretations and processes of
cathartic transformation, and thus they may open up possibilities for a variety of
epistemic processes.

Embodied interaction

As Derrick de Kerckhove observed as early as the 1990s, although Western cultures
since the Renaissance have replaced proprioception with "self-visualization . . . as the
chief point of reference for one's own position within reality," interactive technologies
allow us to return from our purely visual relationship to the environment to a tactile
and proprioceptive one.[183] This view, which clearly draws on Marshall McLuhan's
thesis of the growing significance of the tactile in "acoustic space,"[184] may seem sur-
prising, insofar as in the last decade of the twentieth century most media theorists
were still concerned with the trend toward a disembodiment of human beings.[185]
However, the visions associated with the buzzwords of cyberspace and virtual reality
were not only triggers for theories of disembodiment, but could also be grasped as
harbingers of a renaissance of the corporeal—in the form of bodily action in virtual
worlds. These expectations were driven forward by artistic projects such as Char
Davies' *Osmose* (1995), an immersive environment that allowed recipients to control
movement in virtual worlds using their own breathing.

Such involvement of the human body in a simulated spatial experience is only one
way of heightening the recipient's awareness of his physicality, however. As early as
the 1990s, Myron Krueger highlighted the importance of physical activity in his own
vision of interactive art, which he characterized as artificial reality and which, he
asserted, "depends on the discovery of new sensations and new insights about how
our bodies interact with reality and on the quality of the interactions that are
created."[186] Whereas Krueger's approach was to produce a digitally augmented version
of the recipient's shadow, David Rokeby believes that the reproduction of a recipient's
body on a projection screen is incompatible with its physical perception: "When
playing with Myron Krueger's work . . . where you . . . had a visual shadow avatar on
the screen, your feeling of being in your body was blasted away by negotiating the

manipulation of an avatar separate from your body."[187] Rokeby himself thus neither depicts nor represents the human body, instead using acoustic feedback to encourage physical movements and enable enhanced self-awareness. Rokeby's aim is "stereoscopic proprioception" on the part of recipients, in the sense of an interference between the internal feedback from the body and the external feedback from the system.[188]

Keith Armstrong took a different approach in *Intimate Transactions* (2005–2008). He created a highly symbolic, telematic installation in which two participants used specially constructed chair-like frames to cooperate, by means of bodily tension and movement, in shaping evolutionary processes, which were displayed on a projection screen.[189] Whereas Armstrong's work interweaves the symbolic level of representation and the proprioceptive level of body perception, Chris Salter focuses exclusively on creating possibilities for intense physical awareness. His installation *Just Noticeable Difference #1: Semblance* (2009–2010) is based on the experience of sounds, pressure pulses, and barely visible light flashes in a pitch-black space. The visual boundaries of the space are thus negated, but not its material limits.[190]

Figure 4.9
Embodied interaction in a telematic installation. The Transmute Collective (directed by Keith Armstrong), *Intimate Transactions* (2005–2008), installation view (photo by David McLeod).

Performance art, not the media arts, must be credited with the return to artistic concern with the human body. As early as the 1960s, performance art shifted the physical presence of the performer to center stage. When media art uses interactive strategies to valorize the human body, however, this takes place under entirely different conditions. Because physical activity in interactive art is not primarily an intentional performance, the recipient's actions correspond to his everyday corporeity. This means that neither special clothing nor ostentatious nudity, both important elements of performance art, can play any role in interactive art. The action is not primarily carried out as a performance for somebody else, but as (unrehearsed) operation or exploration of a system. As a result, body language is also used less consciously than in performance art, where it may have the purpose of symbolic communication, presentation of particular abilities, or explicit manifestation of corporeity. Although such forms of expression may be used in the realization of interaction propositions, they mainly encourage self-awareness. The non-media-based experiential installations of Allan Kaprow and the Groupe de Recherche d'Art Visuel, for example, focused mainly on the latter objective, as did Bruce Nauman's, Richard Serra's, and Rebecca Horn's works of the 1980s and the 1990s. Interactive works based on technical systems do, however, create possibilities for new qualities of self-perception, insofar as media can be used to reflect actions through direct depiction, through alienation, or through abstract visualization or sonification. Media art may use the physical resistance of material interfaces to set bodily self-perception in direct relation to different types of technical feedback. Masaki Fujihata's *Impalpability*, published on CD-ROM in 1998, enabled a form of bodily self-awareness whose technical simplicity rendered it all the more original. *Impalpability* invited the recipient to turn over a standard computer mouse, which in those days was operated by means of a ball attached to its underside. When the recipient rolled the ball with his thumb, a simultaneous movement took place on a ball depicted on the computer monitor. The depicted ball appeared to be made of human skin, so that it seemed to the recipient as if the skin of his own thumb had been transferred to the screen. In this way, a direct link was created between a haptic sensation and the visual perception of a virtual object. The bicycle in Shaw's *Legible City* operates on much the same principle, except that in this case a familiar pattern of action is invoked in order to make the link between physical action and portrayed movement in virtual space more plausible.

In interactive art, corporeity is either highlighted in terms of its own materiality or thematized by means of visual or acoustic feedback. However, in addition to intensifying the recipient's perception of his own body, or using it as an input medium, interactive art offers the possibility of focusing on the body's relationship to other individuals. The focus of such works is on positioning, or, to borrow Martina Löw's terminology, on spacing and synthesis as superimpositions of spatial and social relations. Such self-positioning is the main theme of Scott Snibbe's project *Boundary Func-*

Figure 4.10
Embodied interaction with a standard interface. Masaki Fujihata, *Impalpability* (1998), user interaction (© Masaki Fujihata).

tions, which orchestrates a spatial positioning or segregation of individuals in relation to one another. Cillari's *Se Mi Sei Vicino*, which has also been discussed from this perspective, uses the visualization and sonification of energy fields between individuals to stimulate reflection on the processes involved when we approach or touch other human beings. The overlap between emotional and physical processes illustrated in *Se Mi Sei Vicino*, and the staging of electromagnetic effects as emotional expression, epitomize the transformation of physical and spatial experiences brought about by the information society. Such approaches increasingly call into question not only the boundary between material and immaterial gestalt, but also that between physical

perception and information flows. This trend is also analyzed by Mark B. N. Hansen, who uses the term "body in code" to highlight the new forms of embodied knowledge made possible by modern media. As mentioned in chapter 2, Hansen believes that the human body doesn't (nowadays) end at the boundaries of its own skin, but rather constructs intimate relationships with digital information flows and data spaces.[191]

The interactive work as a stage or mirror

In addition to the forms of bodily self-expression considered above, the recipient of an interactive work may be invited to adopt positions of representational identification or disguise. The possibility for users to adopt multiple roles is an important characteristic of digital media, especially in the domain of modern communication networks.[192] Participants in online communities often present themselves as fictional characters or as members of the opposite sex, or use an imaginative avatar.[193] In interactive media art, such role playing may be explicitly required. For instance, Stefan Schemat casts the recipient as a blind detective, and Susanne Berkenheger declares him to be an intern. Both assignments come with specific expectations regarding the behavior of the recipient, for the ascription of a role provides him with clues about the operational rules underlying the interaction. In addition, both Schemat's work and Berkenheger's draw the recipient more deeply into the fictional storyline by addressing him directly. The recipient is also directly addressed in Hershman's *Room of One's Own*. However, Hershman's recipient is not assigned a fictional role; instead, the theme of the work is his actual function as a recipient of art.[194] The more the focus shifts from the fictionality of the representation to issues of self-portrayal, the more fluid are the boundaries between incidental self-expression and intentional self-representation.[195] Bruno Cohen's early interactive environment *Camera Virtuosa* (1996) dispenses with assigning an explicit role to the recipient, who is invited to enter into a stage area through a door featuring a standard "on-air" light. Whereas the virtual actors who join him on stage perform clearly recognizable roles (cleaning lady, ballet dancer), it is up to the recipient whether he adopts a fictional role or simply acts out his own personality or corporeity. Whatever his decision, the reactions of the spectators are concealed from him, for although his actions are shown in real time together with the actions of the virtual actors, this takes place on a monitor located outside the recording room. Cohen's work examines the vicariousness of media-based interactions and explores the different domains of presence that can become relevant within a media-based interactive scenario.

In other works, it is the very possibility of self-observation that determines the recipient's attitude. Many installations that record the actions of the recipient present them to him immediately, albeit often distorted through mediation. As was suggested in chapter 1, such works may be regarded as digital closed-circuit installations.[196] One example is Scott Snibbe's installation *Deep Walls*. In this work, too, the recipient is

free to decide whether to stage a fictitious scene, record a particular gesture, or simply portray his own corporeity. We have already seen that in other works body movements trigger visual or acoustic effects that go substantially beyond simple mirroring. The recipient of such works may concentrate on staging his own corporeity and movement, but he also may seek to control the audiovisual effects. As has already been discussed in relation to the possible modes of experience of interactive art, the transition from processes of experimental exploration to processes of expressive creation is generally fluid. The recipient may first grasp the interaction system as an instrument of knowledge that mirrors and distorts his actions, then, a moment later, use it as a tool to create images.

Intentionality

As we have already seen, interpretability can be either a matter of artistic intention or arise unintentionally. Dieter Mersch distinguishes between intentionality as "showing something" (meaning) and non-intentionality as "showing oneself" (event).[197] The latter is the cornerstone of Mersch's interpretation of performativity as "positing." Mersch argues that even gestures or movements that are intended symbolically are by no means consumed by their own symbolism, but also manifest other aspects that cannot be interpreted as signs.[198] As was outlined in chapter 3, theories of the performative describe situations in which traditional production of signs is neglected in favor of a focus on the materiality of the action. According to Mersch, performances create their own realities, "in which all manner of things can happen that may not necessarily be related to any kind of signification or meaning . . . and whose characteristics primarily emerge in the performative, which can be simply described as the process of an event taking place."[199]

Nonetheless, there is still scope for interpretation here. Even semiotic theories allow that a sign need not be an unequivocal proxy for the particular object or topic that it references, but that it may also be an interpretable expression linked to ideas, meanings, and contexts.[200] Recipients may arrive at the understanding intended by the artist, but they may also arrive at associations or interpretations that were not explicitly anticipated. As was discussed in chapter 1, the non-intentional generation of aesthetic configurations, for example through the incorporation of random operators, may complement such open invitations to interpretation.

Like the interaction proposition, which may intentionally or non-intentionally create opportunities for interpretation, the realization of the work on the part of the recipient may alternate between intentional and non-intentional processes. As we have seen, the recipient of interactive art is initially not primarily interested in presenting something, but in accepting the proposition to interact, in realizing the work, and in exploring the system. But because these goals can be achieved only through his own action, the recipient, either deliberately or unwittingly, produces signs (images,

language, or movement). Thus, his action may be an intentional delivery, as in an ostentatious presentation for spectators or for a feedback medium. Alternatively, however, he may be mainly preoccupied with activating the system or creating feedback loops, so that the generation of a gestalt or of interpretable formations may not come about intentionally. This is all the more true insofar as his actions are channeled through the system and thus often take the form of reactivity. The recipient's actions are guided by the rule systems imposed by the artist and are responses to the feedback received from the technical system.

The attitude adopted in the recipient's individual experience depends on the particular artwork, on the exhibition situation, and on the recipient's personality. In Snibbe's *Deep Walls*, for example, the recipient is required to perform for a twofold purpose. He is invited to execute a clearly visible and expressive physical movement, but he also is aware that an abiding documentation of this action will be made, for a video recording of his silhouette will be repeatedly played back as a loop on the projection screen.[201] In Cillari's *Se Mi Sei Vicino*, it is not the action of the recipient that is visualized, but its effect. Moreover, the bodily co-presence of a performer may affect the perception of the interaction primarily as an encounter with the performer, not as a presentation. In the case of longer-lasting interactions with the work, however, the recipient may become more interested in creating visual and auditory effects. His attention becomes divided between watching for potential physical feedback from the performer and the audiovisual feedback of the technical system. The action thus oscillates between the intention of generating an image and the desire to establish interpersonal contact.

The recipient's potential attitudes toward the interactive work bring us back to the question of aesthetic distance, which I will examine now in more detail, starting with a critical consideration of the immersive potential of interactive art.

Illusion, immersion, flow, and artificiality

When a designated object is imitated so well that the recipient comes to believe he is looking at the object itself, the phenomenon is usually called an illusion. Illusion thus relies on the recipient's negation of his own awareness of artificiality (the abstraction of the aesthetic experience from everyday reality). In a study dealing with digital media, what first comes to mind in relation to the concept of illusion is the illusionism of virtual reality. Virtual reality is usually defined as a computer-generated environment which the recipient feels part of or surrounded by and which opens up possibilities of interaction.[202] However, the simulation of spatial situations is by no means the only type of illusion that can be created using digital systems. In addition to visually illusionistic effects, simulations that regard the interaction itself are also possible, for example when a recipient is supposed to perceive an interaction with a technical system as communication with a cogitative partner. This was the case when

Joseph Weizenbaum's computer program Eliza imitated communication with a psychotherapist and fooled many recipients. However, as we have seen, most media artworks dealing with communication situations clearly stage the virtual interlocutor as a machine in order to critically examine ideas about artificial intelligence. In fact, the visions conjured up by the terms "virtual reality" and "artificial intelligence" continue to founder on the impossibility of creating enduring multisensory illusion or convincing simulations of human intelligence and on the fact that our concept of reality itself is becoming less and less solid. The more our everyday existence is shaped through media, the more questionable any attempt to draw a clear boundary between actual and virtual reality becomes. If art can be said to reflect and comment on our lives, then it is clear that media art, especially, doesn't primarily deal with our physically tangible environment, but with the reality of a world that is shaped and structured by media. In our highly mediatized environment, artists are interested not only in dealing with what is physically or socially real, but also in dealing with what has already been simulated. Margaret Morse asserts that the growing dominance of media is leading to the construction of a cyberculture that defines both our subjective perception of the world and our place within it. Morse argues that even socially constructed reality is shaped by "virtualities"—"fictions of presence" that have no clear boundary with everyday life. In the new "virtually shared worlds," we interact in physical space with a world of auditory, visual, and kinesthetic images and event spaces.[203]

As early as 1974, Erving Goffman wrote in *Frame Analysis* that the idea of a singular reality that could be imitated or portrayed was questionable. In his view, the concept of reality denotes only a difference or a flexible frame of reference: "So everyday life, real enough in itself, often seems to be a laminated adumbration of a pattern or model that is itself a typification of quite uncertain realm status."[204] Goffman envisages a multiple layering of experience by means of keyings of the primary framework. "[T]he deepest layering can be expected to occur in scripted presentation of a novelistic, theatrical, or cinematic kind."[205] Interactive art is also based on interplays between the physically real and the artificial, portrayed, or fictitious. For example, Jeffrey Shaw, in his spatially illusionistic 360-degree panoramas, shows film stills from documentary news shows that appear to float freely in space. In *Drift*, Teri Rueb overlays the natural sounds of the seaside with the sound of footsteps (which creates the illusion that real people are present) and with literary citations (which are fragments of other fictitious representations). Schemat's *Wasser* stages a detective story in real space, but Schemat links it to memories of past events; the recipient has no way of knowing whether those even actually happened or whether they are fabrications. In *Bubble Bath*, Susanne Berkenheger feigns the presence of a virus controlling the computer, thus creating an illusion that simulates algorithmic processes.

It is left to the recipient to find his own place within these layers of realities and fictions, for his position is by no means preordained. It is possible, at least in theory,

that the recipient doesn't recognize keyings for what they are, but rather takes the representation for what is being represented. Traditional artists attempted effects of this nature, but ultimately the notion of total illusion (which can be traced back as far as Pliny's legend of Zeuxis) can only—if at all—take the form of a short-term illusion that eventually strives for denouement and is thus primarily significant as a topos of art theory.[206] Regarding the domain of computer games, Salen and Zimmerman use the term "immersive fallacy" to denote the still widespread misbelief in this sector that illusions should be as realistic as is possible. They argue that an intensely pleasurable play experience by no means requires the illusion that one is actually part of an imaginary world.[207]

In most cases, whether in traditional or digital art, the recipient will see through the illusionism of the artwork. However, this doesn't mean that he will necessarily reflect on it critically. In the early nineteenth century, Samuel Taylor Coleridge coined the term "willing suspension of disbelief" in order to explain how recipients readily repress their doubts about the logic of a portrayed or described situation in order to remain engrossed in the plot.[208] Thus, in a way, the recipient may voluntarily adopt the role of naive recipient. According to Myron Krueger, this allows the artist to abstract from certain aspects of reality, to reinforce other aspects, or to circumvent restrictions on reality.[209] Goffman also observes that spectators allow themselves to be captivated by a transcription "that departs radically and systematically from an imaginable original. An automatic and systematic correction is involved, and it seems to be made without its makers' consciously appreciating the transformation conventions they have employed."[210]

This form of reception is quite common in the history of art. It can also be applied to media artworks in which the recipient explores the possibilities offered by the interaction system and allows himself to be induced to participate in an unreflective interaction. Such unreflective absorption in an activity is often called immersion. That term was initially used to describe illusionistic participation in virtual worlds.[211] However, as doubts increased that such a state could actually be achieved, the concept was gradually applied to general phenomena of immersion in any activity—in other words, to a not necessarily visual but rather a primarily cognitive engagement that did not perforce depend on illusionistic deception.[212]

The concept of "flow," mentioned in chapter 3, focuses even more specifically on this phenomenon of cognitive immersion. Mihály Csíkszentmihályi defines flow as a state in which "action follows upon action according to an internal logic which seems to need no conscious intervention on our part. We experience it as a unified flowing from one moment to the next, in which we feel in control of our actions, and in which there is little distinction between self and environment; between stimulus and response; or between past, present, and future."[213] Thus, the focus is exclusively on

the emotional and cognitive intensity of the experience. According to Csíkszentmi-hályi, intensity of this kind can be achieved in different ways. His examples are as varied as playing music, rock climbing, and performing surgery. But flow is also seen as an important aspect of a satisfying play experience. In this regard, Katie Salen and Erik Zimmerman note that play can be an extremely intense, almost overwhelming experience, whether it takes the form of "a cognitive response, an emotional effect, or a physical reaction."[214]

States of flow can also shape the experience of interactive art. Golan Levin describes the ideal reception of his *Manual Input Workstation* as a state of "creative flow"—a kind of rapture. He believes that recipients may become engrossed in the feedback loop in progress and enchanted by the emerging possibilities and relationships becoming apparent between the self and the system, which defy verbalization.[215] In *Very Nervous System*, David Rokeby's aim is that recipients will respond spontaneously to the sounds produced by the work, and Rokeby also strives to bring about a reduction of conscious reflection to the very minimum. Absorption in one's own actions is thus one way in which interactive art can be aesthetically experienced. But how can this conclusion be reconciled with the idea of the epistemic potential of aesthetic experience?

We saw in chapter 3 that game researchers emphasize the make-believe aspect of play. I introduced the term "artificiality" to denote this detachment from everyday life. Artificiality can result from the construction of an illusionistic, make-believe world, but also from the activation of any reference system that differs from that of everyday existence. Unlike the phenomena of illusion, immersion, and flow, aware-ness of the artificiality of one's own actions (that is, of their difference from everyday life) is considered a possible characteristic of gameplay. Gregory Bateson calls such awareness "meta-communication"[216]; Richard Schechner calls it "double negativity."[217] The experience of play is often informed by the very awareness that one is playing, and that, although actions in a game may have some referent in real life, they still take place somewhere outside of it. This is the experience that Gadamer calls the "to and fro" and Scheuerl calls "ambivalence."

The execution of (inter)actions in a spirit of artificiality—that is, as actions or interplays that are removed from daily life (and often alienated, exaggerated, or decontextualized)—also shapes the aesthetic experience of interactive art. This is true for experimental exploration and expressive creation, for constructive comprehension of narratives, and for operating within communication situations. Even if complete absorption in the activity is possible during the realization of interactive artworks (and even if it is intentionally fostered by some works), most artistic projects explicitly stage interactions as artificial. Many even go further and disrupt the interaction processes and their perception in an ironic or critical manner. In Berkenheger's *Bubble Bath*, for

example, the recipient advancing the story by selecting one of the hyperlinks offered is often rebuked by means of simulated error messages of the browser. The work thus debunks the recipient's readiness to accept his assigned role as a naive devotee of technology. The fact that some recipients of *Drift* returned to the distribution station after only a short while, disappointed that they had not been able to hear anything, indicates that this work counteracts stereotypical ideas about interactivity by deliberately not providing constant feedback.

Interactive art does use effects of illusion, immersion, and flow. It does reside in artificial realms, as does play. But it goes a step further by provoking disruptions that induce conscious reflection on the process of interaction itself. When there is not only awareness of artificiality but also explicit examination of its effects, the result is a mental distance to the object of aesthetic interest, even when the object of aesthetic interest is one's own behavior. This reflective component of art reception is the point at which art and play part ways.[218]

Self-referentiality and self-reflection

At the beginning of chapter 2, we saw that an artifact, in order to be considered an artwork, must either seek to convey something or invite the viewer to reflect on something. This meta-level (Danto's "aboutness") can be constituted by a reference to something that lies outside the composition. The work may follow a certain iconographic tradition or adhere to established sign systems. Often, however, works do not refer primarily to extraneous themes, instead exposing their own functionality or mediality and stimulating reflection on these attributes.[219]

This kind of self-referentiality was used as an artistic strategy before the modern era, even though it is primarily associated with modernism.[220] Self-referentiality can be found within a single genre (for example, the focus of Yves Klein's paintings is the substance of the paint); it also can serve as a mode of comparison across genres (for example, Lucio Fontana's canvases feature slashes that create a contrast between painting and plasticity). In interactive art, the complexity and the novelty of the media component further encourage the use of self-referential strategies. Erkki Huhtamo employs the term 'meta-commentary' to "refer to an art practice which continuously de-mythicises and de-automates prevailing discourses and applications of interactivity 'from the inside' utilising the very same technologies for different ends."[221] In interactive media art, we are not dealing with a work showcasing its own paint or plasticity, but with a system scrutinizing its own interactivity or an interface design examining its own underlying programming language.

As has already been discussed in relation to theories of the performative, the self-referentiality of action-based art is not limited to the formal characteristics of the action proposition; it may also inform the actions and processes that are staged or enabled. In interactive art, the interpretability of the interaction proposition enters

into an interplay with the interpretability of the processes of its realization. The system's propositions and the recipient's actions can reciprocally comment on, orchestrate, or counteract one another. This is what happens when the audiovisual feedback to physical relationships arouses associations with energy fields, as in Cillari's *Se Mi Sei Vicino*, or when the supposed precision of technical systems provokes a feeling of disorientation in the recipients, as in Rueb's *Drift*. As *Drift* shows, such self-referential interpretability doesn't necessarily exclude the use of references to traditional sign systems. That work's use of literary passages dealing with the topic of being lost creates a link between traditional signification and processual self-referentiality. In fact, the use of traditional sign systems or narrative assets to contextualize actions, processes, and materialities can reinforce self-referential allusions. In *Room of One's Own*, Lynn Hershman employs film scenes to stage a communication situation in order to comment on processes of presentation and observation that are typical of the art system. When Agnes Hegedüs' *Fruit Machine* invites recipients to piece together components of a slot machine in a kind of jigsaw puzzle, her reference is not only the entertainment industry but also recipients' expectations of interactive art. The purpose of the symbolic elements in these cases is to contextualize the work's processuality and mediality.[222]

The self-referential allusions of the interaction proposition—or its realization—are complemented by invitations to partake in individual self-reflection, which can occur at different levels. In *Very Nervous System*, David Rokeby's goal is heightened sensitivity to bodily self-awareness; Blast Theory's *Rider Spoke* is concerned with meditations on one's own life; Berkenheger's *Bubble Bath* encourages the recipient to consider his position with respect to media-based systems.

Robert Pfaller criticizes art's focus on self-reflection as fostering a kind of narcissistic desire. In his view, the recipients of interactive art are no longer interested in "something which is different to themselves."[223] Here Pfaller is in tune with Rosalind Krauss, who highlighted the narcissistic tendencies cultivated by video artists as early as the 1970s.[224] Although these observations cannot be dismissed, they disregard the critical potential of artistic projects that invite the recipient to take a step beyond naive self-representation. David Rokeby shares this view: "While the unmediated feedback of exact mirroring produces the closed system of self-absorption . . . transformed reflections are a dialogue between the self and the world beyond."[225] Thus, self-reflection is not limited to affirmative self-adulation; rather, like other forms of referentiality, it can trigger various epistemic processes.

In sum, simply noting that interactive art can be self-referential is simplistic, for the "self" that is referenced can be any one of a variety of actors and processes. Projects may refer to the entire art system, to their own genre, to artistic traditions, to the technology they use, to media-based constellations, or to the recipient's behavior.[226] Thus, to say that an artwork is self-referential doesn't sufficiently describe its interpretability.

Self-referentiality encompasses a broad spectrum of possible references within the various institutional, medial, technical, and symbolic systems of reference.

Aesthetic distance and knowledge

We have seen that what differentiates interactive art from play is the fact that interactive art provokes irritation and frame collision and uses different forms of self-referentiality. Unlike the traditional performing and visual arts, the potential interpretability of interactive art doesn't address a distant spectator; rather, an interaction proposition must be activated by the recipient. The work achieves its realization in the process of interaction. Thus, in order for knowledge acquisition to take place, materiality and interpretability must be brought forth and experienced at the same time. Aesthetic distance in interactive art is thus not an absolute value or a stable constellation; rather, aesthetic experience manifests itself in a process of oscillation between flow and reflection, between absorption in the interaction and distanced (self-)perception, and between cathartic transformation and cognitive judgment.

Not all theorists agree that reflection is possible at all during absorption in an activity. Marvin Carlson claims that states of flow impede reflexivity through the merging of action and awareness, the total concentration on the pleasure of the moment, and the loss of a sense of self or goal orientation.[227] Although Mihály Csíkszentmihályi shares this view, he sees reflection as a necessary counterpart to flow. He argues that, because flow prevents reflection on the act of consciousness, interruptions of this state, however minimal, are essential: "Typically, a person can maintain merged awareness with his or her actions for only short periods, which are broken by interludes when he adopts an outside perspective."[228] In the same vein, John Dewey describes a rhythm of surrender and reflection. He asserts that the moment of surrender is interrupted in order to ask where the object of the surrender is leading and how it is leading there. Because surrender to the object is consuming through "cumulation, tension, conservation, anticipation, and fulfillment," one must distance oneself enough to be able to "escape the hypnotic effect of its total qualitative impression."[229]

Both Csíkszentmihályi and Dewey thus posit an alternation between states of flow and reflection. Goffman, by contrast, believes that flow and reflection can occur in parallel. He argues that a person can be simultaneously active in different channels of activity, observing and reacting to other occurrences while engaged in a concentrated action and even communicating in a "concealment channel."[230] Martin Seel, too, argues for a simultaneous existence of reflective and immersive modes of experience when he points out that "for the process of art-related perception, it is not decisive which of these forces—sensuous sensing, imaginative projection, or reflective contemplation—takes the lead; rather, what is decisive is that they come together one way or another and enter into *one* movement sooner or later."[231]

Whether or not the dominant mode in the active realization of interactive art is an alternating or a parallel manifestation of reflective and immersive moments, what matters in this context is that aesthetic distance or reflection is not only possible in the experience of interactive art, but is an essential counterpart to absorption. Aesthetic experience of interactive art is specifically shaped by the interplay between immersion and distance, for only in this way can one's own actions become available as an object of reflection.[232]

The present study has shown that oscillation between different modes of experience, different levels of reality, different systems of reference, and different forms of action is characteristic for interactive media art. The multi-layered, open-ended, and occasionally contradictory interpretability of the interaction proposition finds its counterpart in the subjective perceptions and contextualizations that guide its realization. The knowledge that can be achieved through aesthetic experience feeds on the oscillation between flow and reflection.

The reflective moments of such an epistemic process do not necessarily require the recipient's own action, which, in fact, may sometimes impede distanced reflection. Consequently, the mode of experience of vicarious interaction, as described by Golan Levin, is certainly justified in interactive art, too. Nonetheless, such experience remains one-sided or fragmentary, for it lacks the states of flow and cathartic transformation that complement reflection. The difference between the aesthetic experience of vicarious interaction (Levin) or reflexive imagination (Blunck) and that of active realization is that in the former cases the reflective elements are in the foreground. It is not possible to generalize the significance of this for the experience of interactive art; it can only be assessed with respect to individual works, and perhaps only with respect to each individual experience of a work.

As individual—and thus unique—experiences, aesthetic experiences of interactive art can never be representative. This assessment applies to all reception of art, but its significance is emphasized by the requirement of active realization that characterizes interactive art. The provocation of reflection through action is also present, in principle, in all participatory art forms. However, the potential levels of representation and systems of reference are significantly increased by the use of digital media, insofar as processuality is already present as a potential in the interaction proposition. Rokeby describes this relationship as "partial displacement of the machinery of interpretation from the mind of the spectator into the mechanism of the artwork."[233]

The Ontological Status of Interactive Art

Having located the aesthetic experience of interactive art in the oscillation between flow and distancing and in the oscillation between action and reflection, we can now

Figure 4.11
The ontological status of interactive art. Sergi Jordà, Marcos Alonso, Martin Kaltenbrunner, and Günter Geiger, *reactable* (since 2007).

take a step back in order to examine the question of the ontological status or workliness of interactive art.

Presentation versus performance

The visual arts (and literature) are usually analyzed in terms of the classic triangle of artist (or author), work (or text), and observer (or reader). In the performing arts, the performance is also seen as an entity in its own right in the process of realization of the work. Although the performing arts may be set down in scripts or scores, they are still always created with a view to performance (either by the artist or by an interpreter). Visual arts, by contrast, traditionally denote artistic artifacts that are exhibited rather than performed. However, the boundaries between the genres are by no means as rigid as the traditional academic disciplines tend to suggest. Musical presentations are enhanced by the visual presence of the musicians, and dramatic performances use material elements in the form of scenery and costumes. On the other hand, it has been possible since the nineteenth century to animate images, rendering them performable.[234] And ever since the invention of media storage technology, both performances and animated images can be recorded and thus stored in material form for

subsequent presentation. Moreover, as was discussed in chapter 1, artists have been actively promoting activities that cross genres (for example, in the context of intermedia and action art) since about 1950.

There have always been hybrid forms of performing and visual arts, but interactive art creates a new kind of relationship between these genres. As we have seen, interactive art is based on an interaction proposition that has been developed and constructed by an artist and can be activated at any time in the form of an individual realization—whether or not the artist is present. This twofold basis in presentability and performability must, therefore, be taken into account for an ontological definition of interactive art.

Concept versus realization

Nelson Goodman classifies art not in terms of the way it is presented, but in terms of its nature, distinguishing between autographic (singular) and allographic (potentially repeatable) works.[235] In Goodman's classification, autographic works are artifacts based on the principle of authenticity—for instance, paintings. Allographic works are ideational concepts—for instance, texts or notations. Gérard Genette defines a notation both as an index and as an instrument for distinguishing between obligatory (constitutive) and optional (contingent) aspects of a work's realization.[236] Thus, the notation contains all the indispensable components of the work, but each realization is an individual interpretation.

In interactive art, too, constitutive factors (which are defined by the artist) are combined with contingent factors (which cannot be influenced by the artist). However, the artistic concept has already been given a manifest structure and thus, in a certain sense, has been autographically cast as a technical system and often also as a physical object or installation. This kind of constellation is not envisaged by either Goodman or Genette, for here a singular artifact, which can be considered autographic, embodies a processual potential that is not based on a notation, but on a set of constitutive rules.

The IFLA (International Federation of Library Associations and Institutions) model, offers a different way to describe the complex relations between concept and realization. That model starts at an even earlier phase of the production process, in that it views the work concept as an abstract entity—as a distinct intellectual or artistic creation. In other words, the point of departure is the artistic idea. According to the IFLA model, the concept takes on form as an expression, which is defined as "the intellectual or artistic realization of a work in the form of alpha-numeric, musical, or choreographic notation, sound, image, object, movement, etc., or any combination of such forms."[237] Thus, "expression" is the term used to refer to the articulated structure of texts or musical pieces (musical scores, for example) that can nonetheless be the basis for different material realizations. The possible realizations—termed

"manifestations"—represent another phase of the genesis of the work. Thus, the IFLA model envisages the potential existence of different versions of one work, whether as conceptual derivations or as adaptations for different presentation contexts.[238] The advantages of this distinction, which seems rather abstract at first glance, become clear when it is applied. In Tmema's *Manual Input Workstation*, for example, the general idea of gestural manipulation of audiovisual structures, as well as their differentiation across different program modes, can be understood as a concept, whereas their realization as a performance and their realization as an installation can be seen as different expressions of the same concept. However, these expressions can only manifest themselves in the context of the concrete set-up of the work, which may vary with the location of the exhibition or performance.

However, even the IFLA model doesn't cover all aspects of the variability of interactive art, insofar as each manifestation is subject to numerous realizations as different recipients interact individually with the work. Thus, not only different manifestations of a concept (by the artist) but also (and especially) its individual realizations (by the recipient) are contingent factors of the realization of the interactive artwork. Neither Goodman and Genette nor the IFLA model takes the reception activity of the public into consideration.[239]

As was explained in chapter 3, the moment of realization of the artwork is central to theories of the performative. These theories use the concept of event to emphasize the here-and-now presence of an aesthetic configuration. Erika Fischer-Lichte sees an event-oriented—as opposed to work-oriented—perspective as the sine qua non for contemporary performances.[240] Dieter Mersch describes the event of the artwork as a positing or self-manifestation, as something unexpected that cannot be influenced, and also as a fracture or disruption. In Mersch's view, events (unlike actions) occur unintentionally. Mersch describes an event aesthetics "rooted not so much in the mediated (thus in processes of staging and representation) as in incidents that take place."[241] He sees traditional modern art as being based on an artwork-oriented aesthetics, whereas the art of the post-avant-garde, in his view, operates with an event-oriented aesthetics.[242]

This is not the place to debate whether the art of the late twentieth century and the early twenty-first century can be meaningfully described by the concept of event. But certainly the concept of event is still not ideal for an ontological definition of interactive art. The reduction of interactive art to non-intentional events does just as little justice to their ontological status as does the traditional concept of the work of art as an exhibition object. Even though there is scope for unexpected events in interaction processes, they are still based, on the one hand, on programmed feedback processes from the technical system and, on the other, on actions on the part of the recipients, some of which, at least, are controlled with intent. Moreover, the processes of gestalt formation, the perceptions, and the conditions that determine the experience of inter-

active art do not simply happen, but are actively constructed. In other words, interactive art cannot be adequately described by an event aesthetics. Analyzing interactive art requires an (inter)action aesthetics that does justice to the complex roles of artist and recipient alike in controlling or being controlled by the system's processes.

Interactivity

In chapter 2 of this book, the interactive media artwork was described as an artistically configured interaction proposition that takes on and reveals its actual gestalt only in the individual realization by the recipient. It is thus clear that, despite the necessity of interaction for the realization of each work, the work itself still cannot be reduced to the moment of its realization. Its workliness is based fundamentally on the inseparability of the recipient's action and the manifest entity of the system created by the artist. For even if the work always requires new realizations in order to exist, it is still based on an entity that has been created, that can be described, and that potentially can be conserved. This entity may be presented in different versions and manifestations, but it always maintains its own referenceable structure. The incorporation of interactivity in its very structure is what makes interaction possible in the first place. Whereas artistic movements belonging to the postwar avant-garde often sought to reduce the work to an allographic concept (by creating conditions for possible events, as in George Brecht's event scores) or to an autographic event (by reducing the work to a one-off action), in interactive art programmed processes add potentiality to the manifest entity of the interaction proposition. It is thus possible, in agreement with Peter Bürger, to observe a revival of the work of art, though not in its originally static form but rather as an artistic configuration of processuality that can be activated. Even if such action propositions do not necessarily require the use of digital technologies, this study has shown that technology substantially broadens the range of possible configurations. For the interactivity of technical systems creates new potentials for structuring time, a permanent presence of system processes, and different forms of liveness that rely on the system-based processuality.[243]

Medium and apparatus

As manifestations presented to recipients, visual artworks can be considered a type of medium. Jochen Schulte-Sasse explains that a medium can be described as a "bearer of information that does not convey the information in a more or less neutral way, rather fundamentally shapes it, inscribing itself into the information in a way that is specific to the particular medium, so as to give form to human access to reality."[244] Even if the visions of reality presented through art are often unusual or perhaps provocative (in fact, it is even legitimate to ask whether the objects of artistic presentations can be meaningfully described by the concept of reality at all), artworks are still usually bearers of information that they not only transmit but also shape. But is the

term "medium" also appropriate for interactive art or for the artistically configured system that invites the recipient to interact? In order to discuss this question, we must return to the distinction between data-intensive and process-intensive works. Whereas data-intensive works are certainly (also) bearers of information (insofar as they store pre-produced information, holding it in readiness for retrieval), process-intensive works focus mainly on the generation of information or of configurations in real time. In process-intensive works, information is not conveyed or activated; rather, information is created only during the process of interaction. In addition, both process-intensive and data-intensive works permit a kind of "access to reality" that deviates from Schulte-Sasse's definition in that it is not purely cognitive but rather is based on action.

An artifact whose purpose is the active production of objects or information is usually called a device rather than a medium. Here "device" is taken to be a generic term for the various systems used to translate, manipulate, or transform materials and information, and thus to be particularly applicable to tools, instruments, and apparatuses. Whereas a medium is a mediator *of* something, a device is a mediator *for* something: for a process that creates or at least substantially transforms a product. However, this kind of processuality is based on different characteristics for tools, instruments, and apparatuses. Whereas tools are used to mechanically manipulate material and to enhance a person's physical strength and abilities, we conceive of instruments as more sophisticated or complex. Instruments are used for scientific operations or to carry out measurements, availing of the physical or chemical properties of materials (e.g., glass as a prism, mercury for gauging temperature). A musical instrument also relies on physical effects (vibrations or frequencies, in particular), but, as Sybille Krämer points out, differs from other instruments in that its purpose is not enhancing efficiency but "worldmaking"—that is, the creation of artificial worlds that enable experiences not provided by our everyday surroundings.[245]

Most interactive artworks are invitations to select, manipulate, or generate information or configurations. Although the artist may have a quite specific intention, interpretability is never offered in the form of a finished composition; instead, it is an opportunity to act, or an invitation to create multimodal configurations. For that reason, these systems have much in common with musical instruments and could tentatively be described as multimodal instruments. However, in contrast to musical instruments, there is no direct physical relationship in interactive art between input and output, and, since the mechanisms of the transformation are one-off constructs not standardized as specific types of instrument, they are not known to their user.

Moreover, the concept of instrument doesn't entirely capture the nature of data-intensive projects, in which the focus of the interaction is not on the actual generation of multimodal configurations but rather on the selection, the arrangement, or the activation of assets. Even when the assets are not linearly ordered or spatially delimited in a clear way, often not every asset can be activated at any particular moment or in

any particular place in order to become part of the emerging gestalt. This is what differentiates such systems from musical instruments, which generally make all their options available at all times for use in sound production.[246]

The potential discursive functions of interactive art are also only inadequately captured by the concept of instrument. Dieter Mersch distinguishes between aisthetic and discursive media as means of presenting or means of declaring. Media that present, such as images or sounds, prioritize the creation of perceptions, whereas media that declare, especially words and numbers, are based on logical and syntactic structures.[247] A medium can convey both discursive and aisthetic information; an instrument, as a "worldmaker," has primarily aisthetic functions. As we have seen, interactive art operates both discursively and aisthetically.

Thus, if the concept of medium cannot adequately describe the ontological status of the interactive artwork, the concept of instrument is also stretched to its limits, because it does justice neither to the complex processes of mediation nor to the potentially discursive functions of interactive art.

Apart from tools and instruments, there is also another kind of device that can be taken into consideration as a possible reference model for interactive art: the apparatus. The term "apparatus" is used to denote a sophisticated device that usually combines several different functions or processes (such as, in the photographic camera, chemical processes of exposure, optical processes of focusing, and mechanical processes of shutter control) and is based on complex processes of transformation that are often controlled electronically or digitally.[248] The purpose of the apparatus is likewise not to simplify work, but to generate artificial worlds. As Krämer explains, the apparatus "permits experiences and enables processes that in the absence of apparatuses would not only exist otherwise in a weaker form, but would not exist at all."[249] Accordingly, Krämer denotes the apparatus as a medium with the form of a technical device. Thus, one could interpret Krämer's view as suggesting that the apparatus combines the medium and the instrument with the aim of worldmaking. It is therefore worthwhile to examine the apparatus more closely as a potential ontological model of reference for interactive artworks.[250]

The functioning and the potential of apparatuses was first discussed in the context of the "apparatus debate," a discussion, initiated in France in the late 1960s by Jean-Louis Baudry and others, that analyzes cinema as "an apparatus for the conduit of bourgeois ideologies" and is thus interested in the worldview implicitly conveyed by the institution of cinema.[251] The apparatus analyzed in that debate is not only the technical appliance of the film projector, but the entirety of the technical and institutional framework, including the conditioning of the viewer. Thus, apparatus theory initially focused exclusively on one specific apparatus (the cinema), and in analyzing it in terms of discourse theory rather than in terms of its aesthetics. Nonetheless, the apparatus debate has shaped our concept of the apparatus as a complex system that

is not transparent to the recipient. At the same time, it shifts the spotlight onto the recipient, who is described by Baudry as "chained, captured, or captivated"[252] and as a subject of cinema who voluntarily exposes himself to a simulation apparatus that imitates the effects of dreaming or sleep.[253] Siegfried Zielinski, by contrast, points to the existence of different "practices of subject positioning," which cannot be described satisfactorily by Baudry's apparatus theory and require a more precise differentiation.[254] Vilém Flusser joined the apparatus debate in the 1980s, focusing on technological or media-based factors.[255] His study is concerned with the photographic camera, which he considers exemplary. He defines the apparatus as a cultural product that "lies in wait or in readiness for something" in order to "inform" it (i.e., give it form).[256] Like Krämer, Flusser emphasizes that the apparatus neither carries out work nor creates products, and that its purpose is not to change the world but to change the meaning of the world. Flusser's apparatus is first and foremost a producer of symbols. Flusser calls the processes that take place within apparatuses "programs" in order to distinguish them from their material repositories. He thus concludes that "the question of ownership of the apparatus is irrelevant; the real issue here is who develops its program." Even if the operator of the apparatus—as a "functionary"—is closely entwined with his equipment, the apparatus is still a "black box" to him: "The functionary controls the apparatus thanks to the control of its exterior (the input and output) and is controlled by it thanks to the impenetrability of its interior."[257]

Though one may wonder whether "black box" is the best designation for the photographic camera, in view of its quite standardized technology (which is thus generally familiar to many users), the term is certainly appropriate for most interactive projects, for the recipient really doesn't know what to expect. He doesn't know how the technical system works, and thus initially he has no control whatsoever over its processes.

Flusser's technocritical and sociocritical position is especially interesting in the present context because it has much in common with criticisms that have been leveled against interactive art. As was noted in chapter 1, many critics of interactive art bemoan the fact that the program or its author patronize the user while feigning freedom of choice. As the present study argues, however, this situation can in fact be compared to the "fundamental asymmetry" of the relationship between reader and text described by Wolfgang Iser. Thus, it is not a hindrance to aesthetic experience; rather, it is one of its constitutive factors. If we abstract from the ideological subtext of Flusser's apparatus theory, we can use it to further scrutinize the aesthetic experience of interactive art from an ontological perspective. We can agree with Flusser that the apparatus not only broadens the possibilities for meaning production but also channels or limits them. Even Flusser points out that the productive use of such limitations may be the ultimate goal of working with apparatuses. Flusser argues that this is expressed by the fact that photographers (whom he distinguishes from functionaries or mere operators) do not play *with* their "plaything," but *against* it: "They creep into

the camera in order to bring to light the tricks concealed within."[258] People are attracted to interacting with apparatuses not only by the opportunity to avail of their invitation to produce meaning but also by the desire to test their limits. In this respect, too, parallels can be drawn between the apparatus and the interactive artwork, for in interactive art, too, the recipient is interested not only in exploiting the operational possibilities but also in exhausting the constitutive limits of the system.

Thus, the apparatus defines the modus operandi of interactive artworks quite accurately. Nonetheless, it would be going too far to claim the reverse—that every apparatus is an interactive artwork. For even if interactive artworks are characterized by the modus operandi of apparatuses, their ultimate objective is not to manipulate matter, or to convey information, or to make worlds. The thesis of the present study is that the aesthetics of interactive art manifests itself primarily as an aesthetics of interaction. The focus of interactive art is on the staging, the realization, and the critical analysis of interaction processes, not on the gestalt that may be created or conveyed by means of these processes. The epistemic potential of interactive art is based, as we have seen, on an oscillation between flow and distancing and between action and reflection that originates in the processes of interaction.

Instrumental resistance and virtuosity

As early as 1934, John Dewey pointed out that an aesthetic experience is possible only where there is resistance on the part of the object of experience. Resistance is also a constituent element of the concept of the apparatus. The concept of resistance will be defined more precisely in this subsection, once again availing of a comparison with the musical instrument. As was explained above, one difference between an interactive artwork and a musical instrument is that the user of the interaction system is initially ignorant of its workings, and another difference is that the relationship between input and output is not based on physical processes. The musical instrument uses carefully calibrated but fundamentally simple physical or mechanical effects (air pressure, vibration, leverage, etc.). As a result, there is a direct physical or mechanical connection between the instrument and the person playing it. The manual operation of keys or the closure of tone holes to create vibrations of strings or air flows and the creation of friction in string instruments or of air flows in wind instruments are all straightforward bodily actions. The musician feels the physical resistance of the instrument. As Aden Evens points out, the instrument doesn't interpose itself between the musician and the music, but it also doesn't have the function of a transparent medium; rather, it offers the musician productive resistance. The musician uses his technical abilities to create sound by means of a productive encounter with this resistance: "musician and instrument meet, each drawing the other out of its native territory."[259] The resistance thus substantially determines the creative potential of the instrument. It challenges the musician, and at the same time it is the basis of his accomplishments.

Whereas, according to Flusser, users of apparatuses "control a game over which they have no competence,"[260] the aesthetic quality of a musician's performance is assessed in terms of his technical mastery of the instrument. The word "virtuosity" implies both technical bravura and the musician's ability to reproduce or interpret particular scores. The score permits a temporal separation between composition and performance, allowing for a practice period in between the two.[261] Composition and performance coincide only in improvisation, where the mediating score is absent and the musician's virtuosity becomes apparent in his combination of spontaneous creativity and technical mastery of the instrument. Consequently, Evens considers musical scores to be a constraint for musicians: "How much more difficult it is to discover the music's ownmost possibility when the correct note has been specified in advance. How can the musician become one with his instrument when a score stands between him and the music, mediating his experience of it?"[262] However, Evens concedes that the risk of failure is greater in improvisation. He argues that this is why musicians draw on methods that introduce unpredictable or chance elements, such as altering their instrument or incorporating random factors. In this way, Evens asserts, musicians deliberately increase the resistance of the instrument in order to maintain a quality of experimentation when improvising.[263]

Because conception and execution usually go hand in hand in the visual arts, interpretation and improvisation, as categories belonging to production aesthetics, become irrelevant. In interactive art, by contrast, the recipient's action has similarities with musical improvisation.

Interactive art: The resistance of the apparatus

The tension between action potentials and their restriction through the resistance of an existing system also conditions the realization of interactive artworks. The similarity between interactive art and improvisation is that both usually dispense with scores or directions. However, the recipients of interactive media art face a twofold challenge, because they are not even familiar with the workings of the system. In contrast to a musical interpreter who knows and has mastered his instrument, the apparatus operated by a recipient of interactive media art is entirely unfamiliar to him. The experimental exploration of the system's resistance is an activity in its own right—an aesthetic experience that takes place somewhere on the border between aesthetics of production and aesthetics of reception. For, as we have seen, the system can facilitate rapid understanding of its operations by clearly evidencing the link between constitutive and operational rules or by presenting a highly intuitive interface, but it can also turn the exploration into an irritating and unsettling experience through the use of intentional disruptions.

Flusser argues that an apparatus, in order to fulfill its function, must be complex: "The program of the camera has to be rich, otherwise the game would soon be over.

The possibilities contained within it have to transcend the ability of the functionary to exhaust them, i.e. the competence of the camera has to be greater than that of its functionaries."[264] Unfortunately, Flusser doesn't describe this competence in any more detail. A more in-depth analysis of the functionality of the apparatus and of its significance for the interaction process is needed to establish exactly how the apparatus-like resistance of the interaction proposition influences the processes of gestalt formation and the experiences that take place during the realization of the work.

The emergence of gestalt in art is generally considered to be a result of artistic productivity or creativity. According to Dieter Mersch, fundamental categories of creativity are sought within processes of imagination and figuration. On that view, the artist either creates "out of the free power of his imagination as an inexhaustible source of infinitely new images and ideas" or "refigures [images and ideas], recombines them, and transforms them into other forms that have never been seen before."[265] Following this line of reasoning, one could argue that interactive media art tends to leave in the hands of the recipient aspects of the figuration for which the artist has imagined a figuration apparatus in advance. However, this figuration apparatus is not a simple tool but a complex and resistant system. The extent to which the figuration is already determined in advance by the apparatus and the extent to which the user can intentionally control these processes—and thus their results—therefore vary. For example, sequences of sounds or elements of visual compositions, narratives, and communications may already be stored in the system, awaiting activation or selection by the recipient. Yet Golan Levin, in reference to audiovisual systems, criticizes systems that offer only limited possibilities for the manipulation or arrangement of pre-produced sounds. Though such systems may guarantee a satisfying aesthetic output, they greatly restrict the recipient's freedom. In Levin's view, when recipients have little to lose, they also have little to gain, apart from their pleasure in the artist's compositions: "[C]anned ingredients, all too inevitably, yield canned results."[266] By contrast, Masaki Fujihata, discussing his work *Small Fish*, defends the use of elements that have been composed in advance: "Small Fish is designed so that users will come to understand the musical structure proposed by Furukawa through precisely those limitations." Fujihata explains that, thanks to the use of pre-produced assets, classic musical structures—such as rising and falling sequences or different voices—can be heard "amongst the chaos."[267] What are at issue here are ultimately the pros and cons of what we have identified as the two main modes of experience of interactive art: constructive comprehension and expressive creation, each of which highlights different functionalities of the apparatus.

Whereas constructive comprehension has close parallels with the figuration model (in the form of activation, realization, and synthesis of the pre-programmed assets of the interaction proposition), expressive creation can be described as an imaginative activity (in which forms, movements, or actions are produced and then processed by

the technical system).[268] Both figuration and imagination are, however, determined in interactive art by the resistance of the apparatus, in the sense of a productive resistance that substantially shapes the aesthetic experience of the interaction.

From artwork to device and back

Whereas a musical instrument offers a physical and technical resistance which is overcome by virtuosity, the resistance of an interactive artwork is an experimental challenge. Its resistance is based on the interaction system developed by the artist— with its own logic, which may include paradoxes and delusions. The aesthetic experience of interactive art thus depends on (among other things) the originality of the system, or at least the system's novelty for the user. The functionality of a musical instrument, by contrast, is known and standardized, like the workings of the cinema projector or the photographic camera. Standardization is required for the commercial use and distribution of apparatuses and for the composition of complex scores. At the same time, standardization helps the user in becoming acquainted with a device and in practicing how to operate it. The more familiar the user is with the workings of a device, and the more mastery he has over it, the less attention he gives to it. Instead, his attention is focused on the result he creates. By contrast, the apparatus within the interactive artwork is unique, unknown, and novel, so greater attention is given to its exploration. There are, however, examples of interactive audiovisual systems that were originally created as artworks and then proved so popular that they are now being standardized or sold commercially. One example is *reacTable* (2003–2005) by Sergi Jordà, Martin Kaltenbrunner, Günter Geiger, and Marcos Alonso, a "music table" featuring musical building blocks tagged with markers that can be operated simultaneously by several different users. Another example is Toshio Iwai's *Tenori-on*, a portable panel with 256 LED keys that allow melodies to be programmed, played, and visualized. Both of these systems are now sold commercially and can thus be practiced on at length.

In principle, many interactive artworks offer the recipient the possibility of penetrating the operational and constituative rules of the system through exploration until he is able to operate the system with virtuosity. Then, however, the ontological status of the interaction proposition changes fully from artwork to device, for the exploration of the system's workings fades into the background and the potential moments of reflection diminish.[269] The outcome of the interaction gains in importance because it becomes increasingly controllable and, as an independent result, can itself assume the status of an artwork. As the virtuosity of the recipient increases, the aesthetic experience is ultimately transformed entirely into an aesthetics of production. This point is also made by George Poonkhin Khut, who for this very reason explicitly avoids focusing on instrumental possibilities for expression: "My reluctance to frame the interaction in terms of expression stemmed from concern that audiences might

become fixated on the notion of expression and lose sight of the work's primary goal as a system for sensing and reflecting on their own embodied subjectivity."[270]

To sum up, the concept of the apparatus is of great value for identifying the ontological status of interactive art. The concept of the apparatus does justice to the combination of presentability and performability that characterizes interactive artworks in that they are simultaneously manifest entity, invitation to take action, and basis for performance.[271] Like the apparatus, the interactive artwork calls out to be activated. Both the apparatus and the interactive artwork enable both exploration and expressivity, insofar as complex and programmed resistance—a constitutive element of aesthetic experience—can also lead to the production of (audiovisual) formations. Thus, what we have in interactive media art are apparatus-like artworks whose epistemic potential must be sought in the process of interaction. However, this process may also turn into an experience guided exclusively by production aesthetics. Then the interaction system becomes a device that is used to create manifestations that, in turn, proffer themselves for contemplative reception.

5 Case Studies

The aim of this chapter is to show how the artistic strategies, processual characteristics, modes of experiences, and epistemic potentials identified in earlier chapters take on concrete form as features of individual works. The criteria identified will not be addressed exhaustively for each individual work; rather, they should be understood as an open set of instruments that we can use to look at very different works from different perspectives.

The aim of the case studies is not to provide a representative overview of interactive media art. Instead, each of the selected works portrays specific aspects of an aesthetics of interaction in a particularly striking manner. The works deal with strategies of narration and of fictitious communication, with the complex relationship between real space and data space, with forms of bodily interaction and multi-modal interplay, with stimulation of self-awareness and self-reflection, and with the relationship between exploration and expression.

Case Study 1: Olia Lialina, *Agatha Appears*

Olia Lialina's *Agatha Appears* is an early example of Internet art that, in terms of instrumental interactivity, can best be characterized by the notion of simplicity. It has a classically linear narrative structure and requires only minimal activity on the part of the recipient, who remains almost entirely in the role of observer.

Olia Lialina is a Russian journalist, film critic, and media artist. She has held a professorship at the Merz Akademie in Stuttgart since 1999, claiming that "I was not an artist before I became a net artist."[1] Since 1996, she has created various Internet artworks, many of which feature narrative elements and references to film, but also self-referential investigations of the digital medium itself.

Agatha Appears, one of Lialina's first Internet artworks, was created in 1997 while she was a resident artist at Budapest's C³ Center for Culture & Communication. Márton Fernezelyi collaborated on *Agatha Appears* as a programmer.[2] As of this writing the work can be still accessed at http://www.c3.hu/collection/agatha. However, with advances

Figure 5.1
Olia Lialina, *Agatha Appears* (1997), screenshot.

in browser technology, it became impossible over the years to activate certain features of the work, and some HTML pages disappeared from the servers on which they had been stored. For those reasons, *Agatha Appears* was restored in 2008 by Elżbieta Wysocka and can now be accessed only in its restored form.[3] The following description is based on repeated realizations of the restored version. In the course of these various activations of the work, I noted slight variations in the responses of the system. These can be attributed to the different browser versions, operating systems, and security settings I was using, but also to local and global network problems. In other words, the steps described in the following will never be identical to other realizations, either before or after the restoration, notwithstanding the broadly linear structure of the work.

Agatha Appears is a graphic story presented on the World Wide Web in comic-book style. The viewer proceeds through the linear sequence of Web pages by clicking a computer mouse. Agatha is a young girl from the country seeking a new life in the city. She happens to meet a systems administrator who has just been fired from his job. The administrator offers to teleport her into the Internet, but his attempt fails. Agatha then travels independently through the global networks until she eventually disappears.

In this work, the browser window serves as a frame within which the story is enacted as if on stage. Linguistic elements appear either as mouseovers (that is, they

appear automatically if the cursor passes over the represented figures) or in the status bar at the bottom of the browser frame. The title page of the work shows a frontal view of the system administrator, depicted as a white silhouette on a black background. The silhouette contains strings of characters reminiscent of a computer program screenshot and is traversed by vertical black stripes, so that the administrator appears to be standing behind bars.[4] When the recipient moves the cursor over this figure, the story begins with a mouseover text: "Once a system administrator was fired from his job." The sentence continues in the status bar: "because some important files disappeared from his network."[5] A mouse click takes the recipient to the first scene, in which lines are used to represent streets. These streets are shown in aerial view, whereas the two main characters are depicted from the front. Agatha wears a bustier and a skirt, both of a pattern that again resembles the display shown on a computer screen. In fact, the names and dates visible on a bright blue background recall the screenshot of an MS-DOS directory structure. Agatha first appears as a small figure in the top right corner of the screen, but each time the page automatically reloads she has moved a step closer to the system administrator. Accompanied by the children's song *Goodbye Jack and Sue*, Agatha gradually becomes larger, lending the depicted space a three-dimensional effect.

The text on the title page had begun the story in the third person, but from this moment on the mouseover texts are used only for direct speech by the protagonists, thus functioning as the equivalent of speech bubbles in standard comic strips. The status bar, by contrast, is reserved for the private thoughts of the two characters. For instance, when the mouseover text shows the system administrator speaking the words "hi, who are u, why are u crying?" the status bar reveals his unspoken thought: "she must not be from here."

Initially, the pages reloaded automatically, but now the recipient must move the narrative forward himself. When he uses the mouse to pass the cursor over an image, the cursor arrow changes into a pointing-hand symbol, indicating (in accordance with standard World Wide Web logic) that a hyperlink is available. In other words, the recipient discerns the operational rules by adhering to Internet conventions. Clicking on the links moves the conversation forward one utterance at a time. The dialogue evolves in short sentences such as "God! Take me away from here" and "HA-HA-HA! Baby, have u heard about the INTERNET?" The only action the recipient can carry out is mechanical clicking, which, paradoxically, is made to seem even more repetitive by the fact that its results are not as predictable as one might expect. In fact, clicking on a figure doesn't necessarily activate speech on that character's part; it may lead to an utterance on the part of the other figure. And occasionally the narrative moves forward without any clicking at all, for the thoughts of the protagonists often appear in the status bar only when the cursor has first moved away from and then returned to the hot-spot area. Because the recipient becomes aware of these structural details only

gradually, such processes are often activated by chance while the recipient is engaged in exploratory navigation or is repetitively and mechanically clicking the mouse. Thus, the narrative is partly driven forward intentionally and partly driven forward in a purely mechanical fashion through trial and error.

The first scene ends with the system administrator inviting Agatha to his apartment the following day, from where he will try to upload her into the Internet. The scene change created by the next mouse click is also evidenced in the address bar of the browser. Whereas previously the URL was http://www.c3.hu/collection/agatha/big_city_night_street.html, now the recipient reads http://www.c3.hu/collection/agatha/next_night_sysadms_apartment.html. The new scene is a frontal view of a room featuring simply sketched ceiling lights and a bed on a black background. Agatha has changed into a dress whose pattern consists of color photographs—seemingly from the mass media—of the faces of two men. This is a classic scene change. It is evidenced by the jump in space and time reported in the address bar and by the new setting and new costumes, and is further emphasized by the replay of the children's ditty.

The two main characters greet each other with a brief "hi." Only the thoughts shown in the status bar shed light on their personal impressions. Whereas the reaction of the system administrator is a pleasantly surprised "she came," Agatha comments to herself on the "awful place." During the conversation that follows, which is once again driven forward by mouse clicks, the two characters gradually move left toward the simple bed image. Although it may seem to the recipient that the story is about to take a different course, the conversation concludes with the system administrator instructing Agatha to jump into the Internet: "so jump." A long, narrow pop-up now appears on top of the browser window, spanning the full height of the screen. This pop-up contains several images of the top half of Agatha's head, repeated one on top of the other for the length of the window. The effect is reminiscent of a filmstrip—perhaps specifically of Joan Jonas' famous video work *Vertical Roll* (1972), in which the artist likewise alienates video footage of her own body by showing it in a vertically projected slow-motion filmstrip. However, the repetition of the images in Lialina's work is static. In a standard dialogue box next to the pop-up we see the error message "No, definetly, your legs are too long." In order for the narrative to continue, one must acknowledge this message by clicking on an OK button. The conversation now proceeds for a time only in this dialogue box, which requires confirmation after each message and contains statements such as "Just a moment, i'll make a shortcut" and "What is error 19?" In the first case, familiar HTML terminology is used as a narrative tool. The second utterance can be interpreted as a response by the protagonist to apparently extradiegetic error messages coming from the system.

During this attempt to upload her, Agatha sees "millions of zeros, laughing and screaming," which she finds "disgusting." Ultimately, the teleportation fails. The

Figure 5.2
Olia Lialina, *Agatha Appears* (1997), screenshot.

recipient can respond to the system administrator's resigned apology ("I'm sorry, it always worked . . .") by clicking either on OK or on Cancel in the dialogue box. If the recipient accepts this apology by clicking on OK, the upload attempt starts again—without ever succeeding. If the recipient decides to terminate the process, the narrative returns to the system administrator's apartment, where he explains that something is amiss with the connection. Agatha suggests meeting the following day at the railroad station. Thus, the story skips to the next scene, which is introduced by the following URL in the address bar:

http://www.c3.hu/collection/agatha/late_evening_railway_station_heavy_rain.html.

The scene is set by means of a simple drawing of a coach indicator displayed in the bottom right corner of the screen. In addition to showing departure times in chronological order, the display also shows the order of first-class and second-class coaches, which are depicted in simple ASCII art. The ASCII characters also appear—alternating with fragments of text—as a scrolling text in the title bar that can be seen as a representation of moving trains.[6] Josephine Berry interprets the setting of the scene in a railroad station as a reference to the "historical springboard of industrialised and bureaucratised travel and romantic film and fiction." The railroad station stands, Berry believes, for traditional forms of travel, although the moving cars might also be seen as an analogy to sequences of frames passing through a film projector. Thus, in Berry's view, the setting is also a reminder of the change from a linear narrative to a "database logic."[7] Thus, in addition to the comic-book analogy and the work's earlier reference to a filmstrip, here a reference is made once again to older (non-digital) narrative media.

Agatha has changed dresses again. Her new dress features a screenshot of an email program. The system administrator now appears twice, once to Agatha's left and once to her right. Via mouseover texts alternating between his two instances, he gives her an introductory lesson about the Internet ("Its not a technology, but new world . . .") before disappearing. Agatha speaks her only lines in this scene ("new world? I want to try"), then disappears, leaving only the black background behind her. The mouseover text now reveals the following: "Bye, if problems—sysads_apartment.4am.html." Another mouse click brings Agatha back (alone), promising "but, I'll come here again." Although the recipient never finds out how the teleportation managed to succeed, he can now see in the address bar that Agatha appears on a new server each time he clicks the mouse. She is traveling the world. Each new HTML page describes her journey in the file names that appear in the bar:

http://profolia.org/agatha/was=_born_to_be_happy.html

http://bodenstandig.de/2000/agatha/cant_stay_anymore.html

http://pleine-peau.com/agatha/starts_new_life.html.

As long as all the servers are accessible, the journey continues until Agatha eventually loses interest (". . . /lost_the_interest.html"). Agatha has now had enough and returns to the system administrator, though not before changing her dress again (the new one is made of ASCII characters): "I'm back again? Where is he? I'll try on my new dress." But the system administrator—depicted sitting behind a monitor in the upper left corner of the screen—shows no reaction. And so Agatha goes to a bridge (. . . /old_bridge_early_morning.html), lamenting "he left me, when i started to love this world." The next mouse click leads to a view of Agatha not just on the bridge, but also—three times—in the water under the bridge. Now, for the first time in the story, text elements take the form of hyperlinks, which appear alternately to the right and left sides of the bridge's central pillar. Clicking on them activates a dialogue (somehow reminiscent of a psychotherapy session) between Agatha and an entity that remains unseen. Agatha's disconsolate observation "Internet is our future! . . . But I am nothing" elicits comments such as "dont say it!!!" and "YOU CAN DO A LOT!!!" and Agatha eventually decides to work in the Internet herself, in the world of teleportation. Finally, the recipient ends up on the home page of www.teleportacia.org, another of the artist's projects, which promises the next episode of Agatha's story.[8]

Agatha Appears is an interactive artwork that offers very limited possibilities for action. All the recipient can do is drive forward a predetermined process—a simply recounted and depicted (audio)visual narrative—with practically no means to influence the course of events. The reason this work was chosen for the first case study is that it helps to demonstrate that interactivity's significance isn't proportionate to its complexity.

Agatha Appears is based on a reactive liveness. It proceeds (only) thanks to the recipient's "clicking ahead" (with the exemption of the first few pages, which reload automatically). Therefore, in purely instrumental terms, it depends on an interactive realization. In addition, the recipient's input, although its action potential is inherently minimal and repetitive, is essential for the aesthetic experience. The mouse clicks determine the mechanics of the interaction. Owing to the necessity of their constant execution, they are central to the aesthetic experience of the work. The mouse clicks turn the two main characters into puppets animated only by the action of the recipient, even if that action is purely mechanical and is comparable to flicking through a flip book. The recipient essentially engages in an act of comprehension, which, however, is not so much a constructive realization as a mechanical one. Nonetheless, the reception relies on this mechanical action, unlike the reception of the linear narrative forms of comic books and films (to which various references are made in the work).

The puppet-show impression is further reinforced by the similarity of the protagonists' appearance to dress-up dolls, and also by the background music, which starts anew each time the scene changes. The simplicity of the interaction, the graphics, and

the music, as well as the repetitions and the rhythms of the work, lend it an almost naive and childlike character. This is reminiscent of the artistic strategies used in pop art, as is the work's homage to the comic-book format. The work also plays with stereotypes from the time-based arts, for example by using theatrical scene changes and by adopting plot lines typical of melodramatic films.

This slightly clichéd style is offset, however, by the exhaustive and technically ambitious use of all the options offered by the markup language HTML at the time the work was created. *Agatha Appears* not only features hyperlinks and mouseovers, but also makes use of the status bar, the address bar, and pop-up dialogue boxes to advance the narrative. The page layout is employed to differentiate between statements that are verbally expressed by the protagonists (shown in the mouseover texts), their thoughts (reported in the status bar), and details about the location and time of the action (shown in the address bar). In this work, the status bar, the address bar, and the dialogue boxes— normally used to provide extradiegetic information—become parts of the diegetic narrative.

When—beginning with the railway station scene—the address bar no longer merely describes changing settings by means of page names, but also documents the repeated moves between the various servers on which the individual pages are stored, the diegetic and extradiegetic levels are being merged. Not only is the recipient being informed as to the protagonist's current location; in addition, the Web page in question is also actually physically located on the server named in the address bar, so that the Internet is presented as a geographically disseminated and referenceable entity. Agatha's journey may be fictitious, but it is also very real, for the artwork itself is stored and accessed on a series of servers located in different countries. Whereas the first scenes reside on the server of the C^3 Center for Culture & Communication in Hungary, the original journey subsequently led to Slovenia, Russia, and Germany—that is, to servers used at the time by the Internet art community, including the Austrian network platform thing.at and the Slovenian platform ljudmila.org.[9] The dialogue boxes also operate on the boundary between technical feedback and narrative fiction. Their purpose in the work (in accordance with the usual function of such windows) is to report errors (such as the failed upload), but their presentation is diegetic. The blending in this work of the diegetic and extradiegetic levels—of fiction and reality—is an excellent example of how materiality and signification can be fused in the digital medium.

The specific characteristics of the medium also determine the graphic layout of the main image area. The background is kept decidedly simple, which allows rapid loading—something that was important at the time the work was created. In addition, the page layout is dynamic, allowing the scenery to adapt to changes in the screen size. Very simple means are used to indicate spatiality, such as the changing size of Agatha's figure at the beginning of the work and the indicative depiction of the settings by means of a few lines. This representation of spatiality is based on traditional

approaches to perspective projection and contrasts with the work's portrayal of the global spatiality of the digital network in the form of data crossing national boundaries to servers located in different countries. In extradiegetic terms, the individual pages of the work are distributed across these servers, while it is thanks to them, in diegetic terms, that Agatha can travel the world.

In contrast to the spatial staging of the background scenery, however rudimentary, the figures themselves are emphatically two dimensional. In fact, their silhouettes, which are reminiscent of dress-up paper dolls being pushed across a stage, remain unchanged for the entire duration of the story. Both of their heads, as well as Agatha's arms, show some internal detail in the form of low-resolution black-and-white graphics, but the remainder of their bodies are simple silhouettes patterned with fragments of screenshots. It almost seems as though the figures have been cut out of the black browser window so that the recipient can see through the resulting holes in the screen to layers lying below or to deeper levels of the system architecture. However, the data structures that become visible have no informational value; they are reduced to purely decorative patterns on fabric.

HTML, the basic markup language for Web pages, is thus exploited to the full, creating a multi-layered flow of information and a complex system of self-referential allusions that stand in contrast to the simplicity of the plot and the formal components. The frame collisions that arise do not result from conflicting possibilities of positioning oneself with respect to the work; rather, they result from interactions between diegetic and extradiegetic elements. However, these interactions must be activated by the recipient, even if he is involved neither physically nor emotionally and his role is reduced to that of mechanical button-pusher. *Agatha Appears* uses interactivity as one of many strategies to scrutinize media-based systems by means of a deliberately simple story. If we were to apply a ranking scale of instrumentality, this work would be located at the bottom rung on the scale of interactivity. Nonetheless, the aesthetics of the work would be entirely different if the story were not interactive at all—if it were to self-load and simply unfold autonomously before the eyes of the recipient. On the one hand, the role of the recipient is in line with the extreme simplicity of the story; on the other, it can be interpreted as the performance of a reception strategy. Similar to zapping from one television channel to another, constant clicking allows one to rapidly skim through information while looking for something interesting. Under the guise of a stereotypical story—country girl meets city geek, is dumped by him, then makes a career for herself—an everyday mode of entertainment is staged. Moreover, the dream of teleportation, which was topical at the time the work was created, is not only represented, but actually realized, even if it is only by a virtual protagonist. At the same time, it is her journey that illustrates the work's moorings in physical reality. Some of the error messages that appear are artificially staged, but the widespread distribution of the pages also increases the likelihood of

real error messages warning of blocked connections or inaccessible servers. The fusion of diegetic and real information flows is one possible way to interrelate materiality and signification and so to constitute the interpretability of the work. The effect of the work on the individual recipient is undoubtedly not the same today as when it was first created, when visions of virtual reality had much greater appeal and even a mere illustration of the possibilities offered by HTML would have fascinated viewers. The effect was certainly also different for Eastern European recipients, who would have interpreted the staging of free travel through the networks as a political statement. However, the work's critical engagement with the aesthetics of mainstream media can be analyzed in just the same way today as in 1997.

Case Study 2: Susanne Berkenheger, *Bubble Bath*

Unlike *Agatha Appears* this work is confusing to a degree that left me—and possibly all other recipients—wondering if I had experienced this work in its entirety and fully

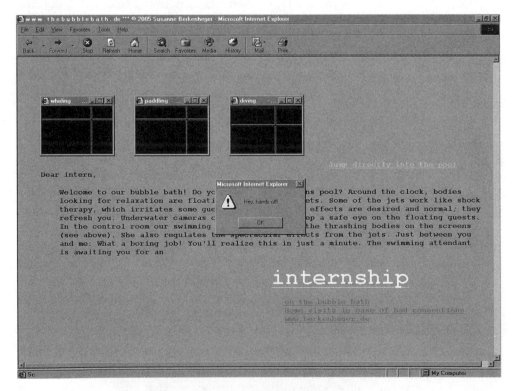

Figure 5.3
Susanne Berkenheger, *Bubble Bath* (2005), screenshot.

grasped its complexity or had actually appreciated only a fraction of its intricacies. A more thorough study of the instrumentality of the work and an effort to better understand its directory structure or to elicit details about it from the artist might, of course, have clarified matters. The reason I did not dig deeper is that the artist herself, in an accompanying text, presented the recipient's uncertainty as a central characteristic of the work.[10] As a result, the work will be described here as I experienced it on several different occasions—up to a level of comprehension that can be regarded as typical for most realizations of the work.

Susanne Berkenheger, a native of Stuttgart, studied literature and subsequently worked as a journalist, in theater, and in digital media. She has created various projects on the World Wide Web since 1997, most of which are deemed hypertext fiction. However, in addition to her "digital" activity, she writes traditional, linear texts and stage plays. Berkenheger's projects examine questions concerning identity and role play, observation and surveillance, and (self-)presentation and communication in the information age. She lives and works in Berlin.

The original German-language version of *Bubble Bath* was called *Schwimmmeisterin* (Swimming Attendant) and went online in 2002. At the time of this writing it can still be accessed at http://www.schwimmmeisterin.de. *Bubble Bath* was created and launched in 2005.

Opening the Internet address http://www.thebubblebath.de leads (after the recipient has been instructed to set the correct screen resolution) to a bright yellow browser window containing the following text:

Dear intern, welcome to our bubble bath! Do you see the attractions pool? Around the clock, bodies looking for relaxation are floating past pulsating jets. Some of the jets work like shock therapy, which irritates some guests at first. These effects are desired and normal; they refresh you. Underwater cameras on the pool walls keep a safe eye on the floating guests. In the control room our swimming attendant monitors the thrashing bodies on the screens (see above). She also regulates the spectacular effects from the jets. Just between you and me: What a boring job! You'll realize this in just a minute. The swimming attendant is awaiting you for an internship!

The screens mentioned in the introduction are three small blue pop-up windows that open in the foreground. A white cross in constant motion within each window creates the impression that we are looking at tiles on the wall of a swimming pool, as our vision is disturbed by waves in the water. Passing the cursor over one of these windows opens a dialogue box containing the text "Please don't touch the monitors. Leaves grease spots." If we try again, a less polite "Hey, hands off!" appears. In this fashion we are familiarized with the swimming attendant's habitual tone of discourse.

Next, the "pool regulations" appear in another dialogue box. They instruct the recipient to close all windows not related to the work, to hide the task bar, and to turn up the volume. Only after we have accepted these rules with the OK button does the postscript "The rules also apply to interns!" appear. Whereas the instruction to set

Figure 5.4
Susanne Berkenheger, *Bubble Bath* (2005), screenshot.

the screen resolution was given in advance, and is thus contextualized outside the work itself, the "pool regulations" have a diegetic flavor. If the recipient now clicks on the "Internship" link provided in the introductory text and also confirms the subsequent dialogue box ("Follow me to your employment test!"), a new browser window opens. This shows blue tiles in faster and slower motion on the left and right sides of a divide featuring the question "How rough a sea can you stomach?" The recipient can choose the "right" or the "left" tiles; either way, the internship now begins. First, a broad green vertical stripe appears on top of the moving blue background. This window can be assumed to present an aerial view, insofar as it bears the inscription "ten-meter diving tower." Thus, the recipient is apparently looking directly down from the ten-meter diving board at the water lapping in the pool. A link proclaiming "Don't want to" can be seen jumping around the green area. The swimming attendant is thus represented by a hyperlink which, when activated, does exactly the opposite to the desire it expresses in textual form: Clicking on the swimming attendant's opposition actually amounts to pushing her off the board. However, carrying

out this task turns out to be anything but easy, for catching the shifting link requires dexterity and rapid reactions. Accomplishing the undertaking briefly opens a pink-colored window containing the follow text: "For a moment the swimming attendant stood in midair." The window then gradually diminishes in size until it disappears altogether, leaving the view clear for the tiled bottom of the pool. The recipient is thus watching the swimming attendant falling off, as symbolized by the pink window getting smaller and smaller. This event is followed by the alarming error message "plot. alert (That was it! On the floor of the pool a few ice cubes clinked.)" Happily, however, the text that appears in the following browser window explains that the lack of water in the swimming pool was only a bad dream: ". . . then she woke up. Blinked in front of the whirlpool monitors. With three hickeys on the neck and a harpoon in the locker. At 3 o'clock in the morning." At the same time, new pop-ups appear, introducing new characters: "giggling man, the ignorant," "pool attendant, the trainer," "angry girl, the innocent," "shark75, the demon," "perdita, the desired one," and "bikini strap, the lost one."

Clicking on the part of the text formatted as a hyperlink—". . . then she woke up"—turns the window green, then makes it flicker, then turns it black. New text appears in a font and a format reminiscent of the news ticker headlines seen in television news broadcasts: "+++ the server reports a security problem +++ a distant demon is trying to log on +++ remain calm +++ smoke cigars +++ drink whiskey +++." The recipient is powerless to intervene as more text fragments and hyperlinks gradually appear and are activated by the cursor, which has suddenly taken on a life of its own. He must watch helplessly as a virus called "shark.exe" is loaded, installed, and "smuggled into the guest's system as a swimming object of desire." Gray-toned fade-in comments enclosed on either side by arrow symbols (as used for marking commentaries in software codes) document the reactions of the swimming attendant to these successive events: "<!-- . . . the swimming attendant remained calm. She had dozed off again and was unsuspecting . . . -->."

The recipient must let this scene play out in front of him like a film. The process described here is thus an example of the kind of passage that Alexander Galloway calls "cinematic interludes" in relation to computer games. The recipient's involuntary passivity is especially emphasized in this moment, for if he takes his diegetic role seriously he will feel compelled to intervene. But all he can do is wait until the scene ends and he is returned to the preceding window, which tells of the swimming attendant waking up. If he clicks again on the link ". . . then she woke up," two dialogue boxes appear—"plot.alert (The challenge of her job as a swimming attendant was to stay awake)" and "plot.alert (Her only fun was to tickle the objects of desire with the cursor when they were floating by in shiny bathing suits)"—followed by a new browser window again featuring the swimming pool. The tile structures now slowly move from left to right to the sound of gurgling water, so that the recipient has the impression

that he is swimming. The characters represented by the pop-up windows begin to move.[11] Although it is theoretically possible to navigate within the presented scene, the recipient must behave entirely passively for a short while before the story proceeds autonomously again. This time the wait is not caused by a cinematic interlude in which the story progresses automatically; rather, it is a "wait in real time"—a phase in which nothing happens. Eventually, a new browser window opens in which the swimming attendant asks herself what is going on in her control room. A conversation ensues between the swimming attendant and the shark, driven forward by the recipient through the activation of text fragments marked as hyperlinks. However, this also involves both dialogue boxes and intermittent self-loading browser windows, which—once again as short, cinematic, albeit text-based interludes—drive the story forward beyond the control of the recipient. The swimming attendant and the shark speak directly to one another, accompanied by reports and comments by the narrator. The swimming attendant occasionally addresses the intern—essentially the recipient—who can respond only by selecting one of the available links. For instance, clicking on the word 'swimming' in the statement

The swimming attendant crossed her legs, grass-green thongs were dangling from them, the apron dress crackled, small sharks were wriggling on it. She hummed, shut the eyes, opened them again. O.K. that is nice of you. But I have work to do. Later perhaps you can come swimming with me, she said, turned squeakily away, fished a bobby pin out of the hairdo and rubbed herself on the neck beneath the unfolding hair.

opens a dialogue box "shark.alert (What are you talking about, swimming, swimming. . . . Let me have a go at it, intern!)"; followed by the self-acting cursor selecting the word "legs" as the "right" link option, which leads to the next text window. Ultimately, the recipient is left with no choice at all. The swimming attendant and the intern appear to be getting to know each other better when suddenly the swimming attendant throws the harpoon at the intern, barely missing him. The shark joins in the exchange again, unnerving the swimming attendant, who wonders whether the intern himself might be the shark. A series of poetic and erotic text fragments are then presented as an interconnected web of daydreams, actual occurrences, and conversations. For example, the swimming attendant sends the following message to the shark:

I was licking, just imagine, a shark on a stick when I ran across Perdita this evening. The ice cream was dripping and at the same time the droplets froze, thin icicles fell on Perdita's champion neck, where they melted and were searching her body for a way to the heat.

<!-- The swimming attendant's head fell to the side. . . . She dreamed with open eyes, in front of open monitors, in front of an open mail to shark75. She had completely forgotten she wasn't alone. Or didn't she care? -->

In the German version, a further link on "way to the heat" leads to a prompt demanding "Say right now what you're looking for." The recipient is no longer asked

to choose from a limited number of possible links, but now is asked to freely enter text of his own making, which potentially could lead to innumerable more pages and developments. However, my own efforts to enter text only led me (via dialogue boxes containing ironic comments) back to the previous browser window. Clicking on the second link ("Or didn't she care?")—the only available link in the English version— produces a further text in which the swimming attendant protests that she does indeed care about the intern. The shark then butts in again, declaring that he will have to shut off the power for a minute, with the result that all the windows turn black. The situation escalates. The swimming attendant, who has dozed off, wakes with a start, alerts the intern, and tears the door open, allowing black figures to storm the control room. After a few more dialogue boxes, a blood-curdling scream is heard—the harpoon appears to have hit its target. I must, of course, withhold the identity of the victim, especially because, as I explained above, this is a description of only one possible version of this project. However, my various realizations of the German version always led to a dialogue box declaring "shark.alert (high time to work on your traumas! regret and forget!)" and subsequently to a page depicting a bogus flow diagram of the sequence of action. This maze-like image is designated as a "whirlpool of thoughts" and also offers the recipient the possibility of starting all over again. In fact, going back to the beginning is positively encouraged, for the German version, at least, explicitly states that "the remaining and most important three rounds of text" have not yet been experienced. The English version, although it also offers the possibility of consulting the "whirlpool of thoughts" doesn't stop at the mysterious scream, but immediately proceeds into a kind of second round with slightly altered texts and—of course—different victims. The description of the work ends here, which is another way of saying that I eventually conceded victory to the system. Probably like most other recipients, I will have to live with the doubt that I perhaps never made it to the real core of the work or to a possible high point of the plot.

Bubble Bath was published seven years after *Agatha Appears* and has a considerably speedier narrative tempo. Berkenheger also uses all the options offered by HTML, but she uses them to entangle the recipient in an extremely confusing story line. Whereas *Agatha Appears* revolves around questions concerning virtual reality and teleportation, *Bubble Bath* comes from an era when discussions about digital media centered on issues such as surveillance, attacks by hackers and viruses, and asynchronous email communication. However, the work also describes situations that are not shaped by media and yet still concern different levels of (un-)reality or states of consciousness: sleep, dreaming, and drug consumption.

In contrast to Lialina's *Agatha Appears*, the recipient of *Bubble Bath* can often choose between options that lead to different plot developments. Even if most of these prove to be only brief diversions that ultimately lead back to the main story line, the recipient still has the impression that he is dealing with a complex system. He has to make

decisions and mostly receives direct feedback about them, even if the feedback often calls these decisions into question with responses such as "That was a mistake." In contrast with *Agatha Appears*, the recipient is not simply an external observer; he is assigned a role and is often addressed directly. But he is never in control of the situation. Not only does he remain trapped in the various options programmed by the artist; he is unable to guess their consequences in advance. Both the diegetic and the extradiegetic level of the work are characterized by the effects of different forms of heteronomy. The swimming attendant gives orders to the intern, but she is threatened in turn by a shark who has infiltrated as a virus. The recipient has some possibilities for personal action, but he is unlikely to experience a feeling of agency (defined in chapter 4 as the ability to exert influence on the course of a game in a logically comprehensible and relevant way). Instead, most of the recipient's decisions—generally choices between different hyperlinks—are criticized, mocked, or dismissed as irrelevant. The recipient who accepts his assigned role as intern ends up irritated and unsettled. He is not directing the course of the story; rather, he is being unscrupulously controlled and dominated. Voluntary participation, as one of the main characteristics of the experience of art, is challenged here by the power constellations created through the diegetic role allocation. Even though the recipient knows that the context of his experience is the reference system of art, and is thus based on artificiality, it is still difficult for him not to be affected by the rough treatment he is subjected to in his role as intern.

Like Lialina, Berkenheger plays with the options offered by HTML (and complementary programs such as Java Script) for interaction and dialogue, and also with its graphic components, which have become more sophisticated and now allow different forms of movement within Web pages (the lapping of the water, the sudden appearance and motion of pop-up windows, the change in size in the browser window when the swimming attendant is pushed into the water and when she wakes up again, and the letter-by-letter appearance or flickering of text). Media effects are used to portray spatial developments and temporal processes, although neither the protagonists nor the control room (the actual setting for the plot) are shown or are described in any detail.

The different levels of mediality in this work directly concern the recipient's positioning in relation to the work and to the story it stages. Events in a swimming pool are surveilled by means of control monitors presented on Web pages. Events in a control room are described by means of text. People are also portrayed through text, as is their movement (for instance, the representation of the swimming attendant on the diving board by means of the words "Don't want to"). Neither the beginning nor the end of the narrative is clearly defined, nor is the boundary between extradiegetic instructions and the fictional plot. The location given to the recipient as intern is a control room that is neither portrayed nor described. Thus, the recipient's individual space of interaction (his private room or other actual location) becomes the control

room: the recipient's own hardware (his computer or laptop screen) merges with the diegetic control monitor, and real space becomes diegetic space, while the control room symbolizes mediatized everyday life. Just as the control room works well as a metaphor for the oscillation of the project's spatiality between mediality and reality, the temporality of the work can be usefully described in terms of the concept of laboratory time. Repetition is not only possible; it is emphatically desired, for it is the precondition for an in-depth exploration of the system. Meanwhile, the recipient's actions are meticulously recorded—at least, the maze-like history log at the end of the work suggests that such documentation has taken place. Although the narrative follows a story line, the recipient is often brought back to pages that have already been opened, either because the system dismisses the choice of a particular link or because—as in the case of the infiltrating virus—it automatically returns to a previous page after a certain amount of time has lapsed. The work thus presents multiple, nested temporalities. The story involves frequent internal loops and may be repeatedly activated by a single recipient or by multiple recipients at different times. This is in contrast to the clearly advancing diegetic plot, which, despite its potential for repetition, is presented as unique. The tension that builds up in the context of the story, together with the formal dynamic of the work and the constant demand for (pseudo-)decisions on the part of the recipient, can certainly lead to phases of flow, but with constant interruptions. This happens formally when the reactive liveness of the work is interrupted by cinematic interludes. And it happens at the symbolic level as the recipient is made aware time and again that he is denied any kind of agency whatsoever. Ostensibly an actor participating in a communication situation, in this work, too, he is actually no more than a button-pusher, and his experience of the communication is ultimately passive because his responses are imposed on him by the system. As in Lialina's work, this situation invites the recipient to reflect on his own agency in digital systems, but in contrast to Lialina's work it also requires him to constantly take a position on his assigned role in the diegetic world, for the recipient is not only irritated here by instrumental strategies but is also subject to quite substantial provocation in the course of the staged communication.

Case Study 3: Stefan Schemat, *Wasser*

This case study and the next one move us away from Internet art and toward locative art. The works treated in these two studies are based on GPS technology. Both were presented at an exhibition I curated in the town of Cuxhaven on Germany's North Sea coast.

Stefan Schemat lives in Berlin. While studying psychology in the 1980s, he became interested in research on consciousness and in machine-induced trance states. Before conceiving *Wasser* (Water), Schemat had already carried out several artistic projects

Figure 5.5
Stefan Schemat, *Wasser* (2004), site of work.

featuring digital narrative. Some of these, like the project presented here, were media-based events staged in open space for which Schemat used the term "augmented reality fiction."[12]

The subject of this case study is the presentation of *Wasser* at the exhibition Ohne Schnur—Kunst und drahtlose Kommunikation (Cordless—Art and Wireless Communication), held in Cuxhaven in 2004. The work was conceived especially for the Ohne Schnur exhibition and with specific reference to the location in Cuxhaven. The description of the work presented in the following is the result of my deep engagement with the project, which lasted more than a year and which included organizational preparations and discussions with the artist, my experience as a recipient and custodian of the work (which allowed me to observe other recipients and to discuss the work with many of them), and several presentations of the project in written publications.[13] The following description thus results from a realization of a work which is based on my own experiences and reflections, on reports by other recipients, and on discussions with the artists. Like most art-historical descriptions of artworks, it is a cumulative construction.

Visitors to Schemat's *Wasser* are given a backpack containing a laptop computer, a GPS device, and headphones, and are then invited to explore a part of the coastline where the Elbe River enters the North Sea at Cuxhaven. Using the exact location of the visitor as established by the GPS system, the computer plays back different text fragments through the headphones. Together, these make up a story whose content is shaped by the recipient's movement, by the direction in which he walks, and by his endurance in exploring the area. The story line is not linear; rather, it takes the form of a mesh of situations, actions, memories, and observations. The basic framework is a criminal case: a woman has disappeared and the recipient is asked to find her.

The texts range from concrete instructions ("Come on, get going!"[14]), through private reminiscences ("But why did you run away?"), to scientific and philosophical observations about the weather and the underwater world, which often lead into musings about transformation and metamorphosis ("As a shell, I am deaf and blind"). The narrators sometimes appear to be detached observers and sometimes appear to be characters in the story. Occasionally they challenge one another ("Don't listen to the voices!"). The story alternates between fact and fiction and between past and present. It is also closely tied to the landscape in which it is being presented. Aspects of the scenery are mentioned, and observations are made about the weather. Descriptions are given of events that have taken place or could take place in locations that the visitor is passing at that very moment. The landscape thus provides imagery to accompany the text, and the recipient might have the sensation of being in a film—except that he is actor and audience at the same time. The spatial and temporal gestalt of the work depend entirely on the action of the recipient. He determines the work's duration and scope, as well as the order and the pace of the blending of texts and scenic elements that constitute the work. He becomes the conceptual, physical, and executive cornerstone of the work, even though its fictional centerpiece, the missing woman, remains hidden from him.

From the perspective of literature studies, Schemat's work is comparable to a drama. Its use of acoustic media relates it to radio drama, while its non-linear structure equates it with a hypertext. In terms of content, it is a detective story told by alternating narrators. The story has a fixed starting point to which visitors are sent after being given their equipment by the staff working at the distribution station. The boardwalk leading to the starting point is bounded on the left by a wind barrier and on the right by an embankment, so that it is practically impossible to stray from the route. The first text passage is thus the only one that is unquestionably heard by every recipient, and the first sentence immediately creates a link between the temporal and the spatial beginnings of the story: "Every story has a beginning. That is exactly where you are standing right now." A short introduction follows in which the visitor learns that he must assume the role of a blind detective who has been commissioned by phone to find a man's daughter. Accordingly, he is asked to close his eyes. He is told that a detective

Figure 5.6
Stefan Schemat, *Wasser* (2004), site of work.

doesn't believe everything he hears, and is then sent on his way: "Don't ask me how you're supposed to solve the case. Just start. . . . Go on, get out of here!"

However, the recipient is given no indication as to where he should go. He must choose either the long beach with its tidal mudflats, the boardwalk, or the dunes. If he follows the brash order to get moving and begins walking in one direction or another, he will encounter further texts spoken in a male or a female voice. Sometimes he is addressed directly; other times he simply listens in to monologues or stories. Some of the passages narrate concrete events or memories or comment on the situation of the blind detective; others are meta-texts describing meteorological phenomena or liminal situations, for instance the experience of drowning ("The drowning man has no time to marvel at the underwater world"). Although it is not clear whether either speaking voice specializes in particular types of text, direct orders and interjected warnings ("They want to pull you into the ocean!") usually are issued by the male voice. The female voice tends to speak more often of past events (such as her memories of her own visits to the beach as a child) and also makes many of the scientific obser-

vations. Nonetheless, there is no clear assignment of roles, and each of the voices occasionally also speaks the other's more typical content. The allocation of roles among recipient, speakers, narrators, and protagonists is likewise often ambiguous. For example, when a woman's voice says "I need your help right now," it is not clear whether she is speaking to the recipient or to a fictitious person. The same is true when the male voice shouts "Go back!" Likewise, the male speaker, who initially has the role of neutral observer, later becomes emotionally involved himself: "Why do the voices always try to lure me into the ocean?" This example also illustrates how the voices themselves are occasionally addressed as actors. The same is true when the recipient is told "Beware of being distracted [by the voices], open your eyes instead."

The texts form a rhizome of potential links with multiple layers that overlap in several respects and at the same time often contradict one another. On the one hand, there are actual acoustic overlaps between voices, while, on the other, there are overlaps between different narrative perspectives and between different temporal structures. For example, some texts allude to two different times in the past ("There was a moment on the first day when I was standing here, right in this place, and it was as though I had never been here as a child"). The texts do not follow an ideal sequence determined by evident links between one and the next, as in a linear narrative. But there is also no preset branching structure, as in hypertext. There are no hints that would constitute invitations to proceed to another text or offer the option of consciously moving on to one of several further texts. The recipient simply listens to a text or a part of a text, moves forward, and encounters new texts.

No two texts are directly linked, but the artist can increase the probability of a consecutive interplay by means of spatial proximity. The criterion that structures the composition of the texts is the landscape. Thus, it is the recipient who determines how the gestalt of the work evolves in each particular realization by deciding to go to a particular location or to choose a certain itinerary.

The landscape forms an integral part of this project. It is thus not just a text-based (auditory) endeavor, but a multi-sensory work. *Wasser* is a drama based on movement and visual perception. This is why a comparison with film seems appropriate, even if the work doesn't have discrete visual elements or segments—akin to film frames—that the artist could process or arrange in chronological sequence. The artist has chosen only the environment in which the story is supposed to take place and the specific locations in which the different texts will be heard. He has no control over the recipient's decision to go or not to go to the different locations, or over what they will look like at the specific moment when they are visited by the recipient. Likewise, the artist has no means of influencing the recipient's angle of vision or his distance from the object on which he is currently focusing (this might be likened to frame selection), nor can he control the duration of the recipient's gaze or the moment in which he changes perspective (as in film editing). It is entirely up to the recipient which visual

phenomena he turns toward, in which direction he moves, and at which speed he advances. His motion takes the place of the motion of the camera, and his eye substitutes for the lens. Continuing the comparison with film, the recipient's role is closer to that of camera operator than to that of audience. Seen from this point of view, Schemat's work is effectively an implementation of Dziga Vertov's theory of the "kino-eye," which equates the filmmaker—or even the camera lens—with the human eye.[15] Whereas Vertov, notwithstanding his theories, remained faithful to the tradition of pre-recorded and edited film in practice, Schemat's work really is based on the recipient's active perceptual choices. Moreover, these "visual selections" are not conveyed via media, as in film, and are thus not even images in the conventional sense, but are actual landscape—that is, matter put on stage by the artist.

The foundation of the aesthetic experience of the work on physical materiality encourages us, in turn, to investigate the work's relationship to the visual arts. Visual artworks traditionally have a material gestalt and a spatial extension. In terms of materiality, Schemat's work can be described as a combination of software and hardware—as a program installed on a portable computer that accesses stored assets (audio files) and processes data received from a GPS device. The only apparent interface is a set of headphones. The recipient is unaware of the input and receipt of information, which is actually triggered by his movement. Nonetheless, the work does have a spatial dimension—the "immaterial materiality" described in chapter 4 above. In fact, this work's materiality is even defined by means of exact geographical coordinates. Furthermore, just like the space of a painting or a sculpture, *Wasser*'s radius of action features compositional arrangements. Some positions are characterized by a tight sequence or overlapping cluster of audio data, others by counterpoints in the form of short, irritating sentences; still others belong to calmer areas where little information is provided. The texts are arranged spatially, and the distances between them are programmed in advance. Each text belongs to its own zone of fixed range. Nonetheless, the positioning of the texts is always only potential until they have been activated by the recipient. The sound composition doesn't linger in space independently of its reception, like an acoustic space created by loudspeakers or a visual space generated by a light installation; here, the sound only manifests itself the moment the recipient enters the zone allotted to that particular text.

Moreover, the work is not located in a neutral space. On the contrary, the geographical coordinates tie the data to a particular piece of the landscape, which, as a result, becomes a fixed component of the work in a material sense, too. As a mise-en-scène of landscape, the work can be compared to land art. Although Schemat doesn't move huge masses of earth, as North American "earth artists" did, he does incorporate the landscape into his work and thus has a similar approach to those land artists who, instead of altering the environment, give it new meaning through temporary, often performative actions. In Richard Long's *Walking a Straight 10 Mile Line Forward and*

Back Shooting Every Half Mile (1980), the artist walked through a landscape, following strict conceptual rules and taking a photograph every half-mile that recorded the exact view of the scenery at that point.[16] Schemat also stages movements within landscape and draws attention to particular areas of the environment. However, unlike most land art projects, he also ties the landscape into new narrative contexts.

But the landscape also tells its own stories, for the area in which the work is set is extremely diverse. On the one hand, the mouth of the Elbe and the mudflats are scenes of elemental acts of nature (in few places on Earth are the tidal cycles as impressive as here), and many of the texts are devoted to these natural phenomena. But the texts are not simply descriptions that seek to translate visual impressions into spoken word; rather, they contextualize the landscape from different perspectives. They contain scientific explanations, poetic adulations, and narrative adaptations, thus enhancing the experience of nature by means of other, often associative dimensions.

On the other hand, this is a man-made environment. The beach is artificial, a boulder wall protects the shipping fairway against silting. An embankment protects the dry land against flooding. Piers have been built as breakwaters, and wooden fences act as windbreaks. A stone-paved boardwalk, a beach restaurant, and wicker beach chairs are provided for tourists. Some of the texts refer to this aspect of the landscape, for example when the detective is instructed to question passers-by ("So now you can walk down the beach, show people the photo, and ask them 'Have you seen this woman?' "), or when the female voice remembers having been at the beach as a child ("I forget the days in the beach chair, wrapped up in a blanket").

A third characteristic of the landscape is represented by an old sea buoy and an abandoned harbor. These can be considered a reminder that shipping has long been an important contributor to the economy of the region. At the same time, they also testify to the historical evolution of shipping. The small harbor is no longer in operation, the buoy is no more than a symbol, and shipping nowadays relies on ultramodern radar technology. Schemat's texts do not explicitly mention shipping, but the recipient is constantly exposed to related technology. The sound of an ocean sonar is heard at regular intervals, almost subconsciously weaving the very heterogeneous texts together. These sounds also evoke a mysterious atmosphere that is well suited to the story of the missing woman.

Schemat chose this location for its ambiguous environmental characteristics. Here natural phenomena, tourist life, and nautical references come together. He used the positioning of the texts to call attention to certain sites, but he did not modify the environment in any way. The sounds and the texts add an extra layer to the landscape, enriching it with stories, explanations, associations, and memories. The landscape and the texts thus become a fabric woven from reality and fiction that constantly blurs the boundaries between documentary description and physical presence, on the one hand, and poetic atmosphere and narrative fantasy, on the other. It would be a mistake

to conclude that the fictional texts are anchored in reality by the actual landscape. On the contrary, the texts often seem to transform the landscape into a world of association colored by metamorphosis and ambiguity.

If the recipient were to follow the diegetic instructions literally, he would never see any of the scenic elements, because he is addressed from the outset as a blind detective and instructed to close his eyes. Though it isn't likely that any recipients follow this instruction for any length of time, envisioning its consequences brings other components of the work—all the sensory impressions not transmitted visually—to our attention. As an object of haptic experience, too, the landscape offers a multitude of different stimuli: the materialities of water, sand, mudflats, stone and concrete, grass and wood can be sensed in all their heterogeneity. Not to mention the wind, which is a characteristic feature of the area. Even the recipient's olfactory perception is stimulated in many ways—by scents that range from the salty intensity of the sea air to artificially perfumed sunscreen. The possibility of sensorimotor experience thus constitutes another important level of the aesthetic experience of this work. As was mentioned in chapter 1, this kind of experience has become a focal point of the visual and performing arts since the middle of the twentieth century. At the latest since Allan Kaprow filled the courtyard of an art gallery with old car tires (in his 1961 work *Yard*) in order to heighten the sensitivity of visitors for the aesthetics of bodily sensations, artists have continued to seek to activate multi-sensory perception.

The interweaving of landscape and fiction in each individual realization of *Wasser* is governed by a complex interplay of different rule systems. The instructions given to the recipient when he is handed his equipment are simple and rapidly articulated: He should put on his backpack and his headphones, walk in a certain direction, remain within the bounds of a specified area, and bring back the equipment within two hours. As was explained above, the recipient receives his first diegetic assignment at the point where he hears the first text passage—the task of looking for the missing woman. His role—that of the blind detective—is also explained to him at that point. Both of these instructions—the extradiegetic directions given by the assistant at the distribution station and the diegetic task given in the text—can be characterized as operational rules. At this point, the recipient has already managed to extrapolate another rule— that he must go to certain locations in order to hear further text passages. However, this rule can also be considered a constituative rule—a part of the logical structure of the work. The underlying logical structure of the system leads to a specific text being played as soon as the GPS device supplies a predefined coordinate. There are other, more complex constituative rules: tolerance values that define the radius of the sound zones, and settings that determine what happens if, for example, the recipient moves while a certain text passage is still being played.

The operational and the basic constituative rules are thus easily explained. However, what are equally important for the aesthetic experience of the work are the implicit

rules—the unwritten laws of behavior that decisively influence the perception of action, especially when a project is located in a public space rather than in a gallery. These rules are closely associated with the question as to the framework in which the recipient contextualizes his activity. If the recipient accepts his role as a blind detective, he must obey the order to close his eyes, and his first aim—no matter what—should be to look for a missing woman. If he sees himself primarily as the recipient of an artwork, he should commit himself to concentrated perceptual awareness, to reflecting on the artwork, to exploring its structure, and to observing the interplay of the different components, both form and content. However, he should also handle the equipment he has borrowed with care, avoid placing it at any kind of risk, and be careful about returning it on time so that other people will also get a chance to experience the work. If he is mainly interested in the technology that has been used, he will particularly want to explore the programming behind the work. He will repeatedly enter and leave certain sound zones in order to test the reactions of the system, he will try to find the limits of the installation, and he may even be tempted to unpack the technical devices in order to understand the way they work. If he sees himself mainly as a tourist who has come for the beach (who perhaps only passed the lending station by chance and borrowed one of the devices out of curiosity), he will try not to stand out too much and will avoid disturbing other tourists (for example, by coming too close to their beach chairs). However, he will find it difficult to suppress or conceal the materiality of the technical system, for Schemat has no interest in technological transparency. Both the backpack that contains the laptop computer and the head phones are quite large.

The frames within which the recipient may perceive his own actions are kept consciously open. The artist doesn't prescribe the "right" reception attitude. Accordingly, very few recipients will adhere to a specific frame setting, but a recipient may prefer to switch from one attitude to another. The resulting frame collisions are a major component of the aesthetic experience, which is a consequence not of a sophisticated program but of the positioning of the interaction proposition in public space and of the self-positioning of the recipient with respect to the interaction proposition. Technically, the work is a fixed system. The composition of the texts in relation to the landscape was defined in advance, and every visitor always finds the same texts in the same place. The interaction proposition presets the content, style, and composition of the texts, as well as their location in the landscape; this is a data-intensive, not a process-intensive work.[17] In terms of the ranking-scale classification models described in chapter 4, the kind of interaction enabled by this work is purely navigational. If, nonetheless, the work can be said to be extremely complex, that isn't due primarily to the code on which it is based, but to factors that go beyond its information technology structure—namely the interplay activated by the recipient between the textual world and physical space. In other words, the changing weather conditions and social

circumstances in which the work is realized each time create new contexts for the texts. As a result, the work can be said to have an emergent character, in the sense of a gestalt that becomes concrete over the course of the interaction. This emergence isn't based on the interplay between operational and constituative rules, however; it is based on the interplay between implicit and operational rules and between materiality and interpretability in each individual realization. And yet here, too, there is no agency on the part of the recipient. Although he is assigned a diegetic role, he actually has no freedom to act within the narrative. Although solving the mystery of the missing woman is formulated as a diegetic goal, this is by no means the main factor motivating the interaction, insofar as the recipient is inclined from the outset to ignore a significant feature of the role he has been assigned—the fact that the detective is blind. Thus, the fictional goal is not—or at least not necessarily—crucial for the activity of the recipient.

While exploring a narrative structure, the recipient has to adopt a position with respect to different possible social roles, trapped as he is within a state of oscillation between reality and fiction. It is nearly impossible to experience the interaction as a seamless process, for complete immersion in the fictional plot, on the one hand or appreciative or critical reception of art, on the other is constantly impeded. It is highly unlikely that the recipient believes he is participating in an actual dialogue, although he is interacting with digital data—in this case with pre-recorded audio files. More probably, he will contextualize the project as a mise-en-scène and will be interested in exploring its structure. Consequently, he may well stray from the apparent goal of looking for a missing woman and instead listen over and over again to the same text passage because it moves him. He may also defy other diegetic rules of the work, such as the requirement that he close his eyes, because he doesn't feel them to be binding. In fact, the work encourages recipients to violate this rule, because, despite the clear order at the beginning to keep one's eyes closed, one is later explicitly encouraged to open them. At the same time, the work constantly prompts the recipient to traverse the boundary from art to everyday life and vice versa. To an external viewer the recipient is no different from any normal person walking on the beach, But the recipient quickly becomes aware of his double role as a walker (i.e., a participant in the everyday life of the health resort) and a recipient of art (i.e., an aesthetic observer of the activities he is carrying out). The ambivalence between the activities of contemplating art and strolling on the beach guides the reception of the work. Frame collisions of this kind are a basic component of the aesthetic experience of interactive art. The recipient is torn between the realization and the refutation of an action and has to decide whether to strictly observe to rules of the interaction proposition or to explore it more freely. This oscillation between identification and reflection contributes to the recipient's becoming aware of his own ambivalent position within the complex fabric of fictional elements, associations, and materialities that the work unfolds.

Schemat addresses the cultural and ecological setting of the North Sea coast as a tourist resort with its own memories and stories, but he also presents it as a scene of physical phenomena and imagined metamorphoses. In this way, he relates the mysterious heterogeneity of the environment to the mystery of a story that likewise interweaves personal memories with descriptions of natural phenomena. At the same time, he contrasts the experience of what is happening in the here and now (the actual presence of both the recipient and the landscape) with the cycles of nature and memories of past events. Schemat's work uses narration and fiction, although these are by no means either linear or seamless. The fact that this fiction is embedded in a real environment, however, means that physical activity is required on the part of the recipient, and consequently also a social self-positioning within everyday life. As in Berkenheger's *Bubble Bath* the emphasis is on the recipient's position with respect to the story. In Schemat's work the recipient's position takes effect within a complex arrangement of layers of reference systems which is substantially shaped by the localization of the experience within the space of everyday life. Not only are spacing and synthesis central components of the interaction proposition (in the sense of a spatial staging and contextualization of the narrative elements); they are also central components of the reception. The reception is accompanied by processes of spatial construction and perception that—just as Martina Löw describes in her sociological analysis of space (discussed above in chapter 4)—concern not only material space but also social space. In this way, reality constitution and interpretability enter into relationship, and the realization of this interplay is at the core of the aesthetic experience of Schemat's *Wasser*. The work takes on form only as a result of the recipient's act of synthesis. The emerging gestalt of the work concerns not only the paths chosen by the recipient and the resulting selection and sequencing of passages of text, but also the recipient's individual construction of interpretability at the boundaries of fact and fiction.

Case Study 4: Teri Rueb, *Drift*

Teri Rueb is a professor of media studies at the State University of New York at Buffalo. Since the late 1990s she has been creating site specific installations and interactive sound walks in both urban and rural public environments. These works invite recipients to explore landscapes of text and sound that have been configured using GPS technology. *Drift*, like Rueb's later project *Itinerant*, is based on literary texts. In more recent works, Rueb created location-based compositions of sound and noise.

Drift was presented at the exhibition Ohne Schnur—Kunst und drahtlose Kommunikation, held in Cuxhaven in 2004, which also featured Stefan Schemat's *Wasser*.[18] Because it depends on tidal flows, *Drift* was not only conceived for a specific location, but also for a specific period of time—the duration of the exhibition. The software

Figure 5.7
Teri Rueb, *Drift* (2004), visitor wandering in Wadden Sea (© Teri Rueb).

was created by computer science students of Professor Zary Segall at the University of Maryland. The computer scientist Erik Conrad assisted with the on-site configuration in Cuxhaven. My description of this work, like my description of *Wasser*, is based on my extensive conversations with the artist, on my own reception experience, and on observations of and exchanges with visitors.

The recipient of *Drift* first visits the distribution station, which is housed in a room provided by the lifeguard service in a building on the boardwalk. Here he is given a small backpack and a set of earphones and is instructed to head into the tidal mudflats of the Wadden Sea. He is also shown the 2-kilometer-by-2-kilometer area he is invited to explore. Unlike the path along the boardwalk that marks the "start" of Schemat's work, in *Drift* the recipient is not asked to follow any particular route across the beach into the Wadden Sea, and therefore the work doesn't have a distinct starting point. The recipient wanders freely through the mudflats. As he roams through this unique terrain, there are long phases during which his earphones remain completely silent and all he hears are the natural sounds of the landscape—the sounds of seabirds, wind, water, boat engines, and his own footfalls on the wet, sandy soil.

Suddenly, however, the recipient hears footsteps that he recognizes are not his own. After a little while, a voice begins to talk about walking, scenery, and journeys. The recipient may hear a complete train of thought, but sometimes the voice breaks off suddenly and the sound of footsteps also slowly fades away. After a while, the recipient hears another text, again heralded by the sound of approaching footsteps and again dealing with the topics of wandering or searching. The texts—fragments from the writings of James Joyce, Thomas Mann, Dante, and other writers—are spoken alternately in German and English; the recipient cannot choose one language or the other. The theme of all the texts is the feeling of being lost or disoriented. For example, one fragment consists of the opening lines of Dante's *Divine Comedy* ("Midway upon the journey of our life, I found myself within a forest dark, For the straightforward pathway had been lost"[19]) and another of a passage from Rousseau's *Reveries of a Solitary Walker* ("and there, stretching myself out full-length in the boat, my eyes turned to heaven, I let myself slowly drift back and forth with the water, sometimes for several hours, plunged in a thousand confused, but delightful, reveries").[20]

If the recipient, having listened to the texts while walking, turns back so as to hear a text again, he will be disappointed. It is nearly impossible to ever find the same text again, although the recipient doesn't know whether this is due to his (possibly weak) orientation skills, whether the text has been lost for technical reasons, or whether its disappearance is a conceptual part of the work. In other words, searching and wandering are not only the subject matter of the texts, but also modes of experiencing the work. Often the recipient is left to roam at length through the fascinating landscape. The complete absence of either physical or narrative landmarks focuses him on himself and on his own perceptions of the environment. When he eventually happens on a text again, it is as though he has met a stranger reflecting on his own loneliness.

Figure 5.8
Teri Rueb, *Drift* (2004), graphic visualization (© Teri Rueb).

The reason for the ephemeral nature of the texts is revealed in a video projection that accompanies the work[21]: the texts wander across the Wadden Sea in correspondence with the North Sea tides. In other words, the recipient chances upon the texts, all of which may be heard in different locations a few hours later. The transient nature of the data space corresponds to the character of the landscape in which the texts are played, for the Wadden Sea is also in a constant state of change. It is flooded by the incoming tide at regular intervals, only to emerge again in a new guise, shaped each time anew by the weather conditions, the wind, and the ocean currents. The texts and the landscape enter into a symbiosis in which the ephemeral soundscape is interwoven with the cyclical movements of the tides. The temporal structure of the work is thus tied to a rhythm that—as one of the oldest timetables of all—predates manmade time systems. The rhythm of the work places the original cycles of nature at center stage.[22] These cycles have now been studied scientifically, can be forecast almost to the second, and thus can be simulated by a computer program. The wandering assets also present a more recent potential of time, which has been described by Paul Virilio as "delayed time"—stored time that can potentially be activated at any moment. However, in Rueb's work the location of this stored time depends on the tides. The recipient must conform to these cycles, which are dictated by nature and are now taken up by the computer program.

The simulation of the tides by means of the computer program belongs to the constitutive rules of *Drift*. These rules are also responsible for the evaluation of the recipient's GPS coordinates, which activate the recorded texts. But the text fragments are not bound in a permanent way to these coordinates, for the allocation of particular texts to particular geographical positions changes constantly. Because the location of the texts is based on the tidal calendar, only an additional query regarding the time of the activation determines which text will be heard at the recipient's current position.

The operational rules, on the other hand, which are conveyed at the lending station before the beginning of the interaction, consist of just a few simple indications. The visitor is shown the area within which he is free to walk, and a maximum borrowing time for the equipment is agreed upon. In contrast with Schemat's work, the operational rules in *Drift* are limited to extradiegetic instructions. The recipient is not addressed directly during the interaction. He is not assigned any role, nor is he given a diegetic goal to pursue. There is also a fundamental difference between the implicit rules of the two works, although both are interactive artworks presented in public space and one might be tempted to assume that they have similar reference systems. The fact that Rueb doesn't assign the recipient a task belonging to a fictional framework means that the recipient is not obliged to decide either for or against taking on this role. Rueb goes even further by not even pretending to present a coherent narrative. The texts, which are literary citations in various languages, are solitary fragments—isolated passages that have been robbed of their original context. Nonetheless, they

have a common theme, and together they create an associative space of potential intertextual relations.

Since the text passages do not address or involve the recipient directly, he finds himself in a role similar to the distanced observer of art, or at least so it initially seems. As a recipient of art, he has certain expectations, which, however, differ considerably—regarding interactive art—from expectations concerning traditional artworks. Interactive art is often associated with the idea of complex and direct feedback processes that are as similar as possible to face-to-face communication. But Rueb's work defies such expectations, for example when she allows for lengthy stretches during which no sounds are heard from the earphones. Like the impossibility of returning to a location in order to listen a certain text again, these silent phases irritate the recipient. I met many visitors who returned prematurely to the distribution point believing that their equipment was defective or that they had not correctly understood the operational rules. It is not at all easy to accept the work as it is and to fill in its gaps (to borrow Wolfgang Iser's terminology, as discussed in chapter 2) in a productive way.

Rueb instrumentalizes the recipient's expectations of interactive art to heighten his sensitivity to the natural sounds of the environment and his connection with nature. Another strategy to achieve this goal is the deception of the recipient's sensory organs, which leads to a deeper perception of central features of the work. The unpredictable alternation between natural noises and transmitted sound bites makes it difficult to distinguish between the two. For example, the recipient may begin to wonder whether he is listening to his own footsteps, to those of other walkers, or to a recording. Such doubts become all the more likely as the recipient finds it difficult to believe that the work really could foresee such long passages without mediated sounds. The recipient knows that the work is based on a technical system, so he expects this system to do something. As a result, he may assess each and every acoustic perception—including the real sounds of the environment—seeking to understand whether or not it is part of the work. This activity of evaluation and questioning, in turn, increases his receptiveness to the feelings of disorientation described in the texts.

The way the work plays with real and fictitious environmental sounds also draws the recipient's attention to the landscape. The illusionistic sound of footsteps increases the recipient's awareness of his own movement, so that his gaze automatically shifts downward to the sand of the mudflats. The Wadden Sea, which is shaped by wind and water and is in a constant state of change, can be understood as a metaphor for our changeable journeys through life and our fleeting perception of space. The Wadden Sea consists of a broad and flat expanse with no prescribed paths or insurmountable obstacles. The experience of not having to follow a specified path but having complete freedom to choose the direction of one's own footsteps is unusual for contemporary man. At the same time, this huge area has an internal structure in the form of countless patterns on the ground. Each day, the wind and the waves sculpt new designs on

the wet, sandy soil. These web-like corrugated structures consist of ridges and grooves that open, merge, and separate again, each time either channeling or blocking the flow of the shallow water lying within them. In *Drift*, this physical structure is overlaid by the mobile network of the wandering citations. The spoken texts create an immaterial land made of stories and thoughts, on the one hand, and data streams, on the other. This land appears to be floating freely, but it is actually bound to the cycles of nature, because it changes with the tides.

As with Schemat's *Wasser*, it is the interplay between landscape and texts—activated by the recipient—that determines the aesthetic characteristics of the work. However, in Rueb's work the links between the landscape and the texts are fleeting and changeable. Drawing on Martina Löw's terminology concerning spatial analysis, the Wadden Sea is a place that resists "spacing"—the construction of space through the positioning of goods or people. If such positioning happens at all, it lasts only a short time before being obliterated. And yet the recipient does construct a spatial structure in his perception, of which the text passages he hears become an integral component. These processes of synthesis must build on memories, and the work becomes manifest as an ephemeral process in constant flux, each individual participant constructing his own relational map of his own movements, the texts he has heard, and the places he has visited. The next recipient will find the texts in different locations. The themes of Rueb's work are the transience of our spatial attachments, our rootlessness, and our disorientation. At the same time, she shows that where spaces are constructed on the basis of perception, ideation, and recall, this process may be governed by images and sounds from our individual memory as well as from external data sources.

Although Rueb's work doesn't construct a fiction, it does feature different levels of illusionism. In addition to the possible sensory deception stemming from the overlap between natural and artificial sounds, Rueb works with an illusion that concerns the technical structure of the work. As described above, the recipient perceives the interaction as a walk through drifting clouds of sound. He appears to be wandering through a mysterious data space. This interpretation of the work as a soundscape that exists independently of its activation is supported by the spatial dynamic of the sounds, wandering with the tides irrespective of visitor actions. Nevertheless, although Rueb strives to keep the required technology inconspicuous, technically the recipient of *Drift* still carries the data space on his own body—in fact, all the sounds are stored on the minicomputer he is carrying around with him. The only direct link with the "Hertzian space" is an integrated GPS device that constantly verifies the recipient's current position.[23] Thus, technically this work is only rudimentarily connected to what Manuel Castells has termed the "space of flows" of local and global data and communication networks (discussed above in chapter 4). Nonetheless, the aesthetic experience of the recipient is that of wandering through streams of sound or text that preexist in Hertzian Space and are rendered audible by the recipient. This experience

is in line with the work's goal of revealing the wandering streams of data and relating them to the constant variability of nature and to our own physical and emotional journeys. Not every form of illusionism in media art must, therefore, provoke its own exposure by means of built-in disruptions. In this case, appearances are maintained, which is, in fact, an important aspect of the work.

Schemat's *Wasser* and Rueb's *Drift* offer entirely different aesthetic experiences, despite the fact that they share the same exhibition site, technology, and core mechanics (walking and listening). Schemat works on a cultural and natural space by describing physical phenomena, imagined metamorphoses, memories, and stories. He sends us into a world that challenges the boundaries between fact and fiction. Rueb takes a different approach. She doesn't choose specific locations; rather, she stages the area as a landscape in which at best only temporary spacings can take place. She addresses this landscape both as a stage and as a metaphor for the challenges posed by the information society by synchronizing the physical experience of disorientation with the acoustic perception of literary texts dealing with that topic. She invites the visitor to actively explore the multiple links between floating data and texts and the rhythms of nature. Both works are based on an ambivalent relationship between materiality and signification. Whereas Schemat relates the landscape to a fictional story and metaphoric descriptions, Rueb presents it in its dual role as a physical location for walking and as an abstract metaphor both for our life's journey and for the challenges of today's information society. Rueb addresses the recipient as a contemplative wanderer whose receptiveness to questions about the goals of our journeys is heightened by the mingling of recorded texts and the real sounds of nature. Schemat immediately places the recipient in a fictitious role and gives him a task that will never be accomplished.

Wasser and *Drift* are based on different types of frame collisions that stage aesthetic experience as oscillations between materiality and signification, between immersion and distance, and between action and reflection. Although both works make use of a technology whose usual purpose is precise navigation and orientation, they nonetheless create an unsettling, disorienting experience. In *Wasser* this leads to reflection on the relationship between fact and fiction and the capacity of media to manipulate, but the primary aim of *Drift* is to encourage more intense self-reflection on the part of the recipient. At the same time, Rueb's work can as well be interpreted as a critical commentary on our expectations regarding the information society in general and media art in particular.

Case Study 5: Lynn Hershman, *Room of One's Own*

This case study analyzes a pioneering work in interactive art in which interaction is staged as real-time communication—or mutual observation. Lynn Hershman is an

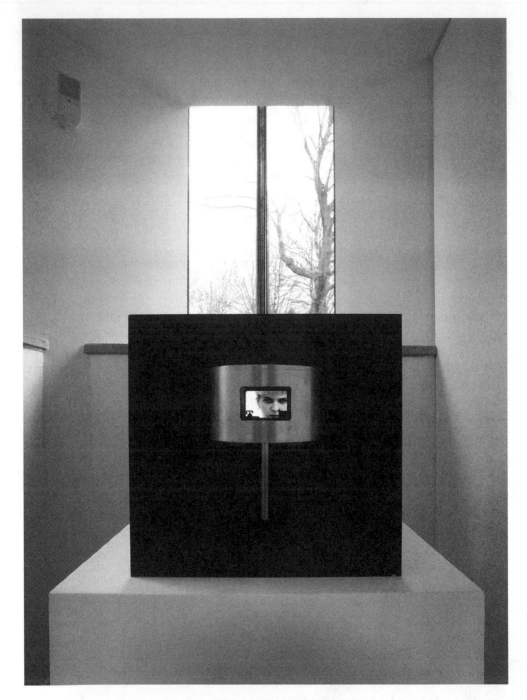

Figure 5.9
Lynn Hershman, *Room of One's Own* (1990–1993/2006), installation view at LehmbruckMuseum, Duisburg (photo: Jürgen Diemer, © Lynn Hershman Leeson and Paule Anglim Gallery, San Francisco).

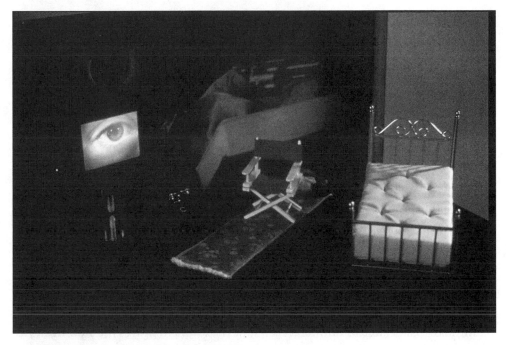

Figure 5.10

Lynn Hershman, *Room of One's Own* (1990–1993/2006), interior view (© Lynn Hershman Leeson and Paule Anglim Gallery, San Francisco).

artist and filmmaker based in California who has been working with new media since the 1970s. Her earlier interactive projects took the form of installations, but nowadays she often conceives Internet artworks.[24]

The interactive sculpture *Room of One's Own* was created between 1990 and 1993 in collaboration with Sara Roberts and Palle Henckel.[25] Four copies of the work were made. One is in the artist's possession; the other three are housed in the Lehmbruck-Museum (Duisburg), in the Donald Hess Collection (Napa, California), and in the National Gallery of Canada (Toronto). All four copies were restored in 2005 by Palle Henckel.[26]

The following analysis is based on personal explorations of the work conducted during several visits to the LehmbruckMuseum in 2007. In addition, I produced substantial video documentation of *Room of One's Own*, which I then used to support my description of the work. After viewing the work, I interviewed Gottlieb Leinz, the curator of the sculpture collection at the LehmbruckMuseum, and visited Hershman in her atelier in San Francisco. I also consulted the documentation of the work kept at the museum, and a 2005 film about the restoration of the work that describes its technical composition and its functioning in detail.

Visitors to the permanent exhibition at the LehmbruckMuseum in Duisburg hear, at irregular intervals, the sound of cheerful whistling, singing, and a woman's laughter. Those who seek the source of the sound end up in a small, slightly hidden room containing a box measuring about 30 centimeters wide and standing at eye level on a pedestal. The front of the box is fitted with a stainless steel cylinder that can be turned by a handle. A rectangular peephole allows one visitor at a time to look inside the box.

Moving closer to the box and peering through the viewing device, one sees a miniature room furnished with a bed, a carpet on which a few pieces of clothing are strewn, a director's chair, a table with a telephone, and a television. As soon as a recipient approaches the viewing device, a film begins to play on the back wall of the miniature room.[27] The protagonist of the film is a short-haired blond woman wearing a red leotard and sitting on a chair that resembles the director's chair in the miniature room. She is looking directly at the recipient. A woman's voice begins to ask questions: "Excuse me, what are you doing here? How did you get here? Would you please look away?" The last question is accompanied by the appearance of a close-up of a face on which the word "WATCH" is inscribed. The image of the blond woman then reappears, and more questions are asked.

The tiny room is bathed in a reddish light. There are small lamps affixed to the ceiling above each piece of furniture. Each time the recipient moves the viewing device so as to bring a particular object into his field of vision, the lamp above it lights up and a new film is played on the wall behind it. For example, when one looks at the bed on the right, the film in the background shows a woman lying on a bed, gripping the bars, and moving so vigorously that the mattress is squeaking. Both the image and the noises suggest that a sexual activity is taking place, although no other person can be seen. The film then cuts to a close-up of the face of the protagonist, who is now lying on the bed.

The film that plays when the recipient shifts his gaze to the carpet also shows the blond woman, this time wearing only underwear, tights, and boots. She looks at the recipient and begins to undress. The recipient is asked what he is doing there and ordered to avert his gaze: "There is nothing in here for you to see. Look at your own eyes in the television."

When the recipient shifts the viewing device further to the left, toward the director's chair, he sees the woman sitting on the chair, as in the initial film, and the questions he hears are similar to those asked at the beginning of the interaction. Once again, a close-up of a woman's face briefly appears, but this time the picture it is overlaid with a crosshair followed by the words "ARE OUR EYES TARGETS?" The subsequent view of the face once again shows the inscription "WATCH." The film concludes with another shot of the woman sitting on the chair.

If the recipient looks further to the left, at the telephone, the film shows the woman interacting on the telephone. Together with her interlocutor, whom the recipient

cannot hear, she appears to be imagining an erotic encounter in a prison cell: "Finally, it's about time you called. It's been two weeks. . . . Well, are you all dressed up again? . . . I guess then we should begin, right? . . . OK? . . . Where are we? . . . Ah, we're in a prison cell." After she has described her clothing to her interlocutor, the film starts at the beginning again. Like all the film sequences in *Room of One's Own*, it is programmed to run as a loop.

If the recipient points the viewing device at the television in the left corner of the room, he sees—as anticipated by the voice—his own eyes on the screen. However, he can still see a film in his peripheral vision. It now shows a woman pointing a gun directly at him and firing.

The five film scenes described here are supplemented by bridging sequences between the middle three films. These are short film excerpts that show the protagonist walking from the chair to the carpet or to the telephone and back again. The visuals are accompanied by brief statements (e.g., "Excuse me, I have to get dressed"). At the same time, the film projection on the back wall of the room shifts from the previous point of view to the new one.

Hershman relates *Room of One's Own* to the kinetoscope, a device (developed in Thomas Alva Edison's laboratory in 1891[28]) that was used to project films that could be watched through a peephole. Hershman recounts that the kinetoscope was often used to show film scenes of seductive women, and that it was the prototype for the peep show.[29] The reference to the tradition of the kinetoscope manifests itself in several ways in *Room of One's Own*—in the media-based apparatus, and in the themes dealt with in the film scenes and in the red-light atmosphere.

However, parallels can also be drawn with a much older tradition of mediated mise-en-scène. The artist's creation of a miniature room that can be observed though a peephole is reminiscent of Dutch *perspectyfkas* (perspective boxes). These devices, which allow viewers to peer through a small eyehole into an interior scene depicted within a box, first appeared in the seventeenth century.[30] They are, first and foremost, vehicles of optical deception, in that they convey the illusion of great spatial depth and obscure the boundaries between three-dimensional built spaces and two-dimensional pictorial representations. At the same time, however, the invitation to observe domestic scenes also thematizes the issue of intrusion into the private sphere. The art historian Celeste Brusati focuses on the specific physical relationship between the observer and the miniature world depicted inside the box. She argues that the artifice of the peephole isolates the viewer's eye and thus creates in him the expectation of privileged visual access to a normally inaccessible world. At the same time, Brusati writes, the eye of the viewer is held captive at the juncture of its own world and the artificially crafted world. Thus, she continues, the *perspectyfkas* illustrate the potential of art to seduce and satisfy the eager eye by offering up a domestic scene and its female inhabitants to the curious gaze of a male voyeur. This interpretation is

Figure 5.11
Schematic drawing of W. K. L. Dickson's kinetoscope, mid 1890s (source: Wikimedia Commons).

supported by the fact that Samuel van Hoogstraten, the creator of the most famous *perspectyfkas*, often thematized voyeurism by depicting a representative male voyeur inside the box.[31]

Brusati's considerations about the role of the observer can also be applied in many respects to Hershman's work. Here, too, a situation of voyeuristic observation is created using a special viewing device. In physical terms, the observer is both involved and excluded at the same time, and traditional role models are also scrutinized. However, there is no need to portray a representative observer in *Room of One's Own*, for the recipient is directly addressed and confronted with his own voyeurism. In this way,

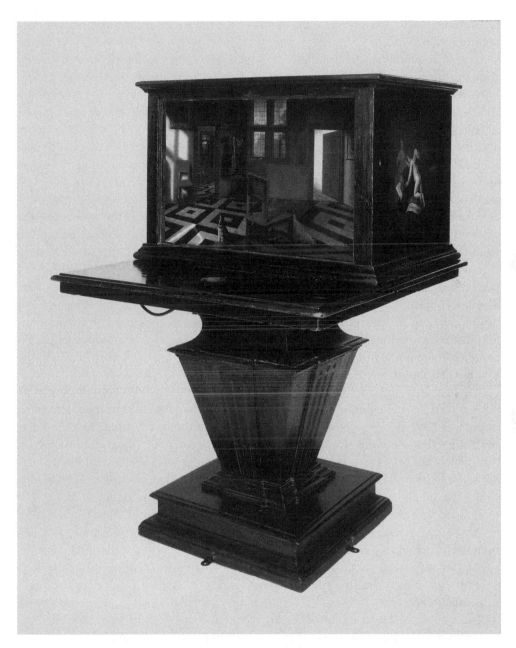

Figure 5.12
Samuel van Hoogstraten, *A Peepshow with Views of the Interior of a Dutch House* (ca. 1655–1660) (National Gallery, London, presented by Sir Robert and Lady Witt through The Art Fund, 1924).

Hershman's work seeks to reverse the theory of the male gaze as formulated by Brusati, among others.

Hershman combines the principle of the peep box with that of the kinetoscope by showing film scenes on the rear wall of the room. In contrast to the *perspectyfkas*, however, she is not interested in achieving a deceptively realistic transition between the three-dimensional miniature room and the two-dimensional (cinematic) image. An illusionistic blurring of the boundaries between the space of the miniature room and the film sequences to create one continuous scene is prevented by the changes in the size and the position of the cinematic images, in the colors (color versus black-and-white film), and in the sequence of images (insertions of close-ups and text sequences), not to mention the changing clothing of the protagonist. Furthermore, Hershman doesn't seek to create consistency between the space of the viewer and the space of the narrative. Even though the recipient may feel that he is directly involved from the very start, that is not the case for at least three reasons. First, he is looking through the viewing device into a miniature space (as in a *perspectyfkas*). Second, the person he sees is "only" a filmic projection and therefore is not "present" in the room. Third, the voice is not produced by the protagonist but comes from "off stage." The only scene in which the protagonist speaks is the one in which she is on the telephone, and in that scene she is not speaking to the recipient, but to the interlocutor on the other end of the line. But if, in the other scenes, it is not the protagonist who is speaking, how should this voice-over be interpreted?

The recipient (when he is not looking through the viewing device) can clearly see perforations on the exterior of the box, indicating that the loudspeakers are facing outward.[32] The sound is not coming from inside the room, but from the exterior of the interactive sculpture. Consequently, the utterances made by the voice can be interpreted not only as statements made by the protagonist of the film scenes but also as "statements made by the work." On this interpretation, the voice wouldn't belong to the diegetic domain of the filmic fiction, but to the work as an active entity. The work itself would then ask why the recipient is looking at it, and what he expects of it. It would complain that the viewer is annoying and tell him to turn away. Hershman herself provides a clue that supports such an interpretation, although it is rather vague and at the same time somewhat poetic. Hershman explains that she deliberately separated the voice from the film scenes and compares it to the voices of the sirens in Homer's *Odyssey*.[33]

The staging of the situation of the art recipient (who exhibits himself while contemplating artworks) in allusion to a peep show has illustrious precursors in twentieth-century art—especially in the work of an artist that had intensely interested Hershman: Marcel Duchamp. His last work, *Étant Donnés* (1946–1966), is an installation concealed behind a wooden door. Only by peeping through a small eyehole can the viewer see the naked female body lying in the grass behind a destroyed wall. Because of the

disconcerting position of the woman's body, and the fact that it appears to be life sized, Duchamp's installation has a more direct impact than Hershman's media-based work.[34] Nonetheless, the way in which the observation situation is staged in the exhibition space is similar. Both works—like the *perspectyfkas* before them—use their hermetic external form to stage the act of observation. The recipient becomes part of the staging as an actor who can be observed, in turn, by other visitors. All three works, by thematizing voyeuristic behavior, place the observer in an ambivalent situation. Voyeurism is considered to be unseemly behavior. Usually it is carried out in secret because discovery would be extremely embarrassing. By contrast, the viewing of artworks in the exhibition context is a socially accepted, expected, and even appreciated type of behavior. The fact that in these works the recipient is forced to combine the two behaviors in a single action makes frame collisions practically inevitable—he is coerced into an ambivalent experience of the work.

Hershman also turns the tables by contrasting the act of observation *by* the recipient with an active observation *of* the recipient—in both technical and symbolic terms, starting with the possibility of the recipient's being observed by other visitors. If the recipient engages with the work, he is initially enticed, but is then berated, asked for an explanation, and ordered to look away. If he immerses himself in the fictitious world of the protagonist, he should—as a polite fellow human being—immediately leave his place at the viewing device as she has requested. However, if he wants to examine the work in detail—as a conditioned museum visitor—he will have to defy the protagonist and ignore her demands.

This active questioning of the work's status as an exhibit can be analyzed more closely in comparison with yet another media art installation. The video artist Tony Oursler, renowned for exhibiting dolls on whose pillow-like faces he projects filmed images of actors' visages, staged a similar situation in *Getaway #2* (1994). Oursler's protagonist is lying beneath a mattress and appears to be in an extremely difficult situation. And yet her contact with visitors consists only of demands that they leave her in peace and get out of the room, followed by foul insults. But whereas in Oursler's work the encounter between the doll and the visitor is not commented on further, Hershman directly thematizes the implications of observation as well as the conflicting nature of the gaze. On the one hand, the questions of the female voice continuously thematize the observation situation. She doesn't limit herself to simply insulting the recipient; rather, she asks him whether he expects her to do something and whether he would behave in the same way if she were a man. In addition, she lectures him that it would be polite to look away.

But Hershman goes a step further by staging a reversal of the observation in technical terms, too. One of the orders given to the recipient is "Look at your own eyes in the television." If the recipient points the viewing device at the tiny television in the miniature room, he will see his own eyes, images of which are being transmitted to

the screen via a closed circuit. At the same time, in his peripheral vision he can see a film scene projected onto the wall beside the television in which a woman is pointing a gun directly at the viewing device—and thus at the recipient—as though she intends to shoot him in the eyes.[35] A shot rings out and a pane of glass shatters. In other words, as soon as the recipient looks at himself, he is attacked. This is the culmination of what was hinted at in the inscriptions on the film sequences accompanying the director's chair. As has already been recounted, a close-up of a face with the inscription "WATCH" was followed by a still in which another close-up was overlaid by crosshairs and the words "ARE OUR EYES TARGETS?" Thus, eyes are addressed here not only as a means of observation, but also as its target. In this way, Hershman demonstrates that every observer is potentially also being observed: "[T]he viewer's 'gaze' both determines the narrative and is captured in the act of surveillance." This is also why she calls the work a "reverse peep show."[36] Margaret Morse emphasizes the gender perspective of this interpretation; she argues that interactivity is potentially the most powerful and the most effective means of surveillance and social control over the user. In Morse's view, the work shows that neither looking through a camera nor looking at a television is one of the power positions postulated by theories of the "male gaze"; rather, both are particularly effective forms of subjugation to regimes of social control. Morse asserts that Hershman's interactive model of subjectivity socialized by media inverts the idea of looking as power into its opposite,[37] while Hershman herself refers to "feminist deconstruction of the male gaze—particularly as it occurs in media."[38]

This "deconstruction of the gaze" is just one component of a multi-layered media-based unsettling of the recipient. The interaction begins with an initial ascertainment of the presence of the visitor. The first effective interactive elements are thus the sensors that determine whether or not a visitor is standing in front of the work.[39] If no visitor is present, the loudspeakers emit the sound of a woman's laughter and cheerful whistling and singing. It is only when a viewer is present that a woman's voice begins to ask questions. In this way, two modes are staged. When it is unobserved and thus "undisturbed," the installation conveys a relaxed, happy mood; only its observation or disturbance triggers the annoyed tone of the questions asked by the woman. The work thus presents two different states: a self-contented state of satisfaction (symbolized by the cheerful voices) and an irritated state of disturbance. And yet this is only one possible description. If one switches from the diegetic perspective to one examining the technical characteristics of the work, the processuality of the system presents itself in a different light. Technically speaking, the difference is between a state of presentistic expectation and a state of recipient-controlled liveness (which begins when the visitor approaches the work). Although the cheerful sounds heard at the beginning by no means—at the symbolic level—represent an invitation to interact, the system is "present." It is waiting for input. Technically speaking, it is ready to interact, although the symbolic level suggests the very opposite.

As soon as the recipient approaches the installation, the presentness of the work turns into a liveness constituted by the interplay between the technological system and the human recipient. However, if one switches perspective once again and attempts to describe the work at a symbolic level, it becomes difficult to characterize the interaction between the protagonist and the recipient as "liveness," just as the experiential mode of communication is relevant here because of its ultimate frustration. What the work is really about is the failure of communication; the theme is mutual observation, perhaps even mutual mistrust.

Room of One's Own illustrates that the instrumental design of interactivity doesn't have to comply with the way interaction is staged diegetically. On the contrary, it is the very difference between instrumentality and signification (in this work, a clear contrast) that creates an inherent tension in the work, and that guides the recipient in exploring and reflecting on it.

Moreover, Hershman plays quite consciously with different levels of mediality and reality. The viewer's space is set against the miniature room and the individual spaces of the film sequences; the impression that the protagonist is addressing the recipient directly is called into question by the fact that the voice seems to be coming from outside the room; and the supposed television broadcast is staged as a closed-circuit installation. The artist is not interested in creating a seamless, immersive situation, either in the spatial sense or in terms of a perfect simulation of face-to-face communication.

The fragmentation of the filmic elements into sequences that can be activated separately supports the multi-faceted presentation of the work's theme. Neither the work nor the protagonist is consistent. A range of media are used—images, audio, texts, television, telephone, camera, cinema film—and the protagonist can be seen in different roles, wearing different clothes, and from different perspectives. Even the bridging sequences that guarantee a smooth transition from one visual position to another do not prevent the protagonist from being seen in the following scene in different clothing or from another perspective. Technical continuity and heterogeneity of content are thus in a productive conflict with one another. This is also evidenced by the built-in closed-circuit installation. Not only does it invert the positions of who is observing and who is being observed, as described above; at the same time, the medial transportation of the recipient into the domain of the film images further contributes to the multi-faceted reflection of the media and the human role models, which constitutes the core of this work.[40]

This corresponds to Hershman's approach in general, which doesn't address personality as a homogeneous subject, but as a multi-faceted construct that defines itself through its perception of self and its perception of the Other. Hershman thus also sees as the most important theme of *Room of One's Own* "the explosive effects that are attached to the social construction and media representation of female identity."[41]

The work may be said to belong to the tradition of (optical) apparatuses, which Jonathan Crary has called attention-manipulating media.[42] However, *Room of One's Own* is an artistic apparatus that stages its capacity to manipulate as a critical commentary on contemporary forms of control by media. Hershman's "optical apparatus" actively resists the recipient at both the discursive level and the aisthetic level. The recipient, when he encounters the work's resistance, may simply be amused or may be unsettled, but at the same he is invited to reflect on the (gender-specific) roles of the actors in media-based stagings of communication, be it in "real life" or in an artistic context.

Postscript: What about Virginia Woolf?

The title of Hershman's work is a reference to Virginia Woolf's 1929 essay "A Room of One's Own," in which a private space is used as a metaphor for the intellectual freedom of women. Woolf's essay presents the concept of a room of one's own as something positive—a room in which one can develop one's own character and follow intellectual pursuits. Hershman depicts a different kind of room—a room that is primarily a venue for sex and violence. Although in the main scenes the protagonist is alone in the room, she is intruded on from all sides: by the viewing device, by the telephone, and by the television. It is not clear whether she is hurt in some way by these incursions or whether she sets herself up for and provokes such injuries to herself.

Hershman's work challenges various aspects of female identity, staging, and role assignment, with a particular focus on corporeity and individuality. Although the work also deals with the fragility of the private sphere, Hershman doesn't portray the "room of one's own" as being associated with intellectual activities. Accordingly, Hershman herself sees only loose parallels with Woolf's text and has explained that she chose the title only after the work had been completed.[43]

Case Study 6: Agnes Hegedüs, *Fruit Machine*

Fruit Machine by Agnes Hegedüs is another early example of interactive media art. One of the earliest works to highlight the relationship between interactive art and games, it also stages and scrutinizes basic aspects of social interaction. *Fruit Machine* encourages recipients not only to interact with a technical system, but also to communicate with one another.

Hegedüs, a Hungarian artist, initially specialized in video art. She began to create interactive installations during her studies at the Städelschule in Frankfurt in the 1990s, and continued to do so while working at the Institute for Visual Media at the Zentrum für Kunst und Medientechnologie in Karlsruhe. At this writing, she lives and works in Australia.

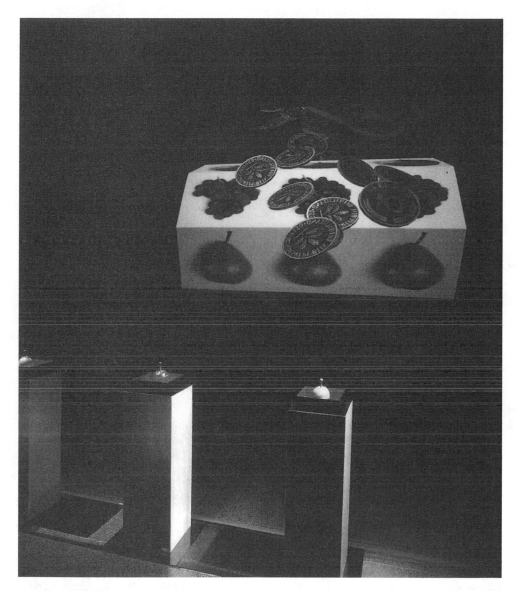

Figure 5.13
Agnes Hegedüs, *Fruit Machine* (1991), installation view (© Zentrum für Kunst und Medientechnologie Karlsruhe and Agnes Hegedüs).

Fruit Machine was created in 1991 in collaboration with Gideon May (software) and Hub Nelissen (hardware). It is now in the possession of the ZKM's Media Museum, where it has been exhibited almost without interruption since the museum opened in 1997—usually together with other media artworks, but occasionally in the section dedicated to the history of computer games. In 1993, Hegedüs made a second version of the work, *Televirtual Fruit Machine*, which invites interaction from recipients located in two different places.[44] This case study concerns the 1991 stand-alone version and is based on my observations and experiences of the work during numerous visits to the Media Museum.

A large projection screen shows three pieces of a three-dimensional object floating freely in black space. In front of the screen are three consoles fitted with joysticks. Color filter glasses are provided so that recipients can view the images in 3D. The basic operational rules are thus immediately apparent, and there is a clearly evident objective to achieve: The three pieces must be slotted together like parts of a jigsaw puzzle, and the joysticks will serve that purpose. The deducible shape of the reassembled object (a half-octagonal cylinder) and the very conventional depictions of fruit on its surface bring to mind the rotating reels of a slot machine.

Each of the joysticks is connected to one of the three pieces of the object, which can be moved in all three dimensions. When three volunteers engage with the work together, they usually all begin to move "their" pieces at the same time. But it quickly becomes apparent that this strategy is not ideal, for it is much more difficult to fit three moving objects together than to slot them one after another into an immobile piece. Completing the task thus requires agreement among the recipients, and not just activity, but also requires passivity and patient waiting until it is "one's own piece's turn." Several observations of recipients engaging with the work revealed that one

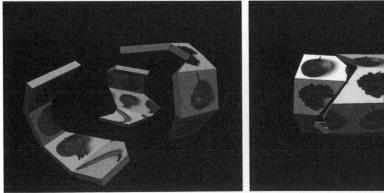
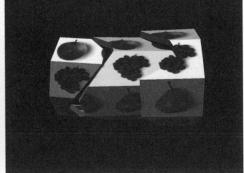

Figure 5.14
Agnes Hegedüs, *Fruit Machine* (1991), projection details (© Zentrum für Kunst und Medientechnologie Karlsruhe and Agnes Hegedüs).

participant often took charge of the proceedings, occasionally even taking the place of others in order to help them. When the recipients succeed in fitting the parts together, the half-cylinder disappears from view and a cascade of congratulatory coins fills the screen.

Fruit Machine has a minimalistic appearance; it has no particular spatial context and is not embedded into any kind of narrative. The material setup in the exhibition space is purely functional and is spatially quite independent from the virtual half-cylinder, although the 3D animation techniques are intended to create the impression that the cylinder is floating in the room. The work's simple appearance may be attributable primarily to its very early date of origin, but it is also conceptually interesting from today's point of view because it clearly pushes the process of interaction to center stage. The minimalism also gives a special significance to the jackpot moment, which may be stereotypical in its manifestation, but is nonetheless rich in detail, dynamically filling the entire screen. The jackpot creates an element of surprise, similar to the coveted moment at a slot machine when a win is rewarded by a shower of coins. Compared to the rest of the graphics its visual impact is truly spectacular. The jackpot moment also receives special attention because it is the only cinematic interlude in this otherwise entirely reactive work. In this process-intensive project, the joysticks immediately signal that the system is present and awaiting input. In the absence of input, the pieces remain frozen on the screen. The work's minimalistic visual appearance thus places the focus on the process of interaction itself and also reinforces the contrast with the more sophisticated visuality and cinematic quality of the jackpot.

One might, at first, be inclined to classify *Fruit Machine* as a normal computer game. According to Salen and Zimmerman's definition, a game is a system in which players engage in an artificial conflict that they seek to resolve while abiding by certain rules, and the solution must be a quantifiable outcome (in other words, its accomplishment must be clearly recognizable to all players). *Fruit Machine* is also based on a conflict—a task to be solved, where the required outcome is plainly evident. The broken object must be pieced together again, and the arrangement of the installation indicates clearly that the joysticks should be used to this end. The recipient's scope for action is prescribed by the technical set-up: on the one hand, he must operate the joysticks; on the other, the constituative rules determine exactly how he can use them to move the virtual objects. What remains unclear, however, is how the participants should best proceed in order to arrive at the required objective. There is no predefined sequence of actions, nor is there any indication whether or not three visitors must participate at the same time. The negotiation of the best strategy is left entirely up to the recipients.

Although it has much in common with games, *Fruit Machine* cannot be characterized as a ready-made, functioning game that has been taken out of the context of the entertainment industry and exhibited in the context of a media art collection in order

to heighten sensitivity to its structure and workings. If it were a game, *Fruit Machine* would be a commercial failure because the conflict to be resolved is not a conflict between competing players, only one of whom can achieve the defined objective and thus win the game. The task can only be completed through cooperation. And when the goal has been accomplished, the outcome—the reward—is purely symbolic. The work is reminiscent of a pedagogical training program for cooperative skills or of the "new games" movement of the 1970s, rather than of conventional games. The most appropriate characterization seems to be that it is a "test scenario" that allows observation of the negotiation of roles in a communication situation. Whereas Florian Rötzer (who exhibited the work in an early show titled Künstliche Spiele, meaning Artificial Games) argues that *Fruit Machine* is a game displayed in an art context, and that it challenges the reception habits of art, Hegedüs is convinced that it could not function as a game even if it were housed in an amusement arcade. In Hegedüs' view, *Fruit Machine* is an artwork that—in part—makes use of gaming strategies: "In other words, this artwork adopts the operating mode of video games as its own mode of interactivity."[45] Hegedüs sees the thought-provoking potential of the work in the following characteristics: First, she uses traditional elements of games of chance in the context of a game of skill, and thus examines the relationship between chance and strategy. Second, she turns what would normally be a game contested by three players into a cooperative game, and thus provokes reflection on game mechanics: "Contrary to its ancestry, this new fruit machine is not a game of chance but a game of skillful coordination and cooperation between the three players."[46]

The attraction of a slot machine is that the player has a certain feeling of agency in what is, in reality, purely a game of chance. At the same time, the action is rendered appealing by the wagering of money. The only motivation to play is the outcome of the game. *Fruit Machine*, by contrast, has nothing in common with a game of chance. It is based on dexterity and cooperation, and a reward is given only symbolically, or rather the reward consists in the shared joy at having accomplished the task. Rötzer believes that the work could be played "as a game without ever thinking of art."[47] Recipients could, in fact, conceivably focus their interaction entirely on achieving the clearly attainable goal. This is just as true for *Fruit Machine* as it is for other goal-oriented projects presented for reception in artistic contexts, such as *Pain Station* by //////////fur//// or Blast Theory's *Can You See Me Now?* (2001). These works function as games, but then again they do not, because they also counteract certain conditions of games, such as their goal-orientedness, the integrity of the players, and the concept of competition. The distinctive feature of these projects is that they contain disruptions that give pause for reflection.[48]

However, observations of various recipients interacting with *Fruit Machine* showed that the collaboration required doesn't always proceed entirely without competitiveness. In the exhibition context, the actions of the players take place in public and are

often observed by onlookers. The recipients' participation becomes a performance in which the collaboration is negotiated in the public space, active and passive roles can be assumed, and destructive or domineering behavior is just as possible as cooperative interaction. Different ways of organizing communication can be tested. The players must actively reach agreement with one another and at the same time demonstrate in public how well they are able to maneuver the joystick and how good their visual thinking skills are. Spectators may intervene by offering tips or making suggestions as to how the task should be best accomplished, by cheering the players on, by commenting on their progress or on their mistakes, and by celebrating when the puzzle has been completed.

The communication between the players—and its potential observation by spectators—is a central aspect of the aesthetic experience of this work. In a kind of model situation, actions are described, feelings are verbalized, and roles are negotiated. The aesthetic experience is a result of the creation of temporary relationships and role allocations—processes of identification with and distancing from others that become observable because they are negotiated in an artistic context. These phenomena are not staged or presented for the recipients, as they would be in theater or in painting. They are performed by the recipients themselves, who are motivated and channeled by the interaction system. The work literally orchestrates emotions that range from intense concentration to impatience, frustration, and indifference. It generates groups and lone wolves. Some people take charge; others follow orders. The work is still fascinating today not because of its (simple and now outdated) graphics and programming, but because of the constantly changing behavioral situations it generates. They are accentuated by their presentation in an artistic context and the resulting artificiality of the action, and they are staged as potential sources of aesthetic experience. In this work, social interaction in the form of face-to-face relations really is a central element of the aesthetic experience. The work requires social interaction and at the same time invites recipients to reflect on the relationship between art and play.

Case Study 7: Tmema, *The Manual Input Workstation*

This case study and the next describe works in which the primary focus is on multimodal experience. Both of these works were displayed in the exhibition See This Sound—Promises of Sound and Vision, shown at the Lentos Kunstmuseum in Linz in 2009 and 2010, and both were documented, like the last of the cases studies presented here, in the context of research projects carried out at the Ludwig Boltzmann Institute Media.Art.Research.

Golan Levin and Zachary Lieberman have been working as media artists since the late 1990s. Levin focuses on audiovisual software; Lieberman is renowned for including magical effects into his works. Between 2002 and 2007 the two artists collaborated

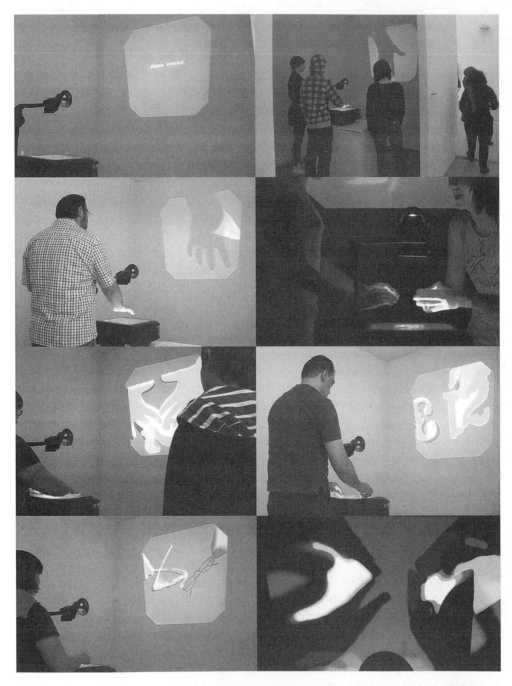

Figure 5.15
Tmema (Golan Levin and Zachary Lieberman), *The Manual Input Workstation* (2004–2006), visitor interactions at Lentos Kunstmuseum, Linz, 2009 (© Tmema).

under the name Tmema, creating several audiovisual art projects. Levin has also studied audiovisual software intensively at the theoretical level, and in 2000 he submitted a master's thesis titled "Painterly Interfaces for Audiovisual Performance."[49]

In New York, in 2004, at a Whitney Biennial evening dedicated to the topic of performing technology, Levin and Lieberman presented a performance titled *The Manual Input Sessions*, which subsequently became an interactive installation. *The Manual Input Workstation* has been exhibited in a variety of different locations, including the Ars Electronica Center in Linz. In the autumn and the winter of 2009–2010, the work was on view at the See This Sound exhibition at the Lentos Kunstmuseum in Linz. It was during that exhibition that Ingrid Spörl and I carried out a research project, with Lizzie Müller as a collaborator. The project included an in-depth interview with Levin (who was responsible for the Linz installation) and observations and interviews with several recipients using the method of video-cued recall.

The Manual Input Workstation is an interactive installation that allows users to create and manipulate images and sounds. At first glance, it resembles a normal overhead projector with some cut-out cardboard shapes lying next to it. Visitors can place the shapes on the glass top so that shadows of the shapes are projected onto the facing wall. But the work does more than simply project the shadows—it also records them with a video camera attached to a computer. The software analyzes the video data, then generates sounds and animated objects corresponding to the shapes, which are superimposed via a beamer onto the overhead projection. Thus, the visitors seethe silhouettes of the shapes overlaid by computer animations and accompanied by sounds. Most visitors quickly realize that they can create images using not only the shapes that have been provided but also other objects—especially their own hands. In fact, visitors can use hand movements and gestures to discover more sophisticated ways of creating dynamic shapes.

In Linz, the installation offered three different program modes. The NegDrop mode invites the recipient to create closed contours that the system then fills with colored shapes. If the contour is opened, the shape inside drops to the bottom of the screen and bounces repeatedly, each time triggering a sound. The sounds vary, depending on the size, the form, and the fall speed of the shape. The second mode, Rotuni, generates sound-image formations based directly on the shadows created by the recipient. Starting from the center of the shape and extending only as far as its contours, a green radar arm rotates at a steady rhythm in clockwise direction. Each advance of the arm generates a tone, whose pitch is determined by the length of the arm (which depends, in turn, on the extension of the contours of the underlying shape). In addition, the entire shape lights up briefly when a very high note sounds. The third mode, Inner-Stamp, is again based on shapes that the system generates in order to fill out contours created by the user, but in this case the new forms are immediately sonified. As a result, the sounds can be modified in real time by altering the shapes. A large shape

generates a low tone, a small shape a high tone. Squeezing the shape changes the pitch and modulates the frequency, whereas moving the shape alters the stereo quality of the note. When the shape is "released" from its contours, the sound sequence and the animation that have been created are repeated in a loop.

The possibility of manipulating the sounding objects in real time allows the recipient to observe the interplay between shape and sound precisely. The factors that contribute to the generation of notes (volume, pitch, and timbre) are directly assigned to the characteristics underlying shapes (volume, contours, and position). Thus, the manipulation of shapes and sounds in real time enables the recipient to reflect, via exploration, on basic visual and acoustic phenomena.

In this process-intensive work (there are no recorded sequences of images or sounds), the constitutive rules play an essential role in the interaction process. The software on which the system is based not only analyzes the shadows projected onto the wall and then recorded on video camera; it also generates the animated shapes and accompanying sounds in real time, then superimposes them on the shadows. The software determines exactly how the system should react in the different modes to changes in shape, position, or size. It also has a pattern-recognition feature to manage the switch from one mode to another. The cardboard shapes provided for visitors include the numbers 1, 2, and 3, which refer to the three different modes of the work. As soon as the recipient places one of these numbers on the projector, the system recognizes its shape and activates the appropriate mode. The change in mode is thus built into the constitutive algorithm, but can also be generated operationally; the numbers act as a tool for switching between the different modes. Whereas in earlier manifestations of the work the visitors were left to grasp this function for themselves, for the See This Sound exhibition Levin decided to render the rule explicit by writing on the respective numbers the instruction "Place on the projector in order to switch to Scene 2" (or 1 or 3). In fact, Levin went even further in the explicit formulation of operational rules. He informed visitors that they could engage with the work by programming it to project the words "Please Interact" onto the wall whenever there was an absence of input, because he thought that instruction was necessary in the specific context of the Linz exhibition. In the first place, he observed, because the installation was displayed in a closed-off white cube, it wasn't likely that visitors would be able to watch earlier interactions by other visitors that might provide pointers for their own interaction. Second, the exhibition included only a few interactive works, so visitors could not be expected to realize that this was an interactive installation. Third, the fact that it was presented in a museum for contemporary art, rather than, for example, at the Ars Electronica Center, meant that the visitors would not necessarily be familiar with interactive art.[50]

However, there is also another reason for the need to explain the mode change: the dual function of the number shapes. The number shapes are analyzed by the

system as abstract forms, which are animated and sonified, as are all the other shadows that are generated. But these three shapes also act as interpretable signs that bring about a change in mode. They operate both aesthetically and discursively. In Levin's view, the availability of different program modes (he calls them "scenes") is an important feature of the work because the artists were interested in presenting variations on a theme. In fact, each of the three modes of the work approaches the theme from a different angle.[51] However, Levin allows that the mode changes might lead to interruptions of flow experiences.[52] He thus sees the mode-change function as a flaw in the work that is a consequence of its history. In the original performance version, he recounts, switching from one mode to the next by laying down numbers worked very well because it was perceived as integral to the general workings of the system and was immediately comprehensible to the audience. In the installation version, however, Levin sees that the fact that the numbers react differently to all the other shadow forms that can be created causes irritation. Levin feels that his decision to write instructions about the mode changes on the numbers is a sort of capitulation.[53]

The research project showed that the aesthetic experience of the work is significantly influenced by the dual functionality (discursive and aisthetic) of the numbers, and that this is true whether the operational rules are made explicit or not. The explicit formulation of the operational rules did not, in fact, guarantee that they would be unconditionally observed. Whereas one of the recipients reported that he saw the numbers but did not use them until he was reminded to do so by the camera team (when he was about to leave the work), another visitor had also noticed the shapes, but was so fascinated by the creative possibilities offered by her own gestures that she didn't make use of the numbers until much later.[54] In addition, placing the numbers on the projector doesn't always lead to a mode change, for the pattern-recognition feature works only if the number can be recognized for long enough as a solitary shape. (If the number is held by the recipient's hand or is touching other shapes, the system cannot recognize the pattern.) Another visitor, a media theorist experienced with interaction systems, immediately grasped the dual function of the numbers, but was then mainly interested in exploring whether these numbers could open up emergent potentials in the work. He reported that he initially interpreted the number shapes as actual orders of magnitude that might indicate a gradual increase in the complexity of the interactivity or of the audiovisual output. He dedicated a large share of his interaction time to the numbers, whereas the other two visitors were less interested in their special function.

One visitor, who described himself as musical, was initially attracted mainly by the acoustic phenomena.[55] When he arrived, the work was in Rotuni mode, and he immediately began to move his fingers in time to the sounds, as though he were plucking the strings of a guitar. Observing himself on video afterward, he said he had found the overhead projector to be a physical hindrance, and he was surprised to see how

little he had moved. He also explained that he had found it difficult to coordinate his two hands with the mirror-inverted projection, a problem he had also often noticed in his job as a teacher.[56] Such individual self-observations reveal not only how greatly aesthetic experiences can vary from one visitor to another, but also how much they depend on formative influences and previous experiences on the part of the recipients.

While formulating his reflections retroactively during the video-supported self-observation, the teacher said that while interacting he had mainly felt immersed in the work. His evident enthusiasm for the process of interaction was confirmed by the fact that while watching the recording of his interaction he spontaneously commented on the shapes he was creating with the words "Looks cool!"[57] A female recipient was also enchanted by the constellations that emerged: "That was fascinating, when all these little things fell down and I knew they were coming from my hands, I liked that very much, I just liked the colors and I saw them falling, I didn't think so much about the music then, it was more the colors, the shapes that were fascinating me, so I tried them very often because I thought it was really nice."[58] Like the visitor cited above, she started the interaction by making shapes with her hands. The acoustic elements of the work were, she said, of secondary importance to her, in contrast to the teacher. Her full attention was captured by the work's visual potentials. This visitor's focus was on the creation of visually perceptible shapes, not on physical activity. Both of these visitors also experimented with placing other objects (eyeglasses and a ring) on the projector. Generally speaking, their approach can be described as experimental exploration led more by intuition then by a quest for analytical understanding. They both allowed themselves to be guided by spontaneous ideas and to be enthralled by the shapes that were created. The female visitor even declared that she could have continued for hours.

The media theorist, on the other hand, explored the workings of the different modes in great detail. For example, he characterized the Rotuni mode as the least interactive of the three because all it did was set off an automatic process.[59] It quickly became clear in his self-observation and self-description that he was used to dealing with interactive art. He was able to apply appropriate strategies when he explained how he approached the work ("I think my first approach was to try and figure out how it worked more or less and then to use it as an expressive device. That's what I was hoping to do."[60]) and when, after about three minutes of interaction, he described the situation as follows: "Up until now I was really laboring a lot to try and figure out, ok, what are the rules of interaction and hopefully they will be more interesting than something you just do once and then it's over."[61] At another point of the recording, he recalled that his main aim had been to find the most efficient way to achieve something new "as opposed to sort of repeating the same thing over and over again."[62] Thus, his self-description focused on the exploration of the system's functionality, and he was also interested in discovering the limits of the work. For example, he spent a

lot of time trying to find out whether there were interim steps between two modes or whether such steps could be created, with the intention of making the Rotuni mode more interesting: "Here again I am perhaps too stubbornly insisting on trying to do something different with mode number two."[63] He also verbalized the difference between immersing himself in the activity and reflecting on it: "This is like an interesting tension between, on the one hand, trying to deal with it in a sort of right-brain kind of way, as here for example, just sort of playing with it, and then, on the other hand, sort of a left-brain kind of way, to try to figure out what some of the algorithmic logic and intuition there is."[64] Whereas this visitor explicitly verbalized the oscillation in the aesthetic experience between exploration, creativity, and immersion, the other two visitors tended to reflect on single aspects of their experience, such as their gestures or their focus on either acoustic or visual creations.

The statements of the visitors also show how the process of exploring the system repeatedly turned into a sense of creativity. The female visitor described this feeling as follows: "You are creating . . . not something important but something nice. . . . I know I don't create, but in this moment, I am creating."[65] Such statements suggest that the question about the ontological status of interactive artworks discussed in chapter 4 deserves closer examination concerning this installation. As a process-intensive installation designed for the production and manipulation of abstract shapes and sounds, *The Manual Input Workstation* has quite a lot in common with musical instruments. In fact, Golan Levin says that his work is hugely motivated by the desire to develop new types of instruments: "The idea that these things can be both visual instruments and musical instruments was a core motivating factor."[66] Likewise, when asked if the installation could be considered a musical instrument, one visitor agreed that it could because it allowed the recipient to control pitch and rhythm, especially in NegDrop mode.[67] The media theorist called the system an instrument within an instrument, comparing the projector to a music theater in which the modes were the instruments and the shapes the music.[68]

We should therefore investigate the parallels with musical instruments in more detail. Owing to the use of human gestures, there is no distancing interface between input and output. The shapes are generated directly by hand. The artists themselves emphasize the novelty of the system, "in which the hands are used to simultaneously perform both visual shadow-play and instrumental music sound."[69] As the observations show, however, one mode of perception or the other tends to predominate in actual experience. Whereas one visitor moved his fingers in time to the sound, another said that she hardly noticed the sounds at all.

Unlike works that seek to activate the recipient's entire body (for example, Cillari's *Se Mi Sei Vicino* and Rokeby's *Very Nervous System*), in *The Manual Input Workstation* the interaction is focused on the recipient's hands, a part of the body often used for performing symbolic acts. The reduction of the gestures to two dimensions in the shadow

play also shifts the focus more to (bodily) expression than to embodied perception in this project. And yet the recipients' hands are not used to create conventional symbols. The recipients do not express commands, make choices, or enter concepts as input; what they do is invent shapes. (The only exception is the use of the number shapes to change modes.) But although the recipients operate the system directly by hand, there is no direct physical or mechanical causality between their gestures and the animations and sounds they elicit. The relationship is based exclusively on programmed settings. The position of a shape could just as easily be mapped to the pitch as to the timbre of a sound. Technically speaking, this system is another black box. It interprets the gestures visually and sonifies them, but the gestures do not physically create the sounds and animations. However, the animations imitate physical causalities; rather, they behave *as if* a shape were squeezed by a hand, *as if* it were to fall to the ground because of its weight, and *as if* a sound were created by the impact. As a result, recipients can ignore the mediating role of the apparatus, believing that the audiovisual results are in fact directly created by gestures. This would correspond to the situation characterized by Coleridge as "willing suspension of disbelief," because the recipient ultimately knows that the animations result from complex calculations. Nonetheless, the recipient may sense an immediacy in the relationship. On the other hand, the existence of the different modes—which the artist himself describes as variations on a theme—encourages the recipient to reflect on the arbitrary nature of the mapping.

As was explained in chapter 4, Dieter Mersch identifies imagination and figuration as basic parameters of creative productivity—in the sense of new, inventive creation, on the one hand, and in the sense of manipulation and combination of existing forms, on the other. One could thus argue that, whereas Tmema leaves a share of the figuration work up to the recipient, this figuration work is based on a figurational apparatus which has been created by the artist. But one could just as easily argue that it is the recipient who first uses his own gestures to create shapes in complete autonomy, and that the shapes are then interpreted and refigured by the artistic apparatus. The fact that the two descriptions are simultaneously valid is a factor in the aesthetic experience of *The Manual Input Workstation*. The act of exploring the system responds to the creative concept of the artist, which is conserved in the apparatus of the interaction proposition. The recipient's shadow play emerges from an interplay between action and reaction. The recipient bases his actions on the reactions of the system in order to understand the algorithms that guide the process of mapping shapes and sounds. Even if this process is similar to musical improvisation, it is different in that the user is not familiar with the way the system works. The better the recipient understands these processes, the better he can productively "counter the resistance of the apparatus" and actually use the system as an instrument and achieve virtuosity in playing it. However, despite the relatively long time visitors spent interacting with the installation, and despite their detailed discussions of the processes of interaction in the

follow-up video-cued recall interview, neither their statements nor the video recordings suggest that they had internalized the specific workings of the different modes (which in fact follow clear constitutive rules) enough to use them in a controlled manner to create specific animations or acoustic compositions. On the contrary, it seems that they were not really interested in penetrating the work to such an extent, or rather that their interest in penetrating the work was secondary to their attempt to discover the limits of the system.

Levin and Lieberman emphasize the importance of a combination of simplicity and complexity for a successful interaction between human beings and audiovisual systems: "[T]he system's basic principles of operation are easy to deduce and self-revealing; at the same time, sophisticated expressions are possible, and true mastery requires the investment of practice."[70] This is why these artists develop systems that react consistently to input from users but are nonetheless boundless because they register the smallest variation in the input. Thus, from the first moment on, the structure of the system enables a rich experience. The recipient can interact intuitively with the system, and can explore its functionality on different levels by means of direct audiovisual feedback which is clearly related to his actions.

The recorded reactions of visitors show that this concept is fruitful. For example, one visitor recounted that he had made clear progress, remarking that "now I could spend days and weeks with it."[71] The media theorist summed it up as follows: "The artist was able to keep . . . me very engaged in that liminal space between looking for something that I was trying to play with, so I could understand a certain functionality . . . , on the one hand, and, on the other, keep it sufficiently open ended that I didn't become bored by it too quickly, and a number of interesting surprises like these little apparitions, for example, came up, as well as certain things that I was sort of going after, but never achieved . . . for example the idea of trying to get two modes to interact at the same time."[72]

Thus, this work does, indeed, allow for a certain degree of emergence, because the recipient's own creativity can elicit audiovisual configurations from the work that the artists perhaps had not anticipated. Thus, visitors can experience a feeling of agency concerning their own creative potential, even if they have not understood the workings of the system so well that they are entirely in control of the emerging audiovisual configurations. The artists themselves have shown in their performances—which preceded this installation version—that it is possible to master the operation of the system. Mastering it requires an amount of practice time that would be difficult to arrange in an exhibition context, however. If mastery could be achieved, then (according to the arguments presented in chapter 4) the ontological status of the work would change, for the recipient's perception would be focused not on experimental exploration but on achieving a certain result. The work would become an instrument for audiovisual performance. However, a performance of this kind, too, if it is to be

convincing, requires that the apparatus be visible. Its effect is not based on the audio-visual composition alone, but also on the observable ways and means with which the sounds and images are created. The apparatus and the way the user handles it are always components of the manifestation. Levin makes this clear when he emphasizes that the point is not primarily visual or acoustic splendor, but the nature and the quality of the reaction: "The work is not about the relationship of sound and image but about the relationship of sound and image together to gesture."[73] This is why it is important for Levin that the public at the performance version of the piece was also able to understand the interaction processes, "making sure the audience understands that it is not canned."[74]

Tmema's installation is an example of an interactive work that uses multi-modal interplays in a process-intensive system to support feelings of agency on the part of the recipients. More than the other works discussed here, it places the experience of expressive creation at center stage. However, this doesn't mean that media-reflective interpretations and insights are excluded. On the contrary, the work invites the recipient to reflect—whether incidentally or consciously—on media-based interrelations of visual, acoustic, and gestural formations.

Case Study 8: David Rokeby, *Very Nervous System*

David Rokeby is a Canadian media artist who began specializing in interactive art while he was studying experimental art in the early 1980s. His installations and environments look at the relationship between humans and digital technology, also with respect to visions of artificial intelligence and the implications of surveillance technology.

Rokeby's early interactive environment *Very Nervous System* is a complex system for interaction between human motion and sound. Since its creation in the 1980s, the system has been exhibited on numerous occasions in many different international locations. In 1991 it was awarded the Golden Nica for Interactive Art at the Prix Ars Electronica. The work has been modified several times. This case study is based on a research project carried out during the presentation of the work at the See This Sound exhibition held in 2009 and 2010 in the Lentos Kunstmuseum in Linz, during which Caitlin Jones, Lizzie Muller, and I interviewed visitors (using the video-cued recall method) and conducted a detailed interview of the artist.[75]

Visitors who enter *Very Nervous System* encounter an empty, silent space. As soon as they move, however, they hear sounds—either the timbres of different musical instruments or everyday noises such as human breathing or gurgling water. The system records the visitor's movements via video camera, analyzes them digitally, and responds to them by emitting sequences of sound. In the Linz presentation, the curators allocated the work a space measuring three by three meters which was accessed through

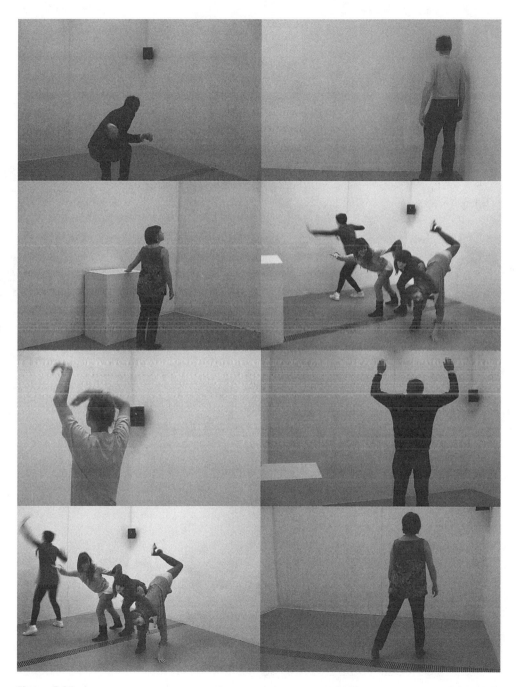

Figure 5.16
David Rokeby, *Very Nervous System* (since 1983), visitor interactions at Lentos Kunstmuseum, Linz, 2009.

a narrow corridor. The room was painted entirely in white and dimly lit from an indirect light source. It was empty except for a white box (containing the hardware) standing to one side and two loudspeakers and a camera attached to the wall. Many recipients who walked into *Very Nervous System* were surprised at first and took a while to realize that there is a connection between their movements and the noises. Some of the participants interviewed in Linz recounted that they were initially astonished not to find any objects or visual compositions in the room. However, most of them quickly began to explore the work by moving around the room, trying to understand its spatial limits and the structure of the sound.[76] One participant explicitly recounted that she was trying to "find" sounds.[77] Rokeby clearly understands the interaction as a spatial acting out when he describes the work's radius of action as having a sculptural presence.[78] The system has a presence that can be described as an immaterial materiality of acoustic configurations in space. Although this spatial extension of the sound is pre-programmed into the interaction system, it is only elicited and thus rendered perceptible by the actions of the recipient. As in the works by Schemat and Rueb, it can only be perceived as a reactive sound event, but in contrast to those two works—which use headphones—the sound waves fill the entire room. Rokeby, who has installed this work several dozen times in numerous different locations, comments that there are different possibilities for good spatial settings, whether the work is positioned in a closed-off area of a larger space or in a self-contained room. In Rokeby's view, what is important is that the space convey a pleasant atmosphere and that the number of visitors expected (which he calls "people flow") be appropriate to the size of the space.[79]

Rokeby emphasizes the significance of every single component of the spatial setting, and their individual importance is confirmed by observation of visitors. Owing to the material minimalism of the installation, close attention is played to each and every detail. The recipients not only examined the light and the visible technical components to see what significance they had within the work; they also scrutinized the white box that was used in the Linz manifestation merely to conceal the required hardware. This illustrates that it is not always easy to distinguish the aesthetically effective elements of a work from its exterior framing. The fact that the box was stored inside the action space led many recipients to spend a considerable amount of time wondering whether it was aesthetically relevant. In reality, Rokeby had accepted the position of the box as a compromise dictated by the exhibition situation. In this case, the resulting irritation constitutes an obstacle to the aesthetic experience of flow, which, as we will see, is actually the state that Rokeby seeks to achieve with this interactive work.

In the Linz manifestation of the project, Rokeby installed two sound compositions that were activated in alternation with one another. If a recipient remained motionless at length, or if a new visitor entered the installation, the composition being played

was changed. The first piece was oriental in style; the second consisted of a combination of metallic sounds that might be described as clinking, jangling, grating, grinding, and tinkling. Rokeby considers the latter composition, the second in order of creation, to be the less intense of the two. Whereas one could immerse oneself completely in the first composition and become so enthusiastic that a critical reflection would be prevented, he says, the second composition allows room for critical distance.[80] This statement demonstrates that, although Rokeby sees the generation of flow effects as the main objective of the work, at the same time he wants to allow for critical reflection. He specifically seeks to enable the recipient to oscillate between the two states, and considers both the volume and the quality of the sound as important for the achievement of this effect. Rokeby explains that the work requires a certain volume because below a specific threshold the recipients can no longer really feel the sounds in their bodies.[81] The second composition consists of sounds that are reminiscent of everyday noises. Recipients are inclined to attribute them to particular events, such as crushing a tin can, rattling a bunch of keys, or dragging rocks. A critic who viewed the work in 2004 in the Ontario town of Oakville wrote that rapid, impulsive movements created a sound effect that reminded her of a kitchen cabinet falling over and losing its contents. Subtler movements, she observed, led to effects that resulted in particular associations: "Standing very still and fluttering the fingers of one hand, I provoked a low, purring growl, like the sound of a lion at rest. Stepping back, I heard a screeching sound, like the ripping up of packing tape."[82] Other noises reminded her of eating crunchy potato chips or smashing a beer bottle.

Observation of visitors showed that willingness to engage intensively in exploring the effects of different movements varied greatly from one person to the next. Many recipients were more comfortable exploring the sounds by moving through space than by specifically moving individual body parts. Such movements were mostly limited to swaying back and forth, crouching down, or carefully raising one's hands. Other recipients, one of whom was a theremin player, explicitly experimented with moving individual limbs.[83] One visitor explained in detail that not only had he wanted to explore the boundaries of the interaction space; he was also trying to find out which movements created which sounds, and trying to reproduce the same sounds again and to deliberately trigger individual sounds.[84]

Rokeby emphasizes that his interest in interactivity is not focused on straightforward and intellectually comprehensible control of processes. He objects to interpretations of interaction as control. His aim is to create a system based on intuitive bodily actions in order to challenge the image of the computer as a logical machine with no connection to the body. He is interested not in control but in resonance, not in power but in the recipient and the system adjusting to one another.[85] He describes an imaginary ideal recipient as someone who "tries to control it . . . hard to tell . . . then lets go of that and starts to relax into the piece. . . . Sound moves against her body."[86]

Ideally, Rokeby explains, "the body starts to lead in a way that does not seem to be guided by consciousness. So the body is responding to sounds that are produced by movements you still haven't taken possession of consciously."[87] Rokeby uses the word "resonance" to emphasize the way that the recipients' actions can take place unconsciously. As soon as recipients allow themselves to react spontaneously to the sounds of the system, the recipients are "played by the installation . . . allowing the music of the system to speak back through one's body directly, involving a minimum of mental reflection."[88]

Rokeby even wants the change in the recipients' perception to last beyond the time spent in interaction with the system, so that even after leaving the installation they will still have the feeling that the sounds they hear around them are directly connected to their movements.[89] Rokeby has had this experience himself, which he calls "aftereffects": "Walking down the street afterward . . . the sound of a passing car splashing through a puddle seems to be directly related to my movements."[90]

The elaborately calibrated technical system on which *Very Nervous System* is based is the result of a long period of conceptual and experimental development. As was mentioned in chapter 4, an early version of the installation reacted only to Rokeby's own movements. As Rokeby explains, he had adapted his movements to the system: "I had evolved with the interface, developing a way of moving that the interface understood as I developed the interface itself."[91] Rokeby also recounts that he initially tried to incorporate as many parameters into the feedback processes as he could, mapping separate sound parameters to the velocity, the gestural quality, the acceleration, the dynamics, and the direction of each physical movement. But he was forced to concede that he was overwhelming the recipient: "Ironically, the system was interactive on so many levels that the interaction became indigestible."[92] As was discussed in chapter 4, what Rokeby addresses here is his experience with what Noah Wardrip-Fruin calls the Tale-Spin effect—the fact that audiences might not be able to cope with extremely complex interaction systems.

In reference to an earlier manifestation of the system, Rokeby describes the testing attitude that some visitors adopted, when they entered the installation, by using strategic behavior to systematically explore the constitutive rules. The first gesture, repeated several times, embodied the question "What sound will you make?" As soon as the recipient saw that he could create a certain sound with this gesture, he repeated it again, but this time as a command: "Make that sound!" But the change in intention had altered the gesture to such an extent that it led to a distortion in the response of the system. Rokeby explains that body movements can be read either semantically or formally. However, Rokeby's system doesn't interpret the semantics; rather, it reacts to the formal dynamics of the gesture: "The questioning and commanding gestures were semantically similar but quite different in terms of physical dynamics."[93] Though it would be possible to filter out such dynamics, Rokeby deliberately refrained from

doing so. He wanted to develop a system that was programmed to resist conscious control. The result is a situation that responds to the recipient, but at the same time is too complex to be cognitively understood. Consequently, the recipient can have a sense of agency only if he gives in to this circumstance, whereas any attempt to control it is doomed to failure.[94] In fact, two of the participants in the research project pointed out that it was not really possible to control the work. Nonetheless, neither of them, contrary to the artist's intention, seems to have entirely abandoned herself to this situation. They simply limited themselves to further exploring the functioning of the system. One of the two described her attitude toward the installation as intellectual, as opposed to a potentially more emotional approach.[95]

The conscious prevention of control in Rokeby's work differentiates it from musical instruments, such as the theremin, that are built to allow controlled generation and manipulation of sounds by means of hand movement. Tmema's *Manual Input Workstation*, which invites the user to engage in creative exploration and is based on investigation and gradual cognitive understanding of the functionality of the system, takes a different approach. Recipients of *The Manual Input Workstation* use gestures to intentionally create figurations, whereas *Very Nervous System*, when it invites the visitor to use body movements, gives higher preference to the subconscious than to mental control.

Rokeby describes every sound that can be activated as a behavior—that is, an electronic personality that observes the recipient and selects its actions accordingly. For example, a sequence of sounds might tend to play on offbeats or to switch rhythms when a recipient accelerates his movements.[96] Rokeby emphasizes the fact, discussed in chapter 4, that the recipient's perception of the interaction processes can deviate substantially from the work's technical processuality. He recounts that many recipients tend to synchronize their movements with the rhythms of the system but perceive this synchronicity as a response by the system to their movements. According to Rokeby, the feedback processes of the real-time interaction are so rapid that it is no longer possible to ascertain who is controlling whom: "[T]he intelligence of the human interactors spreads around the whole loop, often coming back in ways they don't recognize, causing them to attribute intelligence to the system."[97] He sees this effect as being further reinforced by the fact that physical reactions take place more quickly than cognitions. This immediacy is also a result of the fact that the interface in *Very Nervous System* offers no physical resistance. This is a further difference between the work and traditional musical instruments. When Philip Alperson writes that it is often difficult when playing musical instruments to grasp where one's body ends and where the instrument begins, he is referring to the physical causal chain that leads from body movements or air supply via the keys, strings, or sound box of an instrument to the resulting note.[98] The visual tracking technology used by Rokeby and Tmema, by contrast, create what seems an almost magical way for the body to influence sounds and images, because it happens without any physical resistance whatsoever. But this also

means that the sound emitted in each case is ultimately arbitrary. Predetermined in advance by the artist, it has no direct physical relation with the movement of the recipient.

The observations of recipients and the subsequent interviews with them using video-cued recall provide more examples of the many different ways in which recipients of interactive art can oscillate between reflection and flow, and of different ways of verbalizing the associated aesthetic experiences. One visitor experienced the difference between Rokeby's installation and traditional artworks as a feeling of closer proximity to the work. He believed that this depended on the invitation to actively participate, but also on the fact that the work did not require interpretation in the usual sense. This recipient explained that this work had a very low entry threshold and he found it simply fun to interact.[99] At the same time, he mentioned several times that he had tried to find out how the system worked and where its spatial boundaries lay. Nonetheless, he experienced the exploration as playful and enjoyable. Another visitor also tried to investigate how the installation responded to her, but entirely ignored its technical workings. (She reported that she never understood how it worked at all throughout the entire interaction.) However, it was also clear from the interview that understanding the work was not important to her. She actually experienced the interaction as at least a potential resonance with the system: "I didn't quite find out whether the sounds wanted to make me move or not, but it was more enjoyable all the time."[100] At another point she described how her own movements merged with the sounds of the system, speaking of a sense of abandoning herself to the sounds. Other participants compared their enjoyment of the interaction with that of a child trying out a new toy[101]; still others described the meditative effect of the installation, which they said had made them slow down.[102]

Thus, the epistemic potential of Rokeby's *Very Nervous System* is primarily based on possibilities for cathartic transformation, in the sense of a self-knowledge achieved through new forms of experience. These are found on the boundary between physical and cognitive awareness and on the boundary between conscious control and unconscious reaction. Experimental exploration of the system of this work doesn't result in increasing mastery over it; in the ideal case, it becomes an interplay whose attraction is the very fact that it presents an alternative to the interpretation of interaction with media as communication or control. The work has practically no consciously implemented disruptions that seek explicitly to provoke an oscillation between reflection and flow by means of frame collisions or ambivalent signification. On the contrary, the system is presented as an autonomous media-based interlocutor, and the interaction draws its aesthetic potential from the fact that the recipient can experiment with novel forms of feedback whose effect becomes manifest neither as control nor as communication, but as resonance.

Case Study 9: Sonia Cillari, *Se Mi Sei Vicino*

Like Rokeby's *Very Nervous System*, Sonia Cillari's *Se Mi Sei Vicino* (If You Are Close to Me) focuses on physical activity and self-awareness. However, in this work a performer is used as an interface, so that the relationship between humans and machines is dealt with in quite a different way.

Cillari, an Italian artist and architect, lives in Amsterdam. She has been exhibiting her work—initially digital models and sculptures, subsequently interactive environments— since the beginning of the new millennium. In recent years, she began working—as in the project presented here—with a combination between interactive environment and performance. She explains that she came to media art through architecture, a field in which she had developed a desire to study human experience of space and to explore personal perception of internal and external worlds through the sensory organs. One of her current fields of research is "the body as interface."[103]

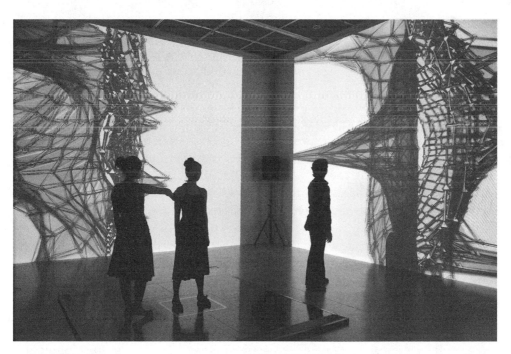

Figure 5.17
Sonia Cillari, *Se Mi Sei Vicino* (2006–2007; co-produced by Netherlands Media Art Institute and Studio for Electro-Instrumental Music; supported by Rijksakademie van beeldende kunsten, Amsterdam), installation view (Photo: Summer Yen).

Se Mi Sei Vicino was created in 2006 on commission for the Netherlands Media Art Institute, where it was also first exhibited.[104] It was produced in collaboration with the programmer Steven Pickles and the sound engineer Tobias Grewenig. The following description is based on a manifestation shown at the Ars Electronica Cyberarts exhibition in Linz in 2007, where *Se Mi Sei Vicino* received an honorary mention in the Interactive Art category of the Prix Ars Electronica. In the context of a joint research project between the Ludwig Boltzmann Institute Media.Art.Research and the Johannes Kepler University Linz, students of cultural sociology interviewed the artist and observed and interviewed visitors.[105] I interviewed the two performers who assisted in the Linz manifestation and spoke to the artist about the work on several occasions. My description below also draws on documentation of other manifestations of the project.[106]

On entering the dimly lit room containing the installation, the recipient's attention is immediately captured by a woman standing motionless in the middle of the room and by two large abstract graphics projected onto two of the walls. Each of the graphics depicts a three-dimensional vertical structure—a spindle-shaped, flexible grid that stretches from the bottom to the top of the projection area. While the upper and lower extremities of this structure are fixed and immobile, the grid itself is in a state of constant, wave-like motion. The nodes of the grid are highlighted as white triangles resembling force arrows. Cillari herself denotes these structures as "real-time algorithmic organisms."[107]

If the visitor looks down, he sees that the woman is standing in the center of a slightly raised square area covered with a black tarpaulin. Her exact position on the tarpaulin is marked inside a white frame. The woman is standing quite motionless and is thus clearly recognizable as belonging to the mise-en-scène. She will be referred to in the following as the performer, although, insofar as she is entirely immobile, her role in the interaction process initially seems to be characterized by complete passivity.

When a visitor walks onto the black mat and approaches the performer, an arrangement of metallic sounds with a muffled background of rumbling noise begins to play. At the same time, the grid begins to expand sideways and to sprout horizontal peaks. Touching the performer intensifies the effect. The spaces in the grid begin to fill up, first with gray tones and then with colors. The sounds become louder and turn into a sizzling reminiscent of newly lit fireworks. Thus, the audiovisual feedback can be interpreted as a representation of the performer—specifically, as a visualization and sonification of her reactions to people approaching her. These reactions are represented as a crescendo of sound, as structures that enter into motion, as uniform rhythms, and as momentary peaks or eruptions.

What we have here is a paradoxical situation in which the performer, despite her apparent passivity, is at the heart—in both spatial and processual terms—of the

interaction, and the visitors, who are much more active, only act as effectors. The performer is outwardly passive, like a puppet. But it is her body, not the visitor's, whose reactions are represented by the grid formations on the projection screens. When people approach her, this can be perceived only indirectly as a reaction or eruption of the audiovisual formations that represent the performer.

Moreover, the light in the room is dim, so other visitors can barely see the performer and the participating recipients against the bright projection screens. Thus, for the observers the physical activity taking place is overshadowed by the representational level of visualization and sonification. This mediation creates a sense of alienation. Notwithstanding the physical materiality of the human bodies, their presence is manifested for the observer primarily through the audiovisual feedback.

Observations of visitors and various documentations of the piece reveal that the recipients experiment with different ways of making contact with the performer—by touching different parts of her body, moving her arms, or executing sweeping movements or simple choreographies themselves—and observe the effects of their movements or approaches. However, the audiovisual feedback makes it is virtually impossible to isolate the precise effects of individual actions. The resulting effect has been described by Noah Wardrip-Fruin as the Eliza effect. The responses of the audiovisual feedback are experienced as being much more complex than they are in reality. The technical diagram for the work shows clearly, for example, that it makes no difference for the audiovisual feedback which part of the performer's body is touched, or whether or not parts of her body are moved.[108] Even minimal physical contact is visualized as a sizeable outswing in the graphics and a loud swell in the sound. As the artist explains, the system simply distinguishes three states of approach: low proximity, high proximity, and touch.[109] The grid usually bulges toward the point where the recipient is standing; however, smaller eruptions in the opposite direction are also often seen. Such irregularities in the reactions of the system make the constitutive rules of the work appear more complex than they actually are. At the same time, they create leeway for different interpretations. If the grid is interpreted as an abstract representation of a body, the observer can conclude that the reaction to approaching recipients is not limited to the part of the body that has been touched, but concerns the entire body. Bulges in the opposite direction can also be interpreted as a power play between attraction and rejection, or as an emotional reaction located somewhere between inclining toward and drawing back. The graphics and the sound thus present a visualization and a sonification, respectively, of the relationship between human bodies. Their abstraction allows for a wide range of different associations and interpretations.

Furthermore, the work has a progressive structure. The acoustic composition and the movement and colors of the grid change over time, depending on how long visitors interact with the performer.[110] Again, the underlying constitutive rules will remain unknown to most visitors because it is difficult to judge whether the changes

in audiovisual feedback are a direct reaction to a certain type of contact, movement, or gesture, or simply to the duration of the interaction. The progressive feature thus lends a variability to the system that makes it appear both animate and complex. This is all the more true as the attempt to explore the technical processes is inseparably overlaid in the recipient's perception by the desire to understand the role of the performer as a "human interface." Even if the performer remains completely passive, she still has considerable influence on the feedback processes. This is true in a physical sense because the work is based on the manipulation of electromagnetic fields. The body of the performer is under a weak electrical charge, so that the approach of a visitor alters the resulting electromagnetic field, which in turn informs the audiovisual feedback. But the central role of the performer is not reduced to a technical function. Her presence shapes the behavior of the recipients. Ultimately, the recipients are not able to ascertain the extent to which the audiovisual feedback is controlled by electromagnetic processes or by emotional, cognitive, or proprioceptive responses on the part of the performer.

The work reveals very little about its own technical functioning. All the observer can grasp from the feedback is that the distance between the recipient and the performer is measured somehow. The lack of cameras and the division of the black action area into two separate sectors can be taken as clues that electrical charges are being calculated, but it is mainly the audiovisual feedback that can be interpreted as an indication of the technical processes underlying the work. In fact, the sounds and shapes conjure up an atmosphere that might colloquially be called "electric." The graphics allude to connections and contacts; the sounds are reminiscent of ignition and electricity. At the symbolic level, therefore, associations with electromagnetic waves are awakened, suggesting that the work is based on this kind of technology. *Se Mi Sei Vicino* is an example of how abstract forms and sounds can function as signs alluding to invisible technical processes. If one looks more closely at the graphical structure projected onto the screens, one sees that it is not a solid entity with a specific volume, but a grid that can contract and expand. Looking closer still, one sees two separate grids, which are intertwined with one another when in their contracted state. When a visitor approaches or touches the performer, one of the grids shoots out to one side; the other either remains compact or expands in the opposite direction, leaving an empty space in the middle. Thus, the grid structure is not designed to represent the performer by creating bodily associations through an impression of volume, but through an image of an elastic surface that depicts (permeable) boundaries. It can thus be interpreted as a representation of the performer's skin—as the boundary between the body and the environment. This interpretation is supported by the artist's own descriptions. She claims to be particularly interested in sensations of physical proximity that do not depend on direct touch, specifying that "my concern was with realizing that the boundaries of self extend beyond our skin."[111] This

statement brings to mind Mark B. N. Hansen's observations (already discussed in chapter 2) about the human body reaching out into the environment. What Hansen is interested in, however, is a reaching out of cognitive processes and information flows into global data networks, whereas Cillari is attracted by the idea of an atmospheric presence, which she orchestrates here as a reciprocal referencing between human bodies. The human being doesn't relate to his surrounding space primarily through discourse, but by means of his physical presence. This relation is not only based on an active effect on the environment, but also on a kind of physical receptivity. Elsewhere, in fact, Cillari describes the performer as a human antenna. Here, she is highlighting the kinetic passivity of the performer, who nonetheless is highly responsive proprioceptively and exteroceptively.[112] During interaction, this passive presence is transformed into an affective, neuronal reaction, which is externalized, or at least represented, by the audiovisual formations.

The basic operational rules of *Se Mi Sei Vicino* can be discovered by exploring it, a task that is facilitated by the spatial arrangements. The layout of the room, with a clearly visible black tarpaulin on the floor and a white frame marking the inner section, clearly identifies the interaction space, while the fact that the performer stands immobile in the center of the room creates a situation of affordance. What could be the meaning of the much larger outer area on the sensor mat if not to invite the recipient to walk onto it, insofar as otherwise the installation appears to be in a kind of "at rest" state? Moreover, at the Linz exhibition most visitors, upon entering the room, were able to see other recipients already in action. The black mat doesn't cover the entire floor space, so space for observers is explicitly made available. Interestingly, the interaction space is smaller than the space filled by the full installation, so observers can sit or stand inside the environment delimited by the projections and still find themselves outside the "magic circle." Because the interaction processes are easy to observe in this work, the division of roles between trailblazers and imitators has great significance. It turns out that the recipients make a clear distinction between actively entering the "magic circle" of the black mat and observing from a distance. The fact that the action space is clearly marked means that walking onto the black mat indicates a conscious decision to actively participate, and this readiness is clearly visible to other people in the room.

However, the spatial setup only conveys that recipients can or should in fact enter the interaction area. It is not clear to them how they may behave, unless they have been able to draw their own conclusions by observing other visitors. In this work, the operational rules transmute almost seamlessly into implicit rules, because they concern human behavior toward another person. Perceiving the interaction as the mere operation of a technical system hardly seems appropriate when there is a human being serving as an "interface." The situation calls for the common rules of interpersonal behavior. The visitor must decide whether to treat the performer as a passive interface

or as a partner in social interaction. Once again, frame collisions are inevitable in this work. Conventions about how to approach interactive art conflict with conventions regarding interpersonal relations. As a visitor to an exhibition, the recipient assumes that detailed exploration of the exhibits is desired. As a social being—at least in the cultural context of Central Europe—the recipient avoids getting too close to strangers.[113] In order to find out which behavior is the appropriate one, the recipient must transcend the implicit rules of interpersonal behavior and touch the performer. This work certainly features the autopoietic feedback loop that Erika Fischer-Lichte sees as a fundamental condition of performativity—the ongoing negotiation of the relationship between two or more interaction partners. Admittedly, the feedback provided by the performer is actually a refusal to make any contact whatsoever. Her response changes only if certain social norms are breached—for example, if she feels attacked. And even then, as the Linz performers reported, an attempt was first made to clarify the situation through the intervention of an assistant, so that the performer did not have to become active herself.[114] In the interview with the two Linz performers, it became clear that some recipients tried to violate the setting created by the artist, either through aggressive or careless behavior toward the performers or by means of provocation such as concerted efforts to make eye contact. The performers had two explanations for this type of behavior. On the one hand, they were perceived not as human counterparts but as objects; on the other, they were vigorously provoked in the hope that they would abandon their role as a passive interface. At a personal level, they were comfortable remaining in the object role, which allowed them to feel more like a tool of the artist than like a self-determining actor.

Making contact with the performer is not the only form of physical contact available to the visitor, however. Although no instructions are given in this respect, observations and documentations of the work show that often more than one recipient is in the interaction space at the same time. If several recipients are active at once, they often try to see whether touching one another also leads to audiovisual effects. In fact, such effects are generated only if one of the visitors is also touching (or at least approaching) the performer, because only the central area marked with the white frame, and thus the person standing on it, acts as a transmitter in the electrical circuit, while persons in the outer area act as receivers. Nonetheless, it is interesting to observe how an action of this kind takes place. Mostly, the two people seek eye contact with each other in order to make sure that they both consent to reciprocal touching. Although the recipients could conceivably speak to each other, the performer's refusal to speak almost seems to act as a rule that interactions must be carried out in silence. The eye contact between the recipients renders them accomplices. Autopoietic feedback loops may thus emerge in two respects: on the one hand, as an attempted negotiation of the relations between the recipient and the performer; on the other, as an agreement on interactions with other participants.

As was noted above, Cillari has a particular interest in using the human body as an interface. Technically, she achieves this by highlighting the skin as a point of contact between the recipient and the performer, and between electromagnetic and physical information. At the symbolic level, she represents this function of the body through an abstract depiction of a physical reaction to approach and touch, which has an intense emotional effect. Whereas Scott Snibbe's installation *Boundary Functions* visualizes the body's relationship to its environment as a consumption of space, which manifests itself first and foremost as a distancing from other people who are present, Cillari's work portrays physical and emotional reactions to proximity and touch. Cillari refers to the work of Henri Bergson and Francisco Varela when describing her interest in autopoietic processes and proprioceptive perception, in the inseparability of body and mind, and in the potentials of cognitive and physical knowledge. She says that her aim in *Se Mi Sei Vicino* was to "measure" human encounters by rendering closeness and distance visible and audible and by pursuing the idea of consciousness conveyed via the skin.[115]

Se Mi Sei Vicino hinges on the reciprocal interleaving of corporeity and interpretability, on the one hand, and of activity and passivity, on the other. Even if the negotiation of roles and the exploration of the workings of the system initially predominate, an immersive absorption in the audiovisual dynamics of the installation is still possible. Both the visualization and the sonification are highly abstract, but—or perhaps consequently—they are also extremely immersive. The artist has many years' experience in the conception of audiovisual structures that link abstract 3D graphics with sound, and emphasizes the immersive quality of these structures.[116] They strengthen the atmosphere of the installation not only because they can be interpreted as visualizations of the technical (electromagnetic) processes at stake, but also because they reinforce the emotional effect of the work.

Cillari challenges the conception of interactive art as apparatus by using a human being as the interface. Although, as in other interactive installations, a software program mediates between input and output on the basis of clear-cut constitutive rules, awareness of the underlying technological processes is overshadowed by the interaction between human beings. In this work, too, the interaction system is a black box whose workings the recipient is unable to grasp because he is not able to ascertain which reactions are produced by the system and which by the performer. Only the artist (or a recipient who is familiar with the technical setup of the installation) can make this distinction with any degree of certainty. Thus, Cillari explains in an interview that she herself can elicit any audiovisual output she wants from the installation.[117] If an interaction focusing on the expressive creation of audiovisual formations is possible in this work at all, it remains a privilege of the artist.

The aesthetics of this work is mainly based on the contrast between the interpersonal situation (which evokes curiosity, intimacy, and vulnerability) and the abstractness

of the projected graphics (which oscillate between a scientific visualization and an immersive artificial world). The recipient can arrive at knowledge in the form of cathartic transformation (as a half-aware experience of intensive distance or proximity), but also by means of conscious reflection on the potentials of proprioception and the possibilities for embodied expression.

Case Study 10: Blast Theory, *Rider Spoke*

Blast Theory's *Rider Spoke* has many of the features discussed above, but it also invites recipients to partake in another form of interaction. Recipients are encouraged to record their own spoken word as they explore the public space by bicycle.

Blast Theory is a British artists' group (made up of Matt Adams, Ju Row Farr, Nick Tandavanitj, and various collaborators) whose "mixed reality games" (the best known are *Can You See Me Now?* and *Uncle Roy All Around You*) have attracted considerable interest, especially since the beginning of the new millennium. These projects are explicitly structured as games that have clearly communicated rules and goals and use public spaces as their playing field. Blast Theory uses mobile media, tracking technology, and digital communication networks to create a hybrid space that allows players to act simultaneously in urban space and digital space.

Rider Spoke is not conceived as a game, however. The project was first presented in London in 2007, and since then it has been hosted in different cities throughout the world, including Linz in September 2009. *Rider Spoke* is the result of a collaborative venture involving Blast Theory, the Mixed Reality Lab at the University of Nottingham, Sony Net Services, and the Fraunhofer Institute for Applied Information Technology under the EU research project IperG (Integrated Project on Pervasive Gaming).

The following description is based on documentation and interviews carried out in the course of an international research project when the work was presented in Linz. In a joint venture of the Ludwig Boltzmann Institut Media.Art.Research (represented by Ingrid Spörl and me), the Department of Drama of the University of Exeter (represented by Gabriella Giannachi), and the Mixed Reality Lab in Nottingham (represented by Duncan Rowland), nine recipients were filmed while participating in the project, and their GPS coordinates and sound data were recorded. Subsequently, each of the recipients was interviewed, as was Matt Adams of Blast Theory.[118]

The work starts at a stand located either inside an institution or, as in Linz, in a public space. A recipient is offered the opportunity to borrow a bicycle, the handlebars of which are fitted with an Internet-capable tablet computer, and a pair of earphones with an integrated microphone. After a quick briefing, a recipient is free to cycle in whichever direction he prefers. He soon hears an instrumental piece of music played over the earphones, followed by an introductory text spoken by a woman:

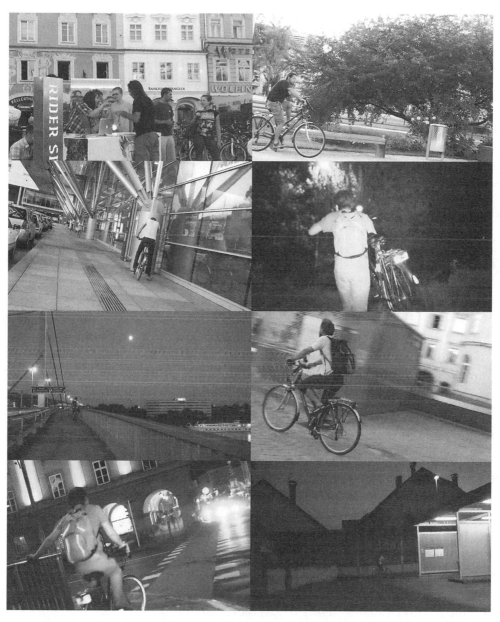

Figure 5.18
Blast Theory: *Rider Spoke* (since 2007), visitor interactions in Linz, 2009.

This is one of those moments when you're on your own. You might feel a little odd at first, a bit self-conscious or a bit awkward. But you're all right, and it's OK. You may feel invisible tonight, but as you ride this feeling will start to change. Relax, and find somewhere that you like. It might be a particular building, or a road junction. It might be a mark on the wall, or a reflection on a window. When you have found somewhere that you like, give yourself a name, and describe yourself.[119]

As with Schemat's *Wasser*, the operational rules of this work are communicated in two separate moments. At the beginning, general instructions are given by an assistant; later a recorded woman's voice gives further directions via earphones. Matt Adams explains that the exact moment when the artistically staged interaction begins—when the recipient "enters into" the work—is primarily a question of individual interpretation. The artists see the brief introductory moment as an integral component of the project. Indeed, they consider it to be particularly significant for the very reason that many of the recipients do not yet contextualize it as part of their experience of the work.[120] At this stage of the work, the frames assumed or constructed by the different actors (artists and recipients) are not identical, and this brief mismatch facilitates a special moment of interaction—a smooth transition from organizational preparation to the real experience of the work.

The request that a recipient give himself a name is an invitation either to emerge from anonymity and act under his own name or to record his input under a pseudonym. All the participants interviewed reported having used their own names. In fact, in this project, it proved to be much more difficult to create a role (that is, to think up a fictitious story in response to the questions) than to respond honestly—perhaps because of the way in which the questions and requests were formulated.[121] This doesn't mean that it was easy to answer all the questions honestly, however. A recipient's willingness—or refusal—to reveal personal details is a crucial aspect of the aesthetic experience of this work, and represents a difficult challenge for many participants. Why should I confide personal experiences to a digital storage system? How should I spontaneously find answers that are worth recording? How do I feel about the topics that are addressed? How will I behave if I am not willing to be truly honest?

The invitation to look for a place to stop and give oneself a name changes a participant's behavior. Now he no longer wanders aimlessly around the city; instead, he looks for an appropriate location in which to make his recording (or perhaps he cycles toward a place he already knows and considers suitable).

A recipient records his statement through his headset's microphone, using a simple recording function that can be controlled via the touch screen of the tablet. Once the recording has been completed, the recipient can choose on the touch screen between answering a further question and listening to the answers of other participants: "Do you want to hide again or look for others?"

The two possible activities proposed in the work are those of the game Hide and Seek. Although the analogy with that children's game is mentioned in the project descriptions, at Linz it was not at the focus of the participants' attention.[122] In that manifestation of the project, it was easy to find responses by other participants because it was not necessary to locate the exact places where they had recorded them, but only the general area. Furthermore, it is almost impossible to hide in the city with a bicycle, apart from the fact that it is not really clear from whom one should be hiding—from other recipients who might find the recorded answers at a later time, from passers-by who might listen in as the recording is made, or simply from distractions in the immediate surroundings. Moreover, the technical workings (that is, the constituative rules) of the project do not really support the idea of a game of Hide and Seek. The hiding place must have WLAN reception so that the system can generate tracking information for the answer. The result is a curious situation: One must be locatable in Hertzian space while being asked to hide in real space.

Although the aim really isn't to hide successfully, the search for a suitable spot may nonetheless influence a recipient's mood and his perception. The searching phase gives the recipient time to reflect and at the same time increases his awareness of the surroundings. Similarly, the very proposal to look for others affects the recipient: Even if I am not really looking for other people (or places where others have answered questions), the idea that other participants are present or may have been present in the same area evokes a certain awareness of the space around me. I am prompted to experience it as an environment that contains spaces for personal withdrawal and levels of meaning that are not directly visible, and which is also colored by the present, past, and future presence of people.

If a recipient decides to look for "others" and resumes cycling, his display soon shows the names of other participants who have recorded statements near his current location. These can be activated via the touch screen. If the recipient decides to hide once again, a new request is made—to talk about a party he remembers, for example, or to choose a place that his father would like:

Please, will you tell me about your father? You might want to pick a particular time in your father's life, or in your life. Freeze that moment, and tell me about your dad. What they look like, how they spoke, and what they meant to you. And while you think about this, I want you to find a place in the city that your father would like. Once you find it, stop there and record your message about your father in that moment in time.

It becomes evident that the requests follow a particular style. The recipient is asked politely to do something or recount something as a favor to the speaker, almost as if it were a personal courtesy. It is made clear that the recipient's willingness to divulge his thoughts is highly appreciated. However, the requests are elaborated and formulated in different ways, offering different alternatives ("in your father's life, or in your

life" / "what they look like, how they spoke"). The repetitions and variations create a distinctively calm and concentrated atmosphere, and also leave the recipients plenty of scope to reply. The operational rules are thus enveloped in atmospherically or emotionally suggestive formulations, while at the same time their specific details are often deliberately formulated in a very open way. Moreover, spatial and temporal references are often included in the requests. There are references to past times and events, but also to the current time and place of the recording ("pick a particular time" / "find a place your father would like" / "that moment in time" / "once you find it"). Although the questions are very open, they nonetheless steer the recipient's thoughts in a specific direction, insofar as they emphasize the importance of temporal relations, on the one hand, and the possible emotional impact of certain places or the personal memories and associations they evoke, on the other, even though they do not refer to specific places or times.

The artists composed the texts with great care. In fact, apart from the general architecture of the system, text is the means available to Blast Theory for orchestrating the activity of the recipients and shaping the emotional environment and the potential experiences of the work. The artists shape the experience via the content, wording, and tone of the requests and questions, as well as the music (a piece by the band Blanket). They know that they are asking a lot of the recipients in this project. Not only are the questions themselves very personal; the fact that the recipients must verbalize the thoughts that have been provoked in them, speak them out loud, and store them in a more or less public computer system, doesn't make it any easier to comply.[123] Thus, the artists had to create an atmosphere that would facilitate active participation. Their hope was that the texts would stimulate an "internal monologue" in which recipients would review and reflect on the questions and verbalize their own reactions and responses to them.[124] After various attempts, they decided not to engage a professional speaker to read the texts, but to entrust the task to Ju Row Farr, a member of Blast Theory. She recorded the texts in the middle of the night in a specially constructed, acoustically isolated setting. The texts themselves were written collaboratively by the artists and often relate to their own experiences or memories.[125] Thus, in a sense, the artists made a kind of advance investment by not simply formulating demands but also linking them to their own lives and recollections, composing the texts carefully, and charging them (e.g., by means of the chosen voice and tone) emotionally and atmospherically.

The recipients considered the voice and the wording of the requests an essential component of the work. Some of them noted that the questions had been very personal, or commented that normally they wouldn't talk about themselves in public. Although all claimed to have answered honestly (only two reported that they preferred not to respond to one question), some said that they had had to find a balance between their true thoughts and what they were willing to divulge. They felt that the

speaker's voice had been particularly important. One recipient said "the voice made me think a lot,"[126] and another recounted that she had asked herself afterwards what had led her to answer such very personal questions, and had concluded "I think it was the voice."[127] The participants did not generally experience the voice as a direct partner in communication, but neither did they feel that they were receiving purely technical feedback. One participant reported having experienced the interaction as communication with the artists. He compared the situation to reading a book, which also conveys the feeling of listening to the author's voice.[128] Participants who said that they had been nervous or uncertain at the beginning of the work reported that they were able to relax after a while, in many cases thanks to either the music or the voice.

The philosopher Gernot Böhme agrees that a text can conjure up an atmosphere: "The peculiar thing about reading a story or listening to a story being read is this: it not only tells us that there is a particular atmosphere reigning in some other place, but it also summons or conjures up that atmosphere."[129] This observation can also be applied to *Rider Spoke*. The voice creates a particular atmosphere, even though there is no construction of a fictional story in which the recipient is given a role. The artists make use of this circumstance in order to set the mood. By means of texts and music, they create an atmosphere that optimally supports the experience of the work.

A recipient can access other participants' responses to a question only if he has already answered the same question. Only after recording his own answer can he listen to other participants' responses. Many of the recipients we interviewed reported that they found it interesting to listen to other people's contributions, and some reported having been moved by particular responses.[130] Others were surprised by their own level of interest in the statements of strangers. Nearly all the recipients reported that other participants' responses had encouraged them to divulge their own thoughts. Matt Adams explains that the aim of the project was to create a "mutual supportive network of people talking in honest and intimate ways."[131] The artists wanted to give each participant the feeling that they belonged to a temporary community in which intensive communication could take place. They have repeatedly rejected the term "user-generated content" as applying to their works, for they believe that each of its words is too tainted with commercial connotations. For that reason, they prefer to speak of "publicly created contributions."[132] The participants in their projects would thus contribute in public to a collective project. But the participants' shared interest in something and their willingness to actively participate in it are at least as important as the archivable recordings.

Adams points out that the central theme of Blast Theory's work is social interaction, especially interaction between strangers in the urban context. The kind of interaction the group orchestrates is not based on face-to-face or real-time communication, however, nor does Blast Theory attempt to emulate these either in the relations between the recipients or by means of the pre-recorded texts. Even though the voice

addresses the recipient directly, it is clear that this is not an illusionistic simulation of real-time communication. In this project, communication takes the form of a general, asynchronous, and in a sense even anonymous exchange of reflections on and memories about one's own life and the city hosting the project. In accordance with the arguments by Nick Couldry discussed in chapter 4 above, Adams doesn't see this kind of communication as being in any way unusual. In fact, as social networks increasingly involve absence, distance, and technical mediation, this is becoming a more and more common everyday modality.[133] In the case of *Rider Spoke*, the asynchronous nature of the communication, together with the anonymity of the recorded statements, excludes the possibility of a direct reaction, which seems to make it even easier for some participants to divulge personal information.

The collection and the archiving of personal memories in *Rider Spoke* are reminiscent of oral history projects that view history as the sum of individual experiences and memories and therefore seek to document those experiences and memories authentically. Such projects are now also increasingly initiated by artists and directly linked by means of digital technology to significant places.[134] However, in *Rider Spoke* the focus is neither on the location of the recording nor on a particular historical or social theme. The project is about personal thoughts and recollections that serve more to create a kaleidoscope of human reflections and emotions than to document experiences of historical relevance. One could even argue that the content of the questions is of secondary importance. Whether the recipient is asked to talk about a party or an episode from his childhood, or about his father or some other close relative, the main purpose of the questions is always to encourage reflection on his own life and his social environment. The questions are designed to put the recipient in a certain mood—one in which the trip through the city is associated with personal thoughts and memories that are actively formulated and expressed. The texts are not so much operational demands as literary fragments that are supplemented in the context of the artwork by texts (or even thoughts) produced by the recipients. The result is the kind of intertextuality described by Roland Barthes. (See chapter 2 above.) The texts can be understood as elements of a network of expressed and consciously concealed, recorded and deleted, past, present, and potential thoughts that refer to one another in different ways.

Adams also points out that the main intention of the work is to give the recipient an opportunity to reflect on and talk about particular aspects of his life. However, it also offers the recipient the peculiar experience of being simultaneously very private and extremely public ("sliding across the line of entirely private and radio station broadcast to the entire population of a city").[135] The invitation to make a recording is also a means of encouraging the recipient to express personal thoughts out loud and in public.[136] The aim is not only to acquire utterances for storage that can be listened to by others, but also to induce the recipient to formulate them explicitly and to

express them in audible form, which, as speech-act theory points out, gives a statement a special status. The objective of this work may not be reality constitution in the sense of constitution of practical facts, but the participants' thoughts are nonetheless given linguistic and acoustic form. A survey of visitors conducted when the work was presented in London showed that this type of public self-expression was initially a challenge for many participants, no doubt also because the risk of being listened to by passers-by is much greater in a metropolis such as London than in a small city such as Linz, where it is easier to find places where one can be alone.[137]

Reality is also constituted in this project in the form of movement in real space, for the spatio-temporal setting of the work is another important element of the aesthetic experience. The spatio-temporal setting entails both the work's localization in public and urban space and the chosen time of day. For instance, the bicycles are not lent out until dusk, so the recipients experience the city in evening light and at a time of day when the streets are usually less busy, the pedestrians are less rushed, and the participants may be more at leisure to abandon themselves to the proposed experiences. Their experiences are significantly shaped by the combination of the movement through the city with the invitation to recall things. The mode of locomotion significantly influences the perception of space. On the one hand, cycling gives one a feeling of a direct physical presence in space. On the other hand, because the participants ride in a slightly elevated position and at cycling speed, there is a certain degree of distance between them and pedestrians. Cycling combines physical presence and distanced observation. The speed of locomotion can be varied, so that participants can perceive certain details thoroughly, if they wish, but can also quickly escape areas or situations they find uninteresting or frightening. Cycling encourages aimless wandering around the city. Because cyclists can get from one place to another relatively quickly, it is easy to decide spontaneously to change direction or to cycle into unknown areas. Matt Adams associates cycling with a feeling of freedom. He also believes that cycling has its own relationship with space and time, insofar as the length of a space-time unit amounts to about ten meters for a pedestrian but about fifty meters for a cyclist. His point is that cyclists cover a much greater distance than pedestrians between the intake or processing of different pieces of information or between two different strands of thought.[138]

Although cycling is not an unusual activity, the type of urban exploration proposed in *Rider Spoke* probably represents a novel experience for most of the participants. A bicycle is normally used either to reach a certain destination or for sport. And even people who are touring a city by bicycle usually follow either a guide or a map. They are usually not engaged in spontaneous and unguided exploration of the city or in the observation of details such as reflections in windows or marks on walls, as prompted in the introductory text. But the texts not only draw the recipient's attention to this type of detail; they also interpret the urban atmosphere and the events

located within it as potential triggers of personal memories or thoughts. Some participants were surprised themselves at this effect: "It is crazy how many memories come back just by going to places."[139]

Thus, the project is not concerned with actual places of public interest or buildings, nor is it a purposeful guided tour through urban space; rather, it focuses on the atmospheric potential of the city and on the recipient's experience of the city in the present moment. The interviews reveal that some of the recipients had decided in advance which locations they would like to visit, either because they particularly appealed to them or because they associated them with something special, but then in the course of the activity they spontaneously decided differently and ultimately tended to cycle aimlessly through the city and to stop in places that seemed to invite them to do so in the here and now. For example, one of the interviewees described the condition of "not knowing where I am going, even though I do" as a significant element of his aesthetic experience.[140] As a result, he succeeded in allowing himself to drift aimlessly through his native city. *Rider Spoke* enables a new perception of the urban space by means of purposeless action, which can be understood here in the spatial sense as non-directionality.

In addition to the intensive perception of the city and of details in the immediate environment, the project also invites recipients to observe strangers. One of the requests goes as follows:

Will you be a voyeur for me? Please will you cycle back towards a busier place and look for someone who catches your eye? Stay back, don't intrude—just watch them and follow them. Think about who they might be, and where they might be going as you track them. Don't be afraid to make it all up. Then stop your bike, let them go, and tell me about them.

This request renders evident another strategy of the artists, one that further enforces the self-positioning of the recipient. The speaker sends the recipient onto the street as a spy. His job is to make observations on her behalf and then communicate them to her. In this moment, the recipient is working for an audience; he is invited to present something and thus to distance himself as an observer. The invitation to combine exploring the city with observing people can be interpreted as a statement about the basic components of a city. This project suggests that the (individual) perception of urban space is informed not only by buildings, scenic details, and objects, but also by the people who move within it. Thus, the project can be addressed as a successful manifestation of what Martina Löw calls synthesis—the arrangement of goods and people to form spaces by means of processes of perception, ideation, and recall.

The artists also point out that their projects differ from many other locative artworks in that they are not interested in a precise geographical characterization of a place, but in the encounter between spatial and social situations.[141] Thus, it is not

surprising that the interface doesn't provide a map of the area.[142] All it shows during the work is a deliberately simple comic-book-style drawing of a stereotypical city fringed by houses. The activity of hiding and the hiding places of others are symbolized by single houses, which also have no real connection to the city space.

However, the loose connection between both the interface and the texts and the actual surroundings irritated some of the Linz participants. They said that they would have expected a closer relationship between the requests and responses and specific locations, or that the participants' statements would refer more closely to the places they chose to make their recordings. In other words, these participants articulated typical expectations of a locative art project. But the artists call these expectations into question, also by means of the chosen technology. In fact, *Rider Spoke* doesn't use the GPS technology common to such projects; instead it uses "WiFi fingerprinting," which calculates the position of electronic devices by measuring the signal strength of the wireless networks available at their actual location so as to acquire an indexing "fingerprint" of the recipient's position. The result is a map of the action space that updates itself constantly as the positions and the succession of the different participants are recorded.[143] However, this tracking method also leads to substantial fluctuation in the evolving map, for wireless networks can be turned on and off, and transmission capacity varies depending on utilization levels. The consequence for *Rider Spoke* is that, although the responses of the players are indeed localized in the city, the positioning is based on a data network determined not only geographically but also socially. In other words, the technology of WiFi fingerprinting is the perfect companion to the perception of the city prompted by the texts as a place characterized by ephemeral situations and actions.[144]

The idea of staging an interactive artwork as a ride through a city is not a new one. Two of the pioneering works of interactive art were based on this concept: *Aspen Moviemap* (co-authored by a team of artists and engineers beginning in 1979) and Jeffrey Shaw's *Legible City* (1988–1991). However, each of those works consists of an interactive representation or simulation of a ride through the city, not a real activity in public space. Whereas Shaw, like Blast Theory, selects the bicycle as means of transportation, the authors of *Aspen Moviemap* select a car and (in a later version, *Karlsruhe Moviemap*) a tramway.

Nowadays, mobile technologies make it possible to stage such mediated forms of exploration in real space. Likewise, the participant's own movement through this space is no longer an illusion, but is real. Whereas the creators of the different versions of the *Moviemap* presented the chosen means of transportation via an interface featuring a typical control panel, Shaw created something that was at least comparable to the experience of cycling by using a modified bicycle, similar to a home trainer, as the work's interface. In *Legible City*, the recipient has to carry out the physical action

that an actual bicycle ride requires. The distance between the recipient and the virtual space is thus reduced; the physical movement simulates the real experience of cycling, which is supposed to be perceived as a trip through a model of a city.

In Blast Theory's work, a home trainer is no longer needed to make simulated locomotion seem more realistic, because the recipient really finds himself on a bicycle in the city. In addition to the physical experience of activating the equipment, he now also has the experience of locomotion in real space. As was noted above, the physical exertion of cycling has its own rhythm and even evokes a feeling of agency in some recipients.[145] Nonetheless, here, too, locomotion by bicycle leads to a distancing effect. Because everything is real, it is the bicycle that, as explained, causes a certain mental distance from the surrounding space, and this, in connection with the purposelessness of the movement, opens up the possibility of distanced observation.

Unlike the works described in the preceding case studies, *Rider Spoke* allows ongoing storage of assets on the part of the recipients. In addition to the texts recorded by the artists' group, the system stores personal memories, stories, and observations by the recipients. The project has a constantly growing archive of audio data that can be localized using a map that develops anew in each city, combined with an interface for recording and retrieving these assets.[146] It thus definitely has an emergent character, insofar as both the collection of texts and the map that shows where to find them take shape as they are referenced over the course of the project. Nonetheless, the concept of a growing archive doesn't adequately grasp the aesthetic potential of the work, insofar as the single recipient doesn't perceive the project primarily as an archival endeavor, but as an unrepeatable individual experience. This is based on the activity of cycling, on the atmosphere provided by the city space, and on the thoughts that the texts articulate and evoke. Although the realization of the interaction proposition can be described as a spatial activity (as a journey) or as a chronology (a succession of assets that are listened to, recorded, and retrieved), the aesthetic experience is constituted primarily through sensitization and self-reflection, which may be made possible by referenceable spatial and temporal activities but cannot be reduced to these. This is in accordance with the openness of the interaction proposition. Not only is the recipient entirely free to decide where he goes; he can activate or record texts or statements whenever he wants. The voice of the speaker makes suggestions about the perception of the city and prompts chains of thought, but then allows the participant time to reflect on these perceptions and thoughts. Although there is a time limit on the overall duration of the experience and on the duration of each single audio asset, the project only makes structural suggestions about the configuration of this time span and about the moment at which and the frequency with which assets are retrieved or recorded.

But what is it that frames the bicycle tour offered by *Rider Spoke* as a specifically aesthetic experience? On the one hand, aimless cycling around the city combined with

texts that heighten awareness leads to a more intense perception of the environment, including the notice of tiny details or momentary events. On the other hand, the speaker's requests encourage reminiscence, intense contemplation of one's own life, and an active self-questioning whose outcome—thanks to the invitation to speak aloud—is a perceptible manifestation. Both the atmosphere and the discursive inter-textuality of the statements develop in an emergent process, insofar as ultimately neither can be controlled either by the interaction system or by the recipient alone. Matt Adams explains that Blast Theory's projects are challenging for recipients because they do not specify the framing conditions that apply to them—that is, where the boundaries should be set. Whereas recipients usually seek a clear distinction between art projects and their daily life, the artists try to circumvent these boundaries: "[T]hat sense of being imbalanced is an engine that sits at the heart of the work in some ways."[147] The realization of the work and its experience by the individual recipient oscillate in the borderline area between active commitment, distanced reception, and immersed participation, in the sense of being part of the atmospheric and intertextual emergence of the project. Again, in this work, not only may knowledge be achieved through conscious reflection on one's own experiences with the interaction proposition; knowledge can also be achieved through a cathartic transformation.[148] Exploration of the city becomes exploration of one's self—and vice versa.

Conclusion

The point of departure for this study was the observation that interactive art challenges fundamental categories of aesthetic theories of art: the work as its primary object, aesthetic distance as its condition, and the distinction between sensory perception, cognitive knowledge, and purposeful action as its basis. For, on the one hand, the work is based on an artistically configured interaction proposition, while, on the other, its realization depends on the recipient's action. The materiality, the gestalt, and the interpretability of the work must be actively brought into being and individually experienced in order to allow epistemic processes to arise. As a non-purposeful action, the reception of interactive art is similar to the activity of play, with which it also shares its process-based gestalt, its foundation in rule systems, and its ambivalent relationship with "reality." However, unlike play, interactive art actively engenders disruptions and frame collisions, as well as using different forms of self-referentiality.

The aesthetic experience of interactive art is based on rule systems that both complement and counteract one another. It is the result of an interplay of instrumental constellations, material and figurative mise-en-scènes, the processual activation of the latter by the recipient, and their contextualization within different possible reference systems and personal horizons of experience. The reception of interactive art can involve several different modes of experience: experimental exploration, constructive comprehension, communication, and expressive creation.

Aesthetic distance doesn't exist as a stable condition in interactive art; rather, it manifests itself in oscillation between artificiality and reality constitution, and between absorption in the activity and distanced (self-)perception. The multi-layered, open, and potentially contradictory interpretability of the interaction proposition goes hand in hand with the fact that the epistemic potential of the aesthetic experience is grounded in subjective perceptions and constructions of meaning. Knowledge acquisition is not pursuant to sensory perception; rather, it is a process of awareness that can take place either by means of emotional or physical (cathartic) transformation or by means of conscious reflection. In any case, it is always based on action.

Interactive media art can assume many different forms. It can be presented as Internet art, locative art, interactive installations, or interactive environments. It can stage narratives, simulate communication situations, make use of game structures, or invite the recipient to engage in physical experiences or cooperative activities. Knowledge can ensue through heightened sensitivity for media-based paradigms, the necessity to position oneself with respect to roles assigned by the work, immersive identification, bodily experiences, or distanced (self-)observation.

Recipients of Olia Lialina's *Agatha Appears* are reduced to the role of button-pushers with no power of influence over the work. Nonetheless, the constructive comprehension of this media-based mise-en-scène is significantly shaped by recipients' repetitive, mechanical actions. By contrast, the recipient of Susanne Berkenheger's *Bubble Bath* is forced into a role that ultimately renders him the helpless pawn of an interaction proposition that he actually controls. Stefan Schemat's *Wasser* provokes frame collisions between the narrative space of the artwork and the real-life surroundings, with respect to which the recipient must adopt his own position. By contrast, Teri Rueb's *Drift* doesn't assign the recipient an active role; rather, it plays both with his expectations concerning interactive media art and with an intricate overlaying of data flows and a natural environment. Lynn Hershman's interactive sculpture *Room of One's Own* confronts the visitor with a complex and incongruous set-up of different actors, one of which is the work itself. Agnes Hegedüs' *Fruit Machine* not only deals in a concrete manner with the relationship between media art and games, but also instigates social interactions between different recipients. Tmema's *Manual Input Workstation* and David Rokeby's *Very Nervous System* focus on multimodal experience. These works illustrate particularly clearly the potential states of ambivalence between flow and reflection, as well as the instrumentality of interactive art. Sonia Cillari's *Se Mi Sei Vicino* also deals with questions of bodily self-awareness, but the artist's use of a performer as an interface thematizes the relationship between humans and machines in a very different way. Blast Theory's *Rider Spoke* brings us back to the public space, although this work stores the recipients' spoken contributions and thus also thematizes the topics of retrospection and asynchronic communication.

What all these works have in common is that they not only require activity on the part of their recipients, but also orchestrate, control, and channel the resulting actions. Accordingly, to reduce these projects to processual presence would do just as little justice to their ontological status as does the traditional concept of the artwork, which is based on exhibitable artifacts. For even if the interaction process leaves scope for the unexpected, it is still based on feedback processes programmed into the technical system, on the one hand, and on intentional actions on the part of the recipient, on the other. Ontologically, interactive media art can therefore be compared with an apparatus. Apparatuses unite presentability and performability in the sense that they are at one and the same time manifest entity, invitation to act, and basis

for performance. They explicitly call out to be activated. The concept of the apparatus thus admits both exploration and expressivity, insofar as its complex and pre-programmed resistance is the constitutive element of the reception experience. Inter-active media artworks are comparable to apparatuses, although their aesthetic potential should primarily be sought in the realization of the processes they enable. However, this doesn't exclude the possibility that this realization may also turn into a creative activity, within which the interaction system will become a facilitator for the creation of manifestations—which in turn can become the object of a contempla-tive observation.

Outlook

In the fall of 2010, Sonia Cillari presented a work titled *Sensitive to Pleasure* at a number of international festivals. Cillari used a performer in this work, as she had in *Se Mi Sei Vicino*, but this time she also involved her own body in the interaction process. The work featured a black cube installed in the middle of the room—a patently inaccessible space within the exhibition space. The cube contained a naked female performer. Cillari stood just in front of the enclosed space. The artist wore a harness of wires, which were clearly visible to observers and which extended through the wall into the interior of the cube. She allowed only one visitor at a time to enter the cube through a side door. If the visitor inside approached the performer or touched her, he triggered electrical impulses that were conducted by the wires to the body of the artist. The title of the work suggests that the electrical impulses could produce both painful and plea-surable effects. However, since the active recipient was inside the cube, he wasn't able to observe the effects of his actions on the artist. He was, however, face to face with the performer, standing in front of her in a dimly lit space. If he had been observing events from outside the cube, he knew that what happened inside the cube affected the artist—although he couldn't be sure exactly how his behavior would affect the electrical impulses. Thus, the direct negotiation of the recipient's physical relationship with the performer was in tension with his uncertainty about how his actions would affect what was happening outside the cube. The artist was at the mercy of events inside the cube, even though she herself had programmed the feedback processes. She presented herself to the public as an actor, condemned to passivity, who freely risked being injured by her own work. She alone knew whether the physical feedback she would receive from the cube might be dangerous.

The theme of *Sensitive to Pleasure* is the role of the artist in interactive art. This book proceeds from the premise that the interactive artwork should be understood as a processual gestalt based on an artistically configured interaction proposition, whereby the work takes on concrete form and reveals itself in the course of its individual real-ization by a recipient.

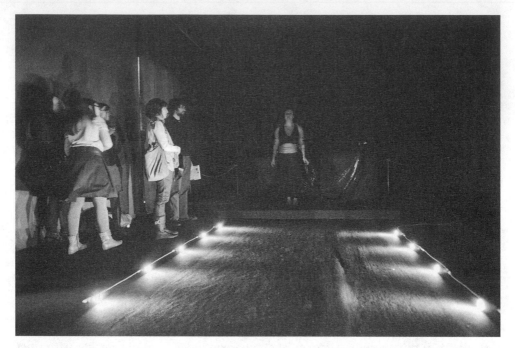

Figure 6.1
Sonia Cillari, *Sensitive to Pleasure* (2010–2011, co-produced by Netherlands Media Art Institute, Studio for Electro-Instrumental Music, and Claudio Buziol Foundation; supported by Fonds BKVB and Optofonica Laboratory for Immersive Art-Science), installation view. Photo: Summer Yen.

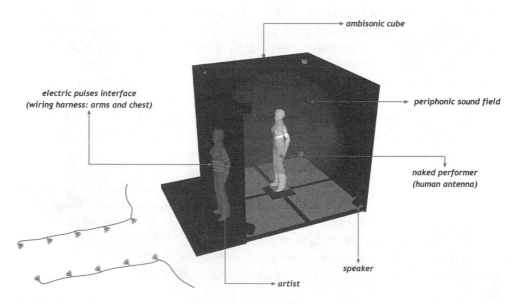

Figure 6.2
Sonia Cillari, *Sensitive to Pleasure*, technical drawing.

We have seen that the absence of the artist at the moment of reception is limited to the artist's role as author, but that the artist may participate in the interaction process as an observer, a performer, or a typical recipient. Whereas this book has focused on the aesthetic experience of the recipient, Cillari's work reflects the consequences of the traditional distribution of roles in interactive art for its authors. In *Sensitive to Pleasure*, Cillari places herself not only at the beginning of the work's process of evolution, but also at the center of its realization. However, here she is not performing her authorial role as creator; rather, she acts as a heteronomous receiver of the system's feedback who is exposed to the effects of the interaction process. She deals with the sensations of artists who are confronted with the individual realizations of "their" interaction proposition that are beyond their control and presents these sensations as a potentially pleasurable but also a possibly painful experience. In Vilém Flusser's words, she lets the recipient "creep into" the apparatus. The recipient literally disappears into the black box of the interaction proposition, but still doesn't acquire full control over the process of interaction. While the work offers a complex metaphorical interpretability, it also requires that the active recipients, as well as the observers, quite concretely take a position regarding the feedback processes that, in their effects on the artist, acutely constitute reality. At the same time, the work challenges the concept of the interactive artwork's realization as independent of its author.

Cillari's work illustrates that the instrumental, conceptual, and aesthetic potentials of interactive media art—and thus of mediated interactions in general—have by no means been exhausted. As a hybrid of different artistic genres, interactive media art continually presents new interrelationships between "workliness" and performativity, between mediated processes and social positionings. Interactive media art makes us aware of the potentials of mediatized interactivity, and, even more, invites us to experience them actively. At the same time, it highlights issues related to process and reception aesthetics that are pertinent to other forms of art too. For questions concerning the roles of the various actors in the process of a work's realization and concerning the complex factors involved in the aesthetic experience of art must be continually posed anew and from different perspectives if art history is to adequately fulfill its role as a critical observer and mediator of contemporary as well as historical art.

Notes

Introduction

1. Jonathan Crary, *Techniques of the Observer: On Vision and Modernity in the Nineteenth Century* (MIT Press, 1992), 18.

2. Hans Belting, *The Invisible Masterpiece* (Reaktion, 2001), 388.

3. Michael Fried, "Art and Objecthood," *Art Forum* 5 (June 1967): 12–23.

4. Umberto Eco, *The Open Work* (Harvard University Press, 1989); Lucy Lippard, *Changing: Essays in Art Criticism* (Dutton, 1971); Peter Bürger, *Theory of the Avant-Garde* (University of Minnesota Press, 1984).

5. Mark B. N. Hansen, *New Philosophy for New Media* (MIT Press, 2004); idem., *Bodies in Code: Interfaces with Digital Media* (Routledge, 2006). On page x of the latter work, Hansen describes media artworks as "thought-catalyzing."

6. Lev Manovich, *The Language of New Media* (MIT Press, 2001).

7. Marshall McLuhan, *Understanding Media: The Extensions of Man* (Routledge, 1964).

8. In such non-specific contexts, male pronouns are used for convenience and ease of reading and should, of course, be taken to refer to either gender.

9. This study refers on various occasions to "traditional" works of art, meaning works that do not envisage any physically active involvement on the part of the recipient. They are characterized as "traditional" simply because a more suitable term is not available.

10. Hans Robert Jauß, *Aesthetic Experience and Literary Hermeneutics* (University of Minnesota Press, 1982), 31.

11. Cf. Stefan Heidenreich, "Medienkunst gibt es nicht," *Frankfurter Allgemeine Sonntagszeitung*, January 1, 2008; Inke Arns, "Und es gibt sie doch. Über die Zeitgenossenschaft der medialen Künste," in *Hartware MedienKunstVerein 1996–2008*, ed. Susanne Ackers et al. (Kettler, 2008), 66.

12. Barbara Büscher, Live Electronic Arts und Intermedia, habilitation treatise, University of Leipzig, 2002 (at http://www.qucosa.de). In the present book, foreign-language quotations were

translated into English if there was no English edition of the respective book available. Quotations from German were translated by Niamh Warde; I translated quotations from other languages—K. Kwastek.

13. Jacques Rancière, "The Emancipated Spectator," in *The Emancipated Spectator* (Verso, 2009), 17.

Chapter 1

1. See, for example, Hans Ulrich Reck, *Mythos Medienkunst* (König, 2002), 21.

2. Geert Lovink, *Zero Comments: Blogging and Critical Internet Culture* (Routledge, 2008), 83.

3. The Netherlands Media Art Institute was called Montevideo/Time Based Arts for many years. The Berlin University of the Arts still has an Institute for Time-Based Media.

4. Hans-Peter Schwarz, ed., introduction to *Media—Art—History* (Prestel, 1997), 7.

5. Heinrich Klotz, "Der Aufbau des Zentrums für Kunst und Medientechnologie in Karlsruhe. Ein Gespräch mit Lerke von Saalfeld," in *Eine neue Hochschule (für neue Künste)* (Hatje Cantz, 1995), 35.

6. Siegbert Janko, Hannes Leopoldseder, and Gerfried Stocker, eds., *Ars Electronica Center, Museum of the Future* (Ars Electronica Center, 1996), 46.

7. Gerfried Stocker and Christine Schöpf, eds., "New Media Art. What Kind of Revolution?" in *Infowar—Information.power.war*, Ars Electronica 1998 festival catalog, volume 1 (Springer, 1998), 292.

8. See Heidenreich, "Medienkunst gibt es nicht"; and Reck, *Mythos Medienkunst*, 10f. Reck contrasts "media art," which he sees as the perpetuation of "artistic assertion as expression, depiction, and representation" with "art through media," described as process and experiment. For a detailed discussion of this question, also see Lovink, *Zero Comments*, 79–127.

9. Geert Lovink and Pit Schultz, "Der Sommer der Netzkritik. Brief an die Casseler," n.d. (at http://www.thing.desk.nl).

10. Arns, "Und es gibt sie doch," 66.

11. Ibid., 66.

12. Heidenreich, "Medienkunst gibt es nicht."

13. Rosalind Krauss, *A Voyage on the North Sea: Art in the Age of the Post-Medium Condition* (Thames & Hudson, 2000); Lev Manovich, "Post-Media Aesthetics," 2001 (at http://www.manovich.net).

14. Dieter Daniels, "Was war die Medienkunst? Ein Résumé und ein Ausblick," in *Was waren Medien?* ed. Claus Pias (Diaphanes, 2010).

15. Beryl Graham and Sarah Cook, *Rethinking Curating* (MIT Press, 2010), 21.

16. Until 1995, the annual publication accompanying the Prix Ars Electronic was titled *International Compendium of Computer Arts*. For other early exhibitions and publications with this title, see Heike Piehler, *Die Anfänge der Computerkunst* (dot-Verlag, 2002); Christoph Klütsch, *Computergrafik. Ästhetische Experimente zwischen zwei Kulturen. Die Anfänge der Computerkunst in den 1960er Jahren* (Springer, 2007).

17. In *Digital Art*, Christiane Paul makes a clear distinction between the use of digital technology as a tool for producing artistic works in different forms (photography, graphics, sculpture, music) and its use as a processual artistic medium. Christiane Paul, *Digital Art* (Thames & Hudson, 2008), 8.

18. Söke Dinkla, *Pioniere interaktiver Kunst von 1970 bis heute: Myron Krueger, Jeffrey Shaw, David Rokeby, Lynn Hershman, Grahame Weinbren, Ken Feingold* (Hatje Cantz, 1997), 8, note 6.

19. See, for example, the discussion of the concept of interactivity in Katharina Gsöllpointner and Ursula Hentschläger, *Paramour: Kunst im Kontext neuer Technologien* (Triton, 1999), 71–78 and 145–147, and Paul, *Digital Art*, 67f. Marion Strunk and Christian Kravagna, for example, consider participation to be a freer, more advanced form of observer involvement; see Marion Strunk, "Vom Subjekt zum Projekt: Kollaborative Environments," in *Kunst ohne Werk. Kunstforum International* 152 (2000),126; Christian Kravagna, "Arbeit an der Gemeinschaft. Modelle partizipatorischer Praxis," in *Die Kunst des Öffentlichen. Projekte, Ideen, Stadtplanungsprozesse im politischen, sozialen, öffentlichen Raum*, ed. Marius Babias and Achim Könneke (Verlag der Kunst, 1998), 30.

20. James Mark Baldwin, "Interaction," in *Dictionary of Philosophy and Psychology*, volume I (Macmillan, 1901), 561f.

21. See Heinz Abels, *Einführung in die Soziologie*, volume 2, *Die Individuen in ihrer Gesellschaft* (Verlag für Sozialwissenschaften, 2004), 204–206.

22. Edward Alsworth Ross, *Social Psychology: An Outline and Source Book* (Macmillan, 1909), I; George Herbert Mead, "Social Psychology as Counterpart to Physiological Psychology," *The Psychological Bulletin* VI, no. 12 (1909): 401–408; for the history of the term, see Hans Dieter Huber, "Der Traum vom Interaktiven Kunstwerk," 2006 (at http://www.hgb-leipzig.de).

23. Herbert Blumer, "Social Psychology," in *Man and Society: A Substantive Introduction to the Social Sciences*, ed. Emerson Peter Schmidt (Prentice-Hall, 1937), 170.

24. Blumer, "Social Psychology," 171.

25. Ibid., 191.

26. Norbert Wiener, *The Human Use of Human Beings: Cybernetics and Society*, revised edition (1950; reprint: Da Capo, 1954), 16.

27. Wiener, *The Human Use of Human Beings*, 33.

28. J. C. R. Licklider, "Man-Computer Symbiosis," *IRE Transactions on Human Factors in Electronics* HFE-1 (1960): 4–11.

29. Ivan Edward Sutherland, Sketchpad: A Man-Machine Graphical Communication System, PhD thesis, Massachusetts Institute of Technology (at http://www.cl.cam.ac.uk), 17. Also see the introduction to the electronic edition by Alan Blackwell and Kerry Rodden.

30. Douglas C. Engelbart, *Augmenting Human Intellect: A Conceptual Framework*, SRI Summary Report AFOSR-3223, October 1962 (at http://www.dougengelbart.org).

31. See Brad A. Myers, "A Brief History of Human Computer Interaction Technology," *ACM interactions* 5, no. 2 (March 1998): 44–54; Paul A. Mayer, ed., *Computer Media and Communication: A Reader* (Oxford University Press, 1999). The best-known conference on this topic is the CHI Conference, which has been taking place since 1982.

32. See, for example, Lucy A. Suchman, *Human-Machine Reconfigurations: Plans and Situated Actions* (Cambridge University Press, 2007).

33. Interaction as a subset of communication is characterized as a kind of (ideally multi-channeled) communication based essentially on feedback processes. When, by contrast, communication is considered a subset of interaction, then interaction is defined generally as any action that refers to another action, whereas communication occurs only if interactions lead successfully to understanding. Christoph Neuberger, "Interaktivität, Interaktion, Internet. Eine Begriffsanalyse," *Publizistik* 52, no. 1 (2007): 33–50.

34. Neuberger, "Interaktivität," 37.

35. For a similar view, see E. D. Wagner, "In Support of a Functional Definition of Interaction," *American Journal of Distance Education* 8, no. 2 (1994), 20: "Thus, interaction focuses on people's behaviors, while interactivity focuses on characteristics of the technology systems." Jens F. Jensen, on the other hand, suggests that the concept of interaction be used for human communication and that of interactivity for mediated communication; Jens F. Jensen, "Interactivity. Tracking a new Concept in Media and Communication Studies," in Mayer, *Computer Media*, 182.

36. Here, too, cf. Jensen, "Interactivity," 1997. Critical attempts to define the concept, such as Ken Jordan's "passive interactivity," can be taken as a critique of such blanket glorification: Ken Jordan, "Die Büchse der Pandora," in *Kursbuch Internet: Anschlüsse an Wirtschaft und Politik, Wissenschaft und Kultur*, ed. Stefan Bollmann (Bollmann, 1996), 50. Another example is Robert Pfaller's "interpassivity" (see chapter 4).

37. For a detailed discussion, see Katja Kwastek, "The Invention of Interactivity," in *Artists as Inventors, Inventors as Artists*, ed. Dieter Daniels and Barbara U. Schmidt (Hatje Cantz, 2008).

38. See Jack Burnham, ed., *Software: Information Technology: Its New Meaning for Art* (self-published, 1970), 11.

39. Jack Burnham, "Art and Technology: The Panacea That Failed," in *The Myth of Information: Technology and Postindustrial Culture*, ed. Kathleen Woodward (Routledge, 1980), 201.

40. Exhibition flyer, Myron Krueger archives.

41. One such system was the laser disk, which enabled alinear control of digital assets for the first time and thus interactive control of narrations and communications and the exploration of simulated spaces. See Dinkla, *Pioniere interaktiver Kunst*, 14–16.

42. See Frank Popper, *Art of the Electronic Age* (Thames & Hudson, 1993), 172.

43. See, for example, Schwarz, *Media—Art—History*, 7.

44. Scott deLahunta et al., "Rearview Mirror: 1990–2004," jury statement, in *Cyberarts 2004, International Compendium Prix Ars Electronica*, ed. Hannes Leopoldseder, Christine Schöpf, and Gerfried Stocker (Hatje Cantz, 2004), 106.

45. Consider, for example, the Award of Distinction for Bernie Lubell's project *Conservation of Intimacy*, which is based almost exclusively on mechanical processes, and the special prize awarded to Theo Hansen's *Strandbeesten*, a project that dispenses entirely with electronics. The introduction in 2007 of the new category of "hybrid art" should also be seen in this context.

46. Peter Gendolla and Annette Hünnekens also use this differentiation. See Peter Gendolla et al. (eds.), *Formen interaktiver Medienkunst: Geschichte, Tendenzen, Utopien* (Suhrkamp, 2001); Annette Hünnekens, *Der bewegte Betrachter. Theorien der interaktiven Medienkunst* (Wienand, 1997).

47. Because the activity of the recipient is considered to be a necessary and central paradigm of this experience, interactive media artworks that do not require such activation, such as self-sustained generative systems, are not dealt with in this study. This doesn't translate into a negation of their existence and significance, however. Interactions between different technical systems and visualizations of external data can also be meaningfully described by the term "interactive media art." On this topic, see the excellent exhibition catalog *Feedback: Art Responsive to Instructions, Input, or Its Environment*, ed. Ana Botella Diez del Corral (self-published, 2007).

48. On participatory art, see Lars Blunck, *Between Object & Event: Partizipationskunst zwischen Mythos und Teilhabe* (VDG, 2003). On performance and action art, see Thomas Dreher, *Performance Art nach 1945. Aktionstheater und Intermedia* (Fink, 2001). On immersive strategies, see Oliver Grau, *Virtual Art: From Illusion to Immersion* (MIT Press, 2003).

49. See Myron Krueger, *Artificial Reality II* (Addison-Wesley, 1991); Heinrich Klotz and ZKM, eds., *Jeffrey Shaw—a User's Manual: From Expanded Cinema to Virtual Reality* (Hatje Cantz, 1997); Meredith Tromble, ed., *The Art and Films of Lynn Hershman Leeson: Secret Agents, Private I* (University of California Press, 2005); Christa Sommerer and Laurent Mignonneau, *Interactive Art Research* (Springer, 2009).

50. See Dinkla, *Pioniere interaktiver Kunst*; Hünnekens, *Der bewegte Betrachter*; Gendolla et al., *Formen interaktiver Medienkunst*.

51. See Paul, *Digital Art*; Edward A. Shanken, *Art and Electronic Media* (Phaidon, 2009).

52. Dinkla, *Pioniere interaktiver Kunst*, 28; cf. Roy Ascott, "The Art of Intelligent Systems," in *Der Prix Ars Electronica. Internationales Kompendium der Computerkünste*, ed. Hannes Leopoldseder (Veritas, 1991), 25: "The term 'interactive art' refers much more to a field of operations, ideas

and experience than simply to a passing genre or ism. It identifies a very wide range of experimentation, innovation and authentic artistic achievement in a variety of media, which challenges many of our assumptions of what art is or what it might be."

53. Belting, *The Invisible Masterpiece*, 400; Dinkla, *Pioniere interaktiver Kunst*, 25–30; Paul, *Digital Art*, 11–13.

54. See the overview of self-references by media artists in Hünnekens, *Der bewegte Betrachter*, 73–83.

55. Roselee Goldberg, *Performance Art from Futurism to the Present* (Abrams, 1988), passim.

56. Herbert Molderings, *Duchamp and the Aesthetics of Chance: Art as Experiment* (Columbia University Press, 2010), xi.

57. See Dieter Daniels, "John Cage and Nam June Paik: 'Change your mind or change your receiver (your receiver is your mind),'" in *Nam June Paik*, ed. Sook-Kyung Lee und Susanne Rennert (Hatje Cantz, 2010), 108.

58. Harold Rosenberg, "The American Action Painters," *Art News* 51, no. 5 (September 1952), cited in Henry Geldzahler, *New York Painting and Sculpture: 1940–1970* (Dutton, 1969), 342.

59. Rosenberg says only the following about the spectator: "Since the painter has become an actor, the spectator has to think in a vocabulary of action: its inception, duration, direction—psychic state concentration and relaxation of the will, passivity, alert waiting. He must become a connoisseur of the gradations among the automatic, the spontaneous, the evoked." Rosenberg, "The American Action Painters," 344.

60. Paul Schimmel, "Leap into the Void. Performance and the Object," in *Out of Actions: Between Performance and the Object, 1949–1979* (Thames & Hudson, 1998), 18.

61. Christian Janecke, *Kunst und Zufall. Analyse und Bedeutung* (Verlag für moderne Kunst, 1995), 163, note 212.

62. Dreher, *Performance Art*, 68. As Paul Schimmel shows, the GUTAI group had already incorporated electronic media into their works at an early stage. Schimmel, "Leap into the Void," 28–29.

63. Allan Kaprow, "The Legacy of Jackson Pollock" (1958), in *Essays on the Blurring of Art and Life*, ed. Jeff Kelley (University of California Press, 2003), 1–9.

64. Schimmel, "Leap into the Void," 19.

65. John Cage, "45' for a speaker" (1954), in *Silence: Lectures and Writings* (Wesleyan University Press, 1961), 162.

66. George Brecht emphatically invoked traditions rooted in dadaism and surrealism. He was initially also interested in random processes, but these ultimately led him to the exploration of concepts related to observer participation, which will be discussed in detail below. As early as 1957, Brecht wrote a comprehensive text on the history of the use of random elements in art, which was not published until 1966, however. George Brecht, *Chance-Imagery* (Something Else Press, 1966).

67. Allan Kaprow, "Happenings in the New York Scene" (1961), in Kaprow, *Essays*, 19.

68. For details of Cage's position, see Büscher, "Live Electronic Arts," 102–117.

69. See Klütsch, *Computergraphik*.

70. See Florian Cramer, *exe.cut(up)able statements. Poetische Kalküle und Phantasmen des selbstaus-führenden Texts* (Fink, 2010).

71. Krueger, *Artificial Reality II*, 97. For a similar view, see David Rokeby, "Transforming Mirrors: Subjectivity and Control in Interactive Media," in *Critical Issues in Electronic Media*, ed. Simon Penny (State University of New York Press, 1995), 137.

72. Nam June Paik, "About the Exposition of Music," *Décollage* 3 (1962), n.p.

73. See Edith Decker, *Paik Video* (DuMont, 1988), 60–66.

74. On theater, see Blunck, *Between Object & Event*, 28; on film, see George P. Landow, *Hypertext 3.0: Critical Theory and New Media in an Era of Globalization* (Johns Hopkins University Press, 2006), 263 (with reference to Sergei Eisenstein).

75. See Dieter Daniels, "Strategies of Interactivity," in *The Art and Science of Interface and Interaction Design*, volume 1, ed. Christa Sommerer, Lakhmi C. Jain, and Laurent Mignonneau (Springer, 2008), 27f.

76. Robert Rauschenberg in a letter to Betty Parsons, 1951, cited in Blunck, *Between Object & Event*, 65.

77. Schimmel, "Leap Into the Void," 21.

78. Kaprow, "Happenings," 15–26.

79. Allan Kaprow, "Notes on the Creation of a Total Art" (1958), in Kaprow, *Essays*, 11. However, this definition is by no means uncontroversial. See Michael Kirby, *Happenings: An Illustrated Anthology* (Dutton, 1965), 26: "But Happenings presented on a stage with the traditional audience-presentation relationship (and with no environmental aspects) are still happenings."

80. Kaprow, "Notes on the Creation," 11.

81. As a participant at many happenings, Susan Sontag found that the audience was often treated provocatively, sometimes to the point of "abuse." See Susan Sontag, "Happenings: An Art of Radical Juxtaposition" (1962), in *Against Interpretation and other Essays* (Farrar, Straus and Giroux, 1966).

82. See Kirby, *Happenings*, 75; also see the descriptions in Philip Ursprung, *Grenzen der Kunst. Allan Kaprow und das Happening. Robert Smithson und die Land Art* (Schreiber, 2003), 76–87; and in Blunck, *Between Object & Event*, 105–108. The distinction between "visitors" and "participants" is preserved in the score, as can be seen in Alfred M. Fischer, ed., *George Brecht. Events. A Hetero-spective* (König, 2005), 35.

83. Allan Kaprow, "A Statement," in Kirby, *Happenings*, 46. See also Paul Schimmel, "'Only memory can carry it into the future': Kaprow's Development from the Action-Collages to the

Happenings," in *Allan Kaprow—Art as Life*, ed. Eva Meyer-Hermann, Andrew Perchuk, and Stephanie Rosenthal (Thames & Hudson, 2008), 11.

84. Jeff Kelley, *Childsplay: The Art of Allan Kaprow* (University of California Press, 2004), 58–62.

85. Ursprung, *Grenzen der Kunst*, 185–190.

86. The reasons suggested range from the development of video technology, which enabled recording of actions, to their replacement by technological experiments, such as the *Experiments in Art and Technology*. See Dreher, *Performance Art*, 11: "The prominent role played by action theater in the development of forms of intermedia in the 1960s was lost with the arrival of video devices in the 1970s." See also Ursprung, *Grenzen der Kunst*, 121: "The happenings as an artistic trend were definitively buried by the event *Nine Evenings*."

87. See the critical discussion of the concept by Barbara Lange, "Soziale Plastik," in *DuMonts Begriffslexikon zur zeitgenössischen Kunst*, ed. Hubertus Butin (DuMont, 2002). For an English introduction to Beuys' concepts, see Claudia Mesch and Viola Michely, eds., *Joseph Beuys: The Reader* (I.B. Tauris, 2007).

88. There are references to participatory strategies in theater in Erika Fischer-Lichte, *The Transformative Power of Performance: A New Aesthetics* (Routledge, 2008), passim; in Erika Fischer-Lichte, "Der Zuschauer als Akteur," in *Auf der Schwelle. Kunst, Risiken und Nebenwirkungen*, ed. Erika Fischer-Lichte et al. (Fink, 2006); and in Barbara Gronau, "Mambo auf der Vierten Wand. Sitzstreiks, Liebeserklärungen und andere Krisenszenarien," in Fischer-Lichte et al., *Auf der Schwelle*.

89. See Joshua Abrams, "Ethics of the Witness. The Participatory Dances of Felix Ruckert," in *Audience Participation: Essays on Inclusion in Performance*, ed. Susan Kattwinkel (Greenwood, 2003).

90. See Suzanne Lacy, *Mapping the Terrain: New Genre Public Art* (Bay Press, 1995); Miwon Kwon, *One Place After Another: Site-Specific Art and Locational Identity* (MIT Press, 2004); Grant H. Kester, *Conversation Pieces: Community—Communication in Modern Art* (University of California Press, 2004).

91. See, for example, Iñigo Manglano-Ovalle and Street-Level Video: *Tele-Vecindario*, 1995, as described in Mary Jane Jacobs, ed., *Culture in Action: A public art program of Sculpture Chicago* (Bay Press, 1995), 76–87.

92. Cf. Kaprow, "Happenings in the New York Scene," 17: "The most intense and essential happenings have been spawned in old lofts, basements, vacant stores, natural surroundings, and the street."

93. Allan Kaprow, "The Happenings Are Dead: Long Live the Happenings" (1966), in Kaprow, *Essays*, 62. Also see Büscher, "Live Electronic Arts," 46f.

94. See Blunck, *Between Object & Event*, 29–45 (on Duchamp and Cornell).

95. See Hubertus Gaßner and Stephanie Rosenthal, eds., *Dinge in der Kunst des 20. Jahrhunderts* (Steidl, 2000).

96. Büscher, "Live Electronic Arts," 166.

97. Ibid., 21.

98. For a detailed discussion, see Katja Kwastek, "Art without Time and Space? Radio in the Visual Arts of the Twentieth and Twenty-First Centuries," in *Re-inventing Radio*, ed. Heidi Grundmann and Elisabeth Zimmerman (Revolver, 2008).

99. Letter from George Brecht to William C. Seitz of June 7, 1961, cited in Julia Robinson, "In the Event of George Brecht," in Fischer, *George Brecht*, 20.

100. See Robinson, "In the Event of George Brecht," 53.

101. "Medicine Cabinet," typescript, Library of the Museum of Modern Art New York, cited in Blunck, *Between Object & Event*, 141.

102. Umberto Eco hinges his theory of the open artwork on such works by Stockhausen, Pousseur, and Berio, for example; Eco, *The Open Work*, 27–31.

103. See Büscher, "Live Electronic Arts," 119.

104. Score reprinted in Meyer-Hermann, Perchuk, and Rosenthal, *Allan Kaprow*, Figs. 111–113.

105. Robinson, "In the Event of George Brecht," figure on p. 42.

106. George Brecht, *Notebook IV*, cited in Blunck, *Between Object & Event*, 131.

107. Schimmel, "Leap into the Void," 71.

108. George Brecht, *Notebook II*, cited in Robinson, "In the Event of George Brecht," 30.

109. Interview with Michael Nyman, 1976, cited in Robinson, "In the Event of George Brecht," 30.

110. Robinson, "In the Event of George Brecht," 55.

111. Richard Kostelanetz, "Conversations: Allan Kaprow," in *The Theater of Mixed Means: An Introduction to Happenings, Kinetic Environments and other Mixed-Means Performances* (Pittman, 1970), 110.

112. Richard Schechner, *Environmental Theater* (Hawthorn, 1973), 49. For a detailed discussion of this performance, see Gronau, "Mambo auf der Vierten Wand."

113. One exception is the card game *Solitaire*, which was invented by George Brecht. See Robinson, "In the Event of George Brecht," 36, 43.

114. *Une Journée dans la rue* (1966). See Marion Hohlfeldt, *Grenzwechsel: Das Verhältnis von Kunst und Spiel im Hinblick auf den veränderten Kunstbegriff in der zweiten Hälfte des zwanzigsten Jahrhunderts mit einer Fallstudie: Groupe de Recherche d'Art Visuel* (VDG, 1999).

115. One example are the various projects of the artists' group Blast Theory.

116. See Paul, *Digital Art*, 196–203; Hartware MedienKunstVerein and Tilman Baumgärtel, eds., *Games. Computerspiele von KünstlerInnen* (Revolver, 2003).

117. For the history of kinetic art, see Hans Günter Golinski, Sepp Hiekisch-Picard and Christoph Kivelitz, eds., *Und es bewegt sich doch. Von Alexander Calder und Jean Tinguely bis zur zeitgenössischen "mobilen Kunst"* (Museum Bochum, 2006). On op art, see Martina Weinhart and Max Hollein, eds., *Op Art* (König, 2007). Given the substantial overlaps both between the representatives and the works of these two movements, Martina Weinhart suggests that the two should be combined. Martina Weinhart, "Im Auge des Betrachters. Eine kurze Geschichte der Op Art," in Weinhart and Hollein, *Op Art*, 29.

118. The systematic approach of the artists is made particularly evident by the Italian name for this movement: "arte programmata." Weinhart, "Im Auge des Betrachters," 19.

119. Alfred Kemény and László Moholy-Nagy, "Dynamisch-konstruktives Kraftsystem," *Der Sturm. Monatszeitschrift für Kultur und die Künste* 13, no. 12 (1922), cited in Manuel J. Borja-Villel et al., *Force Fields, Phases of the Kinetic* (Museu d'Art Contemporani de Barcelona, 2000), 229.

120. Eugen Thiemann, ed., *Participation. À la recherche d'un nouveau spectateur. Groupe de Recherche d'Art Visuel* (Museum am Ostwall, 1968), 4.

121. Frank Popper, *Origins and Development of Kinetic Art* (Studio Vista, 1968), 244–246.

122. Text from the invitation to the exhibition AGAM, Galerie Craven, Paris 1953; Marc Scheps, *Agam. le salon de l'élysée* (Paris: Editions du Centre Pompidou, 2007), figure 45b.

123. Yaacov Agam, *Texts by the Artist* (Editions du Griffon, 1962), 5.

124. Scheps, *Agam*. One year later, Robert Rauschenberg created his work *Soundings*, which was based on similar principles.

125. Popper, *Art, Action and Participation*, 56 (Parent), 114 (Larrain); Roy Ascott: *Telematic Embrace*, ed. Edward Shanken (University of California Press, 2003), 151 (Ascott).

126. Roy Ascott, "The Construction of Change," 1964, in Ascott, *Telematic Embrace*.

127. Thiemann, *Participation*, 42.

128. Jean-Louis Ferrier, *Gespräche mit Victor Vasarely* (Galerie der Spiegel, 1971), 140.

129. Jean-Louis Ferrier, *Gespräche mit Victor Vasarely*, 137.

130. Jean-Louis Ferrier, *Gespräche mit Victor Vasarely*, 13.

131. Frank Popper, *Art, Action and Participation* (Studio Vista, 1975), 7–8.

132. See Werner Spies, "Karambolagen mit dem Nichts. Jean Tinguelys metamechanische Ironie," *Frankfurter Allgemeine Zeitung*, January 21, 1989, reprinted in Werner Spies, *Zwischen Action Painting und Op Art*, volume 8 of *Gesammelte Schriften zu Kunst und Literatur* (Berlin University Press, 2008).

133. Blunck, *Between Object & Event*, 201–205.

134. Arturo Carlo Quintavalle, *Enzo Mari* (Parma: Università di Parma, 1983), 195. *Modulo 856* was a sculpture into which visitors could stick their heads from below, only then to be faced with their own reflections. In the questionnaire, the visitors were asked to underline any of

thirteen suggested meanings of the work with which they agreed and to write additional possible meanings of their own. The statements provided ranged from classifying the work in a particular artistic context (pop art or op art), thru questions about institutional criticism, to issues of self-perception and self-reflection. See Umberto Eco, "Che cosa ha fatto Mari per la Biennale die San Marino?" *Domus* 453 (1967), reprinted in Quintavalle, *Mari*.

135. Questionnaires have survived from the exhibition Instabilité, held at the Maison des Beaux Arts in Paris in 1962, and from the action "une journée dans la rue," held in Paris in 1966. The evaluations of the questionnaires are reported in Luciano Caramel, ed., *Groupe de Recherche d'Art Visuel 1960–1968* (Electa, 1975), 28–29, 48–49.

136. Jean Clay, "Painting: A Thing of the Past," *Studio International* (July/August 1967), 12.

137. Ilya Kabakov, *On the 'total' installation* (Hatje Cantz, 1995), 276. See also Oskar Bätschmann, "Der Künstler als Erfahrungsgestalter," in *Ästhetische Erfahrung heute*, ed. Jürgen Stöhr (DuMont, 1996).

138. See Jeffrey Shaw and Peter Weibel, eds., *Future Cinema: The Cinematic Imaginary after Film* (MIT Press, 2003), 144–149.

139. For more information on this type of media art, see Slavko Kacunko, *Closed Circuit Video-installationen. Ein Leitfaden zur Geschichte und Theorie der Medienkunst mit Bausteinen eines Künstler-lexikons* (Logos, 2004).

140. Kacunko, *Closed Circuit Videoinstallationen*, 171.

141. Michael Lüthy, "Die eigentliche Tätigkeit. Aktion und Erfahrung bei Bruce Nauman," in Fischer-Lichte et al., *Auf der Schwelle*. Cf. Daniels, "Strategies of Interactivity," 36.

142. Frank Gillette, "Masque in Real Time," in *Video Art: An Anthology*, ed. Ira Schneider and Beryl Korot (Harcourt Brace Jovanovich, 1976), 218f.

143. Dan Graham (1986) in *Ausgewählte Schriften*, ed. Ulrich Wilmes (Oktagon, 1994), 74, cited in Kacunko, *Closed Circuit Videoinstallationen*, 229.

144. Rosalind Krauss, "Video: The Aesthetics of Narcissism" (1976), in *New Artists Video: A Critical Anthology*, ed. Gregory Battock (Dutton, 1978), 52.

145. Ibid., 53.

146. Ibid., 57.

147. Reinhard Braun, "Kunst zwischen Medien und Kunst," in *Kunst und ihre Diskurse. Öster-reichische Kunst in den 80er und 90er Jahren*, ed. Carl Aigner and Daniela Hölzl (Passagen Verlag, 1999), 170.

148. Although works such as those discussed here are now celebrated as artworks of major importance from the 1960s and the 1970s, at the time they were not unanimously praised by fellow artists. For instance, although Allan Kaprow appreciated closed-circuit installations as what he considered the only interesting form of video art, he criticized their manifestations as kitsch—as "part fun house, part psychology lab." He also criticized the fact that the exhibition situation

prohibited an atmosphere of meditation and privacy: "it should be obvious nowadays that everyone entering a gallery is immediately on display as a work of art." Allan Kaprow, "Video Art. Old Wine, New Bottle" (1974), in *Essays*, 151, 152.

149. See also Kathy Cleland, "Media Mirrors and Image Avatars," in *Engage: Interaction, Art and Audience Experience*, ed. Ernest Edmonds et al. (Creativity and Cognition Studios, 2006).

150. For more detail, see Kwastek, "The Invention of Interactivity."

151. CYSP's electronics were controlled by a homeostat built by Jacques Bureau, an engineer employed at the Philips company.

152. Nicolas Schöffer, "Le Spatiodynamisme," lecture at the Amphithéâtre Turgot, June 19, 1954 (at http://www.olats.org).

153. The audience was free to demand repetitions, accelerations, decelerations, explanations, and interruptions of the performance. On Schöffer's work, see Maude Ligier, *Nicolas Schöffer* (Presses du Réel, 2004). On the use of dancers, see Maude Ligier, "Nicolas Schöffer, un artiste face a la technique," *Cahier de recit* 4 (2006): 43–65.

154. Nicolas Schöffer, "Die Zukunft der Kunst. Die Kunst der Zukunft," in *Nicolas Schöffer. Kinetische Plastik. Licht. Raum*, ed. Karl Ruhrberg (Städtische Kunsthalle Düsseldorf, 1968), 28.

155. See Büscher, "Live Electronic Arts," 77–96.

156. Jasia Reichardt, "Cybernetics, Art and Ideas," in *Cybernetics, Art and Ideas* (Studio Vista, 1971), here 11. Reichardt also explained in the exhibition catalog that she was not primarily interested in presenting results, rather specifically wanted to show potentials. Jasia Reichardt, ed., *Cybernetic Serendipity: The Computer and the Arts*, special issue no. 905 (Studio International, 1968), 5.

157. Reichardt, *Cybernetic Serendipity*, 35. Cf. Margit Rosen, "The Control of Control—Gordon Pasks kybernetische Ästhetik," in *Pask Present*, ed. Ranulph Glanville and Albert Müller (edition echoraum, 2008).

158. Reichardt, *Cybernetic Serendipity*, 35.

159. Ibid., 38.

160. See Jonathan Benthall, "Edward Ihnatowicz's Senster," *Studio International* (November 1971): 174.

161. Aleksandar Zivanovic, "The Technologies of Edward Ihnatowicz," in *White Heat, Cold Logic: British Computer Art 1960–1980*, ed. Paul Brown et al. (MIT Press, 2008), 102.

162. Jasia Reichardt, "Art at Large," *New Scientist* (May 4, 1972): 292. Zivanovic also reasons that the complicated acoustics of the exhibition venue made the movements of the *Senster* appear much more sophisticated than they actually were.

163. Jack Burnham, *Beyond Modern Sculpture* (Braziller, 1968), 341.

164. Krueger, *Artificial Reality II*, XII. The views of Krueger cited in the following are taken from the volume he published in 1991, although they were actually developed from the early 1970s on. Many of the observations can be found in texts that Krueger had already written in the 1970s.

165. Krueger, *Artificial Reality II*, 265.

166. Ibid., 64.

167. A one-page description of *Psychic Space* kept in the artist's archives—probably originating from the time of its development—also mentions an ultrasound sensor for detecting movements.

168. The only documentation available on this work are Krueger's own descriptions.

169. Krueger, *Artificial Reality II*, 30.

170. Ibid., 92.

171. Ibid., 265.

172. Ibid., 93.

173. Ibid., 89.

174. Andy Cameron, "Dinner with Myron. Or: Rereading Artificial Reality 2: Reflections on Interface and Art," in *aRt & D: Research and Development in Art*, ed. Joke Brower et al. (V2_NAi, 2005).

175. Author's interview with Myron Krueger, Hartford, Connecticut, 2007; recording and transcript in the author's archives. The reason none of Krueger's works are included among the case studies in this volume is that the last exhibition of these works was held in 2004, so that an analysis of the aesthetic experiences they produced would have to be based exclusively on documentation. Nonetheless, many of the works dealt with in the case studies feature elements of interaction that were previously described by Krueger, for example recipient control of the interaction process by means of a touch-sensitive floor (Sonia Cillari), video recording of a silhouette (David Rokeby), exploration of traditional rule systems (Agnes Hegedüs), and the manipulation of computer-generated shapes (Tmema).

176. Peter Dittmer, "SCHALTEN UND WALTEN [Die Amme]. Gespräche mit einem milchverschüttenden Computer seit 1992" (at http://home.snafu.de).

177. See a discussion of further projects in Paul, *Digital Art*, 146–153.

178. Cf. Kathy Cleland, "Talk to Me: Getting Personal with Interactive Art," in *Conference Proceedings: Interaction: Systems, Practice and Theory*, ed. Ernest Edmonds and Ross Gibson (University of Technology, 2004) (at http://research.it.uts.edu).

179. See Paul, *Digital Art*, 139–145.

180. Christa Sommerer and Laurent Mignonneau, "Interacting with Artificial Life. A-Volve" (1997), in *Interactive Art Research* (Springer, 2009), 87.

181. Another approach is the development of complex system environments—especially in computer games such as The Sims—that allow various factors to be manipulated and thus emulate complex social or natural systems. See Noah Wardrip-Fruin, *Expressive Processing: Digital Fictions, Computer Games, and Software Studies* (MIT Press, 2009).

182. Wardrip-Fruin, *Expressive Processing*, 83: "AI researchers and game creators are interested in models of the world, and behavior within it." Cf. an early contribution by Edmond Couchot, "Die Spiele des Realen und des Virtuellen," in *Digitaler Schein. Ästhetik der elektronischen Medien*, ed. Florian Rötzer (Suhrkamp, 1991).

183. Bertolt Brecht, "The Radio as an Apparatus of Communication" (1932), in *The Weimar Republic Sourcebook*, ed. Anton Kaes, Martin Jay, and Edward Dimendberg (University of California Press, 1994), 615f.

184. Cited in Edith Decker and Peter Weibel, eds., *Vom Verschwinden der Ferne. Telekommunikation und Kunst* (DuMont, 1990), 226.

185. On radio projects in the visual arts, see Kwastek, "Art without Time and Space?"

186. Dieter Daniels, "Interview with Robert Adrian X," Linz, 2009 (at http://www.netzpioniere.at).

187. A good summary of the prehistory of Internet art can be found in Tilman Baumgärtel, "Immaterialien. Aus der Vor- und Frühgeschichte der Netzkunst" (June 26, 1997) (at http://www.heise.de).

188. For a detailed description of the exhibition, see Antonia Wunderlich, *Der Philosoph im Museum. Die Ausstellung "Les Immateriaux" von Jean-François Lyotard* (transcript, 2008).

189. Tilman Baumgärtel thus distinguishes between "net works" realized as closed sites on the World Wide Web and "networks" created for collaborative unions of artists. Tilman Baumgärtel, *net.art. Materialien zur Netzkunst* (Verlag für moderne Kunst, 1999), 15–16.

190. Fred Forest, "Die Ästhetik der Kommunikation. Thematisierung der Raum-Zeit oder der Kommunikation als einer Schönen Kunst," in Rötzer, *Digitaler Schein*, 332.

191. For details, see Dieter Daniels and Gunther Reisinger, eds., *Netpioneers 1.0: Contextualizing Early Net-Based Art* (Sternberg, 2009).

192. See Tilman Baumgärtel, "Interview with Walter van der Cruijsen," in *net.art*.

193. See Baumgärtel, *net.art*; Dieter Daniels, "The Art of Communication. From Mail-Art to E-Mail" (1994) (at http://www.medienkunstnetz.de); Dieter Daniels, "Reverse Engineering Modernism with the Last Avant-Garde," in Daniels and Reisinger, *Netpioneers 1.0*.

194. Tilman Baumgärtel, "Interview with Paul Garrin, 20.04.1997," in *net.art*, 96.

195. See Tilman Baumgärtel, "Interview with Julia Scher, 15.02.2001," in *net.art 2.0* (Verlag für moderne Kunst, 2001), 74; Tilman Baumgärtel, "Interview with Matthew Fuller, 09.05.1998," in *net.art*.

196. Dieter Daniels, "Interview with Wolfgang Staehle," Linz, 2009 (at http://www.netzpioniere .at). For the references of the early Internet artists to Joseph Beuys, also see Daniels, "Reverse Engineering Modernism," 18.

197. Dieter Daniels, "Interview with Helmut Mark," Linz, 2009 (at http://www.netzpioniere.at).

198. See Gene Youngblood, "Metadesign," in Rötzer, *Digitaler Schein*, 305–322. An abridged version of this essay was published earlier in *Ars Electronica Festival Catalog 1986* (Linzer Verant-staltungsgesellschaft, 1986), 238.

199. Tilman Baumgärtel, "Interview with 0100101110101101.org, 09.10.1999," in *net.art 2.0*, 204.

200. Daniels, "Reverse Engineering Modernism," 15–62.

201. On these projects, which have begun to emerge since the turn of the century, see Drew Hemment, "Locative Arts," *Leonardo* 39, no. 4 (2006): 348–355; Katja Kwastek, ed., *Ohne Schnur. Art and Wireless Communication* (Revolver, 2004).

202. See Baumgärtel, *net.art 2.0*, 50–65.

203. See Eric Gidney, "The Artist's Use of Telecommunications," in *Art Telecommunication*, ed. Heidi Grundmann (self-published, 1984), 9.

204. See Baumgärtel, *net.art 2.0*, 88–95.

205. Ken Goldberg, "The Unique Phenomenon of a Distance," in *The Robot in the Garden: Telero-botics and Telepistomology in the Age of the Internet* (MIT Press, 2000), 3.

206. Interview with Paul Sermon, Linz, 1997 (at http://www.hgb-leipzig.de). See also the analysis of this work in Dixon, *Digital Performance*, 2007, 217–220, and in Rolf Wolfensberger, On the Couch. Capturing Audience Experience. A Case Study on Paul Sermons Telematic Vision, MA thesis, 2009 (available at http://www.fondation-langlois.org).

207. Further examples in Paul, *Digital Art*, 154–164.

208. Two groups that work with the incorporation of external actors into theater performances are the Builders Association (e.g., *Continuous City*, since 2007) and Rimini Protocol (e.g., *Call Cutta*, since 2005). Examples of remote control of presentations in public spaces are the project *Blinkenlights* (2001) by the Chaos Computer Club and *Amodal Suspension* (2003) by Rafael Lozano-Hemmer.

209. Grau, *Virtual Art*.

210. Although fantasy spaces were created—e.g. Kurt Schwitter's *Merzbau* (from 1923 onward), the set of Robert Wiene's *Cabinet of Dr. Caligari* (1920), La Monte Young and Marian Zazeela's *Dreamhouse* (1962), which was primarily based on acoustic immersion, and the *Philips Pavilion* designed by Le Corbusier and for which Iannis Xenakis and Edgar Varese composed the *Poème Electronique* (1958)—these were still environments that could be experienced in real space, not illusionistic representations of space and certainly not simulations of spaces that exist in reality.

211. See, for example,Howard Rheingold, *Virtual Reality* (Summit Books, 1991); Mychilo Stephenson Cline, *Power, Madness, and Immortality: The Future of Virtual Reality* (University Village Press, 2005).

212. Jeffrey Shaw, "Modalitäten einer interaktiven Kunstausübung," *Kunstforum International* 103 (1989): *Im Netz der Systeme*, 204.

213. Klotz, "Der Aufbau," 39.

214. Ibid., 41.

215. Jeffrey Shaw was director of the iCinema (Center for Interactive Cinema Research) at Sydney's University of New South Wales until 2009, and is currently building a new research center for digital panorama technology at the Chinese University of Hong Kong.

216. Eco, *The Open Work*, 27.

217. Büscher, "Live Electronic Arts," 46–50, 118–120, citation 46.

218. Kirby, *Happenings*, 16.

219. Büscher, "Live Electronic Arts," 129.

220. Author's interview with Grahame Weinbren, New York, 2007, recording and transcript in the author's archives.

221. Grahame Weinbren, "An Interactive Cinema: Time, Tense and Some Models," *New Observations* 71 (1989): 11.

222. Weinbren, "An Interactive Cinema," 10.

223. Ibid., 11.

224. Author's interview with Scott Snibbe, San Francisco, 2007, recording and transcript in the author's archives.

225. Author's interview with Lynn Hershman, San Francisco, 2007, recording and transcript in the author's archives.

226. Ibid.

227. Ibid.

228. Landow, *Hypertext 3.0*.

229. This project is described in Wardrip-Fruin, *Expressive Processing*, 259–285.

230. The publication *An Architecture of Interaction* designates the various possible reference systems for interactive art as "arenas," naming in addition to the art system itself also politics and education, for example. The authors explain that every arena has its own rule structure, but that interactive art, because it often has to operate in more than one arena at the same time, also has to negotiate a variety of rule structures simultaneously. Yvonne Dröge Wendel et al., *An Architecture of Interaction* (Mondrian Foundation, 2007), 42–46.

231. See Daniels and Schmidt, eds., *Artists as Inventors*.

232. Stephen Wilson, *Information Arts* (MIT Press, 2002).

233. David Rokeby, "The Construction of Experience: Interface as Content," in *Digital Illusion: Entertaining the Future with High Technology*, ed. Clark Dodsworth (Addison-Wesley, 1998), 30.

234. Heinrich Klotz, "Medienkunst als Zweite Moderne," lecture of December 1, 1994, presented at the Godesberg Talks of the Federation of German Architects, printed in Klotz, *Eine neue Hochschule*, 55. On de Kerckhove, see Hünnekens, *Der bewegte Betrachter*, 140.

235. Anthony Dunne, *Hertzian Tales: Electronic Products, Aesthetic Experience and Critical Design* (MIT Press, 2005), 1, 21.

236. "By poeticizing the distance between people and electronic objects, sensitive scepticism might be encouraged, rather than unthinking assimilation of the values and conceptual models embedded in electronic objects." Dunne, *Hertzian Tales*, 22.

237. Kwastek, ed., *Ohne Schnur*, 192–199; Anthony Dunne and Fiona Raby, *Design Noir: The Secret Life of Electronic Objects* (Birkhäuser, 2001), 75–157.

238. Machiko Kusahara, "Device Art. A new Approach in understanding Japanese Contemporary Media Art," in *MediaArtHistories*, ed. Oliver Grau (MIT Press, 2007).

239. See Lovink, *Zero Comments*, 285–299.

Chapter 2

1. For a discussion of the many facets of the concept of aesthetics and of aesthetics theorists' revisiting of the original concept of aisthesis, see Wolfgang Welsch, "Das Ästhetische—Eine Schlüsselkategorie unserer Zeit?" in *Die Aktualität des Ästhetischen* (Fink, 1993). See also Dieter Mersch, *Ereignis und Aura. Untersuchungen zu einer Ästhetik des Performativen* (Suhrkamp, 2002), 53: "All perception is rooted in aisthesis. Aisthesis denotes a type of receptivity to the Other whose structure is characterized not by intent but by response."

2. Jan-Peter Pudelek, "Werk," in *Ästhetische Grundbegriffe*, volume 6, ed. Karlheinz Barck (Metzler, 2005), 522: "[W]ith regard to [the fine arts], it is an *art*-work, while as an object of the aesthetics that constitutes and reflects this 'art,' it is an art-*work*." In Pudelek's view, the term artwork denotes the concept of an absolute object that encompasses both the subject and the object of experience, i.e., both the artist and the recipient. Cf. Gérard Genette, *The Work of Art: Immanence and Transcendence* (Cornell University Press, 1997), 4: "a work of art is an intentional aesthetic object."

3. See Hans Belting, "Der Werkbegriff der künstlerischen Moderne," in *Das Jahrhundert der Avantgarden*, ed. Cornelia Klinger and Wolfgang Müller-Funk (Fink, 2004), 65: "Theory formation has lagged behind this development for so long that until the present today it has still not attended to the difference between art and work, leaving it suspended in the convenient dual concept of 'artwork.' "

4. Wolf-Dietrich Löhr, "Werk/Werkbegriff," in *Metzler Lexikon Kunstwissenschaft*, ed. Ulrich Pfisterer (Metzler, 2003), 390.

5. Lorenz Dittmann, "Der Begriff des Kunstwerks in der deutschen Kunstgeschichte," in *Kategorien und Methoden der deutschen Kunstgeschichte 1900–1930* (Franz Steiner, 1985), 84. Also see Konrad Hoffman's review of Dittmann in *Kunstchronik* 11 (1988): 602–610.

6. Walter Benjamin, "The Work of Art in the Age of Its Technological Reproducibility," in *Walter Benjamin: Selected Writings, Volume 4 (1938–1940)*, ed. Michael W. Jennings (Harvard University Press, 2003). Cf. Jauß, *Aesthetic Experience*, 64: "[T]o one's own manner of seeing, which abandons itself to aesthetic perception as it is led along by the text, there opens up, along with an alien manner of seeing, the horizon of experience of a differently viewed world."

7. Matthias Bleyl, "Der künstlerische Werkbegriff in der kunsthistorischen Forschung," in *L'art et les révolutions: XXVIIe Congrès International d'Histoire de l'Art, Strasbourg 1989*, volume 5 (Société alsacienne pour le développement de l'histoire de l'art, 1992), 152.

8. Bleyl, "Der künstlerische Werkbegriff," 156. John Dewey also sees close parallels between production aesthetics and reception aesthetics: "But with the perceiver, as with the artist, there must be an ordering of the elements of the whole that is in form, although not in details, the same as the process of organization the creator of the work consciously experienced." Dewey, *Art as Experience* (Penguin, 1934), 56. This conclusion by analogy can, of course, only be taken in reference to artistic production up until the 1930s, i.e., the ordering by the observer described here should not be mistaken for interaction, rather should be regarded as a purely cognitive activity.

9. For specific critiques of the concept of the artwork from the perspective of the concepts of autonomy, form, authorship, and originality, see Belting, *The Invisible Masterpiece*, 384. The development of the non-organic artwork in montage, for example, which Bürger saw as already being characteristic for the classical avant-garde, can certainly be taken as an early critique of structural form, although the work still retained its external solidity. Bürger, *Theory of the Avant-Garde*, 117.

10. Hans Belting clearly illustrates the range of perspectives found between artistic self-staging and the merging of art with daily life: "Works that no longer bore any visible trace of artistic intervention were replaced by performances in which artists renounced the proof of the work apart from themselves." Belting, *The Invisible Masterpiece*, 386.

11. See Roland Barthes, "The Death of the Author," in *Image, Music, Text*, ed. and trans. Stephen Heath (Hill and Wang, 1977).

12. Bürger, *Theory of the Avant-Garde*, 57.

13. See Belting, *The Invisible Masterpiece*, 384. Literary scholars have arrived at a similar conclusion via the restoration of authorship. See also Fotis Jannides, "Autor und Interpretation," in *Texte zur Theorie der Autorschaft*, ed. Fotis Jannides et al. (Reclam, 2000).

14. Mersch, *Ereignis und Aura*, 245. Hans Belting sees the same shift away from the primacy of self-reference, although he makes this observation in reference to concept art, in which "the

work's self-reference was out of date if the idea of art could be evoked in a more direct way, through signs or language." Belting, *The Invisible Masterpiece*, 384.

15. One example of media art critically questioning art institutions is artistic network activism. See Daniels, "Reverse Engineering."

16. Krueger, *Artificial Reality II*, 86.

17. Ascott, "The Art of Intelligent Systems," 26.

18. Rokeby, "The Construction of Experience," 27.

19. Krueger, *Artificial Reality II*, 88.

20. For a summary of discussions of aesthetic experience since the end of the nineteenth century, see Georg Maag, "Erfahrung," in *Ästhetische Grundbegriffe, historisches Wörterbuch in sieben Bänden*, volume 2, ed. Karlheinz Barck (Metzler, 2001).

21. Dewey, *Art as Experience*, 39, 204.

22. Ibid., 101, 284, 287.

23. Ibid., 143.

24. Ibid., 123.

25. Ibid., 113.

26. Martin Seel, *Aesthetics of Appearing* (Stanford University Press, 2005), 29.

27. Seel, *Aesthetics of Appearing*, 47. During this process, however, our conceptual apparatus is not disabled; we simply do not apply it as the principal instrument. What happens, in Seel's view, is that the variety of facets and nuances that can be perceived simultaneously leads to an indeterminableness in the moment of perception.

28. Dewey, *Art as Experience*, 102.

29. Seel, *Aesthetics of Appearing*, 82f.

30. Ibid., 90–96.

31. Hans-Georg Gadamer, *Truth and Method* (Continuum, 2004), 60f.

32. Ibid., 74.

33. Ibid., 84.

34. Ibid., 103.

35. Ibid., 112.

36. Ibid., 109.

37. Ibid., 116.

38. Jauß, *Aesthetic Experience*, 31.

39. See Gernot Böhme, *Atmosphäre. Essays zur neuen Ästhetik* (Suhrkamp, 1995), 15.

40. Jauß, *Aesthetic Experience*, 35.

41. Klotz, "Medienkunst," 52f.

42. Fischer-Lichte, *The Transformative Power of Performance*, 199.

43. Concerning the aesthetic theories commonly summed up under the term "reception aesthetics," two different schools of thought must be taken into consideration: Jaußian hermeneutic history of reception (which is interested in the concrete, historical experience of artworks) and the theory of aesthetic response. See Iser, *The Act of Reading: A Theory of Aesthetic Response* (Routledge, 1978).

44. Eco, *The Open Work*, 21.

45. Ibid., 11.

46. Ibid., 21.

47. Ibid., 21.

48. Ibid., 12.

49. Ibid., 12.

50. Eco's theory should not be considered limited to kinetic art, however, rather this focus should be ascribed to the date of the book's publication and to his own particular familiarity with (Southern) European art.

51. Eco, *The Open Work*, 94.

52. Ibid., 96.

53. Iser, *The Act of Reading*, 164.

54. Ibid., 166f.

55. Ibid., 168.

56. Wolfgang Kemp, *Der Anteil des Betrachters. Rezeptionsästhetische Studien zur Malerei des 19. Jahrhunderts* (Maander, 1983). Although Kemp calls his research aesthetics of reception, under Iser's definition it would be designated as aesthetics of response.

57. Wolfgang Kemp, "Verständlichkeit und Spannung. Über Leerstellen in der Malerei des 19. Jahrhunderts," in *Der Betrachter ist im Bild. Kunstwissenschaft und Rezeptionsästhetik* (Reimer, 1992).

58. Wolfgang Kemp, "Zeitgenössische Kunst und ihre Betrachter. Positionen und Positionszuschreibungen," in *Zeitgenössische Kunst und ihre Betrachter*, Jahresring 43 (Oktagon, 1996), 19f.

59. Belting, *The Invisible Masterpiece*, 402. According to Belting, Johan Huizinga's *Homo Ludens* is not only the older but also the more naive role, compared with the analytical attention involved in silent contemplation.

60. Mersch, *Ereignis und Aura*, 94.

61. The Polish art historian Ryszard Kluszczyński, for example, argued in 1995 that the recipient of an interactive artwork became a "(co)creator" because his experience and interpretation constituted the work." Kluszczyński, "Audiovisual Culture in the Face of the Interactive Challenge," in *WRO 95 Media Art Festival*, ed. Piotr Krajewski (Open Studio, 1995), 36.

62. Peter Weibel in conversation with Gerhard Johann Lischka, "Polylog. Für eine interaktive Kunst," *Kunstforum International* 103: *im Netz der Systeme* (1989): 77.

63. See Dinkla, *Pioniere interaktiver Kunst*, 7.

64. Mona Sarkis, "Interactivity Means Interpassivity," *Media Information Australia* 69 (August 1993): 13.

65. Tilman Baumgärtel, "I don't believe in self-expression. An Interview with Alexei Shulgin," Ljubljana, 1997 (at http://www.intelligentagent.com).

66. Mersch, *Ereignis und Aura*, 54.

67. Theodor Holm Nelson, "Getting It Out of Our System," in *Information Retrieval: A Critical View*, ed. Georg Schechther (Thomson Books, 1967), 195. For a more detailed discussion, see Theodor Holm Nelson, *Literary Machines* (Mindful, 1994), 2.

68. Landow, *Hypertext 3.0*, chapter 2 passim and 126. A similar view was expressed in 2007 by Ryszard Kluszczyński in "From Film to Interactive Art: Transformations in Media Arts," in Grau, *MediaArtHistories*, 221. See also Roberto Simanowski, "Hypertext. Merkmal, Forschung, Poetik," *dichtung-digital* 24 (2002) (at http://www.dichtung-digital.de).

69. Landow, *Hypertext 3.0*, 53. However, even Landow concedes that the creative possibilities of the recipient are often limited in hypertexts (125f, 221). According to Landow, it is only rarely possible to add texts to literary hypertexts, so that the recipient cannot be considered a co-author.

70. See Espen J. Aarseth, *Cybertext: Perspectives on Ergodic Literature* (John Hopkins University Press, 1997), introduction and chapters 2, 4, and 8.

71. Simanowski, "Hypertext," chapter 3, "Evangelisten des Hypertext."

72. Simanowski, "Hypertext," chapter 4, "Missverständnis 1, Offenheit des Textes."

73. Similar discussions accompany (not electronically mediated) interactive art. As an example, artistic works of the 1990s are often assigned a democratic claim (in reference to Nicolas Bourriaud's concept of "relational aesthetics"), which is then contested by an author such as Claire Bishop or Christian Kravagna. See Kravagna, "Arbeit an der Gemeinschaft"; Bishop, "Antagonism and Relational Aesthetics," *October* 110 (autumn 2004): 51–79.

74. Some scholars called for such a perspective in the early years. See, for example, Regina Cornwell, "From the Analytical Engine to Lady Ada's Art," in *Iterations: The New Image*, ed. Timothy Druckrey (MIT Press, 1993), 53: "[T]he control is not in the hand of the participant; instead the

interaction opens up a space of fiction for the imagination. And such work asks more basically what we mean by choice—and whether there is any."

75. Jack Burnham, "Systems Esthetics," *Artforum* 7 (September 1968): 31–35; citation 31. Pontus Hultén made a similar observation in 1968 in the catalog for the exhibition titled *The Machine as Seen at the End of the Mechanical Age*: "To create a more intense communication between objects of art and the public is one main trend of the sixties. . . . Technology offers the possibility of creating objects that respond to the spectator's action, for example his voice or his movements." Pontus Hultén, ed., *The Machine as Seen at the End of the Mechanical Age* (Museum of Modern Art, 1968), 193.

76. Burnham, "Systems Esthetics," 32. Also see Vilém Flusser, "Gesellschaftsspiele," *Kunstforum International* 116: *Künstlergruppen* (1991): 66–69.

77. Burnham, "Systems Esthetics," 34, with reference to a work by Les Levine.

78. Burnham, *Beyond Modern Sculpture*, 318.

79. "Negative feedback" is a term used in cybernetics when the present status of a system is used as the benchmark for how the system should be regulated through input. A simple example of this process is the heating thermostat, which closes down the heat supply when a certain ambient temperature has been reached.

80. Burnham, *Beyond Modern Sculpture*, 319, 333.

81. Jack Burnham, "The Aesthetics of Intelligent Systems," in *On the Future of Art*, ed. Edward Fry (Viking, 1970).

82. Burnham, "Art and Technology," 201. On Burnham's place in the history of science, see Edward A. Shanken, "Historicizing Art and Technology: Forging a Method and Firing a Canon," in Grau, *MediaArtHistories*.

83. See, for example, Edmond Couchot, "The Automatization of Figurative Techniques: Toward the Autonomous Image," in Grau, *MediaArtHistories*.

84. For elements of an aisthetic systems theory, see, for example, Dominik Paß, *Bewußtsein und Ästhetik. Die Faszination der Kunst* (Aisthesis-Verlag, 2006). However, Paß, too, deals with art in general, not specifically with processual art forms.

85. Thus, Peter Weibel, for example, quite evidently bases his interpretation of the concept of interaction on cybernetic and systems theories: "We can also see that the concept of systems is already anticipated in the concept of the environment—as an interaction between components of the system, where if one component is absolutely dominant, the system can collapse." Weibel and Lischka, "Polylog," 67. For a summary of Weibel's view, see Hünnekens, *Der bewegte Betrachter*, 52–59. Other systems-theory approaches can be found in Kitty Zijlmans, "Kunstgeschichte als Systemtheorie," in *Gesichtspunkte. Kunstgeschichte heute*, ed. Marlite Halbertsma and Kitty Zijlmans (Reimer, 1995) and in Christine Resch and Heinz Steinert, *Die Widerständigkeit der Kunst. Entwurf einer Interaktions-Ästhetik* (Westfälisches Dampfboot, 2003).

86. Bourriaud, *Relational Aesthetics*, 13.

87. Ibid., 16, 44.

88. Ibid., 21, 22.

89. Ibid., 41.

90. Fried, "Art and Objecthood."

91. See Juliane Rebentisch, *Ästhetik der Installation* (Suhrkamp, 2003). In relation to video and installation art, see Margaret Morse, *Virtualities: Television, Media Art and Cyberculture* (Indiana University Press, 1998), 155–177.

92. Cf. Lucy Lippard, *Six Years: The Dematerialization of the Art Object* (Henry Holt, 1973); Rosalind Krauss, "Sculpture in the Expanded Field," *October* 8 (1979): 30–44.

93. Gerhard Graulich, *Die leibliche Selbsterfahrung des Rezipienten—ein Thema transmodernen Kunstwollens* (Die blaue Eule, 1989), 94, 176, 194.

94. Bätschmann, "Der Künstler als Erfahrungsgestalter," 248–281. For a similar view, cf. Anne Hamker, "Dimensionen der Reflexion. Skizze einer kognitivistischen Rezeptionsästhetik," *Zeitschrift für Ästhetik und Allgemeine Kunstwissenschaft* 45 (1, 2000): 25–47.

95. Anne Hamker, *Emotion und ästhetische Erfahrung. Zur Rezeptionsästhetik der Video-Installationen Buried Secrets von Bill Viola* (Waxmann, 2003), 145.

96. Hamker, *Emotion und ästhetische Erfahrung*, 60.

97. Ibid., 184.

98. Felix Thürlemann, "Bruce Nauman 'Dream Passage.' Reflexion über die Wahrnehmung des Raumes," in *Vom Bild zum Raum. Beiträge zu einer semiotischen Kunstwissenschaft* (DuMont, 1990), 141.

99. Hansen, *New Philosophy*, 2.

100. Bergson defines affection in *Matter and Memory* (1911) as "a kind of motor tendency on a sensible nerve". Cited in Gilles Deleuze, *Cinema 1: The Movement Image* (Continuum, 2005), 68. Brian Massumi, by contrast, understands affection to be "the perception of one's own vitality, one's sense of aliveness, of changeability." Massumi, *Parables for the Virtual: Movement, Affect, Sensation* (Duke University Press, 2002), 36. For a detailed discussion of the concept of affection, see Marie-Luise Angerer, *Vom Begehren zum Affekt* (Diaphanes, 2007).

101. Hansen, *New Philosophy*, 7.

102. Hansen, *Bodies in Code*, 3.

103. Hansen, *Bodies in Code*, 5.

104. The term "enaction" was coined in the 1960s. In the Enactive Network online lexicon, "enactive knowledge" is defined as a "form of knowledge which is characterized by the fact of

not being propositional ('knowing that'), but rather procedural ('knowing how'). Thus, enactive knowledge is primarily 'knowledge for action.' "

105. Hansen, *Bodies in Code*, 95.

106. Another example of a media aesthetics based on the concept of embodiment can be found in Anna Munster, *Materializing New Media: Embodiment in Information Aesthetics* (Dartmouth College Press, 2006).

107. Fischer-Lichte (*The Transformative Power of Performance*, 15) examines performances aimed not at an understanding of the action being presented but at the transformation of the recipient.

108. Krueger, *Artificial Reality II*, 85.

109. Susan Sontag, "Against Interpretation" (1964), in *Against Interpretation and Other Essays*.

110. Brian Massumi, "The Thinking-Feeling of What Happens," in *Interact or Die!* eds. Joke Brouwer and Arjen Mulder (V2_NAi, 2007), 71f.

111. Consequently, Wendel et al. make a clear distinction between observers within the "area of actualisation of the interactive process" and those who only study its documentation. Wendel et al., *An Architecture of Interaction*, 57. Though documentation can never replace real interaction, it can still provide an acceptable basis for scholarly analyses. Part of the work carried out at the Ludwig Boltzmann Institut Medien.Kunst.Forschung has focused on developing approaches to documentation of this kind and on producing related case studies.

112. Cf. Marvin Carlson, *Performance: A Critical Introduction* (Routledge, 2004), 25.

113. Dwight Conquergood, "Performing as a Moral Act: Ethical Dimensions of the Ethnography of Performance," *Literature in Performance* 5 (1985): 1–13.

114. Timothy J. Clark provides an exemplary analysis of two paintings by Nicolas Poussin to illustrate the importance of a repeated observation of paintings for the process of developing one's own scientific stance. Timothy J. Clark: *The Sight of Death: An Experiment in Art Writing* (Yale University Press, 2006).

115. Various documentary collections following this method and an explanatory text by Lizzie Muller ("Towards an Oral History of New Media Art," 2008) have been made available by the Daniel Langlois Foundation at http://www.fondation-langlois.org. See also Wolfensberger, *On the Couch*.

116. Media artists are often obliged to submit documentation in advance to competitions or festivals and, as a result, are compelled to present the work at a very early stage—preferably in its best possible form. But even documentation created at a later stage will seek to present the work in a form that the artist welcomes, insofar as it will often be the only remaining testimony to ephemeral works. Furthermore, videos are often accompanied by a musical score that doesn't belong to the work itself but will still influence the observer's perception.

117. Bätschmann, "Der Künstler als Erfahrungsgestalter," 265.

118. See Rafael Lozano-Hemmer, "Body Movies. Relational Architecture 6" (at http://www .lozano-hemmer.com).

119. Carlson, *Performance*, 26.

120. Ursprung, *Grenzen der Kunst*, 17f.

121. Ibid., 16. Even if such performative research usually requires the researcher's own participation, presence, and involvement in the object of study, this is not actually essential. For example, Antonia Wunderlich, in her 2008 analysis of Jean François Lyotard's 1984 Les Immatériaux exhibition describes the chapter titled "Phänomenologie de la visite" as a "dense re-narration of a fictitious visit to the exhibition, in which objectifiable data flow together with a subjective idea of how such a visit might have proceeded." Wunderlich, *Der Philosoph im Museum*, 17f.

122. See Roman Bonzon, "Aesthetic Objectivity and the Ideal Observer Theory," *British Journal of Aesthetics* 39 (1999), 230–240; Iser, *The Act of Reading*, 27–38.

Chapter 3

1. The theories of play discussed here should not be confused with game theory. The latter is a type of modeling used in economics and the social sciences to predict the probable course of chains of human action. Game theory simulates actions aimed at clearly defined goals that can be achieved by means of logically assessable strategies; it is therefore not particularly relevant for this study. See Christian Rieck, *Spieltheorie. Einführung für Wirtschafts- und Sozialwissenschaftler* (Rieck, 1993).

2. Erika Fischer-Lichte, *Ästhetische Erfahrung. Das Semiotische und das Performative* (Francke, 2001); Fischer-Lichte, *The Transformative Power of Performance*. Not all performative aesthetics are theories of reception, however. For instance, the media philosopher Dieter Mersch views aesthetic experience as a passive responsiveness to non-intentional positing and consequently focuses neither on the artist nor on the potential recipient but only on the event of positing, which he sees as originating in the artwork itself. Mersch argues that aesthetic experience "emerges from the arts in a way that is oblique to their media." Mersch, *Ereignis und Aura*.

3. Ludology sees itself as an alternative model to narratological approaches that view the computer game as a type of narrative. See Jesper Juul, *Half-Real: Video Games between Real Rules and Fictional Worlds* (MIT Press, 2005), 16.

4. Susan Leigh Star and James R. Griesemer, "Institutional Ecology, 'Translations' and Boundary Objects: Amateurs and Professionals in Berkeley's Museum of Vertebrate Zoology," *Social Studies of Science* 19 (3, 1989): 387–420, 393: "Boundary objects are objects which are both plastic enough to adapt to local needs and the constraints of the several parties employing them, yet robust enough to maintain a common identity across sites. They are weakly structured in common use, and become strongly structured in individual-site use. These objects may be abstract or concrete."

5. Ludwig Wittgenstein, *Philosophical Investigations* (Blackwell, 1953), 32.

6. Friedrich Schiller, *On the Aesthetic Education of Man* (Dover, 2004), XV Letter, 76. The significance for Schiller of play, and thus also of aesthetics in human life, is evident in his oft-quoted claim that "man plays only when he is in the full sense of the word a man, and he is only wholly Man when he is playing" (80).

7. Julius Schaller, *Das Spiel und die Spiele. Ein Beitrag zur Psychologie und Pädagogik wie zum Verständnis des geselligen Leben*s (Böhlau, 1861), 12f.

8. Lazarus explicitly rejected the idea of interpreting reception as play: "The reception of the artwork should also have a lasting value and is therefore not play either." Moritz Lazarus, *Über die Reize des Spiels* (Dümmler, 1883), 23.

9. Karl Groos, *Das Spiel. Zwei Vorträge* (Fischer, 1922).

10. Frederik J. J. Buytendijk, *Wesen und Sinn des Spiels. Das Spielen des Menschen und der Tiere als Erscheinungsform der Lebenstriebe* (Kurt Wolff Verlag, 1933), 131–143.

11. Johan Huizinga, *Homo Ludens: A Study of the Play-Element in Culture* (Routledge, 1949), 13.

12. Huizinga, *Homo Ludens*, 10.

13. Hans Scheuerl, *Das Spiel. Untersuchungen über sein Wesen, seine pädagogischen Möglichkeiten und Grenzen* (1954; reprint: Beltz, 1968), 104.

14. Scheuerl, *Das Spiel*, 104: "An objective formal structure always either already exists or is improvised, and within this structure, an infinite playing of effects, to which one abandons oneself timelessly, is always created in the present moment."

15. Gadamer, *Truth and Method*, 102.

16. Ibid., 105.

17. Scheuerl, *Das Spiel*, 105. However, Scheuerl also indicated that "there are also artworks that want to be nothing more than play."

18. In addition to Huizinga's definition, published in 1938, Hans Scheuerl's 1954 synthesis of the various treatises on play deserves mention. Scheuerl identified six fundamental characteristics of play he called "moments."

19. Brian Sutton-Smith, *The Ambiguity of Play* (Harvard University Press, 1997).

20. Katie Salen and Eric Zimmerman, *Rules of Play: Game Design Fundamentals* (MIT Press, 2004).

21. Scheuerl, *Das Spiel*, 69.

22. Roger Caillois, *Man, Play, and Games* (1961; reprint: Free Press, 2001), 10.

23. Scheuerl, *Das Spiel*, 97.

24. Salen and Zimmerman, *Rules of Play*, 95.

25. See Markus Montola, Jaakko Stenros, and Annika Waern, *Pervasive Games: Theory and Design* (Morgan Kaufmann, 2009), 12.

26. Hans Scheuerl, "Spiel—ein menschliches Grundverhalten?" (1974), in *Das Spiel. Theorien des Spiels*, volume 2 (Beltz, 1997), 205.

27. Caillois, *Man, Play, and Games*, 9.

28. Scheuerl, *Das Spiel*, 76.

29. Dewey, *Art as Experience*, 42.

30. Gadamer, *Truth and Method*, 104.

31. Scheuerl, *Das Spiel*, 85.

32. Caillois, *Man, Play and Games*, 10.

33. Both Scheuerl and Huizinga saw the governance of play by rules as an aspect of play's self-containedness. For Caillois, the rules of play constitute a distinct characteristic; for ludology, it is the main field of research.

34. Caillois, *Man, Play, and Games*, 9.

35. See Juul, *Half-Real*, 12f., 121f. and 163f.

36. Scheuerl, *Das Spiel*, 93.

37. Gadamer, *Truth and Method*, 104.

38. Sutton-Smith, *The Ambiguity of Play*, 229. Hohlfeldt, in *Grenzwechsel*, arrives at similar criteria under the broad terms of ontological ambivalence and open determination. On ambiguity, also see Espen J. Aarseth, "Genre Trouble: Narrativism and the Art of Simulation," in *First Person: New Media as Story, Performance, and Game*, ed. Noah Wardrip-Fruin and Pat Harrigan (MIT Press, 2004).

39. Caillois, *Man, Play, and Games*, 19.

40. Ibid., 23.

41. Ibid., 27.

42. Ibid., 30.

43. Salen and Zimmerman, *Rules of Play*, 80.

44. The affinity between interactive art and play has been noted since the early 1990s. It has been the topic of exhibitions like Künstliche Spiele (Artificial Games) in Munich, Spielräume (Play Spaces) in Duisburg and Games in Dortmund. See Georg Hartwanger, Stefan Ilghaut, and Florian Rötzer, eds., *Künstliche Spiele* (Boer, 1993); Cornelia Brüninghaus-Knubel, ed., *Spielräume* (Wilhelm Lehmbruck Museum, 2005); Hartware Medien Kunst Verein, ed., *Games* (HMKV, 2003).

45. Focusing on performance as a quality of execution, Jon McKenzie distinguishes between the social efficacy of cultural performance, the efficiency of organizational performance, and the effectiveness of technological performance. Finding that there is as yet no established research field for the latter concept, he tentatively launches the discipline of "techno-performance

studies." McKenzie believes that all three areas are closely interdependent. The concept of performance in the sense of technological performance of systems is centered on the principles of effectiveness and productivity and is an important aspect of interactive art. In the present book it is dealt with in the context of the liveness of the interactive work. Jon McKenzie, *Perform or Else: From Discipline to Performance* (Routledge, 2001).

46. Carlson, *Performance*, 5. See also Richard Bauman, "Performance," in *International Encyclopedia of Communications*, ed. Erik Barnow (Oxford University Press, 1989).

47. See Richard Schechner, *Performance Theory* (1977; reprint: Routledge, 2003), 22, note 10.

48. Schechner differentiates between "theater" as the realization of the mise-en-scène and "performance" as a performative event. He thus sees performance as an occasion (with changing focuses) whose uniqueness and eventfulness each time transcends the underlying concept, the staging, and the realization.

49. Theatre studies analyze the drama text mainly concerning potential stage directions it contains, leaving the actual work of text interpretation to the ambit of literature studies.

50. However, it is possible to conceive of different versions or manifestations of one work—for example, in the context of different exhibitions—as stagings that don't necessarily have to be realized by the artist himself.

51. Christopher B. Balme, *The Cambridge Introduction to Theater Studies* (Cambridge University Press, 2008), 22–24.

52. Fischer-Lichte interprets this "performative turn" as a (counter-)reaction to the growing mediatization of society. Fischer-Lichte, *The Transformative Power of Performance*, 40, 50, 70.

53. John Langshaw Austin, "Performative Utterances" (1956), in *Philosophical Papers*, ed. James O. Urmson and Geoffrey J. Warnock (Clarendon, 1970), 235: "[I]n saying what I do, I actually perform that action." On the development of linguistic speech-act theory, see Ulrike Bohle and Ekkehard König, "Zum Begriff des Performativen in der Sprachwissenschaft," *Paragrana* 10 (1, 2001): 13–34.

54. Judith Butler, "Performative Acts and Gender Constitution. An Essay in Phenomenology and Feminist Theory," *Theater Journal* 40 (4, 1988): 519–531. Drawing on Turner, Butler emphasized the importance of the repetition of acts and performances for the constitution of reality.

55. Schechner, *Performance Theory*, xviii.

56. Richard Schechner, "Approaches" (1966), in Schechner, *Performance Theory*, 8.

57. Richard Schechner, "Actuals" (1970), in Schechner, *Performance Theory*.

58. Fischer-Lichte, *The Transformative Power of Performance*, 24: "Uttering these sentences effectively changes the world. Performative utterances are self-referential and constitutive in so far as they bring forth the social reality they are referring to."

59. Fischer-Lichte, *The Transformative Power of Performance*, 36–39 and passim.

60. Ibid., 25.

61. Bohle and König, "Zum Begriff des Performativen," 22.

62. The concept of self-reference was first introduced by Niklas Luhmann to indicate the way in which systems refer to themselves. See Luhmann, *Social Systems* (Stanford University Press, 1995), 9. According to Luhmann, systems create and employ descriptions of themselves in order to be able to use the difference between them and their environment as an orientation tool.

63. John R. Searle, "How Performatives Work," *Linguistics and Philosophy* 12 (5, 1989): 543f.

64. Sybille Krämer and Marco Stahlhut, "Das 'Performative' als Thema der Sprach- und Kulturphilosophie," *Paragrana* 10 (1, 2001): 59, n. 6.

65. Krämer and Stahlhut, "Das 'Performative,'" 38. Further: "If Austin's dedicated quest for linguistic criteria that distinguish between performative and non-performative utterances goes astray, the reason is that performativity is not a linguistic but a social phenomenon." (ibid.)

66. Fischer-Lichte, *The Transformative Power of Performance*, 21.

67. Some authors make a distinction between self-referentiality and self-reflexivity. Whereas the first concerns pure self-reference, the second refers to self-commentary. In the visual arts, however, such a differentiation is difficult to uphold, because it is ultimately interpretive in nature. In the context of the present study, therefore, the general concept of self-reference is preferred. The notion of self-reflection is used for subjective processes of perception—that is, for reflections that emanate from individuals and regard their own person or activity.

68. Sybille Krämer, "Was haben 'Performativität' und 'Medialität' miteinander zu tun? Plädoyer für eine in der 'Aisthetisierung' gründende Konzeption des Performativen," in Krämer, *Performativität und Medialität* (Fink, 2004), 14–18.

69. Krämer, *Performativität und Medialität*, 20.

70. Fischer-Lichte, *The Transformative Power of Performance*. For a similar view, see Hamker, *Emotion und ästhetische Erfahrung*, 152.

71. Mersch, *Ereignis und Aura*, 9.

72. Mersch, *Ereignis und Aura*, 247.

73. Ibid., 248.

Chapter 4

1. Stroud Cornock and Ernest Edmonds, "The Creative Process Where the Artist Is Amplified or Superseded by the Computer," *Leonardo* 11 (6, 1973): 11–16.

2. Roy Ascott, "Behaviourist Art and the Cybernetic Vision," in Ascott, *Telematic Embrace*.

3. See the summary of different approaches to classification in Stephen Bell, Participatory Art and Computers, PhD thesis, Loughborough University, 1991 (at http://nccastaff.bournemouth

.ac.uk). Also see Linda Candy and Ernest Edmonds, "Interaction in Art and Technology," *Crossings* 2 (1, 2002) (at http://crossings.tcd.ie).

4. See Alain Depocas, Jon Ippolito, and Caitlin Jones, eds., *Permanence through Change: The Variable Media Approach* (Guggenheim Museum, 2003). As of this writing, the most recent online version of the questionnaire was available at http://variablemediaquestionnaire.net.

5. The distinction often made in this study between active reception of interactive art and non-active reception of traditional art is based on physical activity. There is certainly no intention to call into question the enormous importance of mental and cognitive activity in the reception of traditional art.

6. Wardrip-Fruin, *Expressive Processing*, 3 and 157. Michael Mateas coined the term "expressive artificial intelligence" to denote how a system can be viewed as a "performance of the author's ideas." Michael Mateas, Interactive Drama, Art, and Artificial Intelligence, PhD thesis, Carnegie Mellon University, 2002) (at http://www.cs.cmu.edu).

7. Wendel et al., *An Architecture of Interaction*, 21.

8. Rokeby, "Transforming Mirrors," 150.

9. Rokeby, "The Construction of Experience," 31.

10. Cf. Katja Kwastek and Lizzie Muller, interview with Golan Levin, Linz, 2009 (at http://www .fondation-langlois.org), question 3.

11. Personal conversation with Teri Rueb, 2004.

12. Katja Kwastek, interview with Matt Adams, Linz, 2009, recording and transcript in the author's archives, minute 50.

13. The publication *An Architecture of Interaction* identifies a large group of actors it designates simply as "others." They are all those persons, with the exception of the initiating author, who are involved in some form in the work. The volume lists these others as ranging from participants, researchers, critics, and guinea-pigs, to errorists, imitators, and victims. See Wendel et al., *An Architecture of Interaction*, 14. With respect to the work, the publication further subdivides the "others" into participants, onlookers, and "witnesses of traces." However, it also points out that role changes may be possible: "A person could start out as a Withstander and then become a Creative Co-Player." Moreover, "at a certain moment during the process you as the maker may find yourself becoming Onlooker, whilst an Onlooker takes on the role of Participant-Maker," ibid 16.

14. Katja Kwastek, Lizzie Muller, and Ingrid Spörl, Video-Cued Recall with Helmut, Linz, 2009 (at http://www.fondation-langlois.org); Lizzie Muller and Caitlin Jones, interview with David Rokeby, Linz, 2009 (at http://www.fondation-langlois.org), question 1.

15. Katja Kwastek, interview with Bettina, Linz, 2009 (recording and transcript in the author's archives).

16. Muller and Jones, interview with David Rokeby, question 1.

17. Kwastek and Muller, interview with Golan Levin, question 12. See also Leah A. Sutton, "Vicarious Interaction. A Learning Theory for Computer Mediated Communications," 2000 (at http://www.eric.ed.gov).

18. Shaw, "Modalitäten," 204.

19. Kwastek, Muller, and Spörl, Video-Cued Recall with Helmut, minute 30.

20. See the artists' website (http://www.tmema.org).

21. In 1996, Toshio Iwai and Ryuichi Sakamoto staged a multimedia performance called *Music Plays Images × Images Play Music*, which was based on Iwai's installation *Piano—As Image Media*. The software *Small Fish*, programmed by Masaki Fujihata, Wolfgang Munch, and Kiyoshi Furukawa, was first presented in 2000 in Linz and Warsaw, then presented in 2002 in Karlsruhe as a performance under the name *Small Fish Tale*. A video of the Karlsruhe concert is available at http://hosting.zkm.de.

22. Pfaller coined this term in 1996. For a collection of the relevant essays, see *Ästhetik der Interpassivität* (Philo Fine Arts), 2008.

23. Pfaller, *Ästhetik der Interpassivität*, 30.

24. Ibid., 11.

25. Lars Blunck, "Luft anhalten und an Spinoza denken," in *Werke im Wandel? Zeitgenössische Kunst zwischen Werk und Wirkung* (Schreiber, 2005), 89.

26. Blunck, "Luft anhalten," 97.

27. This topic brings us back to the question (already addressed in chapter 2) as to the status of a reception based only on observation of documentation without a work being available for realization in the moment of reception. If the possibility of an aesthetic experience through vicarious interaction is not excluded, then why should observation of an interaction documented on video not also be considered an aesthetic experience? The reason is that documentation, even disregarding the problem discussed above of its potential manipulation, not only denies the possibility of the individual, embodied experience, but also its spatiotemporal contextualization, which will be considered below. Thus, documentation can be an important source, but it clearly has a different status not only with respect to first-hand realization, but also with respect to second-hand observation of a realization in the here and now.

28. Bruno Latour, *Reassembling the Social: An Introduction to Actor-Network-Theory* (Oxford University Press, 2005), 72. As a social theory, "actor-network theory" unfortunately doesn't analyze the function of technology in interactive processes beyond this basic assumption. Likewise, Nick Couldry, who discusses the significance of actor-network theory for media studies, doesn't deal with media technology itself, but only with the "media" as (mass-media) institutions. See Nick Couldry, "Actor Network Theory and Media: Do They Connect and On What Terms?" in *Connectivity, Networks and Flows: Conceptualizing Contemporary Communications*, ed. Andreas Hepp et al. (Hampton, 2008).

29. Donald A. Norman, *The Design of Everyday Things* (Basic Books, 1988), 9. The psychologist James Gibson was already using the term "affordance" in the late 1970s to define opportunities for action provided by an environment.

30. See Paul Dourish, *Where the Action Is: The Foundation of Embodied Interaction* (MIT, 2001), 117–120.

31. Statement by Ashok Sukumaran at Prix Forum Interactive Art, Ars Electronica Festival 2007, Linz, September 9, 2007, recording in the archive of Ars Electronica.

32. Kwastek, interview with Matt Adams, minute 16. For discussions of additional actors and institutional contexts, see Christiane Paul, ed., *New Media in the White Cube and Beyond: Curatorial Models for Digital Art* (University of California Press, 2008); Sarah Cook et al., eds., *A Brief History of Curating New Media Art: Conversations with Curators* (The Green Box, 2010).

33. Fischer-Lichte, *The Transformative Power of Performance*, 41 and passim.

34. Fischer-Lichte, *The Transformative Power of Performance*, 68.

35. Martina Löw, *Raumsoziologie* (Suhrkamp, 2001). This book is partly summarized in Löw's English-language essay "Constitution of Space: The Structuration of Spaces through the Simultaneity of Effect and Perception," *European Journal of Social Theory* 11 (1, 2008): 25–49.

36. Löw, "Constitution of Space," 35. The term "ordering" refers both to the fact that spaces are embedded in social systems and that they can be configured processually through actions.

37. Löw, "Constitution of Space," 35.

38. Fischer-Lichte, *The Transformative Power of Performance*, 107, 110, 112.

39. The latter are also the kinds of institution that sometimes buy or commission interactive artworks as permanent installations. See, for example, Paul Sermon's *Teleporter Zone* (2006) at Evelina Children's Hospital, London, and Camille Utterback's installation *Shifting Time* (2010) at San José Airport.

40. The exhibition was part of the European Media Art Festival. See Louis-Philippe Demers and Bill Vorn, *Es, das Wesen der Maschine* (European Media Art Festival, 2003).

41. See Rafael Lozano-Hemmer and Cecilia Gandarias, eds., *Rafael Lozano-Hemmer: Some Things Happen More Often Than All of the Time* (Turner, 2007).

42. For a more detailed discussion of the institutional presentation of media art, see Paul, *New Media in the White Cube.*

43. Krueger, *Artificial Reality II*, 97.

44. This aim is illustrated by numerous photographs of the installation that omit the real-world context and only show the bicycle in virtual space, as though the recipient were actually moving in this space. See Klotz and ZKM, *Jeffrey Shaw*, figures 126 and 127.

45. The acronym CAVE stands for Cave Automatic Virtual Environment and denotes a space with rear-projection screens, mostly on five surfaces, in which three-dimensional effects are created and can be perceived through special glasses.

46. See also Lucy Bullivant, *Responsive Environments: Architecture, Art and Design* (V&A Publications, 2006).

47. Muller and Jones, interview with David Rokeby, question 6.

48. Examples are *Murmur* (2003) and *Loca: Set to Discoverable* (2006).

49. Michel de Certeau, *The Practice of Everyday Life* (University of California Press, 1984), 97–98.

50. Some performance works do actually actively involve the public, such as *Love Zoo* (2004) by the Felix Ruckert Company.

51. In geometry, this kind of construction, which is based on distance calculations, is called a Voronoi diagram.

52. See Janet Murray, *Hamlet on the Holodeck: The Future of Narrative in Cyberspace* (MIT Press, 1997), 80: "The computer's spatial quality is created by the interactive process of navigation." Margaret Morse describes cyberspace as potentially the most effective means of surveillance, arguing that it allows the body to be reconstituted as a technical object under human control. She writes that it operates, on the one hand, with a referential fallacy, which dupes visual perception, and, on the other, with an enunciative fallacy, which feigns possibilities for action. Morse, *Virtualities*, 183–184.

53. See Schwarz, *Media–Art–History*, 119.

54. See Susanne Rennert and Stephan von Wiese, eds., *Ingo Günther, REPUBLIK.COM* (Hatje Cantz, 1998).

55. Manuel Castells, *The Rise of the Network Society* (Wiley, 1996).

56. Dunne and Raby, *Design Noir*, 8–12.

57. Pong was one of the very first computer games and has since achieved cult status, also being repeatedly modified by artists. One example is the installation *Pong* by Jan-Peter E. R. Sonntag (2003). See Hartware MedienKunstVerein and Tilman Baumgärtel, eds., *Games*, 81.

58. Löw, *Raumsoziologie*, 101.

59. Fried, "Art and Objecthood."

60. Dieter Mersch, *Was sich zeigt. Materialität, Präsenz, Ereignis* (Fink, 2002).

61. Fischer-Lichte, *The Transformative Power of Performance*, 101.

62. Ibid., 94, 96, 99.

63. Böhme, *Atmosphäre*, 167.

64. Thomas B. Sheridan, "Further Musings on the Psychophysics of Presence," *Presence* 1 (1992): 120–126.

65. Matthew Lombard and Theresa Ditton, "At the Heart of It All: The Concept of Presence," *Journal of Computer-Mediated Communication* 3 (2, 1997) (at http://dx.doi.org).

66. Fischer-Lichte, *The Transformative Power of Performance*, 67–74. The aim of the international research project Performing Presence: From the Live to the Simulated, was to bridge this discrepancy between performance theory and media studies. See Gabriella Giannachi and Nick Kaye, eds., *Performing Presence: From the Live to the Simulated* (Manchester University Press, 2011).

67. Dewey, *Art as Experience*, 189.

68. For a summary of modern philosophies of time, see Mike Sandbothe, "Media Temporalities in the Internet: Philosophy of Time and Media with Derrida and Rorty," *AI & Society* 13 (2000), no. 4: 421–434. On the reflection of these new experiences of time in the visual arts of the twentieth century, see Charlie Gere, *Art, Time and Technology* (Berg, 2006).

69. Gotthold Ephraim Lessing, *Laocoon: An Essay upon the Limits of Painting and Poetry* (Roberts Brothers, 1887), 91.

70. Friedrich Kittler, "Real Time Analysis, Time Axis Manipulation" (1990), in *Draculas Vermächtnis. Technische Schriften* (Reclam, 1993), 183.

71. Kittler believes that genuine real-time analysis is not possible: "Real-time analysis means purely and simply that postponement and delay, dead time and history are processed quickly enough as to be able just in time to move on to sorting the next time window." Kittler, "Real Time Analysis," 201.

72. Paul Virilio, *The Vision Machine* (Indiana University Press, 1994), 66. Jean-François Lyotard conceives of a similar duality, but his arguments are more semiotic in nature in that he describes present-moment real time as "presenting time," whereas the past is "presented present." Lyotard, "Time Today," 1987, in *The Inhuman: Reflections on Time* (Stanford University Press, 1991), 59.

73. Helga Nowotny defines time as a "symbolic product of human coordination and ascription of significance, collectively shaped and moulded at a deep level." Nowotny, *Time: The Modern and Postmodern Experience* (Blackwell, 1994), 8.

74. Mike Sandbothe, "Linear and Dimensioned Time: A Basic Problem in Modern Philosophy of Time," 2002 (at http://www.sandbothe.net).

75. Edward T. Hall, *The Dance of Life: The Other Dimension of Time* (Anchor Books, 1983), 45.

76. Karin Knorr Cetina, "Das naturwissenschaftliche Labor als Ort der 'Verdichtung von Gesellschaft,' " *Zeitschrift für Soziologie* 17 (1988): 85–101, cited in Nowotny, *Time*, 78.

77. Nowotny, *Time*, 93.

78. See Nowotny, *Time*, 14.

79. For a discussion of the different concepts of time in literature studies, see Katrin Stepath, *Gegenwartskonzepte. Eine philosophisch-literaturwissenschaftliche Analyze temporaler Strukturen* (Königshausen & Neumann, 2006), 177–180.

80. Richard Schechner differentiates between "set time" and "event time." Whereas in the first case the duration of the action is defined by a prescribed amount of time (e.g., a game of American football ends after 60 minutes of play), in the second case the activity ends obligatorily when a certain process has been traversed or a certain result has been achieved (as in a game of baseball). Schechner emphasizes that such time structures have great influence on the course and the experience of the activity in question, as when in football the players play "against the clock." Schechner, *Performance Theory*, 6–7.

81. The exceptions are gamelike projects such as *Pain Station* by the artist group ////////////fur//// and Blast Theory's *Can You See Me Now?* (2001) and projects in which time windows are predetermined for technical reasons. Thus, locative art projects commonly define a maximum duration for the interaction, not only for logistic reasons related to hiring out devices, but also because of the limited battery capacity of the devices used.

82. Chris Crawford, "Process Intensity," *Journal of Computer Game Design* 1 (5, 1987) (at http://www.erasmatazz.com).

83. Text cited in Landow, *Hypertext 3.0*, 229.

84. Juul, *Half-Real*, 142: "In a real-time game, not doing anything also has consequences."

85. Alexander R. Galloway, *Gaming: Essays on Algorithmic Culture* (University of Minnesota Press, 2006), 10–11. Wardrip-Fruin (*Expressive Processing*, 69) uses the term "semi-cinematic" to denote games in which the narrative itself cannot be significantly influenced.

86. Author's interview with Grahame Weinbren.

87. Juul, *Half-Real*, 152.

88. Isaac Dimitrov, "Final Report, Erl-King Project," 2004 (at http://www.variablemedia.net).

89. For details, see Katja Kwastek, "'Your Number Is 96—Please Be Patient': Modes of Liveness and Presence Investigated through the Lens of Interactive Artworks," in *Re:live: Media Art Histories 2009*, ed. Sean Cubitt and Paul Thomas (University of Melbourne, 2009).

90. See the entries for "live" and "liveness" in the *Oxford English Dictionary*, volume VIII, ed. J. A. Simpson and E. S. C. Weiner (Clarendon, 1989).

91. Philip Auslander, *Liveness: Performance in a Mediatized Culture* (Routledge, 2008), 58.

92. Auslander also points out that ultimately any transmission of information by means of broadcasting can be considered a live performance, insofar as in the case of television, for example, compared to film, we are dealing with a "performance in the present" in the sense of a television image which is constructed in real time. He further argues that every performance of recorded information is distinct from the previous one, because every process of playing alters the medium. Auslander, *Liveness*, 15, 49–50.

93. Auslander, *Liveness*, 71.

94. Ibid., 69. For a detailed discussion, see Philip Auslander, "Live from Cyberspace: Performance on the Internet," in *Mediale Performanzen. Historische Konzepte und Perspektiven*, ed. Jutta Eming, Annette Jael Lehmann, and Irmgard Maassen (Rombach, 2002).

95. Morse, *Virtualities*, 15.

96. Nick Couldry, "Liveness, 'Reality,' and the Mediated Habitus from Television to the Mobile Phone," *Communication Review* 7 (2004), 355f.

97. This can go so far that the constant connectedness can also be felt to be a threat. See Bojana Kunst, "Wireless Connections: Attraction, Emotion, Politics," in *Ohne Schnur*, ed. Katja Kwastek (Revolver, 2004).

98. Martin Lister et al., *New Media: A Critical Introduction* (Routledge, 2009), 22.

99. Sandra Fauconnier and Rens Frommé, "Capturing Unstable Media, Summary of Research," March 2003, 10 (at http://www.v2.nl).

100. "Capturing Unstable Media, Deliverable 1.3: Description models for unstable media art," 2003 (at http://www.v2.nl). The long-term goal was to produce a detailed technical description, for example by distinguishing between input and output processes and by precisely describing the interface and the directions of communication (one-to-one/one-to-many).

101. Beryl Graham, A Study of Audience Relationships with Interactive Computer-Based Visual Artworks in Gallery Settings, through Observation, Art Practice, and Curation, PhD thesis, University of Sunderland, 1997 (at http://www.sunderland.ac.uk).

102. Lutz Goertz, "Wie interaktiv sind Medien?" (1995), in *Interaktivität. Ein transdisziplinärer Schlüsselbegriff*, ed. Christoph Bieber and Claus Leggewie (Campus, 2004), 108.

103. Lister et al., *New Media*, 23. See also Jensen, "Interactivity." In an essay written in 1993, Lynn Hershman recalled that whereas in 1979 she believed it would be possible to involve the recipient in a dialogue situation, her ideological aspirations had since become more modest. Now she saw interactive art "more as an architecture that one can journey through. We can choose the direction we want to take, but the structure is predetermined. We only have the illusion of an even dialogue because the scheme of possibilities has been laid down in advance. The architectonic space is often invisible and can be deduced on the basis of a series of clues the participant encounters during the interaction." Lynn Hershman Leeson, "Immer noch mehr Alternativen," in *Künstliche Spiele*, ed. Georg Hartwanger, Stefan Iglhaut, and Florian Rötzer (Boer, 1993), 299.

104. See Erkki Huhtamo, "Seeking Deeper Contact: Interactive Art as Metacommentary," *Convergence* 1 (2, 1995): 81–104.

105. Ryszard W. Kluszczyński has developed a classification of interactive art that doesn't make use of the kind of continuum described above, although it can still be considered an instrumental approach. In reference to human-machine interactions, he suggests differentiating between strategies of instrument, game, archive, labyrinth, and rhizome. The latter three terms refer to formal characteristics that are not suitable for analyzing aesthetic strategies, but instrument and

game are interesting reference systems which are also discussed in detail in this study. Ryszard W. Kluszczyński, "Strategies of Interactive Art," *Journal of Aesthetics & Culture* 2 (2010) (at http://journals.sfu.ca). Kluszczyński also describes strategies of system (for interactive processes without direct human intervention), of network (for collaborative projects), and of spectacle (for experiences based on contemplation). These strategies are important referential concepts for processual art, but they are not overly relevant for the human-machine interactions at the focus of this study.

106. Salen and Zimmerman, *Rules of Play*, 316–318. In Andrew Hieronymi's project *Move* (2005), such patterns of action actually become the central theme of an artwork in which Hieronymi exposes the basic actions carried out by participants in action games (Jump, Avoid, Chase, Throw, Hide, Collect). See "MOVE by Andrew Hieronymi" at http://users.design.ucla.edu.

107. Ian Bogost, *Unit Operations: An Approach to Videogame Criticism* (MIT Press, 2006).

108. Manovich defines books as the "perfect random access medium" (*The Language of New Media*, 233).

109. Although the range of icons available in *JCJ Junkman* constantly changes, so that the icons are never all shown together, the choice cannot be influenced by the recipient, nor is there a progressive sequence.

110. In such interconnected communication projects, the aesthetic experience is usually centered around the media-based conditions of interaction. If, however, projects primarily strive toward exploring or reflecting the potentials of artificially intelligent systems, the focus will be on their discursive potential. As was noted in chapter 1, such projects may represent efforts to create a simulation of communication which is as realistic as is possible, but they may also present critical reflections on visions of artificial intelligence.

111. Salen and Zimmerman, *Rules of Play*, 130, 132.

112. Jesper Juul emphasizes this point with respect to computer games, arguing that recipients can concentrate on the fictitious world instead of perceiving the game primarily as a set of regulations. Juul, *Half-Real*, 162.

113. Salen and Zimmerman, *Rules of Play*, 165.

114. Juul, *Half-Real*, 5. Juul also points to the distinction made in play theory between "games of perfect information" and "games of imperfect information" (59)—in other words, between games in which the recipient receives all the necessary information at the beginning of the game and those in which acquiring this information or understanding the rules is one of the goals of the game itself.

115. See Michael Mateas, "A Preliminary Poetics for Interactive Drama and Games," in Wardrip-Fruin and Harrigan, *First Person*.

116. Murray, *Hamlet on the Holodeck*, 143.

117. Ibid., 153.

118. Bogost, *Unit Operations*, 121.

119. See Krueger, *Artificial Reality II*, XII.

120. Ken Feingold, "OU. Interactivity as Divination as Vending Machine," *Leonardo* 28 (1, 1995): 401.

121. Feingold, "OU," 401.

122. Roberto Simanowski describes this attitude as "reducing the encounter with the interactive work to a functional test." Roberto Simanowski, *Digitale Medien in der Erlebnisgesellschaft: Kunst, Kultur, Utopien* (Rowohlt, 2008), 269.

123. Krueger, *Artificial Reality II*, 16.

124. Ibid., 17.

125. Ibid., 41.

126. See Wardrip-Fruin, *Expressive Processing*, 273.

127. Wardrip-Fruin, *Expressive Processing*, 300f. He explains that the point is not to be actually able to program the same system themselves, but to grasp its logical principles (310).

128. Manovich, *The Language of New Media*, 124–160.

129. Landow, *Hypertext 3.0*, 13.

130. Simanowski, "Hypertext," section 8, "Semantik des Links."

131. Brenda Laurel, *Computers as Theater* (Addison-Wesley, 1993), especially chapter 3 and pages 94 and 95.

132. Mateas, "A Preliminary Poetics," 25: "A player will experience agency when there is a balance between the material and formal constraints."

133. Cf. Murray, *Hamlet on the Holodeck*, 26: "Eventually, all successful storytelling technologies become 'transparent': we lose consciousness of the medium."

134. Gonzalo Frasca, "Videogames of the Oppressed: Critical Thinking, Education, Tolerance and Other Trivial Issues," in Wardrip-Fruin and Harrigan, *First Person*.

135. Communication as a mode of experience differs here from communication as an instrumental mode of interaction in that the focus in the first case is not on the actual possibilities for discursive feedback, but on their individual perception, according to which a one-sided reaction can also be experienced as communication. This distinction is in line with Christoph Neuberger's thesis, outlined in chapter 1 above, that communication can be understood either as a superordinate or as a subset of interaction. As a superordinate, it describes the phenomenological perception of a situation as an interpersonal exchange, which corresponds to the mode of experience described above. In fact, processes that do not enable discursive feedback can also be perceived as communication.

136. See Kwastek, *The Invention of Interactive Art*, 190–192.

137. Erving Goffman, *The Presentation of Self in Everyday Life* (Doubleday, 1959), 1.

138. Ingo Schulz-Schaeffer, "Akteur-Netzwerk-Theorie. Zur Koevolution von Gesellschaft, Natur und Technik," in *Soziale Netzwerke. Konzepte und Methoden der sozialwissenschaftlichen Netzwerkforschung*, ed. Johannes Weyer (R. Oldenbourg Verlag, 2000), 192.

139. Wardrip-Fruin, *Expressive Processing*, 33.

140. Krueger, *Artificial Reality II*, 15.

141. Wardrip-Fruin, *Expressive Processing*, passim.

142. Wendel et al., *An Architecture of Interaction*, 42–46.

143. Blunck, "Luft anhalten," 87–90.

144. For a detailed description of the recipients' behavior, see Krueger, *Artificial Reality II*, 27.

145. Gregory Bateson, "A Theory of Play and Fantasy," 1955, in *Steps to an Ecology of Mind* (University of Chicago Press, 2000).

146. Erving Goffman, *Frame Analysis: An Essay on the Organization of Experience* (Harper & Row, 1974), 10.

147. Ibid., 43–44.

148. Margaret Morse doubts the concept of framing can do justice to the complexity of today's world and consequently emphasizes the intersubjective and multiperspectival processes that shape the construction and perception of our society. See Morse, *Virtualities*, 32: " 'Framing' as a task does not entail a referential 'mapping' of what is already there—the two-dimensional forms of the 'map' and even the 'frame' are no longer appropriate metaphors for what is an enunciative process, namely, the construction of cultural models." However, Goffman certainly acknowledges these possibilities of multiple layering.

149. Galloway, *Gaming*, 37.

150. Goffman, *Frame Analysis*, 144.

151. Carlson, *Performance*, 15; Murray, *Hamlet on the Holodeck*, 117.

152. Fischer-Lichte, *The Transformative Power of Performance*, 48.

153. Goffman, *Frame Analysis*, 378.

154. Wendel et al., *An Architecture of Interaction*, 46.

155. Monika Wagner, *Das Material der Kunst* (Beck, 2001), 12.

156. Mersch, *Was sich zeigt*, 18.

157. Ibid., 18.

158. Mersch criticizes the practice of "linking art to the symbolic as the predominant paradigm of aesthetic discourse" (*Ereignis und Aura*, 159).

159. Böhme, *Atmosphäre*, 8.

160. Mersch, *Was sich zeigt*, 419.

161. Arthur C. Danto, *The Transfiguration of the Commonplace: A Philosophy of Art* (Harvard University Press, 1981), 147.

162. Ibid., 174.

163. Thus, in associative processes, meanings can also "emerge" that were not intended by the perceiver. Fischer-Lichte, *The Transformative Power of Performance*, 150.

164. Mersch points out that even when the presence of media is obscured by their own function ("all the better the more inconspicuous they are"), they still determine "their mediatized nature in the sense of a constituent part" and at the same time communicate and structure the process of mediation. Mersch, *Ereignis und Aura*, 58. Cf. Sybille Krämer's distinction between "media marginalism" (the idea of invisible media) and "media generativism" (everything is generated by the media). Krämer, *Performativität und Medialität*, 23f.

165. Jay David Bolter and Richard Grusin, *Remediation: Understanding New Media* (MIT Press, 1999), passim.

166. Muller and Jones, interview with David Rokeby, question 12.

167. See the case study in the DOCAM project: "Daniel Dion, The Moment of Truth, 1991" (at http://www.docam.ca).

168. Email message from Holger Friese to the author, 12 March 2004.

169. Hans Dieter Huber, "Materialität und Immaterialität der Netzkunst," *Kritische Berichte* 1 (1998): 39–53.

170. Wolfgang Tischer, "Die Netzliteratur hat sich gesundgeschrumpft—Ein Interview mit Susanne Berkenheger," *Literatur Café*, January 27, 2008 (at http://www.literaturcafe.de).

171. See Carsten Seiffarth, Ingrid Beirer, and Sabine Himmelsbach, eds., *Paul DeMarinis: Buried in Noise* (Kehrer, 2010).

172. See the detailed documentation of this project carried out by Lizzie Muller and Caitlin Jones for the Daniel Langlois Foundation: "David Rokeby, Giver of Names, Documentary Collection," 2008 (at http://www.fondation-langlois.org).

173. Sommerer and Mignonneau, *Interactive Art Research*, 202–209.

174. Mersch, *Ereignis und Aura*, 95.

175. For details of Lyotard's exhibition Les Immatériaux, shown in 1985 at the Centre Pompidou in Paris, see Wunderlich, *Der Philosoph im Museum*.

176. Böhme, *Atmosphäre*, 27.

177. Böhme, *Atmosphäre*, 48.

178. Ibid., 33.

179. Hamker, *Emotion*.

180. Böhme, *Atmosphäre*, 38.

181. Heinrich Klotz goes so far as to celebrate the potential pictorialness of media art as an opportunity to overcome abstraction. Only in this genre, he writes, is it possible to "continue human beings' great tradition of representation." Klotz, "Medienkunst als Zweite Moderne," 49.

182. In chapter 4 of *The Transformative Power of Performance* Fischer-Lichte refers to the "performative generation of materiality" in the sense of corporeity, spatiality, tonality, and temporality. Mersch also argues that materiality is equally involved "in the execution of gestures and physical expressions, in the performance of an action which refers back, in turn, to the corporeity of the person executing the action or to the spatial, temporal, and material conditions in which such actions take place." Mersch, *Was sich zeigt*, 11.

183. Derrick de Kerckhove, "Touch versus Vision: Ästhetik neuer Technologien," in *Die Aktualität des Ästhetischen*, ed. Wolfgang Welsch (Fink, 1993), 140.

184. Eric Norden, "The Playboy Interview: Marshall McLuhan," *Playboy*, March 1969 (at http://www.mcluhanmedia.com).

185. Cf. N. Katherine Hayles, *How We Became Posthuman: Virtual Bodies in Cybernetics, Literature, and Informatics* (University of Chicago Press, 1999).

186. Krueger, *Artificial Reality II*, 265.

187. Muller and Jones, interview with David Rokeby, question 11.

188. Ibid., question 3.

189. See Keith Armstrong, "Towards a Connective and Ecosophical New Media Art Practice," in *Intimate Transactions: Art, Exhibition and Interaction within Distributed Network Environments*, ed. Julian Hamilton (ACID, 2006).

190. For an excellent overview of the role of new technology in performance, in general, and specifically of performances whose theme is the human body, see Chris Salter, *Entangled: Technology and the Transformation of Performance* (MIT Press, 2010).

191. Hansen, *Bodies in Code*, 3, 95.

192. Erving Goffman differentiates between the person as an individually determinable entity and the functions (e.g., professions) carried out by that person, which he calls "roles"; he denotes the portrayal of a person in a theater play as an onstage part or character. Goffman, *Frame Analysis*, 128.

193. See Allucquere Rosanne Stone, "Will the Real Body Please Stand Up? Boundary Stories about Virtual Cultures" (1991), in Mayer, *Computer Media and Communication*.

194. Of course, it is possible that the roles of "blind detective" and "intern" could also be interpreted as metaphors for art recipient, but this function is not as explicit as in Hershman's work.

195. Matt Adams also points out that it is not actually possible to distinguish between an actual self and a performative self. See Kwastek, interview with Matt Adams, minute 37.

196. See also the discussion of media-based representations of actors in performance art in Steve Dixon, "The Digital Double," in *Digital Performance: A History of New Media in Theater, Dance, Performance Art, and Installation* (MIT Press, 2007).

197. Mersch, *Was sich zeigt*, 65.

198. Ibid., 56.

199. Ibid., 196.

200. See Winfried Nöth, *Handbook of Semiotics* (Indiana University Press, 1995), 92: "The term *meaning* will be used in a very broad sense, covering both of the two more specific dimensions of *sense* (or content) and *reference* (object or denotatum)."

201. For a detailed analysis of this installation, see Simanowski, *Digitale Medien*, 42–46.

202. According to Christiane Paul, the original meaning of virtual reality was "a reality that fully immersed its users in a three dimensional world generated by a computer and allowed them an interaction with the virtual objects that comprise that world." Paul, *Digital Art*, 125.

203. Morse, *Virtualities*, 21. In the same vein, Ursula Frohne observes that the boundaries between private actions and public performances are progressively crumbling as a result of the growing fictionalization of our relationships with our environment. Frohne, "'Screen Tests': Media Narcissism, Theatricality, and the Internalized Observer," in *CTRL [SPACE]: Rhetorics of Surveillance from Bentham to Big Brother*, ed. Thomas Y. Levin, Ursula Frohne, and Peter Weibel (MIT Press, 2002), 256.

204. Goffman, *Frame Analysis*, 562.

205. Ibid., 186.

206. See also Bateson, "A Theory of Play and Fantasy," 182: "Conjurers and painters of the *trompe l'oeil* school concentrate upon acquiring a virtuosity whose only reward is reached after the viewer detects that he has been deceived and is forced to smile or marvel at the skill of the deceiver."

207. Salen and Zimmerman, *Rules of Play*, 450.

208. Samuel Taylor Coleridge, *Biographia Literaria. Or Biographical Sketches of my Literary Life and Opinions* (Leavitt, 1834), 174. Christian Metz calls this situation a "splitting of belief." *The Imaginary Signifier: Psychoanalysis and the Cinema* (Indiana University Press, 1982), 70–73. Morse also observes this intermingling of the real and the simulated in public space and denotes such multiple layering as "semifiction." Morse, *Virtualities*, 99.

209. Krueger, *Artificial Reality II*, 41.

210. Goffman, *Frame Analysis*, 145.

211. Janet Murray defines immersion as the "experience of being transported to an elaborately simulated place." *Hamlet on the Holodeck*, 98, 117.

212. For detailed treatments of the concept of immersion, see Christiane Voss, "Fiktionale Immersion," *montage AV* 17 (February 2008): 69–86; Robin Curtis, "Immersion und Einfühlung: Zwischen Repräsentionalität und Materialität bewegter Bilder," *montage AV* 17 (February 2008): 89–107.

213. Mihály Csíkszentmihályi, *Beyond Boredom and Anxiety: Experiencing Flow in Work and Play* (Jossey-Bass, 1975), 58.

214. Salen and Zimmerman, *Rules of Play*, 336.

215. Kwastek and Muller, interview with Golan Levin, question 6.

216. Bateson, "A Theory of Play and Fantasy," passim.

217. Richard Schechner, *Between Theater and Anthropology* (University of Pennsylvania Press, 1989), 127.

218. Even if Scheuerl allows for a certain degree of reflection in play with his use of the term "ambivalence," this still really refers more to the oscillating awareness between the first and the second components described here than to a reflection on play itself. Some games may, of course, use strategies of disruption and thus generate aesthetic experiences that can be compared to the reflective experience of art. For instance, although Ian Bogost considers computer games to be first and foremost simulations, he also identifies potential disruptions in games, denoting the player's perception of these as "simulation fever" or "the nervous discomfort caused by the interaction of the game's unit operational representations of a segment of the real world and the player's subjective understanding of that representation" (*Unit Operations*, 136). Bogost disagrees with the idea that a clear-cut distinction can be made between the artificiality of play and the reality of daily life, for in his view, "there is a gap in the magic circle through which players carry subjectivity in and out of the game space" (ibid., 135). At any rate, most games do not intentionally provoke irritation or explicitly stage disruptions that consciously highlight their own ambivalence. Marie-Laure Ryan asserts that the displacement of structuralism by deconstructivism has shifted interest in game metaphors from a vision of games as rule-governed activities to the consideration of play as a subversion of rules. Even if Ryan's general interpretation of play as being based on the subversion of rules can be called into question, her observation still applies to the aesthetic experience of interactive art. Marie-Laure Ryan, *Narrative as Virtual Reality, Immersion and Interactivity in Literature and Electronic Media* (Johns Hopkins University Press, 2001), 188.

219. Fischer-Lichte calls this phenomenon a unifying of "materiality, signifier, and signified" in which the physiological process of sensual perception of an object coincides with the mental act of attribution of meaning. *The Transformative Power of Performance*, 144–145.

220. See Victor Stoichiță, *The Self-Aware Image: An Insight into Early Modern Meta-Painting* (Cambridge University Press, 1997); Klaus Krüger, *Das Bild als Schleier des Unsichtbaren. Ästhetische*

Illusion in der Kunst der frühen Neuzeit (Fink, 2001); Erich Franz, "Die zweite Revolution der Moderne," in *Das offene Bild. Aspekte der Moderne in Europa nach 1945* (Westfälisches Landesmuseum, 1992). As Marie-Laure Ryan demonstrates, postmodern theory explicitly calls for artistic work to be self-reflexive, which stands in contrast to immersive strategies. Ryan, *Narrative as Virtual Reality*, 175.

221. Huhtamo, "Seeking Deeper Contact," 84. Roberto Simanowski compares works that use irony to challenge concepts of interactivity with Debord's concept of *détournement*. Simanowski, "Event and Meaning. Reading Interactive Installations in the Light of Art History," in *Beyond the Screen: Transformations of Literary Structures, Interfaces and Genres*, ed. Jörgen Schäfer and Peter Gendolla (transcript, 2009), 141f.

222. In another form of self-referentiality, different types of multimodal reflexivity are manifested in relationships between sound and image. Multimodal works provide an opportunity for mutual commentary and reflection between the visual and the auditory (and occasionally the gestural) in the process of interaction. Such processes are anything but "neutral" computational transformations or translations from one mode to another, rather are based on explicit arrangements chosen by the artist. Sounds and images can be assigned to one another either associatively or symbolically. For example, in the interactive software *Small Fish*, graphic compositions reminiscent of abstract paintings by Kandinsky or Miró are animated, and the movements of their elements and encounters between them activate various sounds and short melodies. An alternative to symbolic attributions are almost indexical conversions, which, as described in the case study on *The Manual Input Workstation*, may nonetheless be based on artistic arrangements. Other projects present mutual reactions between sounds and images as communication, as in Vincent Elka's *SHO(U)T* (2007)—a work in which recipients are invited to stand at a podium and use a microphone to address a virtual woman who reacts with exaggerated mimicry and sounds. In all of these works, the multimodal references are not straightforward visualizations or sonifications in the sense of physical transformations, rather they are based on emphases or even disruptions that provoke conscious awareness of the respective media settings.

223. Pfaller, *Ästhetik der Interpassivität*, 40.

224. Ursula Frohne also discerns a "media narcissism," although she relates this to current forms of mediated self-presentation, for example in the context of Web 2.0. Frohne, " 'Screen Tests,' " 256.

225. Rokeby, "Transforming Mirrors," 146. His use of the term "closed systems" draws on Marshall McLuhan, who in the 1960s defined narcissism in terms of transformation into a closed system.

226. Ruth Sonderegger identifies three possible variations of referencing in Schlegel and the same three again in Gadamer: the interplay of references between different elements of the artwork, the play between the signifier and the signified, and that between the artwork and the recipient. Sonderegger, *Für eine Ästhetik des Spiels. Hermeneutik, Dekonstruktion und der Eigensinn der Kunst* (Suhrkamp, 2000), 126f.

227. Carlson, *Performance*, 22.

228. Csíkszentmihályi, *Beyond Boredom and Anxiety*, 38.

229. Dewey, *Art as Experience*, 150.

230. Goffman, *Frame Analysis*, 219. Mark B. N. Hansen reminds us that a simultaneity of object awareness and consciousness of one's own perception is already described in Husserl's theory of double intentionality. Hansen, *New Philosophy*, 252.

231. Seel, *Aesthetics of Appearing*, 82. Lev Manovich, who observes the competing forces of (immersive) representation and (interactive) control in interfaces, argues that these band together like cinematic shots and counter-shots as a kind of "suturing mechanism" and in the ideal case merge perfectly in a constant oscillation between perception and action to create a marriage between "Brecht and Hollywood." Even if Manovich's equation between transparency (of the interface) and illusionism, and between opacity and interaction, as well as his ideal of perfect overlapping, do not entirely do justice to the complexity of artistic projects, the motif of ambivalence is still evident here, which is also crucial to the aesthetic experience of interactive art. Manovich, *The Language of New Media*, 208–209.

232. By contrast, Roberto Simanowski sees a "double coding" or "dual readership," assuming that a transition from immersion to successive reflection is necessary, but arguing that many recipients are either unwilling or unable to take this step. Simanowski, *Digitale Medien*, 47. "This also means that interactive installations potentially commit themselves to an aesthetics of spectacle and the principle of entertainment." Although I agree with Simanowski to a point, insofar as recipients often devote substantial attention to exploring an interactive work, I cannot view the exploration as aesthetically inferior, but only as one pole in the oscillation between different modes of experience. In fact, processes of exploration are essential to enabling reflection on media-based actions.

233. Rokeby, "Transforming Mirrors," 136.

234. See Erkki Huhtamo, *Illusions in Motion: Media Archaeology of the Moving Panorama and Related Spectacles* (MIT Press, 2013).

235. Nelson Goodman, *Languages of Art: An Approach to a Theory of Symbols* (Hackett, 1976), 113.

236. Genette, *The Work of Art*, 18.

237. IFLA Study Group on the Functional Requirements for Bibliographic Records, "Functional Requirements for Bibliographic Records," 1997, updated 2009 (at http://www.ifla.org).

238. The Capturing Unstable Media project proposes a classification that distinguishes between projects and occurrences, where projects are defined as "long-term activities that are subject to change," whereas occurrences are "activities or products with a distinct, short time span and an autonomous character" with which users can interact. Cf. Fauconnier and Frommé, "Capturing Unstable Media," 12.

239. Jay David Bolter suggests in reference to interactive literature that each reading is not a different version of just one story, but that the readings actually constitute the story: "We could

say that there is no story at all, there are only readings," Jay David Bolter, *Writing Space: Computers, Hypertext, and the Remediation of Print* (Routledge, 2001), 125. Cf. Landow, *Hypertext 3.0*, 226.

240. Fischer-Lichte, *The Transformative Power of Performance*, 161.

241. Mersch, *Ereignis und Aura*, 9, 53.

242. Ibid., 163.

243. Dorothea von Hantelmann shows that these developments also concern performance art. She demonstrates that in present-day media-based performances—in contrast to the performance art of the 1960s—the focus is no longer on the singular, immediate event: "Processes of performatization in contemporary media artworks expose the problematic relationship between presence and representation, between singularity and repetition, and between immediacy and reproduction, and are thus located between the conflicting poles of work and event." Dorothea von Hantelmann, "Inszenierung des Performativen in der zeitgenössischen Kunst," *Paragrana* 10 (1, 2001): 255–270, at 260.

244. Jochen Schulte-Sasse, "Medien," in *Ästhetische Grundbegriffe*, volume 4, ed. Karlheinz Barck (Metzler, 2002), 1.

245. Sybille Krämer, "Spielerische Interaktion. Überlegungen zu unserem Umgang mit Instrumenten," in *Schöne neue Welten? Auf dem Weg zu einer neuen Spielkultur*, ed. Florian Rötzer (Boer, 1995), 225f. The term "worldmaking" was coined by Nelson Goodman in *Ways of Worldmaking* (Hackett, 1978).

246. Ryszard Kluszczyński therefore sees instrumentality as relevant for works that have no preset data structure or ready-made form. Kluszczyński, "Strategies." However, we will see in the following that an ontological differentiation of interactive art in terms of the instrumentality of process-intensive projects, on the one hand, and the mediality of data-intensive projects, on the other, is ultimately not satisfying.

247. Dieter Mersch, "Wort, Bild, Ton, Zahl—Modalitäten medialen Darstellens," in *Die Medien der Künste. Beiträge zur Theorie des Darstellens* (Fink, 2003). Mersch builds here on Lacan's separation of the imaginary and the symbolic, as well as on Flusser's distinction between conceptual and imaginative thought.

248. This is another term whose connotations vary according to the historical and discursive context. Nonetheless, the common denominators that have survived from the original meaning of "piece of equipment" (Latin *apparatus*) are its mediating function and a certain degree of structural complexity. In addition, a focus on optical apparatuses, which has been significantly shaped by the apparatus debate outlined below, can be noted.

249. Sybille Krämer, "Das Medium als Spur und Apparat," in *Medien, Computer, Realität: Wirklichkeitsvorstellungen und neue Medien* (Suhrkamp, 1998), 84.

250. Erwin Panofsky made this comparison in 1939. He classified man-made objects with practical uses as either vehicles of communication or tools and apparatuses, explaining that the

purpose of the former was to transmit a concept, whereas that of the latter was to fulfill a function. Panofsky believed that objects with aesthetic purposes also belonged to one of these categories. Poems and paintings were vehicles of communication, whereas candlesticks and architectural constructions were apparatuses. However, aesthetic objects were never either entirely vehicles of communication or pure apparatuses, rather always contained a little of both: "Therefore, one cannot, or should not, attempt to define the precise moment at which a vehicle of communication or an apparatus begins to be a work of art." Erwin Panofsky, "Introduction: The History of Art as a Humanistic Discipline," 1939, in *Meaning in the Visual Arts* (Doubleday, 1955), 12–14.

251. See Eva Tinsobin, *Das Kino als Apparat. Medientheorie und Medientechnik im Spiegel der Apparatusdebatte* (Verlag Werner Hülsbusch, 2008), 13. On the apparatus debate, also see Robert F. Riesinger, ed., *Der kinematographische Apparat. Geschichte und Gegenwart einer interdisziplinären Debatte* (Nodus, 2003).

252. Jean-Louis Baudry, "Ideological Effects of the Basic Cinematographic Apparatus," *Film Quarterly* 28 (2, winter 1974–1975): 39–47, at 44.

253. Jean-Louis Baudry, "Das Dispositiv. Metapsychologische Betrachtungen des Realitätseindrucks" (1975), in Riesinger, *Der kinematographische Apparat*, 60f.

254. Siegfried Zielinski, "Einige historische Modelle des audiovisuellen Apparats," in Riesinger, *Der kinematographische Apparat*, 170.

255. Similar to the early apparatus theorists, Flusser often uses a metaphorical language full of double entendres that play on the overlap between the technical-analytical and the ideology-critical perspectives.

256. Vilém Flusser, *Toward a Philosophy of Photography* (Reaktion Books, 2000), 21. Flusser's concept of the apparatus is very broad. He counts as apparatuses both social systems, such as the administrative apparatus, and the computer chip, which is controlled through microprocessing.

257. Flusser, *Toward a Philosophy*, 27, 30.

258. Ibid., 27.

259. Aden Evens, *Sound Ideas: Music, Machines, and Experience* (University of Minnesota Press, 2005), 160.

260. Flusser, *Toward a Philosophy*, 28.

261. Heinz von Loesch, "Virtuosität als Gegenstand der Musikwissenschaft," in *Musikalische Virtuosität. Perspektiven musikalischer Theorie und Praxis*, ed. Heinz von Loesch, Ulrich Mahlert, and Peter Rummenhöller (Schott, 2004), 12. The need for practice is actually often used as a defining criterion for the musical instrument. According to Christoph Kummer, "Pocketnoise is a real instrument. You have to practice." Tilman Baumgärtel, "Interview with Christoph Kummer," in *net.art 2.0*, 248.

262. Evens, *Sound Ideas*, 147.

263. Ibid., 159–161.

264. Flusser, *Toward a Philosophy*, 27.

265. Dieter Mersch, "Medialität und Kreativität. Zur Frage künstlerischer Produktivität," in *Bild und Einbildungskraft*, ed. Bernd Hüppauf and Christoph Wulf (Fink, 2006), 80. Whereas Mersch relates imagination to visual media and figuration to textual media, the present study takes the two concepts as informing one another in the process of gestalt formation, independent of genre. Mersch questions the value of both concepts, suggesting a theory of media paradoxes as source of creativity. Without elaborating on his argument in detail, this study follows Mersch insofar as it also emphasizes the importance of disruptions for the gestalt formation of interactive art.

266. Golan Levin, Painterly Interfaces for Audiovisual Performances, MS thesis, MIT Media Laboratory, 2000 (at http://www.flong.com), 46.

267. Masaki Fujihata, "Notes on Small Fish," 2000 (at http://hosting.zkm.de).

268. In this context, imagination is referred to as a category of production aesthetics. Clearly, imagination is also essential to cognitive processes of reception, as is made clear by Blunck's concept of reflexive imagination or Dewey's emphasis on the role of imagination in the individual construction of the object of experience. On imagination as a possible form of reception or aesthetic perception, see Seel, *Aesthetics of Appearing*, 77–87.

269. Simanowski sees some interactive artworks as straddling a "dual role between art and tool for the creation of art." Simanowski, *Digitale Medien*, 38.

270. George Poonkhin Khut, "Interactive Art as Embodied Inquiry: Working with Audience Experience," in Edmonds, Muller, and Turnbull, *Engage*, 164.

271. Simon Penny describes aspects of the apparatus when he distinguishes between "machine-artwork" and "instrument": "In a machine-artwork . . . the embodied experience is integrally related to, and cannot be separated from, the material manifestation of the artifact." Penny, "Bridging Two Cultures: Towards an Interdisciplinary History of the Artist-Inventor and the Machine-Artwork," in Daniels and Schmidt, eds., *Artists as Inventors*, 149.

Chapter 5

1. Tilman Baumgärtel, "Interview mit Olia Lialina," in *net.art*, 132.

2. Elżbieta Wysocka, "Agatha re-Appears. Restoration Project: Olia Lialina's Early Net.art Piece *Agatha Appears* from the Collection of the C³ Center for Culture & Communication Foundation," 2008 (at http://www.incca.org), 10.

3. Wysocka, "Agatha re-Appears."

4. This is the only clue to suggest that in the ensuing story the system administrator may not be operating entirely within the bounds of the law.

5. In the interests of citing the textual elements of the work precisely as they appear on the Internet, spelling errors will be reproduced.

6. Because newer browser versions do not support scrolling texts in the status bar (where they were originally located in *Agatha Appears*), the scrolling text was moved to the title bar in the restored version of the work. See Wysocka, "Agatha re-Appears," 14.

7. Josephine Berry, "Convulsive Beauty Then and Now," post to Nettime mailing list, August 23, 2001 (at http://www.nettime.org).

8. In reality, this is only an empty page with the URL http://www.c3.hu/collection/agatha/canary_tenerife_beach.html.

9. During the restoration of the work carried out in 2008, the artist opted for new locations; most of the pages are now hosted on German servers.

10. Susanne Berkenheger, "Die Schwimmmeisterin . . . oder 'Literatur im Netz ist eine Zumutung,'" 2002 (at http://www.berkenheger.netzliteratur.net).

11. Details are provided about some of them, for instance: "'Miranda, the beginner,' bathing time runs out in 2 minutes" and "'pool attendant, the trainer,' working time overrun by 3:04 hours." The shark also appears with the message "'shark75, the demon,' You don't simply want to disappear?"

12. As well as his "augmented reality fiction," Schemat also created projects he called "hyper trance fiction," which adapt the rhythm of spoken texts to the breathing rate of the recipient.

13. Katja Kwastek, *Ohne Schnur*, 200–209; "Opus ludens. Überlegungen zur Ästhetik der interaktiven Kunst," in Blunck, *Werke im Wandel*; "Geo-Poetry: The Locative Art of Stefan Schemat and Teri Rueb," in *Literary Art in Digital Performance: Case Studies in New Media Art and Criticism*, ed. Francisco Ricardo (Continuum, 2009).

14. This and the following texts from *Wasser* have been translated from the original German.

15. See *Kino-Eye: The Writings of Dziga Vertov*, ed. Annette Michelson (University of California Press, 1984).

16. See Christiane Fricke, *'Dies alles Herzchen wird einmal Dir gehören.' Die Fernsehgalerie Gerry Schum 1968–1970 und die Produktionen der Videogalerie Schum 1970–1973* (Peter Lang, 1996), 99–104.

17. According to the artist, the texts add up to about three hours of audio material. Kwastek, *Ohne Schnur*, 203.

18. See Kwastek, *Ohne Schnur*, 210–219. The artist has also produced her own video documentation of the work (at http://www.terirueb.net).

19. Dante Alighieri, *The Divine Comedy* (early fourteenth century). For the English translation, the artist used the version published by Project Gutenberg at http://www.gutenberg.org.

20. Jean-Jacques Rousseau, *The Reveries of the Solitary Walker* (1782; Hackett, 1992), 66.

21. During the exhibition, this video was shown in the rooms of the Cuxhaven Art Society (i.e., spatially removed from the public space in which the project itself was presented).

22. See Hall, *The Dance of Life*, 16.

23. Dunne and Raby, *Design Noir*.

24. See Tromble, *The Art and Films of Lynn Hershman Leeson*, and the artist's website (http://www
.lynnhershman.com).

25. According to Sara Roberts' website, she was responsible for the design, programming, and
technical construction of the system, whereas Hershman developed the characters and the
scenarios. See "Sara Roberts—works in collaboration" at http://music.calarts.edu. Hershman's
website names Palle Henckel as responsible for "programming and fabrication." A preliminary,
prototypical version of the sculpture was exhibited at the Bonn Biennale in 1992; see Margaret
Morse, "Lynn Hershman's *Room of One's Own*," 1995, PDF version available on DVD in Tromble,
The Art and Films of Lynn Hershman Leeson, 11, note 5.

26. Details of Henckel's restoration can be found in his invoice ("Letter to the LehmbruckMu-
seum," October 5, 2005, LehmbruckMuseum archives). Palle Henckel also made a video in which
he describes the technical features of the installation. A copy of the video can be found in the
museum archives. Also see the sketch of the composition of the project on the archive pages of
the Prix Ars Electronica website: "Prix Ars Electronica 1993. Interactive Art. Honorary Mention.
Room of One's Own. Lynn Hershman" (at http://90.146.8.18/de).

27. The film sequences were originally played back from a laser disc and projected from below
onto a mirror functioning as the back wall of the room. As part of the restoration of the work
by Palle Henckel, a laptop computer was incorporated into the structure and the LCD screen of
the laptop computer now forms the back wall of the miniature room.

28. For a description of the work, see Tromble, *The Art and Films of Lynn Hershman Leeson*, 82–83.

29. Tromble, *The Art and Films of Lynn Hershman Leeson*, 82.

30. For a description, see Celeste Brusati, *Artifice and Illusion: The Art and Writing of Samuel van
Hoogstraten* (University of Chicago Press, 1995). According to Brusati (p. 169), six such *perspecty-
fkas* have survived. See also Susan Koslow, "De wonderlijke Perspectyfkas. An Aspect of Seven-
teenth Century Dutch Painting," *Oud Holland* 82 (1967): 35–56.

31. Brusati, *Artifice and Illusion*, 181. On the portrayal of voyeurs in Dutch painting, also see
Martha Hollander, *An Entrance for the Eyes: Space and Meaning in Seventeenth-Century Dutch Art*
(University of California Press, 2002), chapter 3.

32. In the original concept for this work, the artist planned to record the voice of the viewer:
"The audio instructs the viewer to repeat specific words. When the viewer speaks, parts of the
words are repeated in slightly modified form (echo). These words are strategically amplified from
different locations in the miniature bedroom, with the result that the viewer shifts his gaze
toward the place from where the words are coming." Lynn Hershman Leeson and Sara Roberts,
"*Room of One's Own*," 1992, in Hartwanger et al., *Künstliche Spiele*, 301. However, this idea was
not included in the final version of the work.

33. Author's interview with Lynn Hershman.

34. D'Harnoncourt and Hopps believe that the illusion is so complete that it is impossible for the viewer to penetrate the scene any further. Hershman, by contrast, consciously chose to use clear acrylic material in the back wall of the box so that the hardware would remain visible. Anne d'Harnoncourt and Walter Hopps, "Etant Donnés. 1. La chute d'eau, 2. Le gaz d'éclairage. Reflections on a New Work by Marcel Duchamp," *Philadelphia Museum of Art Bulletin* 64 (1969): 5–58, 8. For other allusions in art to peep- show technology, see Erkki Huhtamo, "Twin-Touch-Test-Redux: Media Archaeological Approach to Art, Interactivity, and Tactility," in Grau, *MediaArtHistories*, 82.

35. An earlier concept envisioned a construction that would allow the observer to see erotic scenes only if he did not focus directly on them. See Hershman and Roberts, *"Room of One's Own,"* 301. This concept was evidently modified for the shooting scene. A similar reversal of observation into self-observation is also staged by Hershman in *America's Finest*.

36. Tromble, *The Art and Films of Lynn Hershman Leeson*, 82.

37. Morse, "Lynn Hershman's *Room of One's Own*," 8.

38. Lynn Hershman Leeson, *"Room of One's Own*: Slightly Behind the Scenes," in Druckrey, *Iterations*, 151.

39. Initially, a sensor mat positioned on the floor just in front of the installation was used to ascertain whether or not there was an observer close to the box. In the 2005 restoration of the work, the sensor mat was replaced by infrared sensors in the box itself.

40. Söke Dinkla's detailed analysis on pages 189–195 of *Pioniere interaktiver Kunst* refers to an earlier version of the work.

41. Hershman, *"Room of One's Own,"* 151. On Hershman's artistic position, also see "Romancing the Anti-Body: Lust and Longing in (Cyber)space," in Lynn Hershman Leeson, *Clicking In: Hot Links to a Digital Culture* (Bay Press, 1996).

42. Crary, "Techniques of the Observer," 18.

43. Author's interview with Lynn Hershman.

44. The recipients communicated through a video-conference system. See Hans-Peter Schwarz, "Retroactive and Interactive Media Art: On the Works of Agnes Hegedüs," in *Agnes Hegedüs, Interactive Works* (Zentrum für Kunst und Medientechnologie Karlsruhe, 1995), 8.

45. Agnes Hegedüs, "The Fruit Machine," 1991, in Hartwanger et al., *Künstliche Spiele*, 294.

46. Agnes Hegedüs, "My Autobiographical Media History: Metaphors of Interaction, Communication, and Body Using Electronic Media," in *Women, Art, and Technology*, ed. Judy Malloy (MIT Press, 2003), 262.

47. Florian Rötzer, "Kunst Spiel Zeug. Einige unsystematische Anmerkungen," in Hartwanger et al., *Künstliche Spiele*, 18. Jean-Louis Boissier shares this view; see Boissier, *La Relation comme forme. L'Interactivité en art* (Mamco, 2004), 164f.

48. This is not to say that such disruptions cannot be present in commercially sold computer games. In fact, Ian Bogost coined the term "simulation fever" to describe the potential moments of reflection generated by computer games. Nonetheless, in commercial games, the feeling of agency usually predominates, while it is often deliberately thwarted in artistic projects. See Bogost, *Unit Operations*, 136.

49. Levin, "Painterly Interfaces."

50. Kwastek and Muller, *Interview with Golan Levin*, question 1.

51. Ibid., question 7.

52. Ibid., question 6.

53. Both Levin himself and one of the visitors who was interviewed expressed the idea of constructing an installation with three individual overhead projectors so that each mode could be experimented on one of the appliances. Kwastek and Muller, Interview with Golan Levin, question 4. At the same time, this visitor thought it was a "clever idea" the way the scenes changed by placing the numbers on the projector. Kwastek, Muller, and Spörl, *Video-Cued Recall with Helmut*.

54. See Katja Kwastek, Lizzie Muller, and Ingrid Spörl, Video-Cued Recall with Heidi, Linz, 2009 (at http://www.fondation-langlois.org); Kwastek, Muller, and Spörl, Video-Cued Recall with Helmut.

55. Kwastek, Muller, and Spörl, Video-Cued Recall with Helmut.

56. Ibid.

57. Ibid.

58. Kwastek, Muller, and Spörl, Video-Cued Recall with Heidi.

59. Katja Kwastek, Lizzie Muller, and Ingrid Spörl, Video-Cued Recall with Francisco, Linz, 2009 (at http://www.fondation-langlois.org).

60. Ibid.

61. Ibid.

62. Ibid.

63. Ibid.

64. Ibid.

65. Kwastek, Muller, and Spörl, Video-Cued Recall with Heidi.

66. Kwastek and Muller, Interview with Golan Levin, question 8.

67. Kwastek, Muller, and Spörl, Video-Cued Recall with Helmut.

68. This visitor went even further and proposed a symbolic interpretation of the three modes as a life cycle progressing from youth to adulthood to maturity. However, it was clear to him that

this interpretation was very associative: "Since the work is so abstract I would tend to think that he had a more instrumental purpose in mind, but it would be refreshing to imagine that he [the artist] was as interpretative as I am in his approach. [laughs]" Kwastek, Muller, and Spörl, *Video-Cued Recall with Francisco.*

69. Golan Levin and Zachary Lieberman, "Sounds from Shapes: Audiovisual Performance with Hand Silhouette Contours in 'The Manual Input Session,' " in *Proceedings of the 2005 Conference on New Interfaces for Musical Expression* (National University of Singapore, 2005), 115.

70. Levin and Lieberman, "Sounds from Shapes," 115.

71. Kwastek, Muller, and Spörl, Video-Cued Recall with Helmut.

72. Kwastek, Muller, and Spörl, Video-Cued Recall with Francisco.

73. Kwastek and Muller, Interview with Golan Levin, question 10.

74. Ibid., question 13.

75. Cf. "David Rokeby. *Very Nervous System* (since 1983). Documentary Collection" (at http://www.fondation-langlois.org). Also see Muller, "Collecting Experience."

76. This approach is at least partially a consequence of the particular situation created by the research project, because the presence of the video camera inevitably transformed the participants into performers. An exploration of space was certainly easier for them in these circumstances than a manifestation based on their own gestures, dance, or theatrics.

77. Katja Kwastek, Video-Cued Recall with Birgitt, Linz, 2009 (at http://www.fondation-langlois.org).

78. Muller and Jones, Interview with David Rokeby, question 6.

79. Ibid., question 7. Although Rokeby tried in previous manifestations of the work to spatially accommodate both passive observers and active recipients, he later abandoned this idea again. Ibid., question 6. However, at the Linz exhibition visitors could stand motionless beside the entrance to the room and observe others without engaging with the work themselves.

80. Muller and Jones, Interview with David Rokeby, question 5.

81. Ibid., question 8.

82. Sarah Milroy, "Where Tech Gives Way to the Exquisite," *Globe and Mail*, April 8, 2004 (at http://www.theglobeandmail.com).

83. A theremin is an electronic musical instrument that is played by varying the distance of the player's two hands from a pair of antennas. The hand movements affect the electromagnetic resonant circuits of the antennas.

84. Lizzie Muller, Video-Cued Recall with Markus, Linz, 2009 (at http://www.fondation-langlois.org).

85. David Rokeby, "The Harmonics of Interaction," *Musicworks 46: Sound and Movement*, spring 1990 (at http://www.davidrokeby.com).

86. Muller and Jones, Interview with David Rokeby, question 1.

87. Ibid., question 3.

88. Rokeby, "The Harmonics of Interaction."

89. Muller and Jones, Interview with David Rokeby, question 4.

90. Rokeby, "The Construction of Experience," 29–30.

91. Ibid., 31.

92. Ibid., 41.

93. Ibid., 35.

94. Muller and Jones, Interview with David Rokeby, question 5.

95. Lizzie Muller, Video-Cued Recall with Susanna, Linz, 2009 (at http://www.fondation-langlois .org); Lizzie Muller, Video-Cued Recall with Elfi, Linz, 2009 (at http://www.fondation-langlois.org).

96. Douglas Cooper, "Very Nervous System. Interview with David Rokeby," 1995, *Wired* 3.03 (at http://www.wired.com).

97. Rokeby, "The Construction of Experience," 42.

98. Philip Alperson, "The Instrumentality of Music," *Journal of Aesthetics and Art Criticism* 66 (1, 2008): 39.

99. Muller, Video-Cued Recall with Markus.

100. Kwastek, Video-Cued Recall with Birgitt.

101. Lizzie Muller, Interview with Alexander, Linz, 2009. Recording and transcript in the author's archives.

102. Lizzie Muller, Interview with Claudia, Linz, 2009. Recording and transcript in the author's archives.

103. Sonia Cillari, "Se Mi Sei Vicino. Interactive Performance," in *Die Welt als virtuelles Environment. Das Buch zur CYNETart_07encounter*, ed. Johannes Birringer, Thomas Dumke, and Klaus Nicolai (Trans-Media-Akademie Hellerau, 2007).

104. The construction of the work was supported by STEIM (Studio for Electro-Instrumental Music) and by the Rijksakademie van beeldende kunsten in Amsterdam.

105. Cf. Ingo Mörth and Cornelia Hochmayr, *Rezeption interaktiver Kunst. Endbericht des Forschungspraktikums aus Kultur & Mediensoziologie 2007/2008* (at http://www.kuwi.uni-linz.ac.at).

106. See, for example, the documentation of the work's presentation at the festival titled 5 Days Off, Netherlands Media Art Institute/Montevideo TBA, 2006. Further documentation is available on the artist's website.

107. Sonia Cillari, "Se Mi Sei Vicino" (at http://www.soniacillari.net).

108. The technical diagram can be viewed on the artist's website.

109. Sonia Cillari, e-mail message to author, February 2, 2009.

110. Ibid.

111. Sonia Cillari, "Performative Spaces and the Body as Interface" (at http://www.soniacillari.net).

112. Cillari, "Se Mi Sei Vicino" (at http://www.soniacillari.net).

113. Sebastian Führlinger, interview with Sonia Cillari, Linz, 2007. Recording and transcript in the author's archives.

114. Katja Kwastek, interview with Amel and Elisa Andessner, Linz, 2007. Recording and transcript in the author's archives.

115. Sonia Cillari, "The Body as Interface. Emotional Skin—Performance-Space Expression," in Birringer et al., eds., *Die Welt als virtuelles Environment*, 118.

116. Führlinger, interview with Sonia Cillari.

117. Ibid.

118. The documentary material was the basis of an archival project titled Riders Have Spoken, a collaboration between the Universities of Exeter and Nottingham and Blast Theory. See Blast Theory, "Riders Have Spoken" (at http://www.blasttheory.co.uk). Copies of the documentary material are preserved in the author's archives.

119. The transcripts of the texts were made available to the author by Matt Adams.

120. Kwastek, interview with Matt Adams, minute 50: "From the first second that they approach us we are looking to create a rich experience. . . . Our ability then to stage the experience and give them subtle cues is very strong."

121. This, at least, was my experience when I participated in the work. However, both the documentary video made by Blast Theory and a survey carried out during the presentation of the work in London show that other participants often adopted roles or invented fictitious incidents. See Alan Chamberlain and Steve Benford, *Deliverable D17.3. Cultural Console Game, Final Report (Integrated Project on Pervasive Gaming, FP6–004457)*, April 15, 2008 (at http://iperg.sics.se), 25.

122. Chamberlain and Benford, *Deliverable D17.3*.

123. In an interview, Matt Adams pointedly asked "Why would you tell this thing anything?" Kwastek, interview with Matt Adams, minute 25.

124. Ibid., minute 29.

125. Ibid., minute 26.

126. Gabriella Giannachi, interview with Christopher, Linz, 2009. Recording and transcript in the author's archives.

127. Gabriella Giannachi, interview with Heidi, Linz, 2009. Recording and transcript in the author's archives.

128. Katja Kwastek, interview with Jakob, Linz, 2009. Recording and transcript in the author's archives.

129. Böhme, *Atmosphäre*, 38.

130. A team of editors listened to all the recordings at the end of each day and then chose a selection. Matt Adams explains that there were certain overall patterns to the responses that enabled an editorial selection, but also emphasizes that it was evident that almost every single statement had significance for the person who recorded it. Kwastek, interview with Matt Adams, minute 35.

131. Ibid., minute 38.

132. Ibid., minute 31.

133. Ibid., minute 40.

134. See, for example, *[murmur]* (2003) and *Urban Tapestries* (2004).

135. Kwastek, interview with Matt Adams, end.

136. Ibid., minute 20.

137. Chamberlain and Benford, *Deliverable D. 17.3*, 24–25.

138. Kwastek, interview with Matt Adams, minutes 14–15.

139. Kwastek, interview with Jakob.

140. Giannachi, interview with Christopher.

141. Kwastek, interview with Matt Adams, minute 21.

142. A map and a telephone number to be used only in the event of emergencies can be found on the bicycle's carrier rack.

143. Chamberlain and Benford, *Deliverable D17.3*.

144. Although the artists originally wanted to use GPS technology, and WiFi fingerprinting was proposed by the collaborating media laboratory, they came to appreciate the technology as the project evolved, especially because it produced a gradually expanding map of the city. See Kwastek, interview with Matt Adams, minute 16.

145. For instance, one participant, a member of the local cycling club, recounted that she had looked for a certain road that had been recently re-laid, because she knew that the cycling there would be particularly good and fast. Kwastek, Interview with Bettina.

146. Like Muntadas' *File Room* or Brucker-Cohen's *BumpList*, in principle the work also offers an interesting aesthetic experience to the very first recipient, but it undoubtedly improves the more it is used.

147. Kwastek, interview with Matt Adams, minute 4.

148. Chamberlain and Benford compare the experience of the work to the catharsis of a psychotherapy session or the anonymity of a confession box. Chamberlain and Benford, *Deliverable D17.3*, 23.

Bibliography

Aarseth, Espen J. *Cybertext: Perspectives on Ergodic Literature*. Johns Hopkins University Press, 1997.

Aarseth, Espen J. "Genre Trouble: Narrativism and the Art of Simulation." In *First Person*, ed. N. Wardrip-Fruin and P. Harrigan. MIT Press, 2004.

Abels, Heinz. "Die Individuen in ihrer Gesellschaft." In Abels, *Einführung in die Soziologie*, volume 2. Verlag für Sozialwissenschaften, 2004.

Abrams, Joshua. "Ethics of the Witness: The Participatory Dances of Felix Ruckert." In *Audience Participation: Essays on Inclusion in Performance*, ed. S. Kattwinkel. Greenwood, 2003.

Agam, Yaacov. *Texts by the Artist*. Editions du Griffon, 1962.

Alperson, Philip. "The Instrumentality of Music." *Journal of Aesthetics and Art Criticism* 66 (2008), no. 1: 37–51.

Angerer, Marie-Luise. *Vom Begehren zum Affekt*. Diaphanes, 2007.

Armstrong, Keith. "Towards a Connective and Ecosophical New Media Art Practice." In *Intimate Transactions: Art, Exhibition and Interaction within Distributed Network Environments*, ed. J. Hamilton. ACID Press, 2006.

Arns, Inke. "Und es gibt sie doch. Über die Zeitgenossenschaft der medialen Künste." In *Hartware MedienKunstVerein 1996–2008*, ed. S. Ackers et al. Kettler, 2008.

Ascott, Roy. "The Art of Intelligent Systems." In *Der Prix Ars Electronica. Internationales Kompendium der Computerkünste*, ed. H. Leopoldseder. Veritas, 1991.

Ascott, Roy. "The Construction of Change" (1964). In Ascott, *Telematic Embrace*. University of California Press, 2003.

Ascott, Roy. "Behaviourist Art and the Cybernetic Vision" (1966–67). In Ascott, *Telematic Embrace*. University of California Press, 2003.

Ascott, Roy. *Telematic Embrace: Visionary Theories of Art, Technology, and Consciousness*, ed. E. Shanken. University of California Press, 2003.

Auslander, Philip. "Live from Cyberspace. Performance on the Internet." In *Mediale Performanzen. Historische Konzepte und Perspektiven*, ed. J. Eming, A. Jael Lehmann, and I. Maassen. Rombach, 2002.

Auslander, Philip. *Liveness: Performance in a Mediatized Culture*. Routledge, 2008.

Austin, John Langshaw. "Performative Utterances." (1956). In *Philosophical Papers*, ed. J. Urmson and G. Warnock. Clarendon, 1970.

Baldwin, James Mark. "Interaction." In *Dictionary of Philosophy and Psychology*, volume I. Macmillan, 1901.

Balme, Christopher B. *The Cambridge Introduction to Theatre Studies*. Cambridge University Press, 2008.

Barthes, Roland. "The Death of the Author." In *Image, Music, Text*, ed. Stephen Heath. Hill and Wang, 1977.

Bateson, Gregory. "A Theory of Play and Fantasy" (1955). In Bateson, *Steps to an Ecology of Mind*. University of Chicago Press, 2000.

Bätschmann, Oskar. "Der Künstler als Erfahrungsgestalter." In *Ästhetische Erfahrung heute*, ed. J. Stöhr. DuMont, 1996.

Baudry, Jean-Louis. "Ideological Effects of the Basic Cinematographic Apparatus." *Film Quarterly* 28 (1974–1975), no. 2: 39–47.

Baudry, Jean-Louis. "Das Dispositiv. Metapsychologische Betrachtungen des Realitätseindrucks" (1975). In *Der kinematographische Apparat*, ed. R. Riesinger. Nodus, 2003.

Bauman, Richard. "Performance." In *International Encyclopedia of Communications*, ed. E. Barnow. Oxford University Press, 1989.

Baumgärtel, Tilman. "Immaterialien. Aus der Vor- und Frühgeschichte der Netzkunst" (1997) (at http://www.heise.de).

Baumgärtel, Tilman. *net.art: Materialien zur Netzkunst*. Verlag für moderne Kunst, 1999.

Baumgärtel, Tilman. *net.art 2.0*. Verlag für moderne Kunst, 2001.

Bell, Stephen. Participatory Art and Computers. PhD thesis, Loughborough University, 1991 (at http://nccastaff.bournemouth.ac.uk).

Belting, Hans: *The Invisible Masterpiece*. Reaktion, 2001.

Belting, Hans. "Der Werkbegriff der künstlerischen Moderne." In *Das Jahrhundert der Avantgarden*, ed. C. Klinger and W. Müller-Funk. Fink, 2004.

Benjamin, Walter. "The Work of Art in the Age of Its Technological Reproducibility." In *Walter Benjamin: Selected Writings, Volume 4 (1938–1940)*, ed. M. Jennings. Harvard University Press, 2003.

Benthall, Jonathan. "Edward Ihnatowicz's Senster." *Studio International*, November 1971: 174.

Berkenheger, Susanne. "Die Schwimmmeisterin . . . oder 'Literatur im Netz ist eine Zumutung'" (2002) (at http://www.berkenheger.netzliteratur.net).

Berry, Josephine. "Convulsive Beauty Then and Now" (post to Nettime mailing list, August 23, 2001) (at http://www.nettime.org).

Birringer, Johannes, Thomas Dumke, and Klaus Nicolai, eds. *Die Welt als virtuelles Environment. Das Buch zur CYNETart_07encounter.* Trans-Media-Akademie Hellerau, 2007.

Bishop, Claire. "Antagonism and Relational Aesthetics." *October* 110 (2004), autumn: 51–79.

Bleyl, Matthias. "Der künstlerische Werkbegriff in der kunsthistorischen Forschung." In *L'art et les révolutions: XXVIIe Congrès International d'Histoire de l'Art, Strasbourg 1989*, volume 5. Société alsacienne pour le développement de l'histoire de l'art, 1992.

Blumer, Herbert. "Social Psychology." In *Man and Society: A Substantive Introduction to the Social Sciences*, ed. E. Schmidt. Prentice-Hall, 1937.

Blunck, Lars. *Between Object & Event: Partizipationskunst zwischen Mythos und Teilhabe.* VDG, 2003.

Blunck, Lars, ed. *Werke im Wandel? Zeitgenössische Kunst zwischen Werk und Wirkung.* Schreiber, 2005.

Blunck, Lars. "Luft anhalten und an Spinoza denken." In *Werke im Wandel?* ed. L. Blunck. Schreiber, 2005.

Bogost, Ian. *Unit Operations: An Approach to Videogame Criticism.* MIT Press, 2006.

Bohle, Ulrike, and Ekkehard König. "Zum Begriff des Performativen in der Sprachwissenschaft." *Paragrana* 10 (2001), no. 1: 13–34.

Böhme, Gernot. *Atmosphäre. Essays zur neuen Ästhetik.* Suhrkamp, 1995.

Boissier, Jean-Louis. *La Relation comme forme. L'Interactivité en art.* Mamco, 2004.

Bolter, Jay David, and Richard Grusin. *Remediation: Understanding New Media.* MIT Press, 1999.

Bolter, Jay David. *Writing Space: Computers, Hypertext, and the Remediation of Print.* Routledge, 2001.

Bonzon, Roman. "Aesthetic Objectivity and the Ideal Observer Theory." *British Journal of Aesthetics* 39 (1999): 230–240.

Bourriaud, Nicolas. *Relational Aesthetics.* Presses du Réel, 2002.

Braun, Reinhard. "Kunst zwischen Medien und Kunst." In *Kunst und ihre Diskurse. Österreichische Kunst in den 80er und 90er Jahren*, ed. C. Aigner and D. Hölzl. Passagen Verlag, 1999.

Brecht, Bertolt. "The Radio as an Apparatus of Communication" (1932). In *The Weimar Republic Sourcebook*, ed. A. Kaes, M. Jay, and E. Dimendberg. University of California Press, 1994.

Brecht, George. *Chance-Imagery.* Something Else, 1966.

Brüninghaus-Knubel, Cornelia, ed. *Spielräume*. Wilhelm Lehmbruck Museum, 2005.

Brusati, Celeste. *Artifice and Illusion: The Art and Writing of Samuel van Hoogstraten*. University of Chicago Press, 1995.

Bullivant, Lucy. *Responsive Environments: Architecture, Art and Design*. V&A, 2006.

Bürger, Peter. *Theory of the Avant-Garde*. University of Minnesota Press, 1984.

Burnham, Jack. *Beyond Modern Sculpture*. Braziller, 1968.

Burnham, Jack. "Systems Esthetics." *Artforum* 7 (1968), September: 31–35.

Burnham, Jack. "The Aesthetics of Intelligent Systems." In *On the Future of Art*, ed. E. Fry. Viking, 1970.

Burnham, Jack, ed. *Software: Information Technology: Its New Meaning for Art*. Jewish Museum, 1970.

Burnham, Jack. "Art and Technology: The Panacea that Failed." In *The Myth of Information: Technology and Postindustrial Culture*, ed. K. Woodward. Routledge, 1980.

Büscher, Barbara. "Live Electronic Arts und Intermedia." Habilitation treatise, University of Leipzig, 2002 (at http://www.qucosa.de).

Butler, Judith. "Performative Acts and Gender Constitution. An Essay in Phenomenology and Feminist Theory." *Theatre Journal* 40 (1988), no. 4: 519–531.

Buytendijk, Frederik J. J. *Wesen und Sinn des Spiels. Das Spielen des Menschen und der Tiere als Erscheinungsform der Lebenstriebe*. Kurt Wolff Verlag, 1933.

Cage, John. "45' for a speaker" (1954). In Cage, *Silence: Lectures and Writings*. Wesleyan University Press, 1961.

Caillois, Roger. *Man, Play, and Games* (1961). Free Press, 2001.

Cameron, Andy. "Dinner with Myron. Or: Rereading Artificial Reality 2: Reflections on Interface and Art." In *aRt & D: Research and Development in Art*, ed. J. Brower et al. V2_NAi, 2005.

Candy, Linda, and Ernest Edmonds. "Interaction in Art and Technology." *Crossings* 2 (2002), no. 1 (at http://crossings.tcd.ie).

Caramel, Luciano, ed. *Groupe de Recherche d'Art Visuel 1960–1968*. Electa, 1975.

Carlson, Marvin. *Performance: A Critical Introduction*. Routledge, 2004.

Castells, Manuel. *The Rise of the Network Society*. Wiley, 1996.

Chamberlain, Alan, and Steve Benford. *Deliverable D17.3. Cultural Console Game, Final Report* (2008) (at http://iperg.sics.se).

Cillari, Sonia. "Se Mi Sei Vicino. Interactive Performance." In *Die Welt als virtuelles Environment*, ed. J. Birringer, T. Dumke, and K. Nicolai. Trans-Media-Akademie Hellerau, 2007.

Cillari, Sonia. "The Body as Interface. Emotional Skin—Performance-Space Expression." In *Die Welt als virtuelles Environment*, ed. J. Birringer, T. Dumke, and K. Nicolai. Trans-Media-Akademie Hellerau, 2007.

Clark, Timothy J. *The Sight of Death: An Experiment in Art Writing*. Yale University Press, 2006.

Clay, Jean. "Painting: A Thing of the Past." *Studio International*, July-August 1967: 12.

Cleland, Kathy. "Talk to Me: Getting Personal with Interactive Art." In *Conference Proceedings: Interaction: Systems, Practice and Theory*, ed. E. Edmonds and R. Gibson. University of Technology, 2004.

Cleland, Kathy. "Media Mirrors and Image Avatars." In *Engage: Interaction, Art and Audience Experience*, ed. E. Edmonds et al. Creativity and Cognition Studios Press, 2006.

Cline, Mychilo Stephenson. *Power, Madness, and Immortality: The Future of Virtual Reality*. University Village Press, 2005.

Coleridge, Samuel Taylor. *Biographia Literaria. Or Biographical Sketches of my Literary Life and Opinions*. Leavitt, 1834.

Conquergood, Dwight. "Performing as a Moral Act: Ethical Dimensions of the Ethnography of Performance." *Literature in Performance* 5 (1985): 1–13.

Cook, Sarah et. al., eds. *A Brief History of Curating New Media Art: Conversations with Curators*. The Green Box, 2010.

Cornock, Stroud, and Ernest Edmonds. "The Creative Process Where the Artist Is Amplified or Superseded by the Computer." *Leonardo* 11 (1973), no. 6: 11–16.

Cornwell, Regina. "From the Analytical Engine to Lady Ada's Art." In *Iterations*, ed. T. Druckrey. International Center of Photography and MIT Press, 1993.

Couchot, Edmond. "Die Spiele des Realen und des Virtuellen." In *Digitaler Schein*, ed. F. Rötzer. Suhrkamp, 1991.

Couchot, Edmond. "The Automatization of Figurative Techniques: Toward the Autonomous Image." In *MediaArtHistories*, ed. O. Grau. MIT Press, 2007.

Couldry, Nick. "Liveness, 'Reality,' and the Mediated Habitus from Television to the Mobile Phone." *Communication Review* 7 (2004): 353–361.

Couldry, Nick. "Actor Network Theory and Media: Do They Connect and On What Terms?" In *Connectivity, Networks and Flows: Conceptualizing Contemporary Communications*, ed. A. Hepp et al. Hampton, 2008.

Cramer, Florian. *Exe.cut(up)able statements. Poetische Kalküle und Phantasmen des selbstausführenden Texts*. Fink, 2010.

Crary, Jonathan. *Techniques of the Observer: On Vision and Modernity in the Nineteenth Century*. MIT Press, 1992.

Crawford, Chris. "Process Intensity." *Journal of Computer Game Design* 1 (1987), no. 5 (at http://www.erasmatazz.com).

Csíkszentmihályi, Mihály. *Beyond Boredom and Anxiety: Experiencing Flow in Work and Play*. Jossey-Bass, 1975.

Curtis, Robin. "Immersion und Einfühlung: Zwischen Repräsentionalität und Materialität bewegter Bilder." *montage AV* 17 (2008), February: 89–107.

Daniels, Dieter. "The Art of Communication. From Mail-Art to E-Mail" (1994) (at http://www.medienkunstnetz.de).

Daniels, Dieter. "Strategies of Interactivity." In *The Art and Science of Interface and Interaction Design*, volume 1, ed. C. Sommerer, L. Jain, and L. Mignonneau. Springer, 2008.

Daniels, Dieter. "Reverse Engineering Modernism with the Last Avant-Garde." In *Netpioneers 1.0*, ed. D. Daniels and G. Reisinger. Sternberg, 2009.

Daniels, Dieter. "John Cage und Nam June Paik: 'Change your mind or change your receiver (your receiver is your mind).'" In *Nam June Paik*, ed. S.-K. Lee and S. Rennert. Hatje Cantz, 2010.

Daniels, Dieter. "Was war die Medienkunst? Ein Resumé und ein Ausblick." In *Was waren Medien?* ed. C. Pias. Diaphanes, 2010.

Daniels, Dieter, and Gunther Reisinger, eds. *Netpioneers 1.0: Contextualizing Early Net-Based Art*. Sternberg, 2009.

Daniels, Dieter, and Barbara U. Schmidt, eds. *Artists as Inventors and Inventors as Artists*. Hatje Cantz, 2008.

Danto, Arthur C. *The Transfiguration of the Commonplace: A Philosophy of Art*. Harvard University Press, 1981.

De Certeau, Michel. *The Practice of Everyday Life*. University of California Press, 1984.

Decker, Edith. *Paik Video*. DuMont, 1988.

Decker, Edith, and Peter Weibel, eds. *Vom Verschwinden der Ferne. Telekommunikation und Kunst*. DuMont, 1990.

De Kerckhove, Derrick. "Touch versus Vision: Ästhetik neuer Technologien." In *Die Aktualität des Ästhetischen*, ed. W. Welsch. Fink, 1993.

DeLahunta, Scott et. al. "Rearview Mirror: 1990–2004." In *Cyberarts 2004, International Compendium Prix Ars Electronica*, ed. H. Leopoldseder, C. Schöpf, and G. Stocker. Hatje Cantz, 2004.

Deleuze, Gilles. *Cinema 1: The Movement Image*. Continuum, 2005.

Demers, Louis-Philippe, and Bill Vorn. *Es, das Wesen der Maschine*. European Media Art Festival, 2003.

Depocas, Alain, Jon Ippolito, and Caitlin Jones, eds. *Permanence through Change: The Variable Media Approach*. Guggenheim Museum, 2003.

Dewey, John. *Art as Experience*. Penguin, 1934.

D'Harnoncourt, Anne, and Walter Hopps. "Etant Donnés. 1. La chute d'eau, 2. Le gaz d'éclairage. Reflections on a New Work by Marcel Duchamp." *Philadelphia Museum of Art Bulletin* 64 (1969): 5–58.

Diez del Corral, Ana Botella. *Feedback: Art Responsive to Instructions, Input, or its Environment*. LABoral Centro de Arte y Creación Industrial, 2007.

Dimitrov, Isaac. Final Report, Erl-King Project (2004) (at http://www.variablemedia.net).

Dinkla, Söke. *Pioniere interaktiver Kunst von 1970 bis heute: Myron Krueger, Jeffrey Shaw, David Rokeby, Lynn Hershman, Grahame Weinbren, Ken Feingold*. Hatje Cantz, 1997.

Dittmann, Lorenz. "Der Begriff des Kunstwerks in der deutschen Kunstgeschichte." In *Kategorien und Methoden der deutschen Kunstgeschichte 1900–1930*. Franz Steiner, 1985.

Dittmer, Peter. "SCHALTEN UND WALTEN [Die Amme]. Gespräche mit einem milchverschüttenden Computer seit 1992" (at http://home.snafu.de).

Dixon, Steve. "The Digital Double." In Dixon, *Digital Performance: A History of New Media in Theatre, Dance, Performance Art, and Installation*. MIT Press, 2007.

Dourish, Paul. *Where the Action Is: The Foundation of Embodied Interaction*. MIT Press, 2001.

Dreher, Thomas. *Performance Art nach 1945. Aktionstheater und Intermedia*. Fink, 2001.

Dröge Wendel, Yvonne, et al., ed. *An Architecture of Interaction*. Mondrian Foundation, 2007.

Druckrey, Timothy, ed. *Iterations: The New Image*. International Center of Photography and MIT Press, 1993.

Duguet, Anne-Marie, Heinrich Klotz, and Peter Weibel. *Jeffrey Shaw—A User's Manual*. Hatje Cantz, 1997.

Dunne, Anthony, and Fiona Raby. *Design Noir: The Secret Life of Electronic Objects*. Birkhäuser, 2001.

Dunne, Anthony. *Hertzian Tales: Electronic Products, Aesthetic Experience and Critical Design*. MIT Press, 2005.

Eco, Umberto. "Che cosa ha fatto Mari per la Biennale die San Marino" (1967). In Arturo Carlo Quintavalle, *Enzo Mari*. Università di Parma, 1983.

Eco, Umberto. *The Open Work*. Harvard University Press, 1989.

Edmonds, Ernest, Lizzie Muller, and Deborah Turnbull, eds. *Engage: Interaction, Art and Audience Experience*. Creativity and Cognition Press, 2006.

Engelbart, Douglas C. *Augmenting Human Intellect: A Conceptual Framework*. SRI Summary Report AFOSR-3223 (1962) (at http://www.dougengelbart.org/pubs/augment-3906.html).

Evens, Aden. *Sound Ideas: Music, Machines, and Experience*. University of Minnesota Press, 2005.

Fauconnier, Sandra, and Rens Frommé. "Capturing Unstable Media, Summary of Research" (2003) (at http://www.v2.nl).

Feingold, Ken. "OU. Interactivity as Divination as Vending Machine." *Leonardo* 28 (1995), no. 1: 399–402.

Ferrier, Jean-Louis. *Gespräche mit Victor Vasarely*. Galerie der Spiegel, 1971.

Fischer, Alfred M., ed. *George Brecht: Events*. König, 2005.

Fischer-Lichte, Erika. *Ästhetische Erfahrung. Das Semiotische und das Performative*. Francke, 2001.

Fischer-Lichte, Erika, et. al., eds. *Auf der Schwelle. Kunst, Risiken und Nebenwirkungen*. Fink, 2006.

Fischer-Lichte, Erika. "Der Zuschauer als Akteur." In *Auf der Schwelle*, ed. E. Fischer-Lichte et al. Fink, 2006.

Fischer-Lichte, Erika. *The Transformative Power of Performance: A New Aesthetics*. Routledge, 2008.

Flusser, Vilém. "Gesellschaftsspiele." *Kunstforum International* 116: *Künstlergruppen* (1991): 66–69.

Flusser, Vilém. *Towards a Philosophy of Photography*. Reaktion Books, 2000.

Forest, Fred. "Die Ästhetik der Kommunikation. Thematisierung der Raum-Zeit oder der Kommunikation als einer Schönen Kunst." In *Digitaler Schein*, ed. F. Rötzer. Suhrkamp, 1991.

Franz, Erich. "Die zweite Revolution der Moderne." In *Das offene Bild. Aspekte der Moderne in Europa nach 1945*. Westfälisches Landesmuseum, 1992.

Frasca, Gonzalo. "Videogames of the Oppressed. Critical Thinking, Education, Tolerance and other Trivial Issues." In *First Person*, ed. N. Wardrip-Fruin and P. Harrigan. MIT Press, 2004.

Fricke, Christiane. *'Dies alles Herzchen wird einmal Dir gehören.' Die Fernsehgalerie Gerry Schum 1968–1970 und die Produktionen der Videogalerie Schum 1970–1973*. Peter Lang, 1996.

Fried, Michael. "Art and Objecthood." *Artforum* 5 (1967): 12–23.

Frohne, Ursula. " 'Screen Tests': Media Narcissism, Theatricality, and the Internalized Observer." In *CTRL[Space]*, ed. T. Levin, U. Frohne, and P. Weibel. MIT Press, 2002.

Fujihata, Masaki. "Notes on Small Fish" (2000) (at http://hosting.zkm.de).

Gadamer, Hans-Georg. *Truth and Method*. Continuum, 2004.

Galloway, Alexander R. *Gaming: Essays on Algorithmic Culture*. University of Minnesota Press, 2006.

Gaßner, Hubertus, and Stephanie Rosenthal, eds. *Dinge in der Kunst des 20. Jahrhunderts*. Steidl, 2000.

Gendolla, Peter, Norbert Schmitz, Irmela Schneider, and Peter Spangenberg, eds. *Formen interaktiver Medienkunst: Geschichte, Tendenzen, Utopien*. Suhrkamp, 2001.

Genette, Gérard. *The Work of Art: Immanence and Transcendence*. Cornell University Press, 1997.

Gere, Charlie. *Art, Time and Technology*. Berg, 2006.

Giannachi, Gabriella, and Nick Kaye, eds. *Performing Presence: From the Live to the Simulated*. Manchester University Press, 2001.

Gidney, Eric. " The Artist's Use of Telecommunications." In *Art Telecommunication*, ed. H. Grundmann. Self-published, 1984.

Gillette, Frank. "Masque in Real Time." In *Video Art: An Anthology*, ed. I. Schneider and B. Korot. Harcourt Brace Jovanovich, 1976.

Goertz, Lutz. "Wie interaktiv sind Medien?" (1995). In *Interaktivität. Ein transdisziplinärer Schlüsselbegriff*, ed. C. Bieber and C. Leggewie. Campus, 2004.

Goffman, Erving. *The Presentation of Self in Everyday Life*. Doubleday, 1959.

Goffman, Erving. *Frame Analysis: An Essay on the Organization of Experience*. Harper and Row, 1974.

Goldberg, Ken. "The Unique Phenomenon of a Distance." In *The Robot in the Garden: Telerobotics and Telepistomology in the Age of the Internet*. MIT Press, 2000.

Goldberg, Roselee. *Performance Art from Futurism to the Present*. Harry N. Abrams, 1988.

Golinski, Hans Günter, Sepp Hiekisch-Picard, and Christoph Kivelitz, eds. *Und es bewegt sich doch. Von Alexander Calder und Jean Tinguely bis zur zeitgenössischen "mobilen Kunst."* Museum Bochum, 2006.

Goodman, Nelson. *Languages of Art: An Approach to a Theory of Symbols*. Hackett, 1976.

Goodman, Nelson. *Ways of Worldmaking*. Hackett, 1978.

Graham, Beryl. A Study of Audience Relationships with Interactive Computer-Based Visual Artworks in Gallery Settings, through Observation, Art Practice, and Curation. PhD thesis, University of Sunderland, 1997 (at http://www.sunderland.ac.uk).

Graham, Beryl, and Sarah Cook. *Rethinking Curating*. MIT Press, 2010.

Graham, Dan. "Rock My Religion" (1986). In *Dan Graham. Ausgewählte Schriften*, ed. U. Wilmes. Oktagon, 1994.

Grau, Oliver. *Virtual Art: From Illusion to Immersion*. MIT Press, 2003.

Grau, Oliver, ed. *MediaArtHistories*. MIT Press, 2007.

Graulich, Gerhard. *Die leibliche Selbsterfahrung des Rezipienten—ein Thema transmodernen Kunstwollens*. Die blaue Eule, 1989.

Gronau, Barbara. "Mambo auf der Vierten Wand. Sitzstreiks, Liebeserklärungen und andere Krisenszenarien." In *Auf der Schwelle*, ed. E. Fischer-Lichte et al. Fink, 2006.

Groos, Karl. *Das Spiel. Zwei Vorträge.* Fischer, 1922.

Gsöllpointner, Katharina, and Ursula Hentschläger. *Paramour: Kunst im Kontext neuer Technologien.* Triton, 1999.

Hall, Edward T. *The Dance of Life: The Other Dimension of Time.* Anchor Books, 1983.

Hamker, Anne. "Dimensionen der Reflexion. Skizze einer kognitivistischen Rezeptionsästhetik." *Zeitschrift für Ästhetik und Allgemeine Kunstwissenschaft* 45 (2000), no. 1: 25–47.

Hamker, Anne. *Emotion und ästhetische Erfahrung. Zur Rezeptionsästhetik der Video-Installationen Buried Secrets von Bill Viola.* Waxmann, 2003.

Hansen, Mark B. N. *New Philosophy for New Media.* MIT Press, 2004.

Hansen, Mark B. N. *Bodies in Code: Interfaces with Digital Media.* Routledge, 2006.

Hartwanger, Georg, Stefan Ilghaut, and Florian Rötzer, eds. *Künstliche Spiele.* Boer, 1993.

Hartware MedienKunstVerein and Tilman Baumgärtel, eds. *Games. Computerspiele von Künstlerinnen.* Revolver, 2003.

Hayles, N. Katherine. *How We Became Posthuman: Virtual Bodies in Cybernetics, Literature, and Informatics.* University of Chicago Press, 1999.

Hegedüs, Agnes. "The Fruit Machine" (1991). In *Künstliche Spiele*, ed. G. Hartwanger et al. Boer, 1993.

Hegedüs, Agnes. "My Autobiographical Media History: Metaphors of Interaction, Communication, and Body Using Electronic Media." In *Women, Art, and Technology*, ed. J. Malloy. MIT Press, 2003.

Heidenreich, Stefan. "Medienkunst gibt es nicht." *Frankfurter Allgemeine Sonntagszeitung*, January 1, 2008.

Hemment, Drew. "Locative Arts." *Leonardo* 39 (2006), no. 4: 348–355.

Hershman Leeson, Lynn. "Immer noch mehr Alternativen." In *Künstliche Spiele*, ed. G. Hartwanger et al. Boer, 1993.

Hershman Leeson, Lynn. "Room of One's Own: Slightly Behind the Scenes." In *Iterations*, ed. T. Druckrey. International Center of Photography and MIT Press, 1993.

Hershman Leeson, Lynn. "Romancing the Anti-Body. Lust and Longing in (Cyber)space." In *Clicking In: Hot Links to a Digital Culture.* Bay, 1996.

Hershman Leeson, Lynn, and Sara Roberts. "Room of One's Own" (1992). In *Künstliche Spiele*, ed. G. Hartwanger et al. Boer, 1993.

Hohlfeldt, Marion. *Grenzwechsel: Das Verhältnis von Kunst und Spiel im Hinblick auf den veränderten Kunstbegriff in der zweiten Hälfte des zwanzigsten Jahrhunderts mit einer Fallstudie: Groupe de Recherche d'Art Visuel.* VDG, 1999.

Hollander, Martha. *An Entrance for the Eyes: Space and Meaning in Seventeenth-Century Dutch Art.* University of California Press, 2002.

Huber, Hans Dieter. "Materialität und Immaterialität der Netzkunst." *Kritische Berichte* 1 (1998): 39–53.

Huber, Hans Dieter. "Der Traum vom Interaktiven Kunstwerk" (2006) (at http://www.hgb-leipzig .de).

Huhtamo, Erkki. "Seeking Deeper Contact. Interactive Art as Metacommentary." *Convergence* 1 (1995), no. 2: 81–104.

Huhtamo, Erkki. "Twin-Touch-Test-Redux: Media Archaeological Approach to Art, Interactivity, and Tactility." In *MediaArtHistories*, ed. O. Grau. MIT Press, 2007.

Huhtamo, Erkki. *Illusions in Motion: A Media Archaeology of the Moving Panorama and Related Spectacles.* MIT Press, 2013.

Huizinga, Johan. *Homo Ludens: A Study of the Play-Element in Culture.* Routledge, 1949.

Hultén, Pontus, ed. *The Machine as Seen at the End of the Mechanical Age.* Museum of Modern Art, 1968.

Hünnekens, Annette. *Der bewegte Betrachter. Theorien der interaktiven Medienkunst.* Wienand, 1997.

IFLA Study Group for the Functional Requirements for Bibliographical Records: Functional Requirements for Bibliographical Records, 1997 (at http://www.ifla.org).

Iser, Wolfgang. *The Act of Reading: A Theory of Aesthetic Response.* Routledge, 1978.

Jacobs, Mary Jane, ed. *Culture in Action: A Public Art Program of Sculpture Chicago.* Bay, 1995.

Janecke, Christian. *Kunst und Zufall. Analyse und Bedeutung.* Verlag für moderne Kunst, 1995.

Janko, Siegbert, Hannes Leopoldseder, and Gerfried Stocker, eds. *Ars Electronica Center, Museum of the Future.* Ars Electronica Center, 1996.

Jannides, Fotis. "Autor und Interpretation." In *Texte zur Theorie der Autorschaft*, ed. F. Jannides et al. Reclam, 2000.

Jauß, Hans Robert. *Aesthetic Experience and Literary Hermeneutics.* University of Minnesota Press, 1982.

Jensen, Jens F. "Interactivity: Tracking a New Concept in Media and Communication Studies." In *Computer Media and Communication*, ed. P. Mayer. Oxford University Press, 1999.

Jordan, Ken. "Die Büchse der Pandora." In *Kursbuch Internet: Anschlüsse an Wirtschaft und Politik, Wissenschaft und Kultur*, ed. S. Bollmann. Bollmann, 1996.

Juul, Jesper. *Half-Real: Video Games between Real Rules and Fictional Worlds.* MIT Press, 2005.

Kabakov, Ilya. *On the "Total" Installation.* Hatje Cantz, 1995.

Kacunko, Slavko. *Closed Circuit Videoinstallationen. Ein Leitfaden zur Geschichte und Theorie der Medienkunst mit Bausteinen eines Künstlerlexikons*. Logos, 2004.

Kaprow, Allan. "The Legacy of Jackson Pollock" (1958). In Kaprow, *Essays on the Blurring of Art and Life*. University of California Press, 2003.

Kaprow, Allan. "Notes on the Creation of a Total Art" (1958). In Kaprow, *Essays on the Blurring of Art and Life*. University of California Press, 2003.

Kaprow, Allan. "Happenings in the New York Scene" (1961). In Kaprow, *Essays on the Blurring of Art and Life*. University of California Press, 2003.

Kaprow, Allan. "A Statement." In *Happenings: An Illustrated Anthology*, ed. M. Kirby. Dutton, 1965.

Kaprow, Allan. "The Happenings Are Dead: Long Live the Happenings" (1966). In Kaprow, *Essays on the Blurring of Art and Life*. University of California Press, 2003.

Kaprow, Allan. "Video Art: Old Wine, New Bottle" (1974). In Kaprow, *Essays on the Blurring of Art and Life*. University of California Press, 2003.

Kaprow, Allan. *Essays on the Blurring of Art and Life*, ed. J. Kelley. University of California Press, 2003.

Kelley, Jeff. *Childsplay: The Art of Allan Kaprow*. University of California Press, 2004.

Kemény, Alfred, and László Moholy-Nagy. "Dynamisch-konstruktives Kraftsystem." *Der Sturm* 13 (1922), no. 12: 186.

Kemp, Wolfgang. *Der Anteil des Betrachters. Rezeptionsästhetische Studien zur Malerei des 19. Jahrhunderts*. Maander, 1983.

Kemp, Wolfgang. "Verständlichkeit und Spannung. Über Leerstellen in der Malerei des 19. Jahrhunderts." In *Der Betrachter ist im Bild. Kunstwissenschaft und Rezeptionsästhetik*. Reimer, 1992.

Kemp, Wolfgang. "Zeitgenössische Kunst und ihre Betrachter. Positionen und Positionszuschreibungen." In *Zeitgenössische Kunst und ihre Betrachter, Jahresring 43*. Oktagon, 1996.

Kester, Grant H. *Conversation Pieces: Community—Communication in Modern Art*. University of California Press, 2004.

Kirby, Michael. *Happenings: An Illustrated Anthology*. Dutton, 1965.

Kittler, Friedrich. "Real Time Analysis, Time Axis Manipulation" (1990). In *Draculas Vermächtnis. Technische Schriften*. Reclam, 1993.

Klotz, Heinrich. *Eine neue Hochschule (für neue Künste)*. Hatje Cantz, 1995.

Klotz, Heinrich. "Der Aufbau des Zentrums für Kunst und Medientechnologie in Karlsruhe. Ein Gespräch mit Lerke von Saalfeld." In Klotz, *Eine neue Hochschule (für neue Künste)*. Hatje Cantz, 1995.

Klotz, Heinrich. "Medienkunst als Zweite Moderne" (1994). In Klotz, *Eine neue Hochschule (für neue Künste)*. Hatje Cantz, 1995.

Kluszczyński, Ryszard W. "Audiovisual Culture in the Face of the Interactive Challenge." In *WRO 95 Media Art Festival*, ed. P. Krajewski. Open Studio, 1995.

Kluszczyński, Ryszard W. "From Film to Interactive Art: Transformations in Media Arts." In *MediaArtHistories*, ed. O. Grau. MIT Press, 2007.

Kluszczyński, Ryszard W. "Strategies of Interactive Art." *Journal of Aesthetics & Culture* 2 (2010) (at http://journals.sfu.ca).

Klütsch, Christoph. *Computergrafik. Ästhetische Experimente zwischen zwei Kulturen. Die Anfänge der Computerkunst in den 1960er Jahren*. Springer, 2007.

Knorr Cetina, Karin. "Das naturwissenschaftliche Labor als Ort der 'Verdichtung von Gesellschaft.' " *Zeitschrift für Soziologie* 17 (1988): 85–101.

Koslow, Susan. "De wonderlijke Perspectyfkas. An Aspect of Seventeenth Century Dutch Painting." *Oud Holland* 82 (1967): 35–56.

Kostelanetz, Richard. "Conversations: Allan Kaprow." In Kostelanetz, *The Theatre of Mixed Means: An Introduction to Happenings, Kinetic Environments and Other Mixed-Means Performances*. Pittman, 1970.

Krämer, Sybille. "Das Medium als Spur und Apparat." In *Medien, Computer, Realität: Wirklichkeitsvorstellungen und neue Medien*. Suhrkamp, 1998.

Krämer, Sybille. "Spielerische Interaktion. Überlegungen zu unserem Umgang mit Instrumenten." In *Schöne neue Welten? Auf dem Weg zu einer neuen Spielkultur*, ed. F. Rötzer. Boer, 1995.

Krämer, Sybille. "Was haben 'Performativität' und 'Medialität' miteinander zu tun? Plädoyer für eine in der 'Aisthetisierung' gründende Konzeption des Performativen." In *Performativität und Medialität*, ed. S. Krämer. Fink, 2004.

Krämer, Sybille, and Marco Stahlhut. "Das 'Performative' als Thema der Sprach- und Kulturphilosophie." *Paragrana* 10 (2001), no. 1: 35–64.

Krauss, Rosalind. "Video: The Aesthetics of Narcissism" (1976). In *New Artists Video: A Critical Anthology*, ed. G. Battock. Dutton, 1978.

Krauss, Rosalind. "Sculpture in the Expanded Field." *October* 8 (1979): 30–44.

Krauss, Rosalind. *A Voyage on the North Sea: Art in the Age of the Post-Medium Condition*. Thames & Hudson, 2000.

Kravagna, Christian. "Arbeit an der Gemeinschaft. Modelle partizipatorischer Praxis." In *Die Kunst des Öffentlichen. Projekte, Ideen, Stadtplanungsprozesse im politischen, sozialen, öffentlichen Raum*, ed. M. Babias and A. Könneke. Verlag der Kunst, 1998. (English version at http://republicart.net.).

Krueger, Myron. *Artificial Reality II*. Addison-Wesley, 1991.

Krüger, Klaus. *Das Bild als Schleier des Unsichtbaren. Ästhetische Illusion in der Kunst der frühen Neuzeit*. Fink, 2001.

Kunst, Bojana. "Wireless Connections: Attraction, Emotion, Politics." In *Ohne Schnur: Art and Wireless Communication*, ed. K. Kwastek. Revolver, 2004.

Kunsthalle Düsseldorf. *Nicolas Schöffer. Kinetische Plastik. Licht. Raum.* Exhibition catalog. 1968.

Kusahara, Machiko. "Device Art. A New Approach in Understanding Japanese Contemporary Media Art." In *MediaArtHistories*, ed. O. Grau. MIT Press, 2007.

Kwastek, Katja, ed. *Ohne Schnur: Art and Wireless Communication*. Revolver, 2004.

Kwastek, Katja. "Opus ludens. Überlegungen zur Ästhetik der interaktiven Kunst." In *Werke im Wandel?* ed. L. Blunck. Schreiber, 2005.

Kwastek, Katja. "Art without Time and Space? Radio in the Visual Arts of the Twentieth and Twenty-First Centuries." In *Re-inventing Radio*, ed. H. Grundmann and E. Zimmerman. Revolver, 2008.

Kwastek, Katja. "The Invention of Interactivity." In *Artists as Inventors and Inventors as Artists*, ed. D. Daniels and B. Schmidt. Hatje Cantz, 2008.

Kwastek, Katja. "Geo-Poetry: The Locative Art of Stefan Schemat and Teri Rueb." In *Literary Art in Digital Performance: Case Studies in New Media Art and Criticism*, ed. F. Ricardo. Continuum, 2009.

Kwastek, Katja. "'Your Number Is 96—Please Be Patient. Modes of Liveness and Presence Investigated through the Lens of Interactive Artworks." In *Re: live: Media Art Histories 2009*, ed. S. Cubitt, and P. Thomas. University of Melbourne, 2009.

Kwon, Miwon. *One Place after Another: Site-Specific Art and Locational Identity*. MIT Press, 2004.

Lacy, Suzanne. *Mapping the Terrain: New Genre Public Art*. Bay, 1995.

Landow, George P. *Hypertext 3.0: Critical Theory and New Media in an Era of Globalization*. Johns Hopkins University Press, 2006.

Lange, Barbara. "Soziale Plastik." In *DuMonts Begriffslexikon zur zeitgenössischen Kunst*, ed. H. Butin. DuMont, 2002.

Latour, Bruno. *Reassembling the Social: An Introduction to Actor-Network-Theory*. Oxford University Press, 2005.

Laurel, Brenda. *Computers as Theatre*. Addison-Wesley, 1993.

Lazarus, Moritz. *Über die Reize des Spiels*. Dümmler, 1883.

Lessing, Gotthold Ephraim. *Laocoon: An Essay upon the Limits of Painting and Poetry*. Roberts Brothers, 1887.

Levin, Golan. Painterly Interfaces for Audiovisual Performances. MS thesis, MIT Media Laboratory, 2000 (at http://www.flong.com).

Levin, Golan, and Zachary Lieberman. "Sounds from Shapes: Audiovisual Performance with Hand Silhouette Contours in 'The Manual Input Session.'" In *Proceedings of the 2005 Conference on New Interfaces for Musical Expression*. National University of Singapore, 2005.

Licklider, J. C. R. "Man-Computer Symbiosis." *IRE Transactions on Human Factors in Electronics* HFE-1 (1960): 4–11.

Ligier, Maude. *Nicolas Schöffer*. Presses du Réel, 2004.

Ligier, Maude. "Nicolas Schöffer, un artiste face a la technique." *Cahier de recit* 4 (2006): 43–65.

Lippard, Lucy. *Changing: Essays in Art Criticism*. Dutton, 1971.

Lippard, Lucy. *Six Years: The Dematerialization of the Art Object*. Henry Holt, 1973.

Lister, Martin, Jon Dovey, Seth Giddings, Iain Grant, and Kieran Kelly. *New Media: A Critical Introduction*. Routledge, 2009.

Löhr, Wolf-Dietrich. "Werk/Werkbegriff." In *Metzler Lexikon Kunstwissenschaft*, ed. U. Pfisterer. Metzler, 2003.

Lombard, Matthew, and Theresa Ditton. "At the Heart of It All: The Concept of Presence." *Journal of Computer-Mediated Communication* 3, no. 2 (1997) (at http://dx.doi.org).

Lovink, Geert. *Zero Comments: Blogging and Critical Internet Culture*. Routledge, 2008.

Lovink, Geert, and Pit Schultz. "Der Sommer der Netzkritik. Brief an die Casseler" (n.d.) (at http://www.thing.desk.nl).

Löw, Martina. *Raumsoziologie*. Suhrkamp, 2001.

Löw, Martina. "Constitution of Space. The Structuration of Spaces through the Simultaneity of Effect and Perception." *European Journal of Social Theory* 11 (2008), no. 1: 25–49.

Lozano-Hemmer, Rafael, and Cecilia Gandarias, eds. *Rafael Lozano-Hemmer: Some Things Happen More Often Than All of the Time*. Turner, 2007.

Luhmann, Niklas. *Social Systems*. Stanford University Press, 1995.

Lüthy, Michael. "Die eigentliche Tätigkeit. Aktion und Erfahrung bei Bruce Nauman." In *Auf der Schwelle*, ed. E. Fischer-Lichte et al. Fink, 2006.

Lyotard, Jean-François. "Time Today." 1987. In Lyotard, *The Inhuman: Reflections on Time*. Stanford University Press, 1991.

Maag, Georg. "Erfahrung." In *Ästhetische Grundbegriffe, historisches Wörterbuch in sieben Bänden*, volume 2, ed. K. Barck. Metzler, 2001.

Manovich, Lev. "Post-media aesthetics" (2001) (at http://www.manovich.net).

Manovich, Lev. *The Language of New Media*. MIT Press, 2001.

Massumi, Brian. *Parables for the Virtual: Movement, Affect, Sensation*. Duke University Press, 2002.

Massumi, Brian. "The Thinking-Feeling of What Happens." In *Interact or Die!* ed. J. Brouwer and A. Mulder. V2_NAi, 2007.

Mateas, Michael. Interactive Drama, Art, and Artificial Intelligence. PhD thesis, Carnegie Mellon University, 2002 (at http://www.cs.cmu.edu).

Mateas, Michael. "A Preliminary Poetics for Interactive Drama and Games." In *First Person*, ed. N. Wardrip-Fruin and P. Harrigan. MIT Press, 2004.

Mayer, Paul A., ed. *Computer Media and Communication: A Reader*. Oxford University Press, 1999.

McKenzie, Jon. *Perform or Else: From Discipline to Performance*. Routledge, 2001.

McLuhan, Marshall. *Understanding Media: The Extensions of Man*. Routledge, 1964.

Mead, George Herbert. "Social Psychology as Counterpart to Physiological Psychology." *Psychological Bulletin* 6 (1909), no. 12: 401–408.

Mersch, Dieter. *Ereignis und Aura. Untersuchungen zu einer Ästhetik des Performativen*. Suhrkamp, 2002.

Mersch, Dieter. *Was sich zeigt. Materialität, Präsenz, Ereignis*. Fink, 2002.

Mersch, Dieter. "Wort, Bild, Ton, Zahl—Modalitäten medialen Darstellens." In Mersch, *Die Medien der Künste. Beiträge zur Theorie des Darstellens*. Fink, 2003.

Mersch, Dieter. "Medialität und Kreativität. Zur Frage künstlerischer Produktivität." In *Bild und Einbildungskraft*, ed. B. Hüppauf and C. Wulf. Fink, 2006.

Mesch, Claudia, and Viola Michely, eds. *Joseph Beuys: The Reader*. I. B. Tauris, 2007.

Metz, Christian. *The Imaginary Signifier: Psychoanalysis and the Cinema*. Indiana University Press, 1982.

Milroy, Sarah. "Where Tech Gives Way to the Exquisite." *Globe and Mail*, April 8, 2004.

Molderings, Herbert. *Duchamp and the Aesthetics of Chance: Art as Experiment*. Columbia University Press, 2010.

Montola, Markus, Jaakko Stenros, and Annika Waern. *Pervasive Games: Theory and Design*. Morgan Kaufmann, 2009.

Morse, Margaret. *Virtualities: Television, Media Art and Cyberculture*. Indiana University Press, 1998.

Morse, Margaret. "Lynn Hershman's *Room of One's Own*" (1995). PDF version available on DVD acompanying Meredith Tromble, *The Art and Films of Lynn Hershman Leeson: Secret Agents, Private I*. University of California Press, 2005.

Mörth, Ingo, and Cornelia Hochmayr. *Rezeption interaktiver Kunst. Endbericht des Forschungspraktikums aus Kultur & Mediensoziologie 2007/2008* (at http://www.jku.at).

Muller, Lizzie. "Towards an Oral History of New Media Art" (2008) (at http://www.fondation -langlois.org).

Muller, Lizzie. "Collecting Experience: The Multiple Incarnations of Very Nervous System." In *New Collecting. Audiences and Exhibitions ofter New Media Art*, ed. B. Graham. Ashgate, forthcoming.

Muller, Lizzie, and Caitlin Jones. "David Rokeby, Giver of Names, Documentary Collection" (2008) (at http://www.fondation-langlois.org).

Munster, Anna. *Materializing New Media: Embodiment in Information Aesthetics*. Dartmouth College Press, 2006.

Murray, Janet. *Hamlet on the Holodeck: The Future of Narrative in Cyberspace*. MIT Press, 1997.

Myers, Brad A. "A Brief History of Human Computer Interaction Technology." *ACM Interactions* 5 (1998), no. 2: 44–54.

Nelson, Theodor Holm. "Getting It Out of Our System." In *Information Retrieval: A Critical View*, ed. G. Schecter. Thomson Books, 1967.

Nelson, Theodor Holm. *Literary Machines*. Mindful, 1994.

Neuberger, Christoph. "Interaktivität, Interaktion, Internet. Eine Begriffsanalyse." *Publizistik* 52 (2007), no. 1: 33–50.

Norden, Eric. "The Playboy Interview: Marshall McLuhan." *Playboy*, March 1969

Norman, Donald A. *The Design of Everyday Things*. Basic Books, 1988.

Nöth, Winfried. *Handbook of Semiotics*. Indiana University Press, 1995.

Nowotny, Helga. *Time: The Modern and Postmodern Experience*. Blackwell, 1994.

Paik, Nam June. "About the Exposition of Music." *Décollage* 3 (1962), n.p.

Panofsky, Erwin. "Introduction: The History of Art as a Humanistic Discipline" (1939). In Panofsky, *Meaning in the Visual Arts*. Doubleday, 1955.

Paul, Christiane. *Digital Art*. Thames & Hudson, 2008.

Paul, Christiane, ed. *New Media in the White Cube and Beyond: Curatorial Models for Digital Art*. University of California Press, 2008.

Paß, Dominik. *Bewußtsein und Ästhetik. Die Faszination der Kunst*. Aisthesis-Verlag, 2006.

Penny, Simon. "Bridging Two Cultures: Towards an Interdisciplinary History of the Artist-Inventor and the Machine-Artwork." In *Artists as Inventors and Inventors as Artists*, ed. D. Daniels and B. Schmidt. Hatje Cantz, 2008.

Pfaller, Robert. *Ästhetik der Interpassivität*. Philo Fine Arts, 2008.

Piehler, Heike. *Die Anfänge der Computerkunst*. dot-Verlag, 2002.

Poonkhin Khut, George. "Interactive Art as Embodied Inquiry: Working with Audience Experience." In *Engage: Interaction, Art and Audience Experience*, ed. E. Edmonds et al. Creativity and Cognition Studios Press, 2006.

Popper, Frank. *Origins and Development of Kinetic Art*. Studio Vista, 1968.

Popper, Frank. *Art, Action and Participation*. Studio Vista, 1975.

Popper, Frank. *Art of the Electronic Age*. Thames & Hudson, 1993.

Pudelek, Jan-Peter. "Werk." In *Ästhetische Grundbegriffe*, volume 6, ed. K. Barck. Metzler, 2005.

Quintavalle, Arturo Carlo. *Enzo Mari*. Università di Parma, 1983.

Rancière, Jacques. "The Emancipated Spectator." In Rancière, *The Emancipated Spectator*. Verso, 2009.

Rebentisch, Juliane. *Ästhetik der Installation*. Suhrkamp, 2003.

Reck, Hans Ulrich. *Mythos Medienkunst*. König. 2002.

Reichardt, Jasia, ed. *Cybernetic Serendipity: The Computer and the Arts*. Studio International, 1968.

Reichardt, Jasia. "Cybernetics, Art and Ideas." In *Cybernetics, Art and Ideas*, ed. J. Reichardt. Studio Vista, 1971.

Reichardt, Jasia. "Art at Large." *New Scientist*, May 4, 1972: 292.

Rennert, Susanne, and Stephan von Wiese, eds. *Ingo Günther, REPUBLIK.COM*. Hatje Cantz, 1998.

Resch, Christine, and Heinz Steinert. *Die Widerständigkeit der Kunst. Entwurf einer Interaktions-Ästhetik*. Westfälisches Dampfboot, 2003.

Rheingold, Howard. *Virtual Reality*. Summit Books, 1991.

Rieck, Christian. *Spieltheorie. Einführung für Wirtschafts- und Sozialwissenschaftler*. Rieck, 1993.

Riesinger, Robert F., ed. *Der kinematographische Apparat. Geschichte und Gegenwart einer interdisziplinären Debatte*. Nodus, 2003.

Robinson, Julia. "In the Event of George Brecht." In *George Brecht: Events*, ed. A. Fischer. König, 2005.

Rokeby, David. "The Harmonics of Interaction." In *Musicworks 46: Sound and Movement* (1990) (at http://www.davidrokeby.com).

Rokeby, David. "Transforming Mirrors: Subjectivity and Control in Interactive Media." In *Critical Issues in Electronic Media*, ed. S. Penny. State University of New York Press, 1995.

Rokeby, David. "The Construction of Experience: Interface as Content." In *Digital Illusion: Entertaining the Future with High Technology*, ed. C. Dodsworth. Addison-Wesley, 1998.

Rosenberg, Harold. "The American Action Painters." *Art News* 51, no. 5, (September 1952). Cited in Henry Geldzahler, *New York Painting and Sculpture: 1940–1970* (Dutton, 1969).

Ross, Edward Alsworth. *Social Psychology: An Outline and Source Book*. Macmillan, 1909.

Rötzer, Florian, ed. *Digitaler Schein. Ästhetik der elektronischen Medien*. Suhrkamp, 1991.

Rötzer, Florian. "Kunst Spiel Zeug. Einige unsystematische Anmerkungen." In *Künstliche Spiele*, ed. G. Hartwanger et al. Boer, 1993.

Rousseau, Jean-Jacques. *The Reveries of the Solitary Walker*. Hackett, 1992.

Ruhrberg, Karl, ed. *Nicolas Schöffer. Kinetische Plastik, Licht, Raum*. Städtische Kunsthalle Düsseldorf, 1968.

Ryan, Marie-Laure. *Narrative as Virtual Reality, Immersion and Interactivity in Literature and Electronic Media*. Johns Hopkins University Press, 2001.

Salen, Katie, and Eric Zimmerman. *Rules of Play: Game Design Fundamentals*. MIT Press, 2004.

Salter, Chris. *Entangled: Technology and the Transformation of Performance*. MIT Press, 2010.

Sandbothe, Mike. "Media Temporalities in the Internet: Philosophy of Time and Media with Derrida and Rorty." *AI & Society* 13, no. 4 (2000): 421–434.

Sandbothe, Mike. "Linear and Dimensioned Time: A Basic Problem in Modern Philosophy of Time" (2002) (at http://www.sandbothe.net).

Sarkis, Mona. "Interactivity means Interpassivity." *Media Information Australia* 69 (1993), August: 13–16.

Schaller, Julius. *Das Spiel und die Spiele. Ein Beitrag zur Psychologie und Pädagogik wie zum Verständnis des geselligen Lebens*. Böhlau, 1861.

Schechner, Richard. "Approaches" (1966). In Schechner, *Performance Theory*. Routledge, 2003.

Schechner, Richard. "Actuals" (1970). In Schechner, *Performance Theory*. Routledge, 2003.

Schechner, Richard. *Environmental Theater*. Hawthorn, 1973.

Schechner, Richard. *Performance Theory* (1977). Routledge, 2003.

Schechner, Richard. *Between Theater and Anthropology*. University of Pennsylvania Press, 1989.

Scheps, Marc. *Agam. Le salon de l'élysée*. Editions du Centre Pompidou, 2007.

Scheuerl, Hans. *Das Spiel. Untersuchungen über sein Wesen, seine pädagogischen Möglichkeiten und Grenzen*. (1954). Beltz, 1968.

Scheuerl, Hans. "Spiel—ein menschliches Grundverhalten?" (1974). In *Das Spiel. Theorien des Spiels*, volume 2. Beltz, 1997.

Schiller, Friedrich. *On the Aesthetic Education of Man*. Dover, 2004.

Schimmel, Paul. "Leap into the Void. Performance and the Object." In *Out of Actions: Between Performance and the Object, 1949–1979*, ed. R. Ferguson and P. Schimmel. Thames & Hudson, 1998.

Schimmel, Paul. "'Only Memory Can Carry It into the Future': Kaprow's Development from the Action-Collages to the Happenings." In *Allan Kaprow—Art as Life*, ed. E. Meyer-Hermann, A. Perchuk, and S. Rosenthal. Thames & Hudson, 2008.

Schneede, Uwe M. *Die Geschichte der Kunst im 20. Jahrhundert. Von den Avantgarden bis zur Gegenwart*. Beck, 2001.

Schöffer, Nicolas. "Le Spatiodynamisme." Lecture at Amphithéâtre Turgot, June 19, 1954 (at http://www.olats.org).

Schöffer, Nicolas. "Die Zukunft der Kunst. Die Kunst der Zukunft." In *Nicolas Schöffer. Kinetische Plastik. Licht. Raum*. Städtische Kunsthalle Düsseldorf, 1968.

Schulte-Sasse, Jochen. "Medien." In *Ästhetische Grundbegriffe*, volume 4, ed. K. Barck. Metzler, 2002.

Schulz-Schaeffer, Ingo. "Akteur-Netzwerk-Theorie. Zur Koevolution von Gesellschaft, Natur und Technik." In *Soziale Netzwerke. Konzepte und Methoden der sozialwissenschaftlichen Netzwerkforschung*, ed. J. Weyer. R. Oldenbourg Verlag, 2000.

Schwarz, Hans-Peter. "Retroactive and Interactive Media Art. On the Works of Agnes Hegedüs." In *Agnes Hegedüs—Interactive Works*. Zentrum für Kunst und Medientechnologie, 1995.

Schwarz, Hans Peter, ed. *Media—Art—History*. Prestel, 1997.

Searle, John R. "How Performatives Work." *Linguistics and Philosophy* 12 (1989), no. 5: 535–558.

Seel, Martin. *Aesthetics of Appearing*. Stanford University Press, 2005.

Seiffarth, Carsten, Ingrid Beirer, and Sabine Himmelsbach, eds. *Paul DeMarinis: Buried in Noise*. Kehrer, 2010.

Shanken, Edward A. "Historicizing Art and Technology: Forging a Method and Firing a Canon." In *MediaArtHistories*, ed. O. Grau. MIT Press, 2007.

Shanken, Edward A. *Art and Electronic Media*. Phaidon, 2009.

Shaw, Jeffrey. "Modalitäten einer interaktiven Kunstausübung." *Kunstforum International* 103: *Im Netz der Systeme* (1989): 204–209.

Shaw, Jeffrey, and Peter Weibel, eds. *Future Cinema: The Cinematic Imaginary after Film*. MIT Press, 2003.

Sheridan, Thomas B. "Further Musings on the Psychophysics of Presence." *Presence* 1 (1992): 120–126.

Simanowski, Roberto. "Hypertext. Merkmal, Forschung, Poetik." *dichtung-digital* 24 (2002) (at http://www.brown.edu).

Simanowski, Roberto. *Digitale Medien in der Erlebnisgesellschaft: Kunst, Kultur, Utopien*. Rowohlt, 2008.

Simanowski, Roberto. "Event and Meaning. Reading Interactive Installations in the Light of Art History." In *Beyond the Screen*, ed. J. Schäfer and P. Gendolla. Transcript, 2009.

Sommerer, Christa, and Laurent Mignonneau. *Interactive Art Research*. Springer, 2009.

Sommerer, Christa, and Laurent Mignonneau. "Interacting with Artificial Life. A-Volve" (1997). In Sommerer, and Mignonneau, *Interactive Art Research*. Springer, 2009.

Sonderegger, Ruth. *Für eine Ästhetik des Spiels. Hermeneutik, Dekonstruktion und der Eigensinn der Kunst*. Suhrkamp, 2000.

Sontag, Susan. "Happenings: An Art of Radical Juxtaposition" (1962). In Sontag, *Against Interpretation and Other Essays*. Farrar, Straus and Giroux, 1966.

Sontag, Susan. "Against Interpretation" (1964). In Sontag, *Against Interpretation and Other Essays*. Farrar, Straus and Giroux, 1966.

Spies, Werner. "Karambolagen mit dem Nichts. Jean Tinguelys metamechanische Ironie" (1989). In *Zwischen Action Painting und Op Art*. Volume 8 of *Gesammelte Schriften zu Kunst und Literatur*. Berlin University Press, 2008.

Star, Susan Leigh, and James R. Griesemer. "Institutional Ecology, 'Translations' and Boundary Objects: Amateurs and Professionals in Berkeley's Museum of Vertebrate Zoology." *Social Studies of Science* 19, no. 3 (1989): 387–420.

Stepath, Katrin. *Gegenwartskonzepte. Eine philosophisch-literaturwissenschaftliche Analyse temporaler Strukturen*. Königshausen & Neumann, 2006.

Stocker, Gerfried and Christine Schöpf, eds. "New Media Art. What Kind of Revolution?" In *Infowar—Information.power.war*. Ars Electronica 1998 festival catalog, volume 1. Springer, 1998.

Stoichiţă, Victor. *The Self-Aware Image: An Insight into Early Modern Meta-Painting*. Cambridge University Press, 1997.

Stone, Allucquere Rosanne. "Will the Real Body Please Stand Up? Boundary Stories about Virtual Cultures" (1991). In *Computer Media and Communication*, ed. P. Mayer. Oxford University Press, 1999.

Strunk, Marion. "Vom Subjekt zum Projekt: Kollaborative Environments." *Kunstforum International* 152: *Kunst ohne Werk* (2000): 120–133.

Suchman, Lucy A. *Human-Machine Reconfigurations: Plans and Situated Actions*. Cambridge University Press, 2007.

Sutherland, Ivan Edward. Sketchpad: A Man-Machine Graphical Communication System. PhD dissertation, Massachusetts Institute of Technology, 1963 (at http://www.cl.cam.ac.uk).

Sutton, Leah A. "Vicarious Interaction. A Learning Theory for Computer Mediated Communications" (2000) (at http://www.eric.ed.gov).

Sutton-Smith, Brian. *The Ambiguity of Play*. Harvard University Press, 1997.

Thiemann, Eugen, ed. *Participation. À la recherche d'un nouveau spectateur. Groupe de Recherche d'Art Visuel*. Museum am Ostwall, 1968.

Thürlemann, Felix. "Bruce Nauman, 'Dream Passage.' Reflexion über die Wahrnehmung des Raumes." In *Vom Bild zum Raum. Beiträge zu einer semiotischen Kunstwissenschaft*. DuMont, 1990.

Tinsobin, Eva. *Das Kino als Apparat. Medientheorie und Medientechnik im Spiegel der Apparatusdebatte*. Verlag Werner Hülsbusch, 2008.

Tromble, Meredith. *The Art and Films of Lynn Hershman Leeson: Secret Agents, Private I*. University of California Press, 2005.

Ursprung, Philip. *Grenzen der Kunst. Allan Kaprow und das Happening. Robert Smithson und die Land Art*. Schreiber, 2003.

Vertov, Dziga. *Kino-Eye: The Writings of Dziga Vertov*. University of California Press, 1984.

Virilio, Paul. *The Vision Machine*. Indiana University Press, 1994.

von Hantelmann, Dorothea. "Inszenierung des Performativen in der zeitgenössischen Kunst." *Paragrana* 10 (2001), no. 1: 255–270.

von Loesch, Heinz. "Virtuosität als Gegenstand der Musikwissenschaft." In *Musikalische Virtuosität. Perspektiven musikalischer Theorie und Praxis*, ed. H. von Loesch, U. Mahlert, and P. Rummenhöller. Schott, 2004.

Voss, Christiane. "Fiktionale Immersion." *montage AV* 17 (2008), February: 69–86.

Wagner, Ellen D. "In Support of a Functional Definition of Interaction." *American Journal of Distance Education* 8 (1994), no. 2: 6–29.

Wagner, Monika. *Das Material der Kunst*. Beck, 2001.

Wardrip-Fruin, Noah, and Pat Harrigan, eds. *First Person: New Media as Story, Performance, and Game*. MIT Press, 2004.

Wardrip-Fruin, Noah. *Expressive Processing: Digital Fictions, Computer Games, and Software Studies*. MIT Press, 2009.

Weibel, Peter, in conversation with Gerhard Johann Lischka. "Polylog. Für eine interaktive Kunst." *Kunstforum International* 103: *Im Netz der Systeme* (1989): 65–86.

Weinbren, Grahame. "An Interactive Cinema: Time, Tense and Some Models." *New Observations* 71 (1989): 10–15.

Weinhart, Martina. "Im Auge des Betrachters. Eine kurze Geschichte der Op Art." In *Op Art*, ed. M. Weinhart and M. Hollein. König, 2007.

Welsch, Wolfgang. "Das Ästhetische—Eine Schlüsselkategorie unserer Zeit?" In *Die Aktualität des Ästhetischen*. Fink, 1993.

Wiener, Norbert. *The Human Use of Human Beings: Cybernetics and Society* (1950). Da Capo, 1954.

Wilson, Stephen. *Information Arts*. MIT Press, 2002.

Wittgenstein, Ludwig. *Philosophical Investigations*. Blackwell, 1953.

Wunderlich, Antonia. *Der Philosoph im Museum. Die Ausstellung "Les Immateriaux" von Jean François Lyotard*. Transcript, 2008.

Wysocka, Elżbieta. "Agatha re-Appears" (2008) (at http://www.incca.org).

Youngblood, Gene. "Metadesign." In *Digitaler Schein*, ed. F. Rötzer. Suhrkamp, 1991.

Zielinski, Siegfried. "Einige historische Modelle des audiovisuellen Apparats." In *Der kinematographische Apparat*, ed. R. Riesinger. Nodus, 2003.

Zijlmans, Kitty. "Kunstgeschichte als Systemtheorie." In *Gesichtspunkte. Kunstgeschichte heute*, ed. M. Halbertsma and K. Zijlmans. Reimer, 1995.

Zivanovic, Aleksandar. "The Technologies of Edward Ihnatowicz." In *White Heat, Cold Logic: British Computer Art 1960–1980*, ed. P. Brown et al. MIT Press, 2008.

Artist interviews and statements

0100101110101101.org (Tilman Baumgärtel). In Tilman Baumgärtel, *net.art 2.0*. Verlag für moderne Kunst, 2001.

Adams, Matt (Katja Kwastek, Linz, 2009). Recording and transcript in the author's archives.

Adrian X, Robert (Dieter Daniels, Linz, 2009) (at http://www.netzpioniere.at).

Andessner, Amel und Elisa (Katja Kwastek, Linz, 2007). Recording and transcript in the author's archives.

Berkenheger, Susanne (Wolfgang Tischer). In *Literatur Café*, 27.01.2008 (at http://www.literaturcafe.de).

Cillari, Sonia (Sebastian Führlinger, Linz, 2007). Recording and transcript in the author's archives.

Fuller, Matthew (Tilman Baumgärtel). In Tilman Baumgärtel, *net.art. Materialien zur Netzkunst*. Verlag für moderne Kunst, 1999.

Garrin, Paul (Tilman Baumgärtel). In Tilman Baumgärtel, *net.art. Materialien zur Netzkunst*. Verlag für moderne Kunst, 1999.

Hershman, Lynn (Katja Kwastek, San Francisco, 2007). Recording and transcript in the author's archives.

Kummer, Christoph (Tilman Baumgärtel). In Tilman Baumgärtel, *net.art 2.0*. Verlag für moderne Kunst, 2001.

Levin, Golan (Katja Kwastek and Lizzie Muller, Linz, 2009) (at http://www.fondation-langlois.org).

Lialina, Olia (Tilman Baumgärtel). In Tilman Baumgärtel, *net.art, Materialien zur Netzkunst*. Verlag für moderne Kunst, 1999.

Mark, Helmut (Dieter Daniels, Linz, 2009) (at http://www.netzpioniere.at).

Rokeby, David (Douglas Cooper, 1995). In *Wired 3.03* (at http://www.wired.com).

Rokeby, David (Lizzie Muller and Caitlin Jones, Linz, 2009) (at http://www.fondation-langlois.org).

Scher, Julia (Tilman Baumgärtel). In Tilman Baumgärtel, *net.art 2.0*. Verlag für moderne Kunst, 2001.

Sermon, Paul (Ars Electronica, Linz, 1999) (at http://www.hgb-leipzig.de).

Shulgin, Alexej (Tilman Baumgärtel, Ljubljana 1997) (at http://www.intelligentagent.com).

Snibbe, Scott (Katja Kwastek, San Francisco, 2007). Recording and transcript in the author's archives.

Staehle, Wolfgang (Dieter Daniels, Linz, 2009) (at http://www.netzpioniere.at).

Sukumaran, Ashok (Statement, Prix Forum Interactive Art, Ars Electronica Festival, Linz, 2007). Recording in archive of Ars Electronica.

van der Cruijsen, Walter (Tilman Baumgärtel). In Baumgärtel, *net.art. Materialien zur Netzkunst*. Verlag für moderne Kunst, 1999.

Weinbren, Grahame (Katja Kwastek, New York, 2007). Recording and transcript in author's archives.

Visitor interviews

Blast Theory. Interviews with Alexander, Bettina, Christopher, Claudia, Heidi, Jakob (Gabriella Giannachi, Katja Kwastek, and Ingrid Spörl, Linz, 2009). Recording and transcript in author's archives.

Rokeby, David. Video-cued recall interviews with Birgitt, Elfi, Markus, Susanna (Lizzie Muller and Katja Kwastek, Linz, 2009) (at http://www.fondation-langlois.org).

Tmema (Golan Levin and Zachary Lieberman). Video-cued recall interviews with Heidi, Francisco, Helmut (Katja Kwastek and Ingrid Spörl, Linz, 2009) (at http://www.fondation-langlois.org).

Index